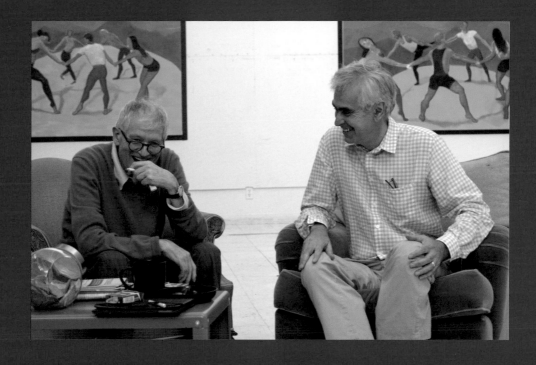

A History of Pictures

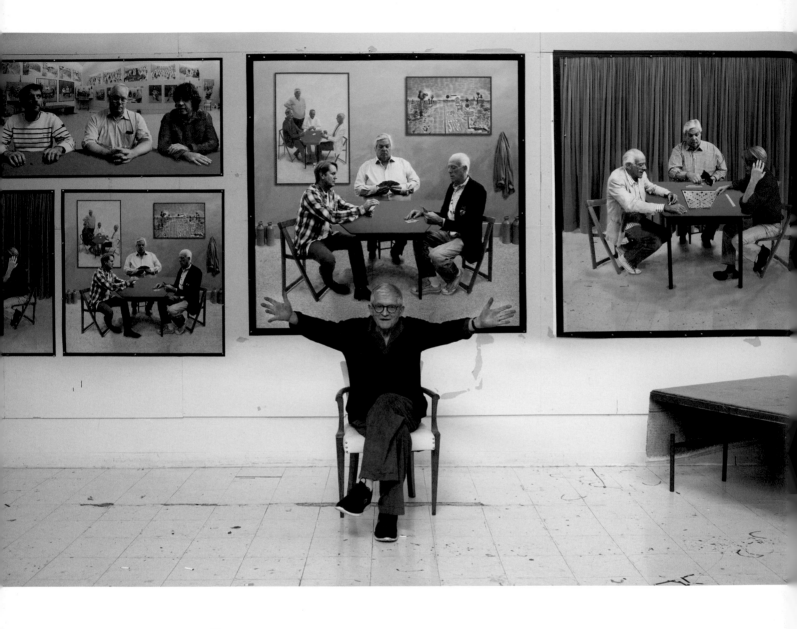

A History of Pictures

From the Cave to the Computer Screen

David Hockney & Martin Gayford

Thames & Hudson

Page 1: David Hockney and Martin Gayford, Los Angeles,
August 2014. Photo: Jean-Pierre Gonçalves de Lima
Page 2: David Hockney in his studio with his new Photographic
Drawings, 27 February 2015. Photo: Richard Schmidt

First published in the United Kingdom in 2016
by Thames & Hudson Ltd, 181A High Holborn,
London WC1V 7QX

British Library Cataloguing-in-Publication Data
A catalogue record for this book is available from the British Library

ISBN 978-0-500-23949-0

Printed and bound in China by C&C Offset Printing Co. Ltd

To find out about all our publications, please visit
www.thamesandhudson.com.
There you can subscribe to our e-newsletter, browse or download
our current catalogue, and buy any titles that are in print.

Contents

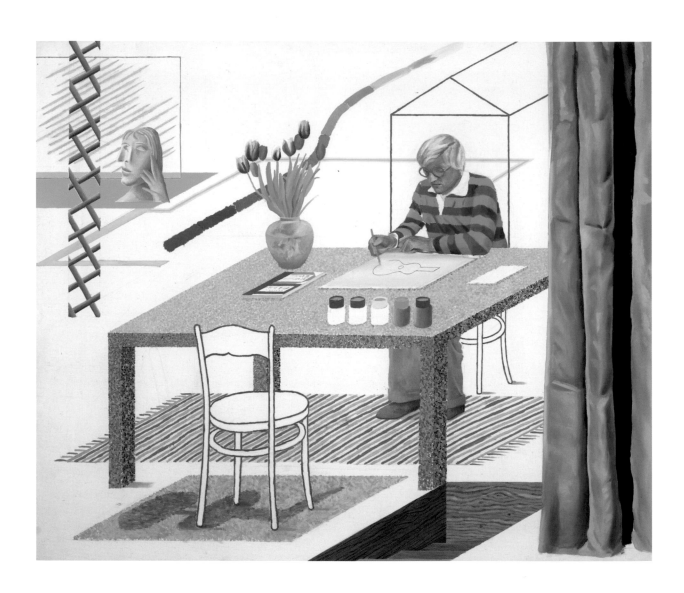

DAVID HOCKNEY
Self-Portrait with Blue Guitar,
1977
Oil on canvas

Preface

Pictures are all around us: on laptops, phones, in magazines, newspapers, books such as this and even – still – hanging on walls. It is through pictures just as much as words that we think, dream and try to comprehend the people and environment around us.

Until now, however, pictures have seldom been considered as a single category in themselves. There are plenty of histories of different *types* of picture, such as painting, photography or film. But not of pictures as a whole – by which we mean representations of the three-dimensional world on flat surfaces such as canvas, paper, cinema screens and smartphones. The continuities and interactions between those differing varieties of depiction are the subject of this book.

Secret Knowledge (2001) pointed to one of the most important. It proposed that European painters had been familiar with images projected by lenses and mirrors – the kind we associate with photography – for centuries before the official birth date of photography, 1839. *A History of Pictures* develops that argument, supports it with fresh evidence and puts it in a wider context. This is a global story but it concentrates on the two traditions that have aimed to capture the world around us – extending in time and space – in two dimensions: the occidental one of Egypt, Europe and the USA, and the quite different approach of China and Japan. It is a narrative that originates in prehistoric caves and is still unfolding.

David Hockney and Martin Gayford

Introduction: Pictures, Art and History

Any picture is an account of looking at something.

DH I once saw a wonderful painting of an owl by Picasso. Today, I suppose, an artist might just stuff the bird and put it in a case: taxidermy. But Picasso's owl is an account of a human being looking at an owl, which is a lot more interesting than a preserved specimen.

 Any picture is an account of looking at something. Pictures are very, very old. They may be older than language. The first person to draw a little animal was watched by someone else, and when that other person saw that creature again, he would have seen it a bit more clearly. That's true of the bull painted in a cave in southwestern France 17,000 years ago. The image was that artist's testimony, made on a surface, of seeing this creature, not the thing itself. That's all a picture can be.

 Every picture ever made has rules, even the ones made by a surveillance camera in a car park. There's a limit to what it can see. Someone has put it there, arranged that it would cover a certain area. There is nothing automatic about it: someone had to choose its point of view.

MG In other words, every picture – good or bad, and even if it does not seem so – presents a personal angle on reality. That's true of this book. It's an individual view of the history of pictures from the standpoint of its two authors: one a painter, the other a critic and biographer of artists. Our aim is to tell the story, and explain the evolution, of picture-making through the eyes of someone who makes pictures and a writer fascinated by how they are made. It is a book that grew out of conversations, so it contains two voices, each adding to the discussion. The subject is looked at through two pairs of eyes; and inevitably each gaze is from a particular vantage point. We hope in this way to write something new: an account of how people have made visual representations of the world around them for thousands of years – and how those are seen by us, right now.

PABLO PICASSO
The Owl, 1952
Oil on canvas

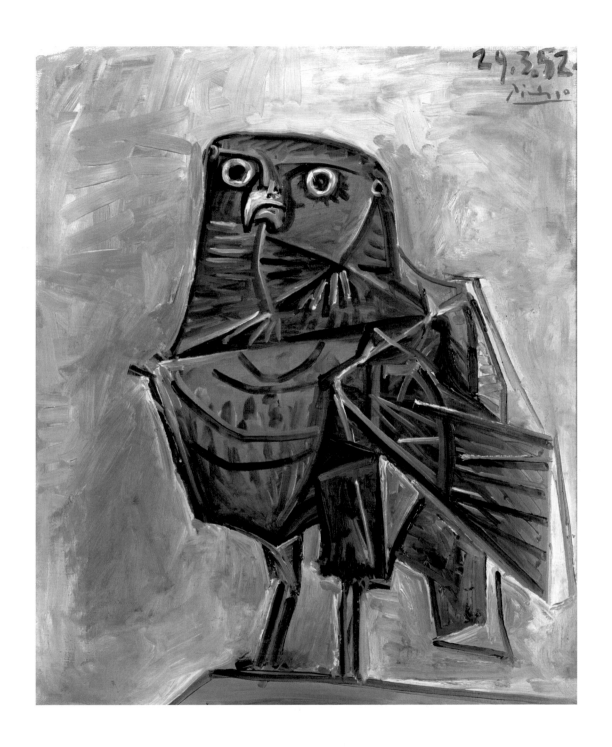

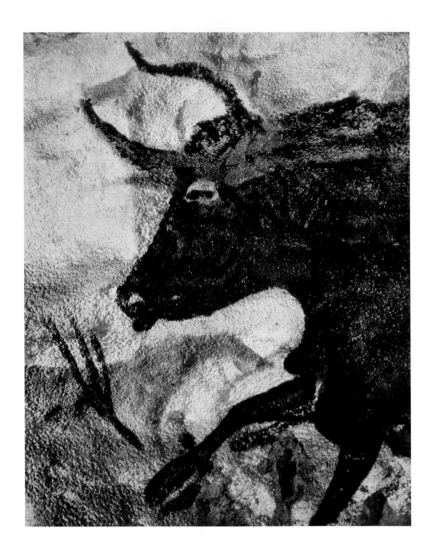

When pictures are discussed they are usually divided into categories based on the methods by which they were made: painting, drawing, mosaic, photograph, film, animation, cartoon, comic strip, collage, computer game. Alternatively, pictures are classified by style and period, such as baroque, classical or modernist. Some of these are regarded as art, and some are not.

DH What makes a work of art? I don't know. There are lots of people who tell you they are making art. Maybe some of them are, but I'm not sure that's true for all of them. Perhaps I'm old fashioned, but that's not a phrase I would use. I'd prefer to say I'm making pictures – depictions. We've had a great many histories of art, what we need now is a history of pictures.

MG The history of pictures overlaps with the history of art, but it is not the same. Art contains much that does not count as a depiction: decoration and abstraction, for example, but also excludes other types of image.

DH Photography and film are a big part of the history of pictures, but nonetheless I question photography. A lot of people don't, they accept the world looks like a photograph. I think it nearly does, but it doesn't entirely. I think it's actually a lot more exciting than that. What's more, we don't have to view the world in the way a lens does; two human eyes and brain do not naturally see in that way. That is the reason why I have made some of my own works with cameras, and why I wrote the book *Secret Knowledge* sixteen years ago. My original title for that was *Lost Knowledge*. I think knowledge can be lost, and found again.

MG In *Secret Knowledge* it was claimed that the spirit of photography was far older than 1839. The argument was that European artists were looking at, and using, images projected by lenses and mirrors for centuries before a practical method of fixing the image came into use. In this book, we contend that this was part of a deep interconnection through time.

DH That complete history has never been told before as a single story. Photography is part of that history, and the cinema is also about pictures. When I was young the cinema wasn't called the cinema – or the movies, that's an American term. It was always the pictures: Can we go to the pictures, Mum?

MG Pictures was also the term used by the scientist John Herschel when Louis-Jacques-Mandé Daguerre showed him the first daguerreotypes in Paris. On 9 May 1839, Herschel wrote to his friend William Henry Fox Talbot in England, having 'this moment left Daguerre's who was so obliging as to shew us all his Pictures on Silver'. Herschel did not call the images he saw 'daguerreotypes' or 'photographs', for neither term had yet been coined (the latter was Herschel's own invention). His initial reaction, shared by many who saw early photographs, was that this was a wonderful new kind of *picture.*

DH He thought they were fantastic. They would have looked amazing, those first daguerreotypes, crisp and sharp. Talbot's first attempts were faint and blurry in comparison. In Bradford, as a boy, I remember noticing the shadows in Laurel and Hardy films; the one in which they are selling Christmas trees, for example. They were wearing overcoats, but there was a great big shadow on the ground. If there was that much sun, I thought, why would they be so overdressed?

Above
LOUIS DAGUERRE
*Still Life (Interior of a Cabinet
of Curiosities)*, 1837
Daguerreotype

Right
JAMES W. HORNE
Big Business, 1929, starring
Stan Laurel and Oliver Hardy
Film still

CARAVAGGIO
The Calling of Saint Matthew,
1599–1600
Oil on canvas

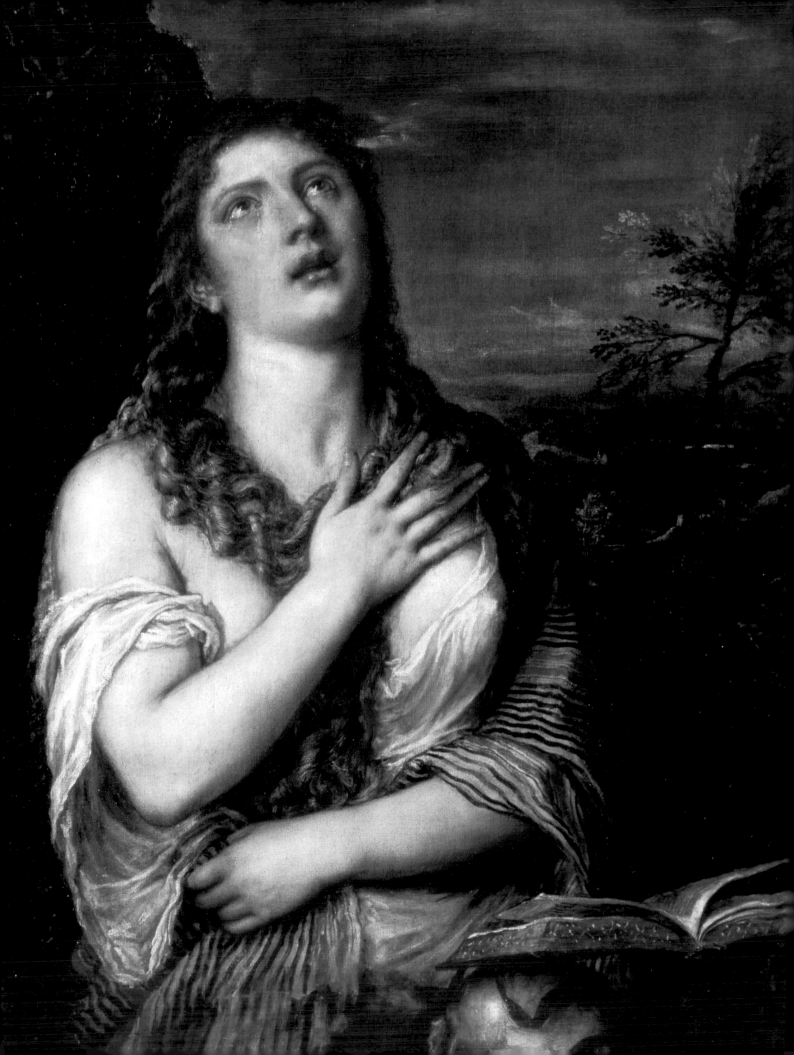

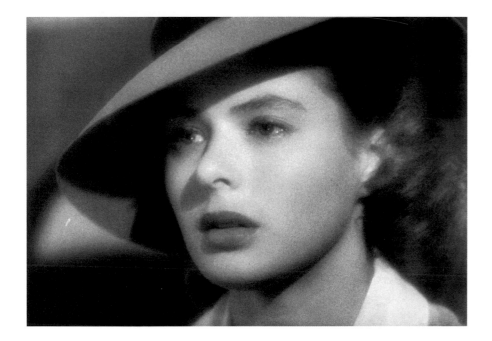

MG The Laurel and Hardy movie was made in Hollywood because the strong light of California was a boon to film-making. In other words, the makers of film were dealing with a problem that engaged the minds of many great painters, including Caravaggio and Leonardo da Vinci: lighting. More precisely, the question was how to illuminate the subject so as to make the most powerfully expressive picture.

DH In the movie *Casablanca*, from 1942, Ingrid Bergman's eyes glisten and have highlights in them. It's Hollywood at its slickest. The lighting is amazing. I know how difficult it was to set that up. Lighting men always studied painting.

MG Bergman looks, indeed, very much like a repentant Mary Magdalene in a 16th-century painting by a master such as Titian. The history of pictures spills over the normal boundaries between high and low culture, moving images and still ones, even good and bad ones.

DH Walt Disney was a great American artist. He might be a bit sentimental, but what he did was quite an achievement. Who were the most famous stars of the 1930s and 1940s? Mickey Mouse and Donald Duck. If you ask people about Hollywood films in the 1930s they start mentioning Humphrey Bogart, Clark Gable or Greta Garbo, but Mickey Mouse and Donald Duck are still there today.

Disney was a bit like Warhol in that he had a factory and didn't do all the work himself. The art world wouldn't like that comparison because they hate his schmaltziness, but that doesn't detract from his achievements with depiction.

If you get a disc of *Pinocchio* (1940) you can look at it frame by frame and see the amazing sequence from where Pinocchio goes into the whale's stomach with Geppetto. There they light a fire to make the thing belch, then there's a wonderful scene where they are thrown out of the whale. It comes after them, and the raft is on the water and in a storm until they are finally cast up on a beach. When I noticed how it was done, what they used for it, I was astonished. There are passages that look like Chinese art, with stylized waves and the sea represented with parallel strokes, and Japanese prints. They'd obviously also looked at photography of water. When Pinocchio and Geppetto are dumped on the shore, the water washes up with bubbles in it then sinks into the sand. It's fantastic.

MG Once you begin to look at the history of pictures as a continuum, you notice connections between images that come from very different times and places.

DH Look at the camels in *Adoration of the Kings* by Giotto, from the Scrovegni Chapel, Padua, painted in the early 14th century. There's Walt Disney.

MG As that example shows, the history we are considering does not move forward in straight lines. All pictures encounter certain problems – how to represent time and space, for example, or how to make a brush or pen mark look like a person or thing. For that reason we begin thematically, before going on to look at particular times and places more chronologically. But technologies come and go, and that alters the history of pictures. Since 1839 mass media – newspapers, moving pictures, talkies, television – have made the images of the lens ubiquitous.

DH Photography increasingly dominates the world, but it is changing, simply because the photograph itself is changing. Perhaps we are more aware that the digits have transformed photography, even that what was known as 'photography' is now over; it lasted about a hundred and sixty years.

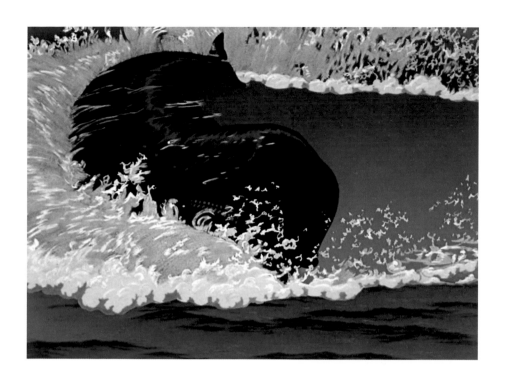

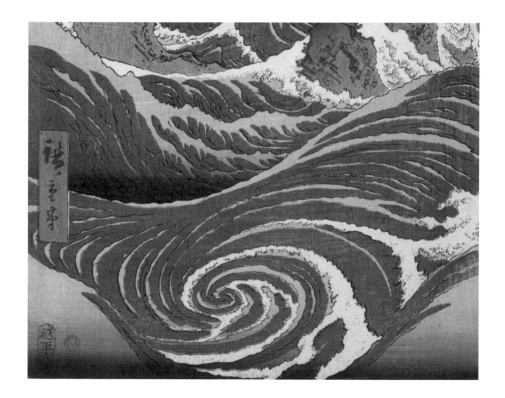

WALT DISNEY PRODUCTIONS
Pinocchio, 1940
Film still

UTAGAWA HIROSHIGE
Naruto Whirlpool, Awa Province (detail), *c.* 1853
Woodblock print

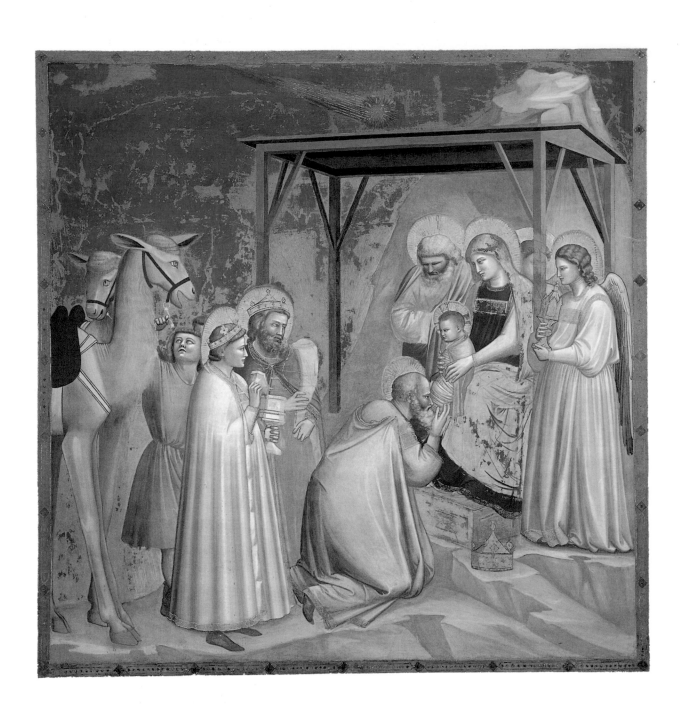

GIOTTO
Adoration of the Magi, 1305–06,
Scrovegni Chapel, Padua
Fresco

MG Essentially a way of fixing the image projected by a lens with chemicals, photography was discovered in the early 19th century, and lasted until the day before yesterday. Now the film, and the chemicals that went with it, have gone. Today, almost all photographs are taken digitally, and can be altered with enormous ease.

This is just the latest of many technical evolutions in the history of pictures, following the appearance of fresco, oil painting, print-making and many other technical innovations. In recent years, the ways in which pictures are created and the methods by which they are disseminated have altered at lightning speed. Never have so many pictures been made; billions are taken every year on smartphones and tablet computers.

DH Now everybody's a photographer. That's what's happened. Most people in the world have a mobile phone, and mobile phones have cameras. In just the same way, everybody has a movie camera, too. And you can edit the pictures on your phone in just a few minutes.

MG Pictures are changing, fast, in certain respects. More people are making them and editing them, more rapidly, than ever before. But they still remain two-dimensional depictions of the world.

DH People like pictures. They have powerful effects on the way we see the world around us. Most people have always preferred looking at pictures to reading, perhaps they always will. I think that humans like images even more than text. I like looking at the world and I've always been interested in how we see, and what we see.

MG This book is about just that: how we see, what we see, and the diverse ways in which those experiences have been translated onto a two-dimensional surface. Pictures are a way of representing the world – and also of understanding and examining it. That is, they are a form of knowledge and a means of communication. We can grasp instantly a great deal from an image. But what do they show? Reality or fiction? Truth or lies?

DH The history of pictures begins in the caves and ends, at the moment, with an iPad. Who knows where it will go next? But one thing is certain, the pictorial problems will always be there – the difficulties of depicting the world in two dimensions are permanent. Meaning, you never solve them.

1 Pictures and Reality

All pictures are made from a particular point of view.

DH Two dimensions don't really exist in nature. A surface only looks two dimensional because of our scale. If you were a little fly, a canvas or even a piece of paper would seem quite irregular, whereas to us, some things can be seen as flat. What's really flat in nature? Nothing. So the flatness of a picture is a bit of an abstraction. However, it is an abstraction that has consequences. Everything on a flat surface is stylized, including the photograph. Some people think the photograph is reality; they don't realize that it's just another form of depiction.

MG It is the essence of a picture that it is two dimensional, but attempts to represent three dimensions. In that respect a picture can be compared to a map. Indeed, a map is a highly specialized type of picture. The task of a map-maker is to describe the features of a curved object – the Earth – on a flat one. To do so with complete fidelity, as was demonstrated long ago, is a geometric impossibility. Therefore, all maps are flawed and partial, and reflect the interests and knowledge of the person who made them. The situation is analogous with that of pictures. They are all attempts to solve the same problems, to which a perfect solution is impossible. The imperfect solutions are infinite, however. Each attempt has its own virtues and drawbacks.

Like many medieval images of the world, a map made by a Venetian monk, Fra Mauro, in the mid-fifteenth century, places Jerusalem near the centre, the point from which all history was thought to radiate. Fifty years later, a map drawn by Johannes Ruysch in 1507 depicts an expanded view to include some of the discoveries made by Portuguese and Spanish explorers. It projects the world in the way the ancient geographer Claudius Ptolemy had suggested, as it would be if one cut

FRA MAURO
World map, *c.* 1450
Vellum
The map is shown with
south at the top

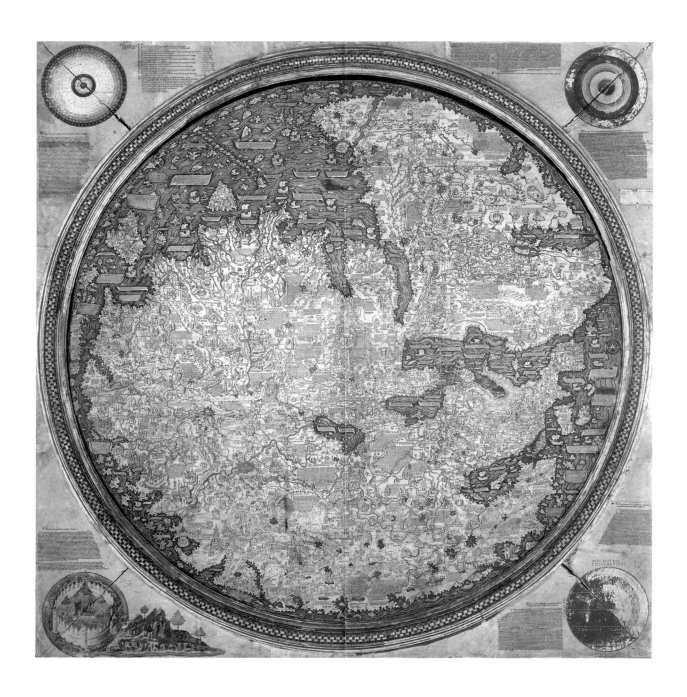

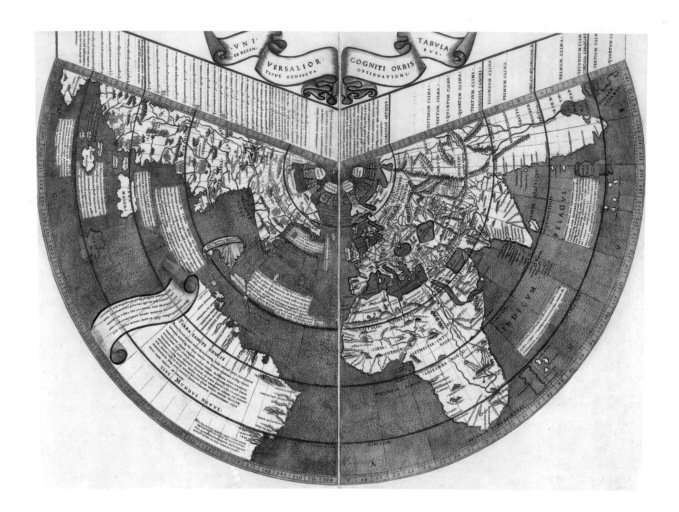

a paper cone open and pressed it down on a table. However, the world is not a cone.

Every map is made from a certain angle of vision. The ones we have been discussing were drawn from a European vantage point. The 15th-century Korean Kangnido map, one of the oldest surviving maps from East Asia, quite reasonably looks at the world in a different manner, one in which China and Korea bulk large, and Europe, the Middle East and Africa are crammed into the margin.

DH All pictures are like that; they are made from a particular point of view. We all see the world in our own way. Even if we are looking at a small square object, a box say, some of us will see it differently from others. When we go into a room we notice things according to our own feelings, memories and interests. An alcoholic will spot the bottle of whisky first, then maybe the glass and the table. Someone else notices the piano; a third person sees the picture on the wall before anything else.

Above
JOHANNES RUYSCH
Map of the world, 1507
Engraving

Opposite
YI HOE and KWON KUN
Kangnido map (detail), *c.* 1470
Paint on silk

1 Pictures and Reality

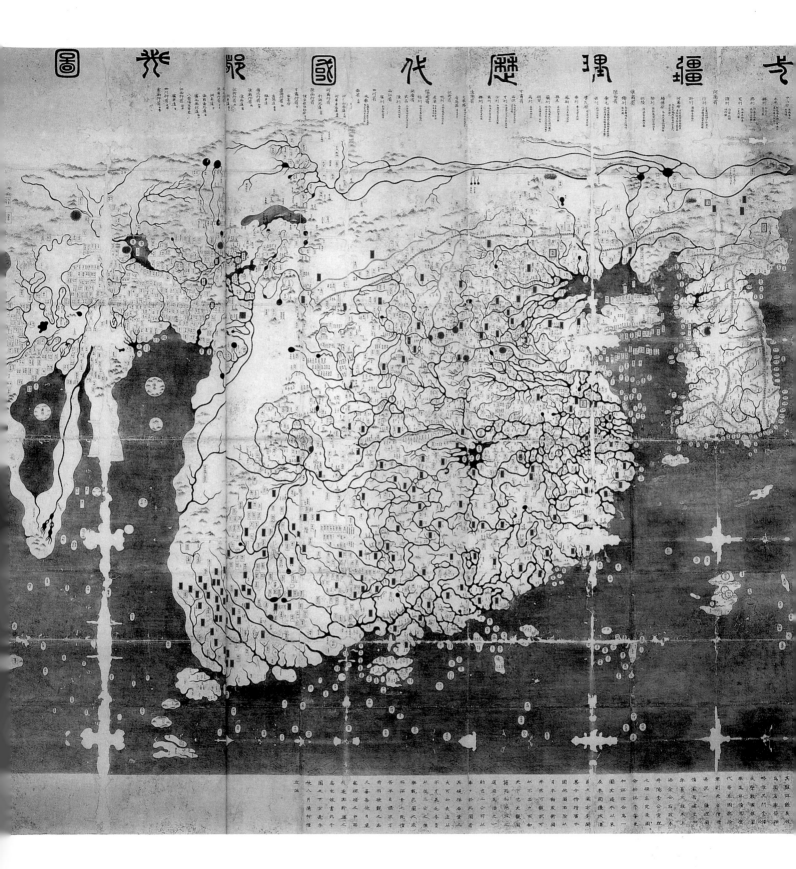

Reality is a slippery concept, because it is not separate from us. Reality is in our minds.

So you ask yourself, what is it you are getting in the picture? In Egyptian art the biggest figure is the pharaoh. Well, if you had measured him in real life he might have turned out to be the same size as anyone else, but in Egyptians' minds he was bigger, so that is how he was painted. That seems to me a perfectly correct way to proceed. The realist way would be to paint him small.

All writing is fiction in some way, how can it not be? The same is true of pictures. None of them simply presents reality.

MG In his pictures of the floating world (Ukiyo-e) the Japanese print-maker and painter Kitagawa Utamaro (*c.* 1753–1806) drew elegantly willowy women. However, the first photographs of Japanese courtesans, taken in the late 19th century, show women who were maybe less than five feet tall.

DH But in Utamaro's time they would have *seen* them as taller! It was only the photograph that made them look squat. Even in their minds they

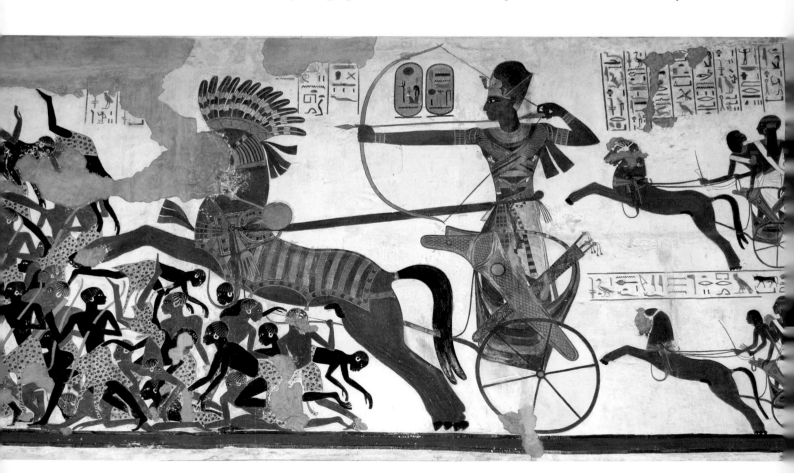

wouldn't have looked like that. Is that what the photograph has done to us? It's made the world look duller? I believe the photograph does that, because it is separate from us. The camera sees geometrically but we see psychologically.

I think, in the end, it's pictures that make us see things. We need pictures; we need them in our imaginations, but first you have to have something down on a surface. Pictures have been helping us see for at least 30,000 years.

MG Picasso is supposed to have suggested art had been decadent since the era of Altamira, the painted cave in northern Spain. And in many ways it's true that painting remains what it was there and at Lascaux.

DH Art doesn't progress. Some of the best pictures were the first ones. An individual artist might develop because life does. But art itself doesn't. That's why the idea of the primitive is wrong, because it assumes that art is a progression. Vasari in his *Lives of the Artists* in the mid-16th century thought Giotto came first and it all finished with Raphael and Michelangelo. Nothing could be better than that. But Raphael isn't better than Giotto.

The people in Giotto's fresco are individuals. I know these faces. They are types, in a way, not studied from actual people, but they have lively expressions, they have personality. The eyes particularly have an intensity of looking. When the whole Scrovegni Chapel in Padua, painted by Giotto, was first done it would have seemed like vivid *reality*, something far more powerful than film or television. It still is an amazing building.

DH One of my ancestors was probably a cave artist. I think cave art must have been to do with someone getting a piece of chalk or something and drawing an animal. Another person sees it and perhaps gestures or reacts, meaning, 'I've seen something like that!'

Once I was in Mexico working on 'Hockney Paints the Stage'. We'd decided to do a roll of people who were at the opera, capturing their facial expressions: concentrating, looking, some were asleep. There was this little guard sitting there, and when I finished a face he'd give me a thumbs-up gesture. So I'd move on. I trusted him. I thought that's what it must have been like in the cave, someone would have been watching. Everybody likes watching people draw.

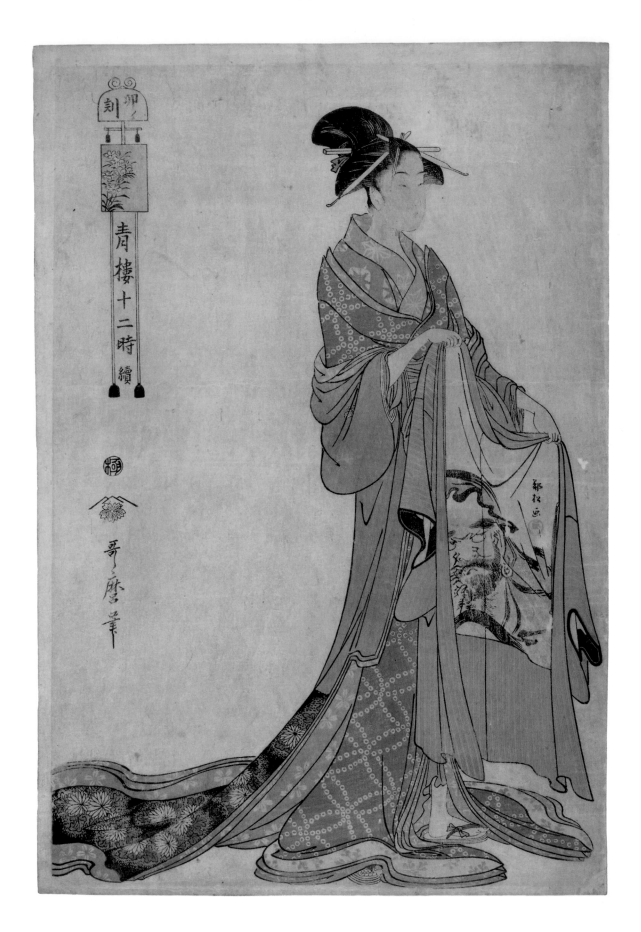

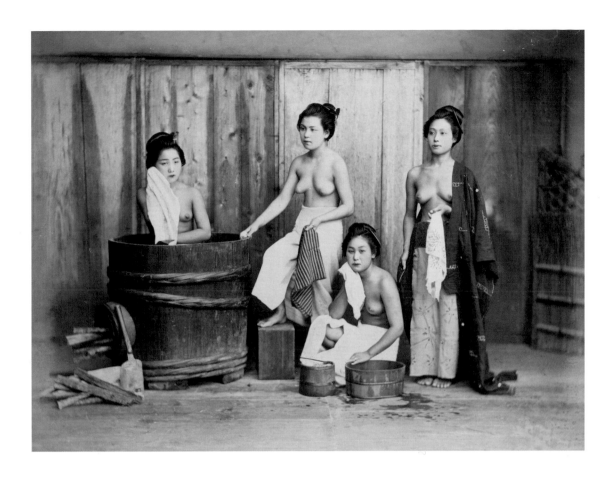

MG A picture can be a sort of performance, a display of skill. The upper walls of the Scrovegni Chapel are curved, because they cover the vault of the building. This kind of surface often occurred when painters were making murals. Tiepolo frescoed baroque ellipses, Michelangelo painted the arched ceiling of the Sistine Chapel. But the picture itself, the film of paint, is flat; it does not follow the curvature of the walls. On the contrary, the illusion it creates may contradict the actual direction of the wall. In an astonishing feat of foreshortening, Michelangelo succeeded in depicting the prophet Jonah leaning backwards on part of the vault of the Sistine Chapel that is, in reality, curving forwards.

All pictures, with the exception perhaps of the work of the mad or the reclusive, are made for an audience. They are made to be seen and understood by the people who look at them. When we see a picture, we assume it has some meaning and if it is not obvious, we might ask ourselves what it is. A good deal of art history consists in trying to answer two questions: why was this image made and what does it mean?

Making a picture of something gives it an added importance. That is why people take particular pictures with their cameras and

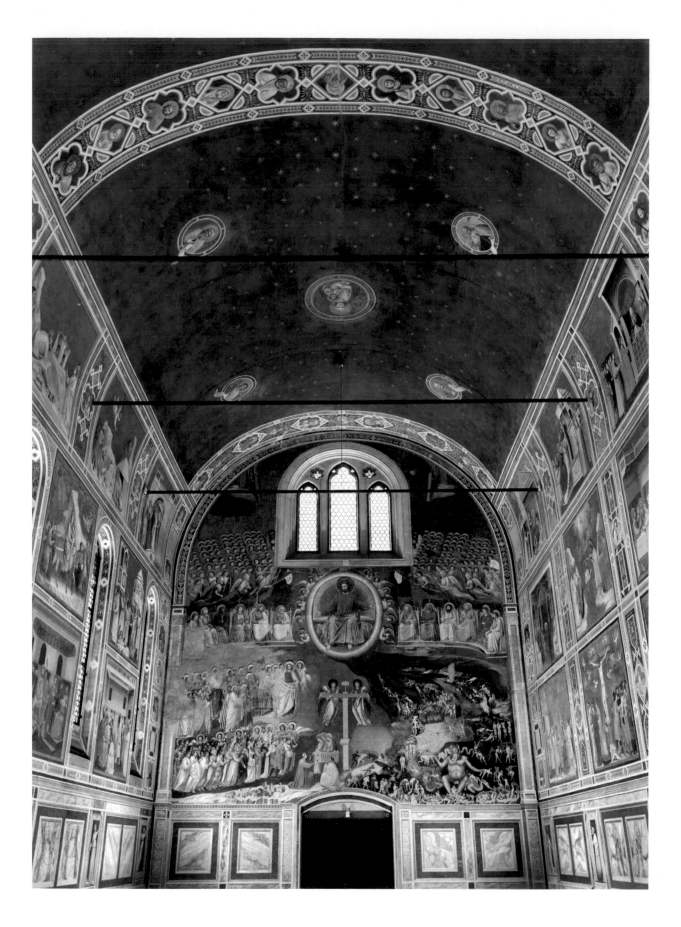

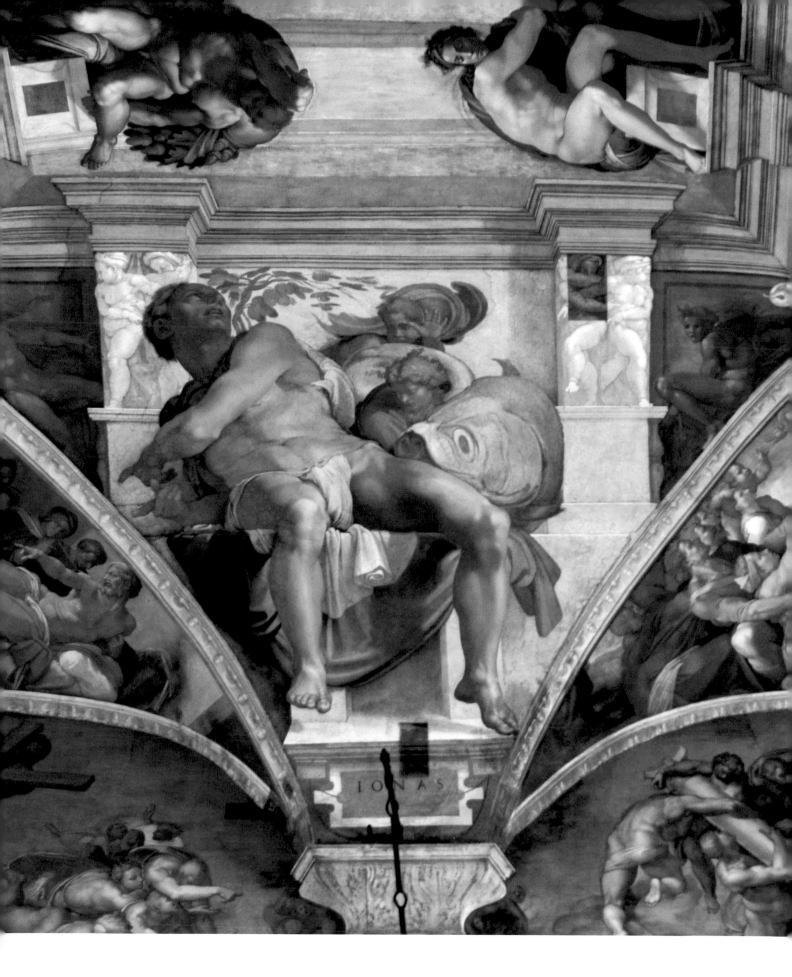

IONAS

phones: to preserve the appearance of something seen. But not all pictures do this equally well. There are enormous differences in power between them.

DH Ultimately, that's why auction prices are so high, because in the end – after you've got a roof, food and warmth – all you can buy is beauty. What else can you spend money on? That's ancient. It's always been there. Pictures are part of that, but of course not all pictures.

We remember only a few out of the millions that are made. I have a memory bank of them. I suppose, no doubt, the trash always disappears in art. Loads of paintings and installations will vanish. So I assume that lots will be lost on computers. The main reason why pictures, and other things, survive is because someone loves them. There are memorable images but we don't really know what makes them so. If we did, there'd be a lot, lot more.

The *Arnolfini Portrait* by Jan van Eyck is just a view of two people in a room, but it comes up in my mind like a slide. There are millions and millions of pictures of a couple of people in a room, but most of them are completely forgettable and consequently they disappear. Hopper's pictures are not like that at all. I can see some of them now inside my head: *Early Sunday Morning* (1930), *Nighthawks*.

Edward Hopper and Norman Rockwell were both American painters and contemporaries who depicted quite similar subjects: everyday life in the USA. However, it is true to say that Hopper's pictures stay in the mind more powerfully than Norman Rockwell's. Rockwell's were done for reproduction in the *Saturday Evening Post*, so they are painted in quite a dull way. It's not Vermeer. But Rockwell was a very good illustrator – so good that his pictures won't go away. At one time, he wouldn't have been seen as part of a serious discussion about 20th-century art, but actually there's an *oeuvre* there. It has to be acknowledged. But it's members of the public, not art historians, who have kept on looking at his works. His pictures are loved by enough people for them not to be forgotten. There's something else in Hopper though.

MG What makes a picture memorable? It is extremely hard to say. It may be to do with the subject, but often the most enduring pictures are of unremarkable sights: two people in a room, four gathered at a bar. Perhaps the power is partly a matter of its structure.

JAN VAN EYCK
The Arnolfini Portrait (detail), 1434
Oil on oak

 1 Pictures and Reality

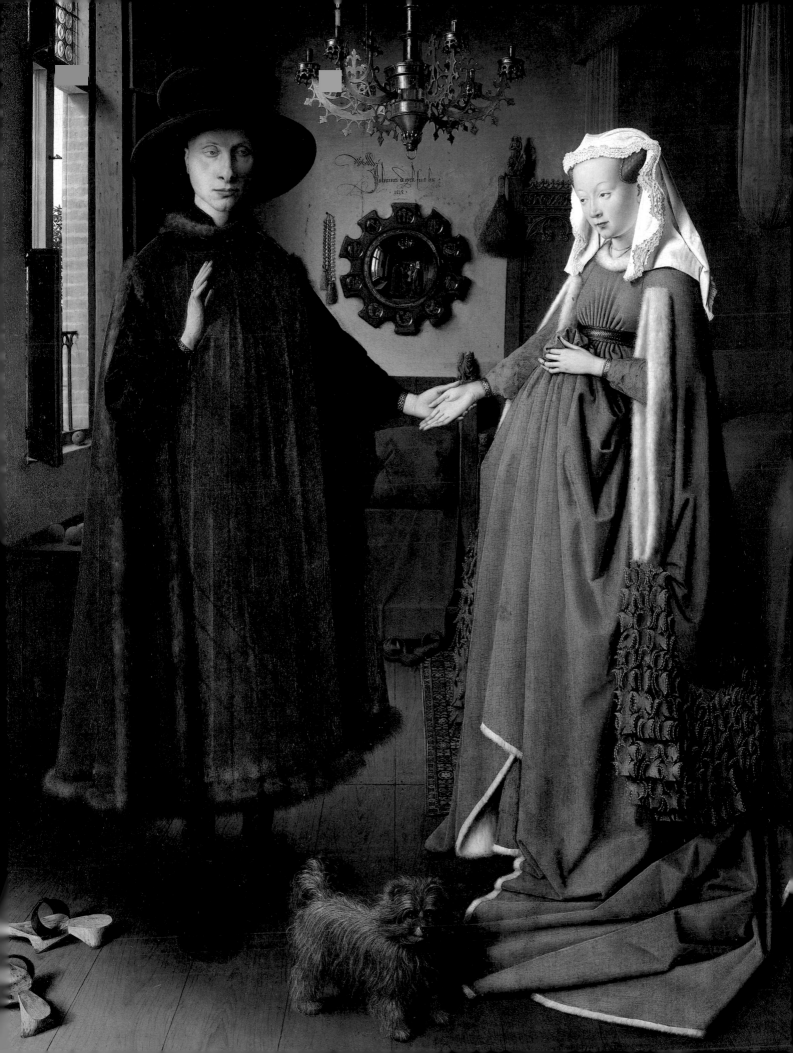

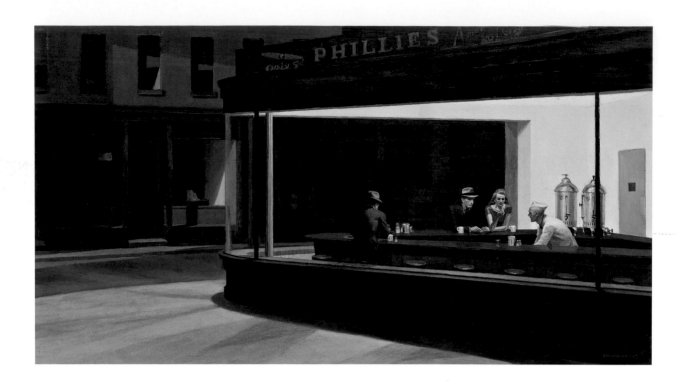

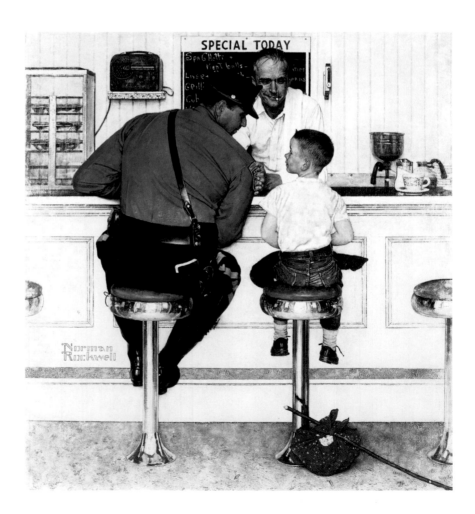

Above
EDWARD HOPPER
Nighthawks, 1942
Oil on canvas

Right
NORMAN ROCKWELL
The Runaway, cover of
Saturday Evening Post,
September 20, 1958

DH A lot of the best photographers, such as Cartier-Bresson, were trained as artists, meaning they could draw, having been taught to look. Cartier-Bresson would look and see more, and take better pictures. And, again, I can see perhaps half a dozen in my mind.

We first met at my drawing show in Paris in 1975. He immediately wanted to talk about drawing, as he did whenever we met after that, and I always wanted to talk about photography. He said to me that what made the photographs good was geometry. I said to him, 'Yes, well, it's a matter of being able to translate three dimensions into two dimensions, which means making a pattern, how you arrange it. It's also a question of looking at the edges.' When my sister got a camera, she started taking courses in photography. She revealed later I'd mentioned something that improved the pictures that no one else had explained to her: 'You told me to look at the edge not the centre.' I said, 'I thought that was elementary. It's the first thing you do. That applies to a painting as well.' The edges counted particularly for Cartier-Bresson because he deliberately didn't crop anything. He made sure that the photograph worked as he took it.

MG Cartier-Bresson's technique required a camera that was both light and fast. Armed with this he hunted images in the street. His aim was to find a picture, like a Surrealist readymade, existing in the world around him, perfectly structured and composed. To this end, he trained his reflexes and his eye so that he could press the shutter at the fraction of a second for which the potential image existed: he called it 'the decisive moment'. Of course, what he found in the world was himself: his own kind of picture.

A portable camera containing a roll of film is a tool that allows a certain type of picture to be made. So, too, is a stick of charcoal, a copper etching plate or a Photoshop program on a computer. They are all tools, and all pictures are made with tools. Therefore, the implements that are available to the picture-maker influence the nature of his or her pictures. The very earliest such items to have survived include shells that were used as palettes and other painting equipment in South Africa around 100,000 years ago – a date that suggests we have lost the first two-thirds of the history of art that preceded the oldest surviving paintings, which were perhaps made some 30,000 years ago.

DH Technology has always contributed to art. The brush itself is a piece of technology, isn't it? But tools don't make pictures. People always have to make them.

2 Making Marks

What makes a mark interesting?

DH The moment you put down two or three marks on a piece of paper, you get relationships. They'll start to look like something. If you draw two little lines they might look like two figures or two trees.

One was made first, one second. We read all kinds of things into marks. You can suggest landscape, people and faces with extremely little. It all depends on that: the human ability to see a mark as a depiction.

MG The whole of picture-making is based on our capacity to see one thing as another. As Shakespeare put it in *Antony and Cleopatra*:

Sometime we see a cloud that's dragonish,
A vapour sometime like a bear or lion.

We can find such images in the sky, or, as Leonardo da Vinci suggested, on 'walls spotted with various stains, or with a mixture of different kinds of stones'. In such random marks Leonardo, who surely had a powerful imagination, could make out 'landscapers adorned with mountains, rivers, rocks, trees, plains, wide valleys, and various groups of hills'. He could also discern 'divers combats and figures in quick movement, and strange expressions of faces, and outlandish costumes, and an infinite number of things'.

In the caves of the Dordogne a stray pebble suggested the lion's eye, perhaps, and other cracks and bulges an ear or a shoulder joint to the prehistoric artists. Subsequently, many sacred buildings – temples and churches – have been places where people looked at pictures and sculptures. Think of Giotto's frescoes in the Scrovegni Chapel, a whole interior filled with religious drama and history. From the earliest times, people have depicted not only what they saw, but also what they believed to exist: gods, myths and demons.

Cave lion, *c.* 12,000 BCE
Les Combarelles cave,
Les Eyzies, France

DH We obviously want to see pictures, don't we? We are geared to seeing images on a flat surface. If we put down four marks, everybody knows it could be a face.

What makes a mark interesting? It's movement, again. Lines have a speed in them, which you can see, whether it's very fast or slow. That's why drawings, or drawings that show the marks, are appealing, whereas those that don't show the marks are not. We *need* the mark. We also know how just a few lines on a piece of paper can suggest almost anything. That's why economy of means is such a valuable quality in drawing. It is a virtue. Everybody is impressed by that, even people who want excess – and we all want excess at times.

I think Edvard Munch was a great painter. Whenever I've been to the Munch Museum in Oslo, I've looked at everything in the collection. In reproduction you sometimes can't quite see the superb economy of means he used. Seeing the real paintings was very exciting. A bed – how little is there to represent a bed.

MG That's part of the alchemy of art, how an artist can transform one thing into another. *Six Persimmons* by Muqi, a 13th-century Chinese Zen priest and painter, has frequently been praised as a supreme example of less being more. It is small (31 × 29 cm), consisting of almost nothing; you could count the number of strokes of the brush the artist made. But the density of ink and direction and speed of the marks varied with such subtlety that the fruit are there, each different, in space.

DH A lot of Chinese painting is like that. They used to practise, say, doing a bird; practise and practise. Starting with maybe ten marks, then slowly getting it down to three or four. It takes one a while to get attuned to that aspect of Chinese art, but the marks are marvellous. The way they handle the brush, holding it in the fist, is different. I once watched a young Chinese artist painting cats, and the placement of every mark was perfect. He was like a young Picasso. The characters of Chinese writing are wonderful, too; calligraphy is still practised in China. That's about subtle changes in little marks. And writing and painting are closely linked.

MG Chinese scholar-painters of the 16th century looked back on the great masters of earlier eras – rather as we might on the Italian Renaissance – and codified a theory of art. To them, painting was numbered with calligraphy and poetry among the highest expressions of the human mind.

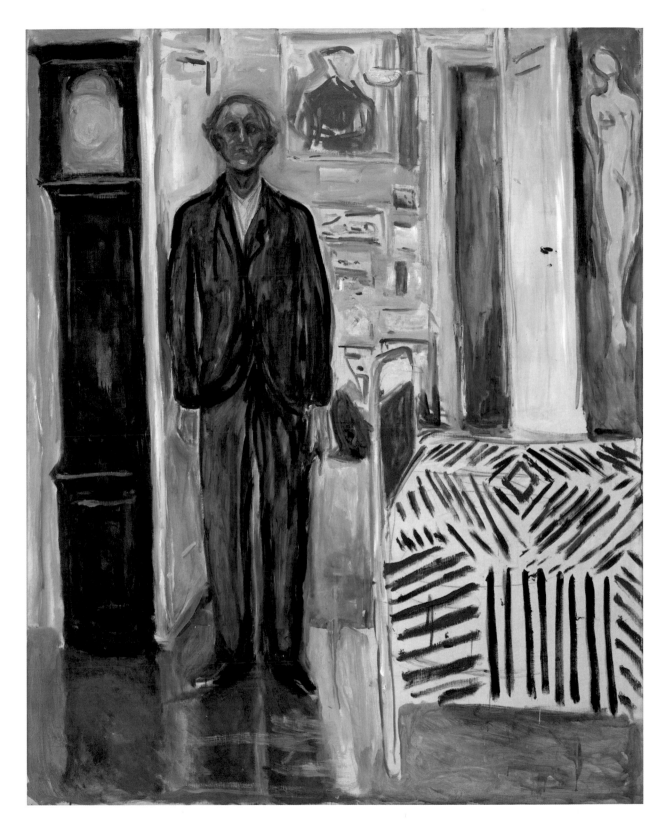

EDVARD MUNCH
*Self-Portrait: Between the Clock
and the Bed*, 1940–42
Oil on canvas

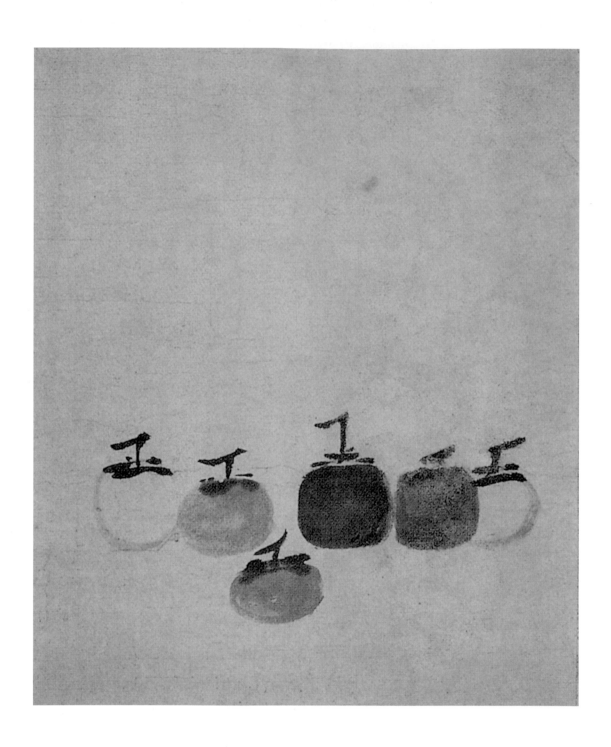

MUQI
Six Persimmons,
13th century
Ink on silk

38

WU ZHEN
Leaf from an album
of bamboo drawings, 1350
Ink on paper

The Chinese painter, calligrapher, art theorist and scholar Dong Qichang (1555–1636) held that it was through depictions of landscape that an educated man could show his understanding of the principles of nature. This was art as a spiritual exercise. But the aim was not, as in much of Western painting of the past few centuries, the portrayal of the outward appearance of a place, so much as a way of becoming attuned to the inner order and flow of the world. That primordial energy found visible shape in the brushstroke.

Certain painters, such as the 14th-century artist Wu Zhen, were masters at expressing the forms and vital essence of the bamboo plant, and some, including Xia Chang, specialized in the subject, often adding a poem. The letters of the text were an integral part of the picture.

Chinese painting is often monochrome, the whole range of form and texture being produced by differing qualities of ink and application of the brush. This act became an obsession: there was analysis of dry strokes, wet strokes, the so-called axe-cut stroke made with the side of the brush, and so on. One writer on art in the Ming dynasty classified no fewer than twenty-six different ways to paint rocks and twenty-seven ways to evoke leaves on trees.

DH The Chinese regarded not acknowledging the brush and the marks it made as a bit crude; to them that was trying to cover something up, so not such a high form of art. European art historians don't look at China very much. They think that's a specialist field. But I suspect Rembrandt must have known Chinese drawings, and had probably seen a few. Amsterdam was a port and the Dutch were trading a great deal in

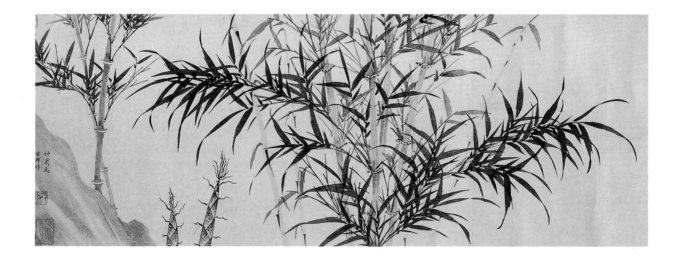

the Far East. For example, a Chinese master looking at Rembrandt's drawing of a family, now in the British Museum, would recognize it as a master-work.

The child is being held by her mother and older sister. The mother grips the child firmly, the sister more hesitantly, and Rembrandt observes her looking at the child's face to *see* how anxious she is. The lines of her shoulders beautifully indicate this; Rembrandt even turned his pen round and scratched through the ink to emphasize it. It makes me see the child's face, a hint of worry in it, indicated only by one or two faint marks. One then begins to look at ink, not mothers and sisters, and marks made by a hand, speedily.

The trace of Rembrandt's hand is still alive. One's eye can go back and forth between brown ink – sister; fast mark – mother. How rewarding this is, to move from the physical surface of the paper to its disappearance when one reads the 'subject', and then back again. How many marvellous layers does this drawing have?

The mother has a double profile, Picassoesque. Was it an accident with the pen that he then used as a master would? Both profiles are fascinating about her character. Her skirt is a bit ragged, without any real detail; one seems to know this, and then marvels at how these few lines suggest it.

Sensing the powerful triangle made by the crouching father, who has excited eyes that are two beautiful ink blobs, one realizes the quite complex space the figures make. But then, there's a passing milkmaid, perhaps glancing at a very common scene, and we know the milk pail is full. You can sense the weight. Rembrandt perfectly and economically indicates this with – what? Six marks, the ones indicating her outstretched arm. Very few people could get near this.

It is a perfect drawing. But that's not what it is saying. A sketch by John Singer Sargent tells you, 'This is a virtuoso drawing!' And it is, but that's all you get, actually. There's not much in his drawings of faces, but in Rembrandt there is no generic face. Each one has been based on observation. He's really looked at something. The eyes! And the mouths! Turned down, turned up, sad, happy.

Rembrandt's drawings aren't that big, because paper was expensive. He had to use every bit. When they are reproduced small you don't necessarily catch everything, but if you see them blown up, then look again, you notice more. You see the sheer beauty of the drawing. The quality of brush marks and pen marks is something everyone gets.

2 Making Marks

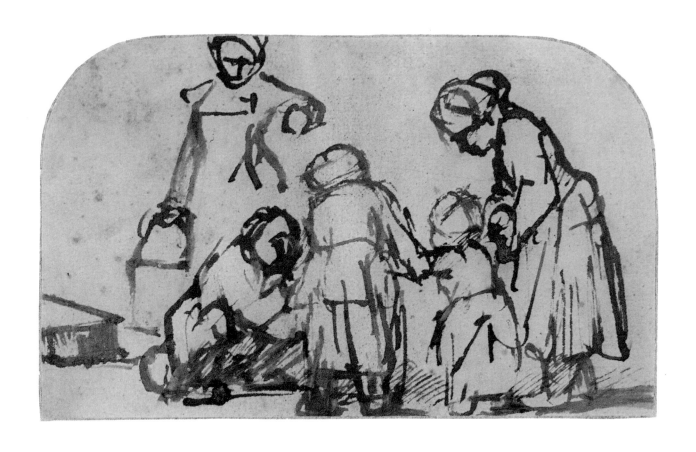

REMBRANDT VAN RIJN
A child being taught to walk, c. 1656
Pen and brown ink on
brownish-cream paper

Right
PABLO PICASSO
Corps de Femme de Face, 1908
India ink on paper

Below
PABLO PICASSO
Four Nude Women and a Sculpted Head,
1934, plate 82 from the *Vollard Suite*,
1930–37
Etching with engraving

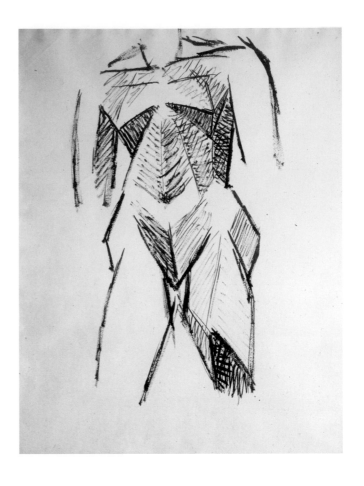

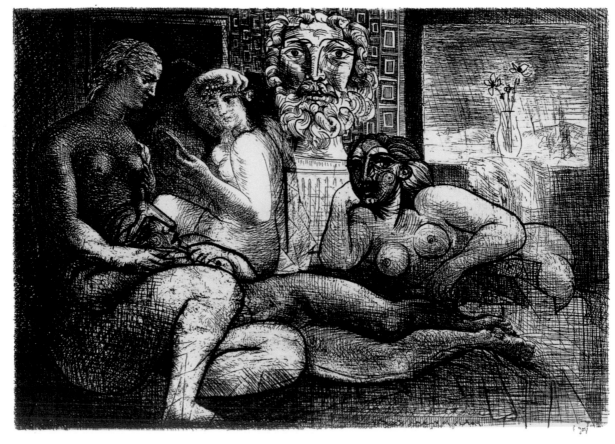

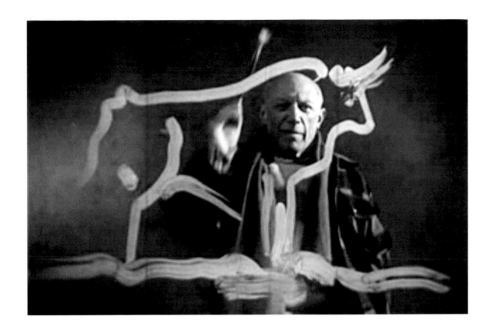

I link Picasso with China, too. Remember that Picasso film by
Paul Haesaerts (*Visit to Picasso*, 1949), where he is painting on glass
and constantly changing things, a horse becomes something else?
He obviously realized straight away that it wasn't the finished drawing
that counted, it was the process of making it. He was putting on a
stunning *performance*. The invention in it! No one else could draw like
that. He said, 'I do not seek, I find.' Well, he did find. His art is all about
mark-making, and he couldn't make an uninteresting mark.

All the great painters got looser as they got older – Rembrandt,
Titian, Picasso – they knew that is all that is needed. If you look at
Picasso's Cubist nudes from about 1907, they are skeletal. It took him
nearly thirty years until, in drawings from the early 1930s, he's doing the
same thing – a girl seen from the front and back view at the same time –
but by then she's unbelievably soft and cuddly. It took him all that time
to get there. He was asking himself: How do I see this? How do I see
her turning?

You need variety in drawing and with a great draughtsman that's
what you get. There are lots of works on paper by minor Italians that
tend to look alike, but a really good draughtsman has a style you can
recognize. For example, Giandomenico Tiepolo's Punchinello drawings
have a beautiful line. He used a reed pen that makes a soft line with sepia.
They are incredibly good.

I saw an exhibition of them all at the Frick in 1980, and we borrowed
the Punchinellos for the production of *Parade* at the Metropolitan

GIANDOMENICO TIEPOLO
Punchinello with the Ostriches,
c. 1800
Pen in brown ink and wash over
black chalk on white laid paper

Opera in 1981. The director, John Dexter, rang me up one morning and said there was a picture in *The New York Times* that we could use. He didn't say what it was, he just said 'Look at it, you'll see it.' So I looked through the paper and found this marvellous reproduction of Punchinello being chased. I rang him back and said, 'It's the Punchinello, isn't it? I'll come to New York and see the exhibition.' I got on a plane and went there.

There's a history of marks, as well as a history of pictures: the different kinds of marks that artists use and borrow from each other. In 1980, I covered a few sheets of paper in what I called 'French Marks', because I was doing *Parade*, and I knew that the French made marks differently and more interestingly than the English, in both painting and drawing. Dufy's mark is rather nice, I think.

In the charcoal landscapes I drew in East Yorkshire during the spring of 2013 I used a big range of marks. You have to have a variety. I'd looked at Picasso, Matisse, Dufy. But I only made the marks a stick of charcoal can make; that's all you can do.

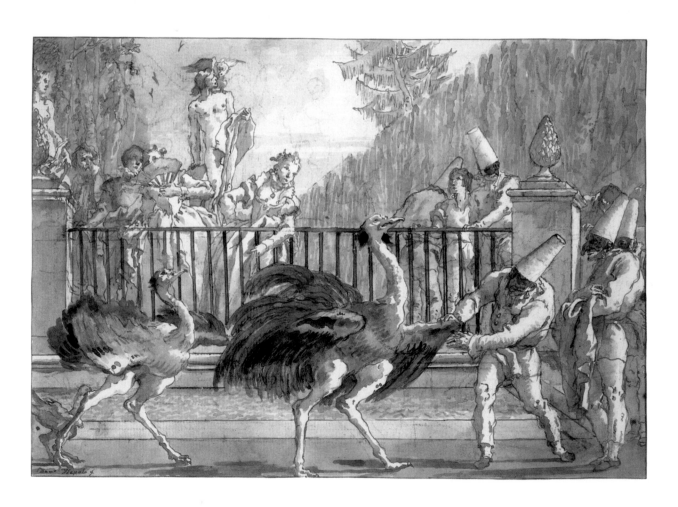

DAVID HOCKNEY
Punchinello with Applause, from
Parade Triple Bill, 1980
Gouache on paper

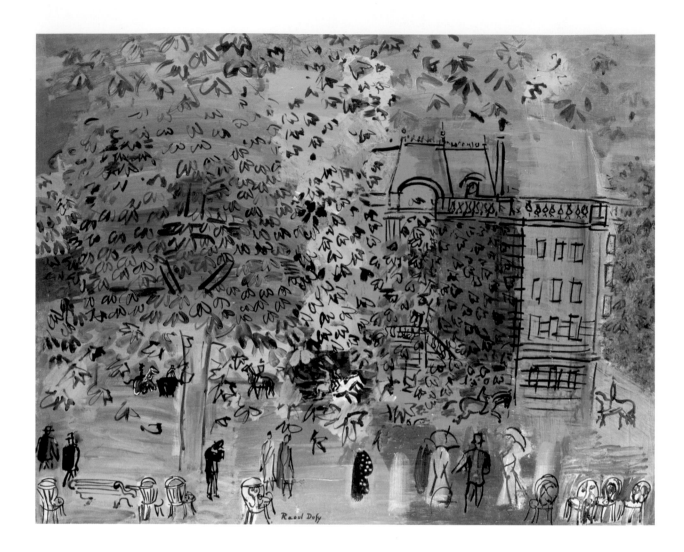

Above
RAOUL DUFY
*The Avenue du Bois de
Boulogne*, 1928
Oil on canvas

Opposite above
DAVID HOCKNEY
Woldgate, 16 & 26 March, from
*The Arrival of Spring in 2013
(twenty thirteen)*
Charcoal on paper

Opposite below
DAVID HOCKNEY
Woldgate, 26 May, from
*The Arrival of Spring in 2013
(twenty thirteen)*
Charcoal on paper

MG Drawing extremely well is something you need to learn. There are certain techniques that were handed down. Michelangelo's early penstrokes show a clear resemblance to those of his master, Ghirlandaio; a little later in his career he picked up certain ideas from Leonardo, though as an old man he was not willing to acknowledge either debt.

At 13 or 14 the apprentice Michelangelo set himself the task of copying an engraving by a northern artist, Martin Schongauer, or perhaps he was given it as an exercise by Ghirlandaio. He tried his utmost, as we learn from his biographer Ascanio Condivi, not just to imitate but to exceed the other work: to depict the subject more vividly and powerfully than Schongauer had himself.

DH I've always admired Degas's copy of Poussin's *Rape of the Sabines*. He did it when he was 27. I look at it and think: What he must have learnt from doing that. That's why he was doing it, to educate himself.

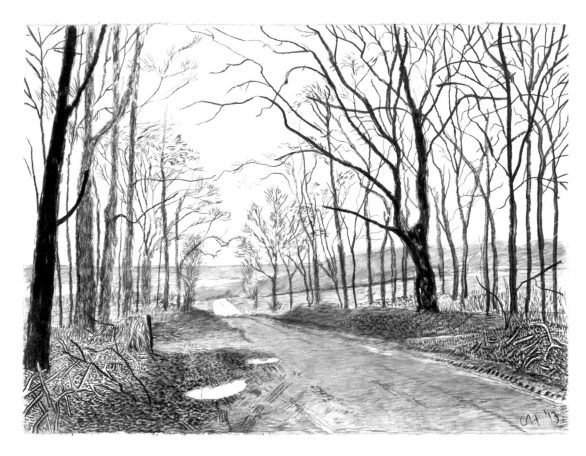

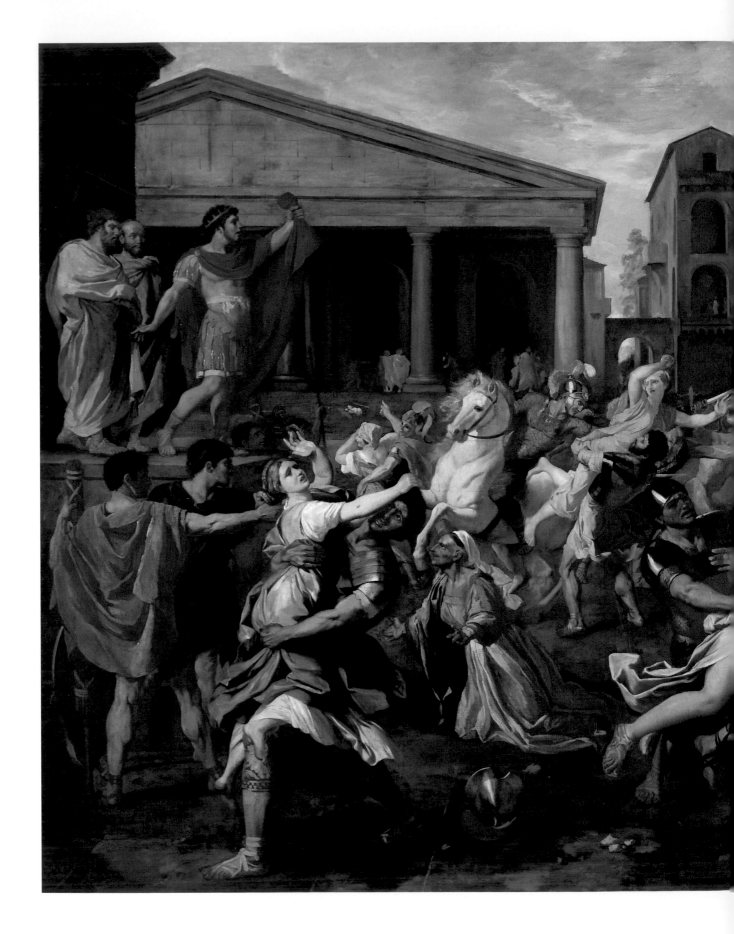

EDGAR DEGAS
The Rape of the Sabines (after Poussin), 1861–62
Oil on canvas

When the Horses of San Marco were exhibited in the Metropolitan Museum, New York, in 1980 a sign went up, 'No Sketching', and I was appalled. How were those horses done in the first place without somebody sketching? You have to support artists, and they have to study. In the end they gave in.

In the old days, every art school had a life room, and you would look at the students in the year above, who had been drawing longer. You'd follow them a bit. When they had a rest, you'd be looking at their pictures, noticing what they did. The way they used to teach drawing was that the model would pose, then you'd start. After half an hour the teacher would come round and he'd start drawing, say, a shoulder. And as he drew, I would think, Well, he's seeing more, I'm not looking hard enough. You could just see it; he drew much better. Afterwards, you'd draw better, too. It was a training in looking as well as mark making – the two together. Most people don't look that hard.

For four years at Bradford School of Art I did drawing. I went there when I was 16, and I drew every day. At the end of four years like that you'd have got quite good at drawing. By that time I was 20, the age students are just starting these days, which is a bit late. Artists in the past started at 12. Musicians begin when they are very, very young.

MG We know that many celebrated artists, such as Raphael, Michelangelo and Turner, began to study and work in their early teens. Drawing is a manual and mental skill like playing tennis or a musical instrument. In his book *Outliers* (2008), Malcolm Gladwell famously posited the '10,000 Hour Rule'. That is, to attain success in a given skill is largely a matter of practising for a long, long time. This is also true of writing: to do it well you need to work at it every day. But there are limits to what can be learnt.

DH At one time, almost everybody could draw. Before photography, drawing was taught at the US Military Academy at West Point because officers in the army had to be able to do it. Engineers needed that skill to depict a machine. It's been the same for 30,000 years, and they gave up drawing around 1975 in art schools. It's funny. They couldn't give it up really. You can't. It's always back to the drawing board.

You can teach most people to draw to a certain level, not like Rembrandt and Picasso. The young Picasso must have been a little

▲ Making Marks

virtuoso. His father was a drawing teacher but he quickly saw that he was better than his father. Most people can be taught the piano, but only one or two can play like Horowitz. There are always elites. People will pay more for good things, and they know what they are, such as a good piano player.

MG In his contemporary biography of Michelangelo, based on the artist's own recollections, Condivi tells the story of how in 1496 a powerful Cardinal dispatched his agent from Rome to Florence to find the artist who had carved a certain sculpture he had bought. This man, a Roman aristocrat named Jacopo Gallo, came to the artist's house. Michelangelo had no work there to show Gallo as proof of his abilities, so he 'took a quill pen and depicted a hand for him with such grace and lightness that he stood there stupefied'.

DH Condivi's story about Jacopo Gallo and the drawing of the hand is totally believable. You *would* be astonished to see a Michelangelo drawing appear in front of your eyes, especially if you did not know much about him. Michelangelo's drawings are amazing. I've held extraordinary ones at the Teylers Museum in Haarlem. You don't know how he did some of them.

MG Everything that can be said about marks made with pen, charcoal, pencil, chalk or any graphic medium, applies just as much to strokes made with the brush and paint. Painting is a matter of drawing, too, as is sometimes quite obvious. If you look closely at a fresco by Giambattista Tiepolo, father of Giandomenico, it is easy to see how he was drawing with virtuoso fluency in paint on the fresh plaster of the wall or ceiling.

At a certain point, however, the brushstroke began to be hidden in paintings, or, at any rate, in ones that were acceptable from the academic point of view. John Constable was told by his mentor, Joseph Farington – a senior member of the Royal Academy of Arts – that Constable himself would stand a better chance of becoming an academician if his work had more 'finish'. He informed Constable as much at breakfast in the summer of 1814. 'I told him the objection made to his pictures was their being unfinished.' Other painters and critics made the same point.

DH They meant the brushstrokes shouldn't be so evident. What happened in the late 18th century was the elimination of the brushstroke.

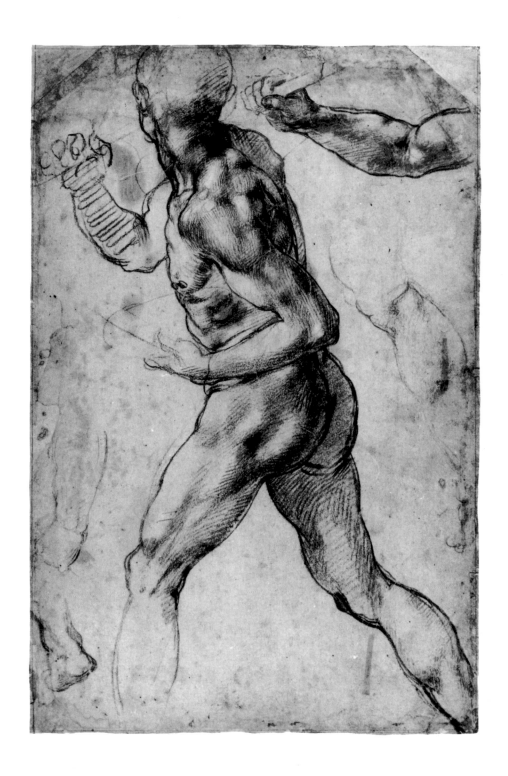

GIAMBATTISTA TIEPOLO
Detail of a supplemental scene to
The Meeting of Antony and Cleopatra,
1746–47, Palazzo Labia, Venice
Fresco

MICHELANGELO
Figure Study of a Walking Man,
c. 1560
Chalk and pencil on paper

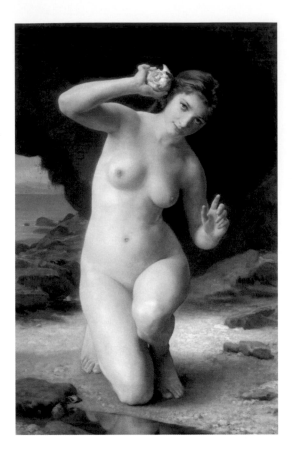

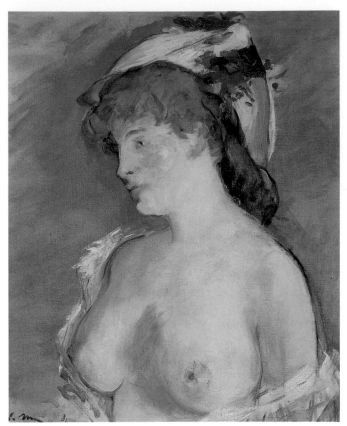

Above left
WILLIAM-ADOLPHE
BOUGUEREAU
Woman with Seashell, 1885
Oil on canvas

Above right
ÉDOUARD MANET
The Blonde with Bare Breasts,
c. 1878
Oil on canvas

Opposite
ANDY WARHOL
Left panel from *Marilyn*
(diptych), 1962
Acrylic on canvas

I believe that was because the images seen in a camera obscura had come to be taken as the standard of reality. I refer to the camera image, either in a camera obscura or chemically fixed in a photograph, as the optical projection of nature because that's what a camera does. By the mid-19th century the smooth surface derived from the photograph had become general in what we call academic painting – the pictures that were shown at the Royal Academy in London or the Salon in Paris.

When Manet began painting in the 1850s and 1860s the brushstroke came back, and awkwardness returned. It dawned on me when I saw an exhibition of academic French painting from the 19th century that this is what Manet and his allies were against. They won the battle: lively painting against dull.

I've noticed that a lot of paintings from the 1960s don't look as interesting as they did when they were done. Roy Lichtenstein's pictures, for example, feel more like design or something. I think the Warhols stand up a lot better. They have a lot more hand in them, of course, even when he's silk-screening the pictures; his hand does the colour underneath.

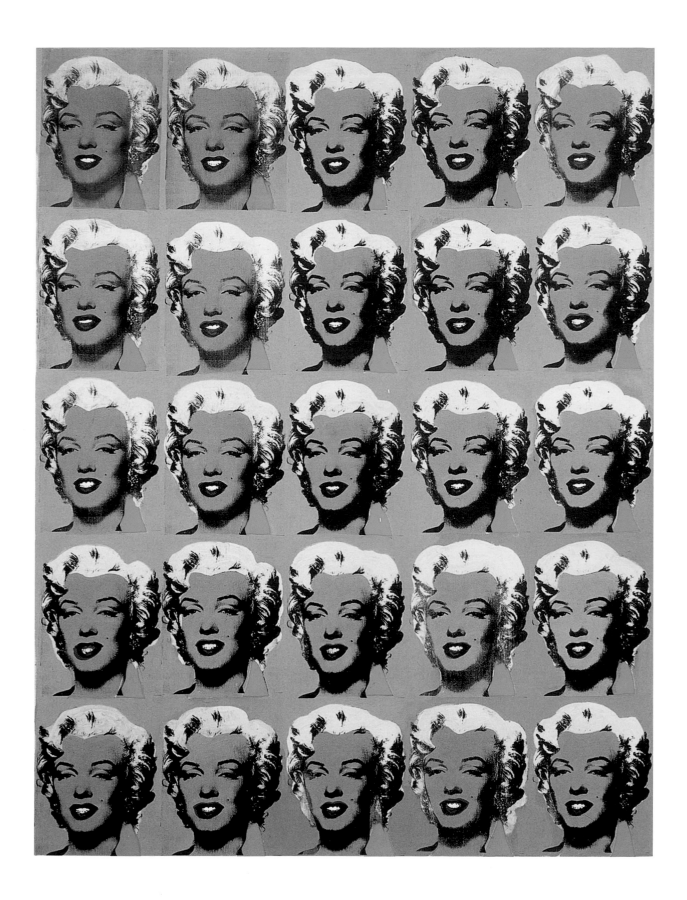

3 Shadows and Deception

To see volume you need light – and shadows.

DH I've always noticed shadows simply because there weren't many in Bradford. At the old Musée d'Art moderne in Paris, I photographed the ones thrown by the Cubist sculptures in the Julio González room. The artificial lighting meant the sculptures cast strong shadows and these completely flattened forms seemed to contradict the idea of the sculpture: a complicated three-dimensional representation of space. I was also amused that the photographs I took were flat. I did two paintings of them, called *Gonzalez and Shadow*. The shadow was just a very thin layer of colour, painted on cotton duck, and the sculpture was painted more thickly.

MG The shadow is a negative phenomenon: it is an area behind an opaque object that is shielded from the source of light. If the illumination comes from a single point – the spotlights of the González gallery, for example – then the shadow is sharp-edged. In effect, it is a projected negative image: an area of darkness surrounded by an outline.

DH The shadow is just the absence of light. But do we necessarily always see shadows? You don't have to see them consciously. The fact that people can take a photograph with their own shadow in it without noticing suggests that they are not aware of them. You can ignore shadows when you are drawing, as the ancient Greeks did, for example. I can, if I draw with just a line; you can choose not to put them in.

We see shadows in photographs, in fact until very recently photographs *needed* shadows, because they needed lighting. Some of the best of the first photographs printed on paper were made in Edinburgh between 1843 and 1848 by David Octavius Hill and Robert Adamson.

DAVID HOCKNEY
Gonzalez and Shadow, 1971
Acrylic on canvas

56

It would have been a very good place to take those photographs, of course, because the city would have had a much longer day in the summer than Paris, some 550 miles to the south, where other pioneer photographers were at work.

MG Many of their pictures were taken at Adamson's studio, Rock House, on the stairs leading up Calton Hill, to the east of Princes Street. The place where the portraits were mainly shot has been described as a 'daylight studio', or, in terms of cinema, a set. An area on the southwest wall of the building – ideal for catching the sun – was furnished with curtains, chairs and props to make it seem like an interior. Hill and Adamson were fortunate in the unusually sunny summers of 1846 and 1847, as well as the long days.

DH They'd have needed those good summers. The direct sun would have been vital. On a dull day, the photographs wouldn't have looked volumetric; without shadows there would not have been enough to

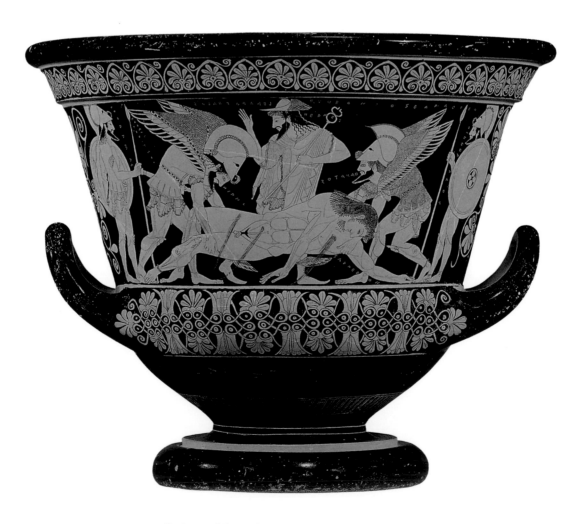

3 Shadows and Deception

DAVID HOCKNEY
W. H. Auden I, 1968
Ink on paper

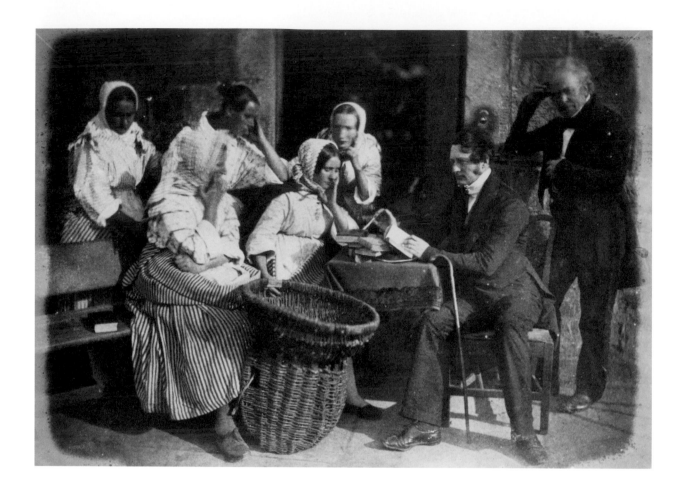

see. Often the answer is to work early or late in the day, because the noon light is generally the least interesting. It flattens everything. Early morning light in particular is very special; anyone doing a lot of looking will be aware of that. In Bridlington on a summer morning we were up at six, when the sun was still rather low but lighting everything in front of you. Of course, if you're going to take photographs, that's what you do.

MG Great photographers are not just aware of shadows; they use them to maximum expressive effect. Some, including Lee Friedlander in this picture taken in New York in 1966, use their own shadow as an informal self-portrait.

In the genre known as film noir, strong lighting and its deep shadows created the dramatic atmosphere. Without the shadows, this idiom would be far less effective. In a still from *The Maltese Falcon* (1941), Humphrey Bogart, playing the private eye Sam Spade, blends with his cigarette and the fabled statuette into a single image in which the shadow is more powerful, and sinister, than the actor himself.

DAVID OCTAVIUS HILL and
ROBERT ADAMSON
The Pastor's Visit, c. 1843–48
Calotype

Above
LEE FRIEDLANDER
New York, 1966
Gelatin silver print

Right
JOHN HUSTON
The Maltese Falcon, 1941,
starring Humphrey Bogart
Film still

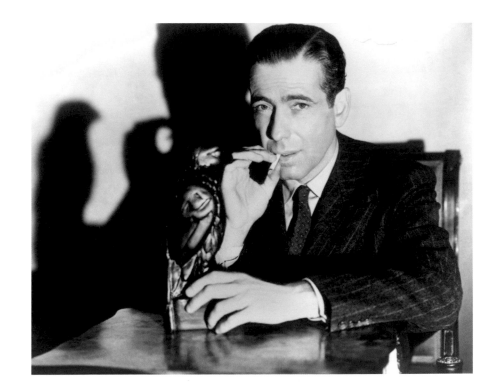

DH It is a kind of joke, but I really mean it when I say Caravaggio invented Hollywood lighting. It is an invention, in that he quickly worked out how to light things *dramatically*. I've always used shadows a bit, because that's what you need below a figure to ground it, but mine are more like Giotto's than Caravaggio's. I use shadows that you see in ordinary lighting conditions; you don't find ones like Caravaggio's in nature.

But there are other varieties of Hollywood lighting. The *Mona Lisa* is one of the first portraits with very blended shadows. That face is marvellously lit, the shadow under the nose, and that smile. The soft transition from the cheekbone down to underneath the jaw is extraordinary. The way that you move from the light to the dark flesh is through incredibly subtle, graded paint that would have taken a long time, technically, to put on. I've no idea how he did it. You don't quite see it in nature, but you certainly do in optical projections. Those unbelievably soft gradations look photographic. That's what makes it remarkable, and why she has that enigmatic smile. It is a haunting face.

CARAVAGGIO
Judith Beheading Holofernes, 1599
Oil on canvas

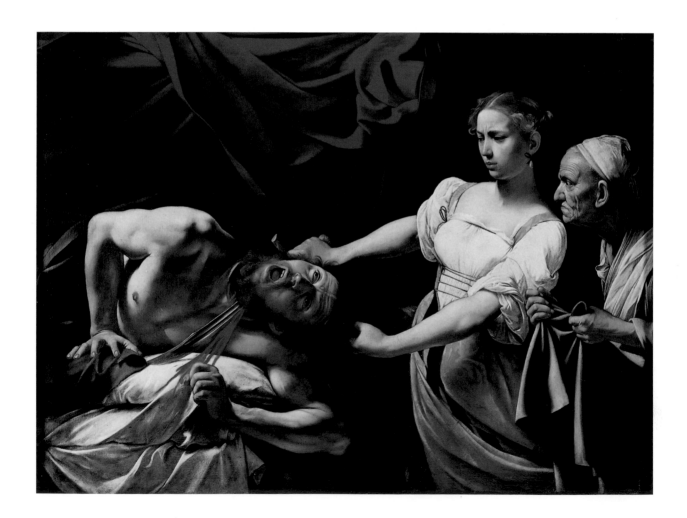

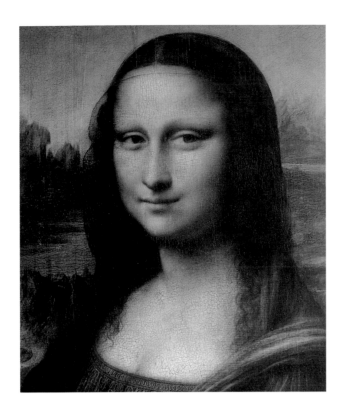

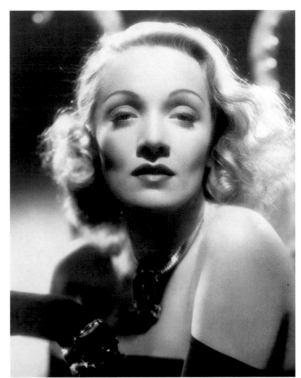

Oil paint lends itself to blending far more than fresco or tempera. Masaccio does blend colours in the Brancacci chapel, but the fresco medium he used is like acrylic where you have to use little linear techniques to achieve this.

It is interesting that shadows are almost exclusively European. Few have pointed it out. Most art historians, who are Europe-centred, don't realize that there are virtually no shadows in Chinese art, nor Persian or Japanese. They are one of the things that make the major difference between Western art and the art of anywhere else. They are incredibly important.

MG It is true that shadows are seldom seen outside Western art, and where they are – as in the faint shading visible in the murals of the Ajanta Caves in India – they may represent an echo, equally faint, of ancient Greek art carried eastwards by the armies of Alexander the Great.

Portraiture, according to the Roman author Pliny the Elder writing in the 1st century AD, began with a shadow. Where it started, he admits, we have 'no certain knowledge': 'The Egyptians affirm that it was invented among themselves, six thousand years before it passed into Greece; a vain boast, it is very evident. As to the Greeks, some say that it

was invented at Sikyon, others at Corinth; but they all agree that it originated in tracing lines round the human shadow.'

All those claims by different Greek communities, and even the ancient Egyptians, were wide of the mark. We now know that painting was some 30,000 years old at the date that Pliny was writing, and probably much older. The idea that painting began with a shadow, however, turns out to have some truth in it. At any rate, some of the images in the cave at Chauvet-Pont d'Arc, in the Ardèche region of France, and at other prehistoric sites, are a sort of stencil – akin to a shadow because it is simply an outline, a negative formed by the absence of paint – made by blowing pigment around the outstretched hand of the artist. Consequently, we know something about the man who made them: he was quite tall and had a bent little finger. In a way, this is the first signed picture. Pliny went on to tell a tale about a slightly more complex kind of shadow-picture, one that forms the basis for a low-relief sculpture:

Below left
Mural painting of Padmapani
(Bearer of the Lotus),
6th century AD
Cave One, Ajanta, India

Below right
Silhouette of a hand, *c.* 32,000 BCE
El Castillo cave, Puente Viesgo,
Spain

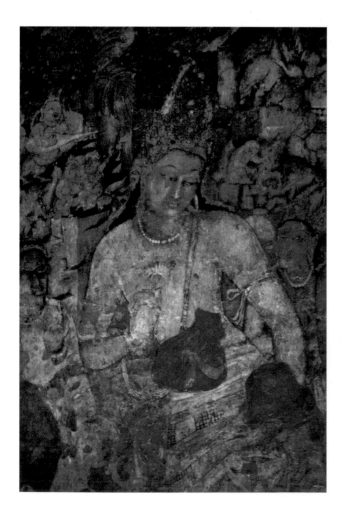

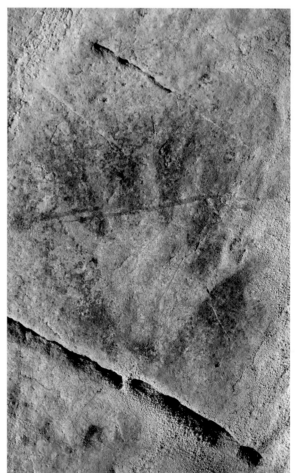

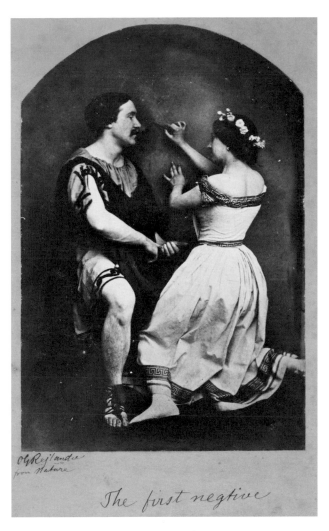

The modelling of portraits from clay was first invented by Butades, a potter from Sikyon, at Corinth; it was really the achievement of his daughter, who was in love with a young man and, when that young man was leaving for a trip abroad, drew an outline of the shadow of his face which was cast from a lamp onto the wall.

The story became a popular subject for painters in the late 18th and 19th centuries – the very era, in fact, that saw the birth of photography (and was, as we shall see, obsessed with projected images). One such picture by Joseph-Benoit Suvée, entitled *Invention of the Art of Drawing*, is from 1791. In 1857, Oscar Gustave Rejlander, the inventor of combination prints – an early type of photo-collage – made a photographic version, which he wittily entitled *The First Negative*.

Above left
JOSEPH-BENOIT SUVÉE
Invention of the Art of Drawing, 1791
Oil on canvas

Above right
OSCAR GUSTAVE REJLANDER
The First Negative, 1857
Coated salt print on collodion negative

DH A silhouette is very distinctive. We can recognize people from one, even from a long way away.

MG In 18th- and 19th-century Europe, 'Silhouettes' were a cheap and popular type of portrait. Reputedly, the name derived from a French finance minister, Étienne de Silhouette, who forced economies on everyone; but in 18th-century Britain they were dubbed 'shades' or 'Profiles'. To produce them, various aids were devised, including the contraption published by Thomas Holloway, an engraver, in 1792. All silhouette portraits were profiles and depended on the human capacity to identify an individual from, in effect, a shadow alone.

DH I once saw a production of Mozart's *Così fan Tutte* that was set on a ship in about 1910. The plot of the opera involves two women, Dorabella and Fiordiligi, who fail to recognize their lovers, Ferrando and Guglielmo,

THOMAS HOLLOWAY
*A Sure and Convenient Machine
for Drawing Silhouettes*, 1792
Engraving

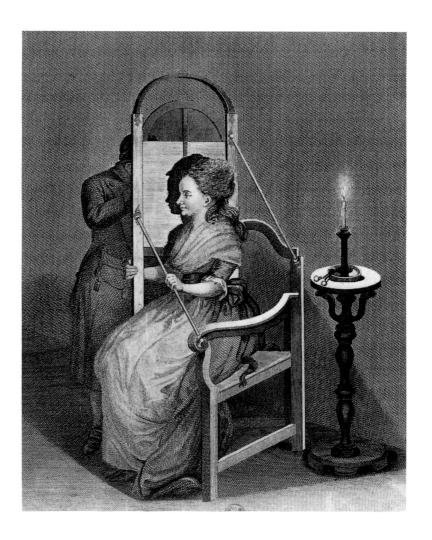

CAROL REED
The Third Man, 1949
Film still

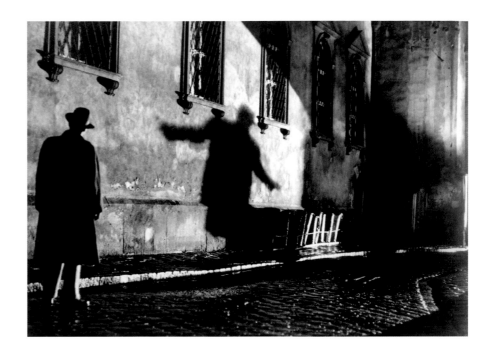

when they appear disguised as Albanians. But in this production, when these men entered in, they came in well-tailored morning suits instead of Albanian costume, so you would have spotted them immediately, even from the back. The story was not believable done that way. In 18th-century Naples, where the opera is set, you'd have deep windows, so if you played with light across the room, and the characters had a new silhouette, muffled in Albanian dress, it's plausible.

MG In cinema, too, a silhouette can be part of the narrative, as in Carol Reed's great film noir, *The Third Man* (1949), when the shadow of the hero/villain Harry Lime is seen disappearing down a Viennese street. As it happens, this is an example of the silhouette as deception in another way. Orson Welles, the actor playing Lime, was off set that day, so the shadow on the wall is actually that of Guy Hamilton, the assistant director, wearing an oversized overcoat and padding to duplicate Welles' portly frame. Shadows can convey information, but also create illusions. If the light source is multiple, or diffused, a more complex type of shadow results: one in which there is a more solid area of darkness – the umbra – and also what is technically the penumbra, a zone in which only some of the light is blocked. In conditions in which the light is partially diffused, as it often is, these blend smoothly into one another. Together, the depiction of these shadows and partial shadows results in an effect of volume.

3 Shadows and Deception

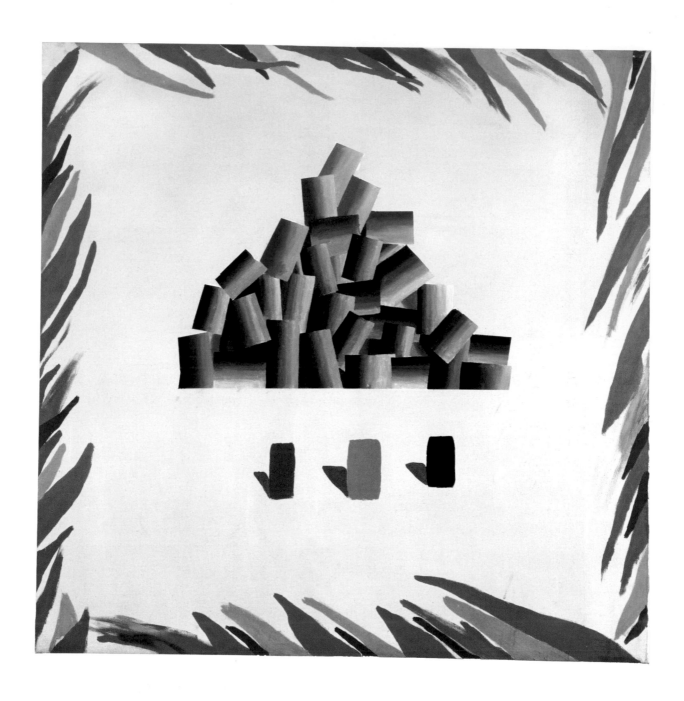

DAVID HOCKNEY
A Less Realistic Still Life, 1965
Acrylic on canvas

DH In 1965, remembering that Cézanne had said that everything can be reduced to the sphere, cylinder and cone, I conceived the idea of inventing some still lifes. The first, *A Less Realistic Still Life*, is a pile of cylinders, made more naturalistic by the suggestion of shadow and other elements to create space.

MG In this witty picture, an almost abstract arrangement of geometric shapes is rendered believable – abracadabra! – by the addition of light and shade; what is often called modelling, or in Italian *chiaroscuro*. According to ancient sources, the first artist ever to use this device was an Athenian named Apollodorus. It was he, according to the historian Plutarch, who 'first invented the fading in and building up of shadow'. Pliny added the information that he became famous around the time of the 93rd Olympiad (408 BC), and that he 'first established the method of representing appearances', that is, illusionistic painting. Apollodorus was called 'Skiagraphos' ('Shadow Painter'). Before he began to model his figures, Pliny says, there was no painting 'which holds the eye'.

DH To see the volume you need light on the subject, and shadows. In 1962, when he saw in the newspaper that the Royal Academy had sold the Leonardo Cartoon, I remember my father saying, 'Ah, yes, that's called "chiaroscuro"'. He had attended a class at the art school in Bradford in the 1920s on light and shade.

 If you studied it you'd be taught to ask: Where does the light come from? Most light sources are above, so shadows are generally underneath. Television pictures tend to be very dull, because the light is from straight in front. In painted portraits, it is very common to have a shadow beneath the nose, which means the light is coming from above – a natural place for it to come from. The portraits found in Egyptian mummies at Faiyum, I've noticed, often have a shadow like that.

MG No paintings by Apollodorus, or, indeed, by any of the famous artists of antiquity, have survived, but we can get some idea of the tradition he founded from these ancient paintings preserved by the heat and dryness of the Egyptian desert. They were painted in the period of the Roman Empire, but by Greek painters working in a culture based on a city, Alexandria, whose founder was Alexander the Great. It is possible that their pictures continued to use the devices, such as ancient Greek chiaroscuro, employed by the star painters of the 4th century BC, who

followed and built on the innovations of Apollodorus. Among these were Alexander's own favourite, Apelles, and Zeuxis.

DH There is a lot about verisimilitude, which requires chiaroscuro, in ancient writing on Greek painting. Think of Pliny's story about the birds pecking Zeuxis' painting of grapes. It's all about illusion and naturalism. But that is only one way of looking at the world.

MG According to Pliny, Zeuxis of Herakleia was the first true star painter in the history of art. He made so much money that he had his name woven into his clothes in gold letters. He worked slowly and valued his works so highly that, presumably having already made his fortune, he gave his pictures away as gifts, saying no price was adequate to buy them. His fame, it is clear from the texts, was based on sensational naturalism.

Pliny tells us that Zeuxis had a contest in realism with another celebrated artist, Parrhasios of Ephesos. Zeuxis painted some grapes so convincingly that birds fluttered around, attracted by the fruit. He was congratulating himself on this victory when he noticed that Parrhasios' picture was still covered by à piece of textile, but when he asked for this covering to be removed it turned out that it was itself the picture: a *trompe-l'œil* linen curtain. This famous anecdote was obviously about a competition in illusionism, which means, among other things, the eye-deceiving placement of shadows.

Although Zeuxis admitted himself beaten, the story – and another in which birds were attracted by his painting of grapes – casts a long shadow in the history of pictures. The 17th-century Spanish still-life painter Juan Fernández, known as 'El Labrador' ('the Rustic'), seems to have attempted to take on Zeuxis himself.

In this contest between artists divided by two thousand years, the obscure Spaniard probably did vanquish the ancient Greek. The astonishing naturalism of Juan Fernández's pictures exceeds that of anything surviving from antiquity, although the painters of the ancient world were capable of producing a naturalistic still life. A picture from the House of Julia Felix at Pompeii perhaps gives a faint idea of what Zeuxis' own grapes would have looked like.

Ancient painting was capable of enough verisimilitude to annoy one extraordinarily influential thinker: the philosopher Plato. Famously, Plato banished the poets from his ideal society, described in *The Republic*,

Mummy portrait (detail), perhaps of a priest, *c.* 140–60 AD Hawara, Faiyum, Egypt Encaustic on limewood

3 Shadows and Deception

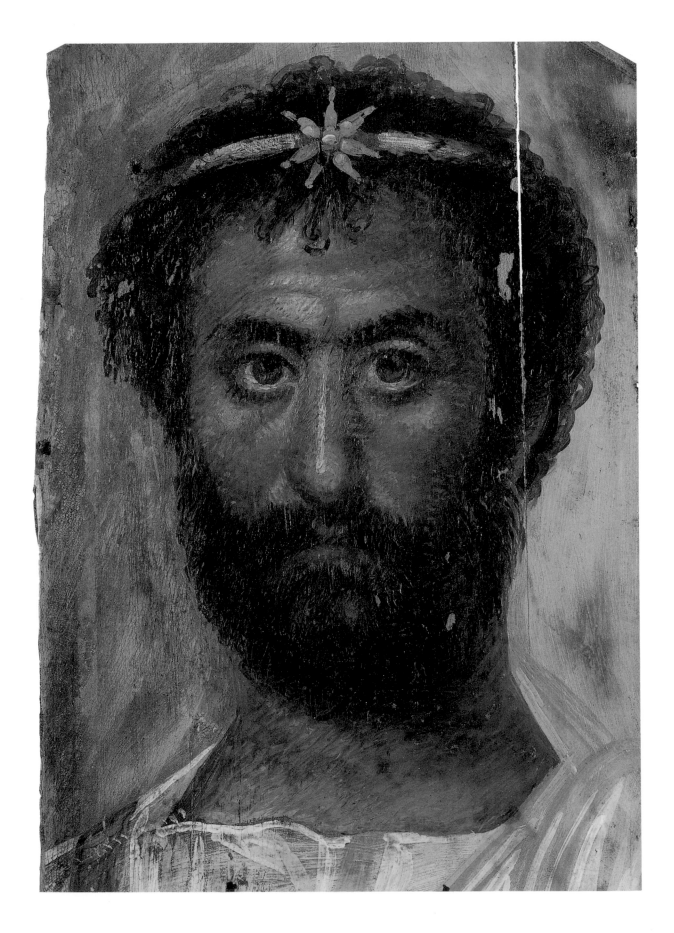

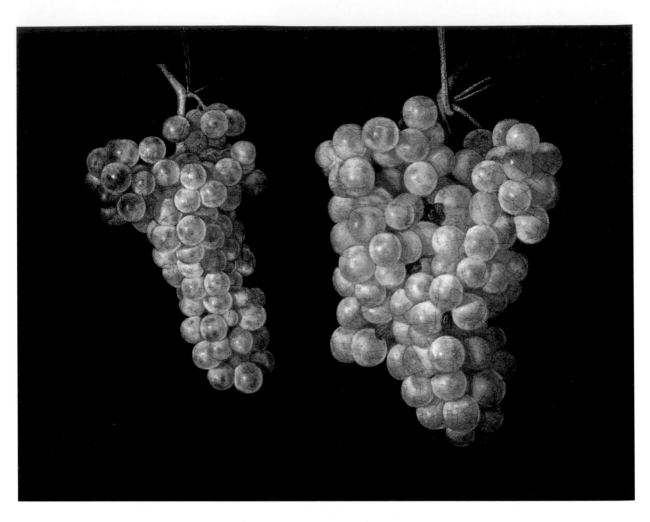

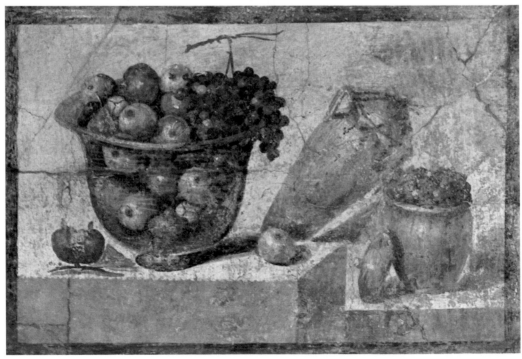

but he also had a low view of painting, and illusionistic pictures in particular. Such an image, in his view, was the opposite of the truth. It is a comparison he makes often. In his dialogue *Theaetetus*, he compares a bad argument to a painting that seems like reality when seen at a distance.

Painting and poetry for Plato were both forms of *mimesis* or representation. The philosopher considered this a very low grade of understanding in comparison with logic, mathematics or its offshoot, geometry. In *The Republic*, Socrates, originally Plato's mentor, but here his mouthpiece, says: 'This process of representation deals with something at third remove from the truth.'

In various passages he explains why he thinks this. It is because a picture does not deal with how an object really is, but only how it *seems*. A stick will appear bent in water, but that is not truly the case. 'It is this natural weakness of ours that the scene-painter and conjurer and their fellows exploit with magical effect.'

DH Why would you be against the picturing of the world? What did Moses know that we don't? Why is the Jewish world against images? Why is the Muslim world against images? I puzzle over the second commandment. I believe that painting can change the world. If you see your surroundings as beautiful, thrilling and mysterious, as I think I do, then you feel quite alive. I've always loved pictures; they give me ideas.

MG In a way, pictures seem to have given Plato ideas, too, or at least a compelling analogy. He was a contemporary of Apollodorus, Zeuxis and Parrhasios. The last actually appears debating with Socrates in a dialogue by Xenophon, so Plato possibly knew him personally. In any case, the development of illusionistic art was one of the striking events of his lifetime, and he evidently found it pernicious. It is surely no coincidence that within a few years of the advent of naturalistic pictures, questions were raised about their veracity. Did they truly represent reality? This is a concern that has continued to be voiced, in one way or another, from that day to this. For example, do photographs present the world as we experience it? Plato would have doubted that.

DH Most people feel that the world looks like the photograph. I believe it almost does, but not quite. And that little bit makes all the difference.

3 Shadows and Deception

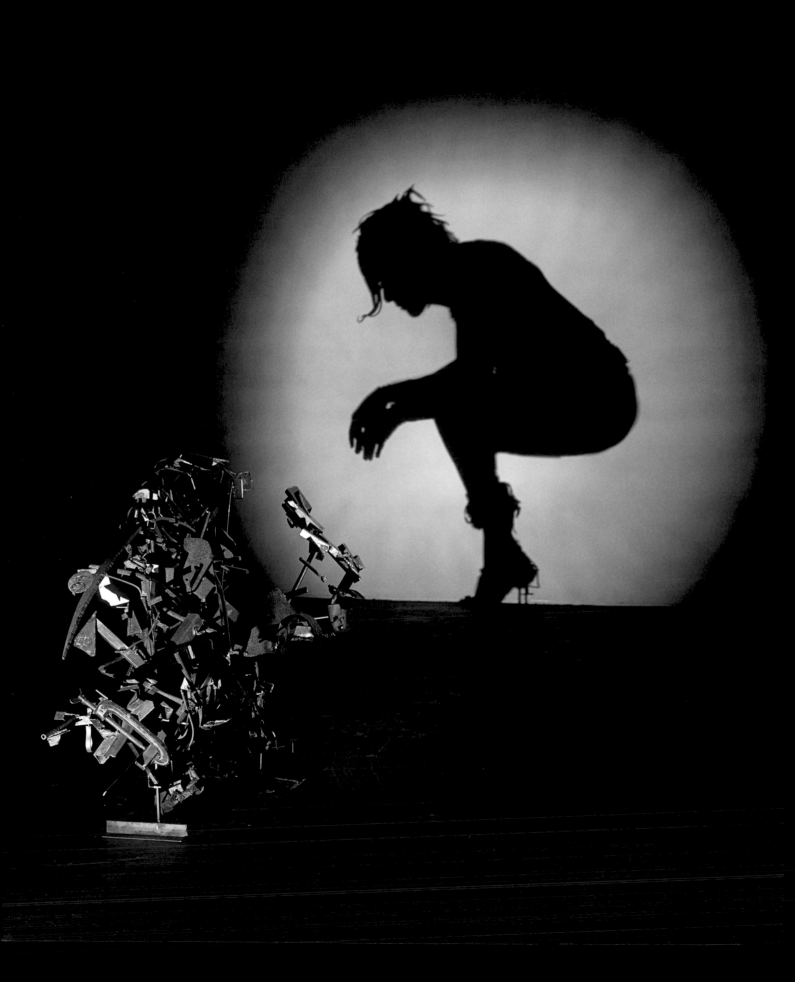

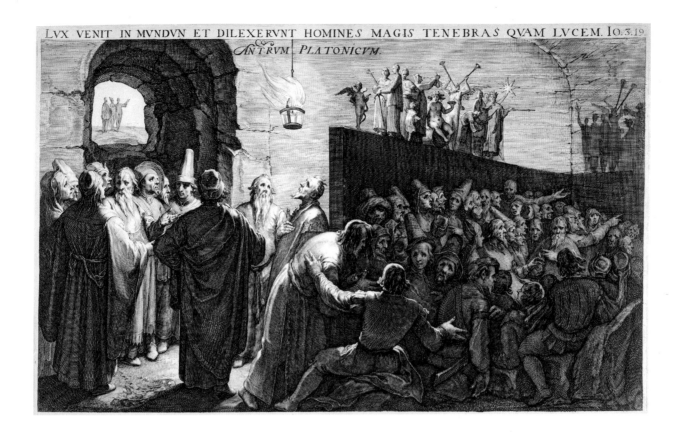

LVX VENIT IN MVNDVN ET DILEXERVNT HOMINES MAGIS TENEBRAS QVAM LVCEM. Io.3.19.

ANTRVM PLATONICVM.

MG For Plato, to show the columns of a temple as receding the further they are from the eye was a sort of lie: really they were all the same size. In his philosophy, truth comes from numbers, measurement, counting and weighing, understood by what he calls 'the element of reason in the mind'. In contrast, pictures are misleading, like reflections in a mirror or shadows on a wall. A shadow, or an image, was not the thing itself: a naturalistic painter, for Plato, was a kind of fraudulent trickster. That deceptiveness of shadows is the basis of a series of striking works by Tim Noble and Sue Webster, in which arrangements of scrap metal and detritus, artfully lit from a certain angle, become human silhouettes of startling verisimilitude.

The most memorable passage in all of Plato's works is, intriguingly, about shadows. This is the 'Simile of the Cave', from *The Republic*, in which Socrates describes an underground chamber, like a cave, which is open at one end to the light. 'In this chamber are men who have been prisoners there since they were children, their legs and necks being so fastened that they can only look straight ahead of them and cannot turn their heads.' What is in front of their eyes is the cave wall. Behind these unfortunate captives there is a fire, and between them and this flickering

Opposite
TIM NOBLE and SUE WEBSTER
HE/SHE (detail), 2004
Welded scrap metal, two light projectors

Above
JAN SAENREDAM after
CORNELIS VAN HAARLEM
Antrum Platonicum, 1604
Engraving

light, a low wall. All the chained prisoners can ever see is the shadows of objects held above this wall: 'figures of men and animals made of wood and stone and all sorts of other materials'. In the Puritan 17th-century Netherlands, the painter Cornelis van Haarlem imagined it as a contemporary theatrical performance, with the audience huddled in the darkness of the cave watching, among others, the shadows of Bacchus and Cupid, gods associated with the idle pleasures of wine and love.

To a modern eye, they look a little like the members of an audience watching a film, who are after all, in a dark space, looking at flickering shadows on the wall. Classical scholars have thought the same: F. M. Cornford suggested that the best way to understand what Plato meant was to replace 'the clumsier apparatus' of the cave and the fire with the cinema. Since then, the comparison between Plato's prisoners and viewers of computer screens, film and the entire gamut of contemporary visual media has been made time and again.

In the painting by Cornelis van Haarlem, which survives only in an engraving by Jan Saenredam of 1604, the more enlightened souls are in discussion behind the wall. They are hence able to see the light of the fire itself, not just the shadows it throws. But the truly wise have walked down the passage out of the cave, and are standing in the rays of the sun: truth itself. In the traditions of the great monotheistic religions of the Middle East, Judaism, Christianity and Islam, truth was derived from divine revelation, and pictures of sacred subjects are viewed with particular suspicion. That is why countrymen of Cornelis van Haarlem sacked churches and destroyed vast quantities of religious art.

DH Plato's story is about the shadows on the wall of a cave, shadows of objects held by people outside walking in front of a fire. That is all the people in the cave see of reality – a sort of projection. What could have been the origin of Plato's shadows in the cave? The camera obscura is a natural phenomenon, which might project shadowy figures walking by outside onto the wall of a cave. I've wondered about that. We obviously must be deeply affected by the optical projection of nature; we're still very attracted to it today. That's what the television picture is.

 3 Shadows and Deception

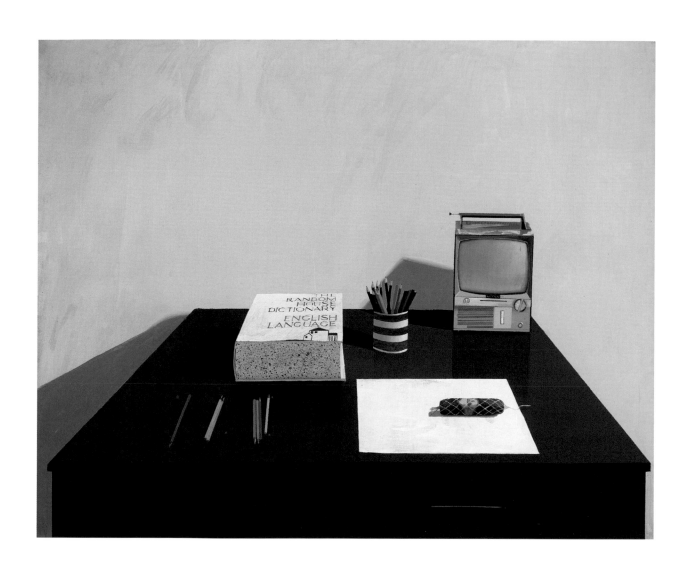

DAVID HOCKNEY
Still Life with T.V., 1969
Acrylic on canvas

4 Picturing Time and Space

We see with memory.

DH In a photograph it's the same time on every part of the surface. That's not true in a painting; it's not true even in a painting made from a photograph. That makes a considerable difference. It's why you can't look at a photograph for too long. In the end, it is just a fraction of a second, so you don't see the subject in layers. The portrait of me by Lucian Freud took a hundred and twenty hours of sittings and you see all that time *layered* into the painting. That's why it's infinitely more interesting than a photograph.

MG All pictures are, in one way or another, time machines. That is, they condense the appearance of something – a person, a scene, a sequence – and preserve it. It takes a certain amount of time to make them. And it also takes time to look at them, varying from a second to a lifetime.

 Van Gogh claimed that he painted the first version of *L'Arlésienne* (November 1888) in one hour. 'Then I have an Arlésienne at last,' he wrote to his brother, 'a figure ... knocked off in *one* hour, background pale lemon – the face grey – the clothing dark dark dark.' The painting shows signs of rapidity, but he had known the sitter, Madame Ginoux, who had been his landlady and friend, for five months before the sitting. He would have stored up many hours of looking at her, and these, too, went into the painting.

DH We see with memory, so if I know someone well, I see them differently from the way I might if I'd just met them. And my memory is different from yours; even if we are both standing in the same place, we're not quite seeing the same thing. Other elements are playing a part. Whether you have been in a place before will affect you, and how well you know it.

LUCIAN FREUD
David Hockney, 2002
Oil on canvas

78

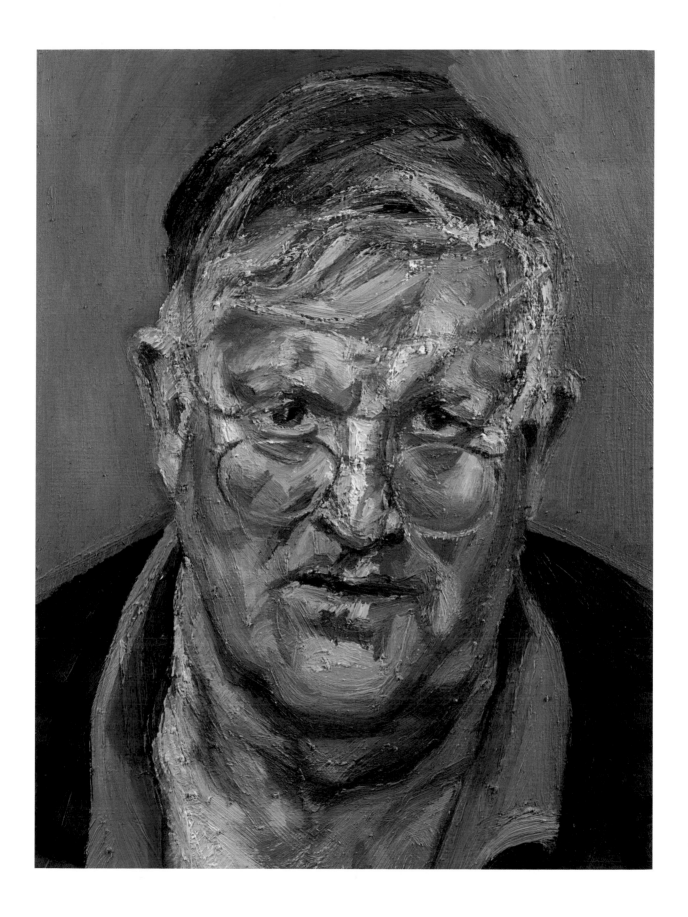

MG Time affects pictures in a variety of ways. One important factor is how long it takes to make a painting, which may be a matter of minutes, hours, days, months or years. Certain subjects come with their own time constraints: one of the problems of landscape painting and drawing is that crucial aspects of the scene are extremely transient.

DH There are some wonderfully free Monet paintings of the ice melting on the Seine at Vétheuil, done in January 1880. They were so free because it was rare for there to be ice on the Seine, so Monet would have had to go down to the river then and there to paint it. He'd know that and be down there.

MG The winter of 1879–80 was exceptionally harsh in northern France: it was one of the coldest of the 19th century. The temperature reached minus 25.6 degrees centigrade on 10 December 1879. The river Seine formed a thick coating of ice, on which deep layers of snow accumulated. Paris was compared to St Petersburg and the Seine to the Neva.

 The recently widowed Monet was living with Alice Hoschedé – a married woman in the process of separating from her husband – together with the eight children of their two marriages, in Vétheuil, a small town downriver from the capital. On the night of 4 January, a thaw began to melt the ice, starting in the east and spreading west on the Seine. Alice Hoschedé described what happened next: 'On Monday [5 January], at five in the morning, I was woken by a terrifying noise, like thunder; a few minutes later I heard Madeleine [the cook] knocking on M. Monet's window, telling him to get up ... I quickly ran to the window, and, dark as it was, I could see blocks of white falling; this time, it was the real break-up of the ice floes.'

DH That would have made him work very fast. There were several paintings called the *Débâcle*, and others of the icy river. As soon as he heard that there were ice floes in the Seine, he must have set to work. The ice might not have lasted even a night once the thaw had begun.

MG Three days later Monet wrote with some satisfaction to Georges de Bellio, a collector and friend: 'Here we had a terrible *débâcle* and of course I tried to make something of it.' The results transcribe extremely fleeting conditions, not only of the ice but also of light, at dawn and sunset.

VINCENT VAN GOGH
L'Arlésienne, 1888
Oil on canvas

4 Picturing Time and Space

DH When the sun is setting you know that you've only got one hour before the light goes so you work faster. He must have been doing very intense looking, my God. Obviously, not everybody is capable of it. Pictures can make us see things that we might not notice without them. Monet made us see the world a bit more clearly.

You have to be in a place for a little while to know exactly when you need to be there for the best light, what the best angle is, which way to move, things like that. If the sun is in your eyes everything will be a silhouette. Later, after painting all those years at Giverny, Monet would have systems in his head for doing all that.

These days, we know that you can't have space without time. But it's only a hundred years ago that everybody thought those were separate and absolute. We now think that they are, in a sense, aspects of the same thing. Time and space are really one. But we can't imagine what it would be like if there wasn't any space. It's impossible for us. We can't escape space or time. We know our time is limited, but we all know time is elastic.

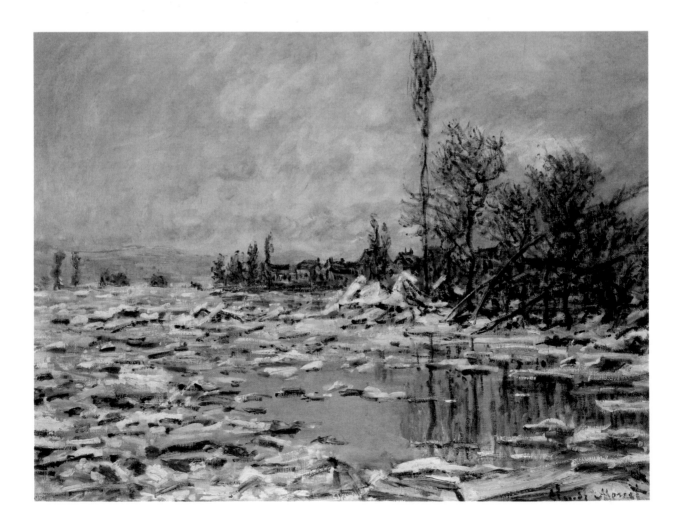

4 Picturing Time and Space

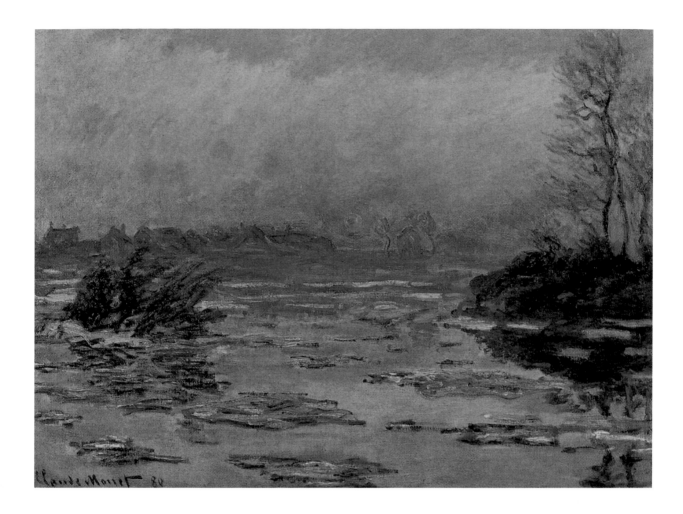

Painting is an art of time *and* space, or so it seems to me. A big thing in drawing is being able to put a figure in space. And you make space through time.

The eye is always moving; if it isn't moving you are dead. The perspective alters according to the way I'm looking, so it's constantly changing. In real life when you are looking at six people there are a thousand perspectives. I've included those multiple angles of vision in paintings of friends in my studio. If a figure is standing near to me, I look across at his head but downwards at his feet. A still picture can have movement in it because the eye moves.

When a human being is looking at a scene the questions are: What do I see first? What do I see second? What do I see third? A photograph sees it all at once – in one click of the lens from a single point of view – but we don't. And it's the fact that it takes us time to see it that makes the space.

You could say the reason photographs can't depict space is that there isn't any space there when the camera takes the picture. But even in

83

the very early days of photography, they were trying hard to improve the sense of space in photographs; stereoscopic pictures were invented within ten years of photography's announcement in 1839. When you look at those, however, you – the viewer – are in a void. You are viewing a picture in this black surround, so you are not a part of it at all. That's hopeless, for 3-D. There's no void between you and a painting.

MG Artists and scientists have long been fascinated by the effects of binocular vision: seeing with two eyes. In the 13th century, Friar Roger Bacon stayed up during a summer night, staring at the stars while opening and closing his eyes alternately so as to try and understand the effects on his perception of having two of them. In 1838, a year before the public announcement of the invention of photography, Sir Charles Wheatstone gave a lecture describing how the impression of depth is created by the mental comparison of two pictures taken from slightly divergent angles. He demonstrated this phenomenon with his Reflecting Mirror Stereoscope. Two mirrors (A & B in the first engraving below) set

Right
SIR CHARLES WHEATSTONE
Reflecting Mirror Stereoscope, 1838

Below
The Brewster Stereoscope,
invented by Sir David Brewster, 1849

4 Picturing Time and Space

at 45-degree angles reflected drawings displayed to the side (D & C) and the viewer looked through the eye-holes (E & F).

Ten years later, in 1849, Sir David Brewster, an eminent Edinburgh-based scientist who encouraged Robert Adamson and David Octavius Hill in their photography, unveiled his stereoscope, in which two photographs – again taken from divergent angles – were seen through a lens, one for each eye.

DH The real world is at least 4-D, time being the fourth dimension. If you could make a film where you were sitting at a real table, the first question I would ask is, 'Where's the exit?' That tells you that it's a mad idea to try to recreate the world. So there's something wrong with 3-D photographs and films. We don't actually see like that.

MG There are, perhaps, as many kinds of space as there are kinds of picture. Different cultures and different historical periods depicted space in diverse fashions.

DH Byzantine painters and medieval artists also had what we would now call reverse perspective. A painting of an altar, table or throne will show both left and right sides. Reverse perspective is more about you. It means that you move, because you can see both sides of the object. What's closer to you is actually in the middle.

ANDREI RUBLEV
Holy Trinity, 1425–27
Tempera on wood

4 Picturing Time and Space

DAVID HOCKNEY
The Second Marriage, 1963
Oil, gouache and collage on canvas

GIOTTO
Annunciation and God Sending Gabriel to the Virgin, c. 1305, Scrovegni Chapel, Padua
Fresco

Medieval artists often used isometric perspective, as did Chinese, Japanese, Persian and Indian ones. The idea that those artists didn't get perspective right is ridiculous. There's no such thing as 'right' perspective. In isometric perspective the lines don't meet at a vanishing point; everything remains parallel. You could say that isometric perspective is more real, since that is closer to how we actually see. Because we have two eyes, which are constantly moving, perspectives are constantly shifting. I preferred it, and I still do in a way. In the 1960s, I did two or three paintings on a shaped canvas of two figures sitting in an isometric box. One of those was *The Second Marriage*.

The chancel arch of the Scrovegni Chapel in Padua, painted by Giotto, is isometric, virtually, in that it has no single vanishing point. There is a fairly conventional perspective on God's throne. The lines recede towards the centre, but the buildings in the Annunciation below, with the Angel and the Virgin inside, are seen from completely different directions.

4 Picturing Time and Space

MG The lesson one learns from that example is that Giotto did not feel bound by any fixed rules. The throne is painted as if it were looked at from the centre, but seen from above, although the viewer is actually below. However, if the balconies jutting from the walls above the Angel and the Virgin were seen in that way – or even from the same direction – it would interfere with the symmetry of the design and hence disrupt the story the artist was telling.

Giotto showed a freedom from any need to follow a set formula for depicting space. In this he resembles a 20th- or 21st-century artist, such as Matisse, Picasso or Hockney. Much of what we call 'modernist' painting was an attempt to find ways of making space that were different from either the space of a photograph or linear perspective. Often they found a way of escape by looking at medieval pictures, or ones from outside Europe.

DH Chinese painting does not have a fixed viewpoint, it is based on a moving focus. I first read *Principles of Chinese Painting* (1947) by George Rowley in the 1980s. I was very interested in Rowley's description of 'a space which implied more space beyond the picture frame', and how the artists 'practised the principle of the moving focus, by which the eye could wander while the spectator also wandered in imagination through the landscape'.

In 1987–88, I made a film with Philip Haas about a 17th-century Chinese scroll in the Metropolitan Museum. The scroll is a different sort of picture. You don't entirely unravel a scroll; you turn it continually. So it doesn't really have edges in a normal sense. The bottom is you, perhaps, and the top is the sky. Therefore, you can't see a scroll in a book – or a film – because in a book the page turns over on itself.

Renaissance European perspective has a vanishing point, but it does not exist in Japanese and Chinese painting. And a view from sitting still, from a stationary point, is not the way you usually see landscape; you are always moving through it. If you put a vanishing point anywhere it means you've stopped. In a way, you're hardly there.

In the film we showed something very fascinating. Notice how subtle the perspectives are in the scroll. When you are looking at the bridge it is from way over to the right, but you are also seeing the houses on the left from an angle, as if you were on the bridge itself. So it's a marvellous complex example of shifting viewpoints that still seem to make perfectly ordered sense to me.

WANG HUI
*Kangxi Emperor's Southern
Inspection Tour, Scroll Seven:
Wuxi to Suzhou, 1689* (detail),
1698
Ink and colour on silk

90

MG By the 12th century, Chinese painting reached a majestic technical and intellectual maturity. This was expressed above all in landscape. There is vast space in these old pictures. In *Mountains, River and Pavilions*, possibly by Yan Wengui (*fl.* 970s–early 11th century), a range of jagged hills comes down to the sea, which in turn fades away at a far distant point where it merges with the sky. As a 12th-century critic put it, 'a thousand miles in a single foot – such was his subtlety'.

For millennia the mountain has been the noblest subject of Chinese art. In the first great surviving masterpieces of Chinese landscape painting – by artists such as Fan Kuan, Li Cheng and Guo Xi, who were active before the Norman Conquest – massive knobs of stone are depicted towering towards the sky.

This was the epic age of Chinese painting, the period to which later generations constantly returned. Of the artists of that period, Guo Xi (*c.* 1001–1090), one of the most important, was a theorist as well as an artist. And he thought about painting entirely in terms of mountains. In his view, there was high distance, which meant 'looking up to the peak from the foot of the mountain'; deep distance – 'standing before the mountain, looking beyond it'; and flat distance, which was viewing a distant range from a nearby mountain.

Of these, the most formidable was high distance, painted on a tall vertical scroll, on which the massive rocky wall rears in front of you.

YAN WENGUI
Mountains, River and Pavilions
(detail), *c.* 1000
Ink and colour on paper

Instead of mentally travelling into the picture, you travel up it: over passes, under beetling crags. Generally, there are signs of humanity within the picture – a party of travellers, a hermit meditating in a pavilion, a temple built improbably on a jagged outcrop – though they are tiny in comparison with the majesty of the terrain. On horizontal scrolls one travels through time as one unrolls the picture, never seeing the entire image all at once.

As in much Western landscape painting, there was a religious idea behind this. It was a Daoist sense of the ying and yang of the universe, perfectly caught in a contemporary description of the work of Li Gongnian (active early 12th century): 'shapes of objects appearing and disappearing in vast emptiness'.

DH The mist is a void from which the landscape appears. Of course, modern China has embraced science and technology. Indeed, it has embraced the Western way of seeing; television and photography now dominate it, even though it says it doesn't want too much Western influence. A scholar of Chinese art told me that the Chinese have now forgotten the principle of the moving focus. Photography dominates the world in a way the Chinese or English language never has.

GUO XI
Early Spring, 1072
Ink and colour on silk

樹繞叢葉溪
閒凍橋閬仙
居家上層不
藓枒挑間黏
微去山早兄
氣如蒸
己卯春月
尚卿

5 Brunelleschi's Mirror and Alberti's Window

Alberti's window is a prison really.

DH The advent of linear perspective is normally given a date and a place: the early 15th century in Florence. In 2010, I took a photograph of a label on the wall in the 'Italian Renaissance Drawings' exhibition at the British Museum. It said: 'One of the great Renaissance artistic innovations was the invention around 1413 of linear perspective by the Florentine architect Filippo Brunelleschi.'

This is standard art-historical opinion: Brunelleschi 'invented' the laws of perspective that we acknowledge today. But Boyle didn't invent Boyle's law. He was describing something that was there. A scientific law isn't invented, it's *discovered*.

MG A letter from 1413 by a poet named Domenico da Prato to a friend in Florence lamented the dull life of the countryside, in comparison with the excitements of the city, such as the activities of 'the perspective expert, ingenious man, Filippo di Ser Brunellesco [that is, Brunelleschi], remarkable for skill and fame'. This suggests that Brunelleschi had created a stir that was both novel and *visual*. The word Domenico da Prato used, 'prespettivo' did not carry its modern meaning in 1413. He meant that Brunelleschi was famed for his innovations in *perspectiva*, or the science of optics.

DH Perspective, as we know, is not an invention; it is just a law of optics. A linear perspective picture is the kind of picture produced by a natural camera. A hole in the wall of a dark room produces a picture like this, hence the name the effect and any piece of equipment goes by: camera obscura, which is just Latin for 'dark room'. Of course, that's where the word 'camera' comes from. This connection alone should make us re-examine the story of perspective in European art.

FRANCESCO DI GIORGIO
MARTINI
The Ideal City (detail),
c. 1480–90
Oil on canvas

MG The biography of Filippo Brunelleschi (1377–1446), written in the 1480s by a younger contemporary, Antonio di Tuccio Manetti, relates that he produced two celebrated demonstrations of perspective. The first was a view of the Florentine Baptistery, the second of the Palazzo Vecchio viewed across the piazza. These were – both disappeared centuries ago – among the most important images ever made. They fundamentally changed the history of pictures.

The point that leaps out from Manetti's description of Brunelleschi's perspective pictures is that they were intended as stunning visual illusions, not as mathematical demonstrations. Describing the first, of the Baptistery, Manetti wrote that Brunelleschi made, 'a representation of the exterior of San Giovanni in Florence'. He did this from a specific, precisely noted viewpoint: 'In order to paint it, it seems that he stationed himself some three *braccia* [approximately six feet] inside the central portal of Santa Maria del Fiore [the Florentine Duomo].' This was the first known picture in history that was intended not to depict a person, deity, story, event or object, but to demonstrate an optical truth.

The picture of the Baptistery was a sort of portable peepshow without a box. To view it, and experience the illusion, the spectator held the back of the painting – which was around a foot across – up to his eye. In the panel there was a hole, 'as tiny as a lentil bean', on the painted side, and widening on the reverse side from which the viewer looked.

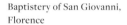
Baptistery of San Giovanni, Florence

5 Brunelleschi's Mirror and Alberti's Window

DH Perhaps before Brunelleschi no one thought of looking at a picture through *one* eye.

MG The viewer looked through the hole in the back of the picture, and at the same time held up a mirror opposite the image, thereby seeing a reflection of the picture. Consequently, the spectators felt the actual scene was before their eyes, as Manetti testified: 'I have had it in my hands and seen it many times.' Instead of a painted sky, Brunelleschi left burnished silver so reflections of real clouds drifted across the sky above his image of the Baptistery. So it seems he was aiming at a totally convincing facsimile of reality: an early 15th-century movie.

DH The spirit of photography is much older than its history, which is what we have discovered. I went to Florence to attend a conference on art and science. And I *stood* on the exact spot where Brunelleschi is supposed to have stood. Then, with a five-inch diameter concave mirror that cost six pounds, I projected the Baptistery onto a panel and traced its outlines, just as Brunelleschi could have done. By standing within the cathedral he would have been able to view the Baptistery from a dark space, in effect a sort of big camera obscura. This would have been true especially in the morning when the sun would fall strongly on the Baptistery but the interior of the Duomo, which stands to the east, would be in shadow.

MG The pinhole camera was certainly known in the Middle Ages; indeed, it was the subject of considerable academic discussion by Friar Roger Bacon, among others. The magic lantern was also used in the 15th century. It projected a drawn or painted image by means of an artificial light.

There is no contemporary record of how Brunelleschi made his pictures. One thing we do know about him, however, was that he was extremely secretive about his technical innovations (to the extent of flatly refusing to divulge the practical details of how he proposed to construct his great dome without centring). A younger contemporary of Brunelleschi, the Florentine architect Filarete (*c.* 1400–*c.* 1469), felt that in some way Brunelleschi's trick had been worked with mirrors.

Writing in the 1460s, Filarete recommended artists to view a scene in a mirror as a way of seeing its outlines, and especially foreshortening,

more easily. 'Truly', he added, 'I think that Pippo di Ser Brunellesco discovered perspective in this way.' Perhaps Brunelleschi did simply look in a flat mirror, and drew what he saw. But a concave mirror would have the added advantage of projecting an image onto a panel – a procedure that would also have seemed to be a reflection to a 15th-century mind. So, too, would a projection by a magnifying glass or spectacle lens, or, even, in a pinhole, lens-less camera. It is by no means impossible that Brunelleschi could have made his picture of the Baptistery by using a projection from a mirror or lens. Alternatively, it is quite feasible that he might have made this extraordinary innovation with a flat mirror, as Filarete guessed.

DH Science and art weren't that separate then, really. Remember, if nobody had seen a photograph, then a projection from nature is going to be of deep fascination to anyone who's making images. Naturally, an artist would be interested in the many ways there are of depicting the world.

MG The fundamental point is that Brunelleschi made a picture that showed a three-dimensional scene just as it would be presented by those optical means. From then on, other artists began to do so, too. However Brunelleschi worked his wonderful trick, the long dialogue between pictures and optics had begun. It led, over four centuries later, to the inception of photography.

DH But a projection would have been easier to use. The difference between a mirror reflecting an image and projecting an image is very great, because the reflected image moves with your body.

MG It is probable that Brunelleschi was intimately familiar with pieces of optical equipment. He was apprenticed, Manetti tells us, to be a goldsmith. Vincent Ilardi, the historian of Renaissance spectacles, noted that 14th- and 15th-century Tuscan goldsmiths were functioning much like modern opticians.

One of the crucial innovations of the Middle Ages was spectacles. These were not mentioned in academic texts but were of huge practical use to those – almost everyone older than 50 – whose eyes became less close-focused with time.

Eye-glasses were invented around 1286 by a craftsman in Pisa, whose name is unknown (probably because he was secretive about his discovery). By the mid-14th century they were in wide use, and being manufactured in

GIOVANNI FONTANA
A magic lantern projecting an image
of a demon, from Bellicorum
Instrumentorum Liber, 1420
Manuscript drawing

Below
TOMASO DA MODENA
Cardinal Hugh of St Cher, 1352,
Monastery of San Nicolò,
Treviso
Fresco

Opposite
MASACCIO
*Trinity with the Virgin, Saint
John the Evangelist, and Donors,*
c. 1425–28, Santa Maria Novella,
Florence
Fresco

quantity in Venice, Tuscany and particularly in Florence, which became
the European centre of the industry. Lenses were not only made out of
glass, but also of rock crystal; examples from the 11th and 12th centuries
have been found on the Baltic island of Visby.

DH It's the *experience* of having looked at an image made by a lens or
a mirror that would have been important. Whether it was made from
crystal or glass, it still produced a standard, lens-perspective of an object.
With the camera it's from a single point in the middle of a lens, and it
pushes things away. The human eye is more fluid. And once someone's
made a camera picture, it will influence everyone else.

MG The first surviving painting that shows clear signs of a new approach is
a fresco of the Trinity in Santa Maria Novella, Florence, dating from
c. 1425–28 and painted by one of Brunelleschi's closest acolytes,
Masaccio. The receding lines of the barrel vault were incised into the
plaster before Masaccio began to paint. This geometry is the template
on which the image was constructed. It made a new space: the prototype
of that in many future pictures.

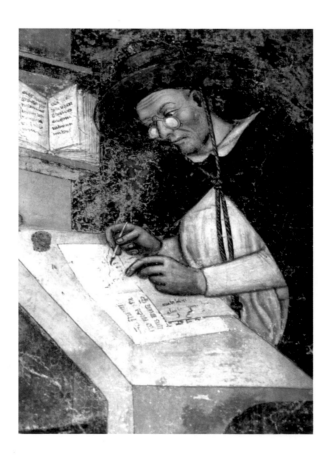

DH How powerful Masaccio's depiction of the Crucifixion would have been in the early 15th century. More powerful than film or television were to later ages, I suspect. Also, there would have been an expressive gain in a perspective picture of the Crucifixion because there is no movement. Christ died because he could not move, nailed to a flat plane. Any other form of execution would have had a before and after. But linear perspective freezes time.

MG Brunelleschi had not produced a geometrical or mathematical exposition of linear perspective – that probably came later. He was a practical engineer and inventor of great brilliance, but academic theorizing was not part of his education. In the Middle Ages there were two streams in the subjects that we would call the sciences. There was scholarly debate, conducted in Latin, and based on the study of texts from the ancient world. Running parallel, but seldom touching, was what we would describe as technological innovation: the introduction of devices that made life easier and more efficient, such as the vertical windmill, wine press and – in the mid-15th century – mechanical printing. These were the work of practical people: artisans and engineers. It was to this second group that Renaissance artists such as Brunelleschi and Leonardo da Vinci belonged.

The first published description of linear perspective was published by Leon Battista Alberti (1404–1472). Unlike Brunelleschi, Alberti was an educated gentleman, who wrote fluently in Latin; he was an artist and architect as well as a writer. His treatise *De pictura* (*On Painting*), published in Italian as *Della pittura* in 1435, is one of the most influential books on art ever printed.

It outlined late medieval optical theory. Rays of light extend from the eye to the objects that are seen. Alberti compared these to threads, stalks sprouting from a bud, and 'the willow wands of a basket cage'. Then Alberti did something unprecedented: he produced a geometric definition of a picture. It was a rectangle that cut across all these rays of light at a certain place, so that the objects further away would appear smaller, the closer ones larger, and the ones in the furthest distance disappeared to nothing, to a point.

Another way of thinking of this was to imagine the picture to be a window, which was how Alberti described his own method of working. When he drew, he first set out a rectangle, which he imagined 'to be an open window' through which he saw what he wanted to paint.

DH The idea that the picture is a window on the world prompts you to ask the question: 'Well, where am I then? I'm sitting in a room looking through that window. I'm not outside, in the world.' With Alberti's perspective we're reduced to a mathematical point. No actual person – literally, no *body* – ever saw the world that way. The eye is always moving, if it isn't you are dead. When my eye moves in one direction, the perspective goes that way. So it's constantly changing. Perspective is really about *us*, not the object depicted.

Van Eyck didn't use linear perspective; he used multiple points of view. In his pictures you feel you are close to everything, even the distant faces in the crowd. I think that is because actually he *was* close when he was drawing them. You are looking not through one window, but through many, which is nearer to the way we actually see.

In the Canon van der Paele altarpiece, Van Eyck's figures are on a quite different scale from the Romanesque church in which they are set, but it takes some time to notice the discrepancy – if you ever do. They are standing in a shallow space, right in front of you; there is no void, you are there, too. You might say the figures are too big for the architecture, but only if you think in terms of optical, linear perspective. Van Eyck's contemporaries would have seen it as amazingly real, which it still is.

MG Alberti's combination of mathematics and aesthetics, however, proved to be hugely influential. Part of the attraction was that Alberti's theory gave intellectual dignity to the art of painting, hitherto considered a skill of artisans. This way of looking at the world was illustrated in woodcuts by Albrecht Dürer (an example of the new type of intellectual artist to whom Alberti's theories were appealing).

JAN VAN EYCK
*The Madonna with Canon
van der Paele*, 1436
Oil on wood

The notion of Alberti's window depended on an absolutely fixed viewpoint, which is why the artist Dürer illustrated drawing a nude has an object like an obelisk in front of his face. At the top is an eye-piece, through which he looks – with one eye.

The grid or net that Dürer's artist has between himself and his model is just one of many such devices: Dürer illustrates three more in his *Four Books on Measurement* (1525). Earlier, Leonardo had discussed and drawn a similar system. Later, more complex instruments for drawing perspectives were devised, notably by Baldassare Lanci (1510–1571), an architect and theatre designer from Urbino. Cigoli, a painter friend of Galileo's, devised yet more.

These were early evidence of a search that persisted until the advent of photography: the quest for a machine that could make pictures. Some are still used: for example, the pantograph, a mechanical copying mechanism that dates back to the 17th century. Van Gogh used a perspective frame when drawing in the late 19th century. In time, however, many artists seem to have found the camera obscura a much simpler substitute for the more elaborate contraptions.

DH I've never been against new things just because they are new. I try them out and see whether they are good tools for me. The fax machine was, the iPad is. But how it's done is not the deepest mystery. Because, in the end, no one knows how powerful and memorable pictures are made. Understanding a tool doesn't explain the magic of creation. Nothing can.

MG Linear perspective became part of the official theory of how pictures should be made. But many artists paid less attention to it in practice. There is a copy of the *Life of Michelangelo Buonarroti*, written by his assistant Condivi and published in 1553, which has annotations that seem to have been dictated by the aged artist himself. At one point Condivi praises the great man's studies in anatomy, architecture and perspective. In the margin the old man's brusque response is noted: 'Perspective, no, because it seemed to me to be a waste of too much time' ('Alla prospettiva non, che mi pareva perdervi troppo tempo').

Michelangelo's frescoes read or 'hold the eye' – as the ancient Greeks put it – magnificently from seventy feet below the Sistine Chapel ceiling. But the space in them is a shallow one, often no more than one body deep. Even the panels telling the story of the Creation in Genesis really consist of figures standing just a little further back, behind the

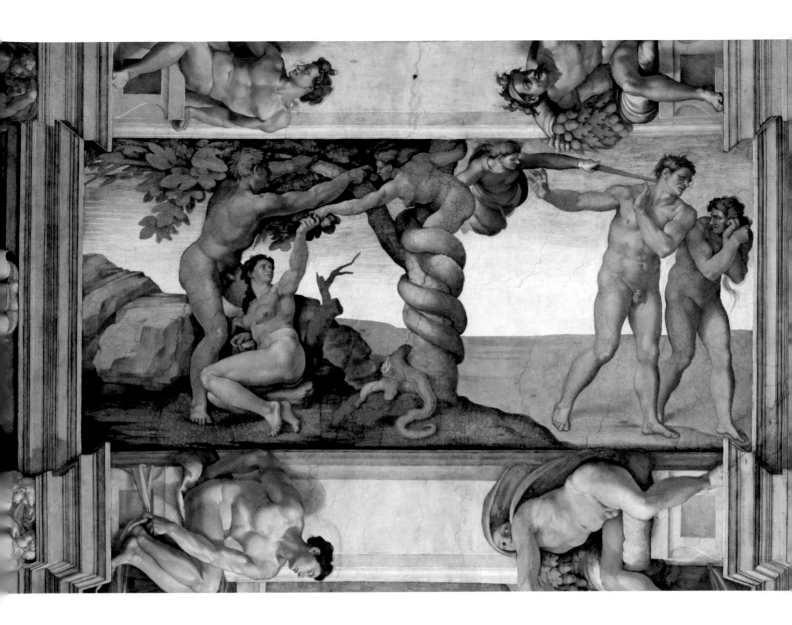

MICHELANGELO
*The Fall and Expulsion from the
Garden of Eden*, 1509–10, Sistine
Chapel, Vatican
Fresco

nudes and prophets seated on the painted architecture. Some are just behind his window-frames, and some are on our side.

Many philosophers and sociologists have discussed the idea of alienation, that is, the way in which, especially in Western culture, people are separated psychologically and economically, both from each other and from the natural world. What a picture constructed according to Alberti's perspective does is – precisely – separate us from our surroundings.

DH Alberti's window is a prison really. But I think that many painters have always known that there was something wrong with conventional, linear perspective; they realized you could bend it.

6 Mirrors and Reflections

Mirrors are powerful because they make pictures.

DH By the sea in California you get a special light, as you do in Bridlington, because of the reflections. It's clearer and sharper than inland. My swimming pool paintings were about transparency: how would you paint water? A nice problem, it seemed to me. The swimming pool, unlike the pond, reflects light. Those dancing lines I used to paint on the pools are really on the surface of the water, which is a kind of rippling, moving mirror.

Mirrors are very powerful things because they can make pictures. All mirrors reflect the world; a concave mirror can also project an image of it. And a projection or reflection of the world is a very different thing, isn't it, from the world itself? It simplifies it, and flattens it. Drawing and painting are ways of translating three dimensions into marks on a flat surface. There are many ways of doing it. Mirrors can help you find some of them.

Leonardo suggests painters should judge their works by looking at them in a flat mirror. Your own pictures look different in a mirror, and a mirror can make the real world look like a picture. The Claude glass, for example, is a slightly convex and tinted mirror. They were made for 18th-century travellers to look at landscape. When you look in one, prominent features such as trees seem to exist in layers going back into space. It made the real countryside seem like a picture by Claude.

MG Reflections are natural phenomena almost as ubiquitous as shadows. From the earliest times, people must have been aware of them in still and moving water and they remain one of the fundamental subjects of pictures: indeed, reflections *are* pictures of a kind.

Historically, many people saw paintings and mirror images as much the same thing. In 1769, the poet Thomas Gray described looking at

DAVID HOCKNEY
Study of Water, Phoenix, Arizona, 1976
Coloured crayon on paper

Derwentwater in the Lake District from the garden of Crosthwaite
Vicarage using his Claude glass. Afterwards, he wrote to a friend that
in his mirror he'd seen a picture 'that if I could transmit to you, & fix it
in all the softness of its living colours, would fairly sell for a thousand
pounds'.

Vasari described how Parmigianino, looking at himself one day in a
convex looking-glass and 'perceiving the bizarre effects produced by the
roundness of the mirror, which twists the beams of a ceiling into strange
curves, and makes the doors and other parts of buildings recede in an
extraordinary manner', had the idea of copying what he saw exactly.
He had a turner make a piece of wood of a similar curvature, and
painted on it. 'So happily, indeed, did he succeed in the whole of this

6 Mirrors and Reflections

PARMIGIANINO
Self-Portrait in a Convex Mirror,
1723–24
Oil on poplar

work, that the painting was no less real than reality, and in it were seen the lustre of the glass, the reflection of every detail, and the lights and shadows.' Except, of course, the picture was not like reality, but perfectly resembled an image reflected on a rounded surface. It is a virtuoso visual joke and an extreme example of a widespread phenomenon. Many painters wanted to make pictures as similar to mirror images as possible.

A mirror seems to show us truth but it is also evidently untrue: the image is reversed, flattened, simplified and perhaps altered by the curvature or colour of the reflecting surface. There are dark mirrors like the one in which the Elizabethan alchemist and astrologer John Dee saw visions of angels and demons. A mirror image is at once true and a lie.

In Plato's *Republic*, the philosopher's mouthpiece, Socrates, points out that in a sense it is not hard to create things. 'The quickest way is to take a mirror and turn it round in all directions; before long you will create sun and stars and earth, yourself and all other animals and plants, and furniture and the other objects we mentioned just now' (Plato had taken beds and tables as examples of objects that painters represent in a misleading way, with perspective distorting the true dimensions of the object). Yes, objects Socrates' conversational sparing-partner Glaucon, 'But they would only be reflections, not real things.'

The word 'reflections' in that remark could also be translated as 'appearances', or, indeed, 'pictures'. As Socrates quickly points out, this is just what a painter does: holds a mirror up to reality and creates illusory images of it – not the true reality.

A profound meditation on this very distinction seems to underlie *Las Meninas* by Diego Velázquez, one of the most celebrated paintings in European art. It is, among many other things, a picture about a reflection. Towards the rear of the painted space is a picture of a mirror in which there is a reflection of the King of Spain, Philip IV, and his queen. According to an early description by Antonio Palomino, this is intended to be a reflection of the picture on which Velázquez is working, in which case it is a picture of a reflection of a picture, but there is some ambiguity, perhaps deliberately, about this point.

Originally, Velázquez made the picture to hang in the King's private apartments. When the monarch looked at it, therefore, he saw, not only his royal painter, palette and brush in hand, contemplating him, but also an image of himself in a mirror looking back. For Philip IV it was therefore a dizzyingly complex set of variations on the questions 'What is reality and what is appearance?' and 'What *are* we looking at?' So in one sense, *Las Meninas* was a picture about a mirror, but in another way, less often noted, it was made by mirrors.

DH We know from an inventory made after his death that Velázquez owned ten large mirrors, which was then a very expensive set of paraphernalia. I made experiments, and the moment I did so I found out how mirrors were used then. They would have been needed to direct light.

MG Velázquez was not the only major painter to have invested in large mirrors. Caravaggio owned one, so, too, did the 16th-century Venetian painter Lorenzo Lotto. Towards the end of his life and rather down

CARAVAGGIO
Narcissus, c. 1597–99
Oil on canvas

DIEGO VELÁZQUEZ
Las Meninas, c. 1656
Oil on canvas

on his luck, Lotto spent a considerable amount of money to buy and transport a 'big crystal mirror' from Venice to Ancona where he was working. It was to replace one that had broken. It is unlikely that the painter, aging and far from wealthy, wanted to admire himself in this – it was clearly an important piece of equipment.

Las Meninas is set in a real place: a long high room in the Prince's Quarters in the Royal Alcázar in Madrid (it was in fact near to Velázquez's own rooms, where those mirrors were kept). On the walls are the paintings, by Rubens, that hung there. The people, almost all identified by Palomino, were real individuals, including the painter himself and the 5-year-old Infanta, Margarita Maria. The scene, however, is orchestrated by light. The princess and her entourage are spotlit. Velázquez himself is illuminated just enough for us to register his presence in from the shadows. The mirror, as Jonathan Brown put it, 'shimmers' in the background, and the man in the doorway – a courtier named José Nieto – is brilliantly backlit.

DH The lighting in *Las Meninas* must have been cast by the sun, as before the days of electricity only the sun would have been able to produce such power. Any lighting person would tell you that, or any cameraman. So Velázquez would have had to reflect the rays of the sun to make it fall the way he wanted; you can do that very simply.

DIEGO VELÁZQUEZ
Las Meninas (detail), *c.* 1656
Oil on canvas

MG Light catches and emphasizes every crucial point necessary to articulate the space and bring out nuances of texture: the side of the canvas, the princess's gleaming hair, the glittering embroidery on the clothes of her attendants. It is also an illusion, created with spectacular and astonishing skill. Move closer to the picture and those utterly convincing surfaces of the princess's costume dissolve into flickering marks made with a brush.

Despite the openness with which the picture emphasizes that it is a series of illusions within illusions, Palomino declared that no praise was too high for *Las Meninas*, 'for it is truth, not painting'. This invites the question, 'What is truth?' Indeed, the painting itself seems to ask it.

DH E. H. Gombrich was one of many to think Velázquez was at the pinnacle of naturalistic painting. Francis Bacon believed that as well. Doesn't Gombrich talk about the conquest of reality? And Velázquez was the painter more than anyone else who seemed to conquer it.

Some critics thought Cubism and modernist painting were distortions of reality. But one might ask: 'A distortion from what?' If you talk about distortion, you imply something is being distorted. And that thing which is being distorted must be the optical view of the world. We always come back to what we think of as an ordinary picture, which seems to be confirmed in photographs. It's very, very hard to escape that.

MG Velázquez was fascinated by optics. We know that from the same inventory that listed his collection of mirrors. His array of picture-making tools included a 'little bronze instrument for making lines', and 'a thick round glass placed in a box'. This last was perhaps a lens or a concave mirror, but most probably, as Martin Kemp has suggested, a camera obscura. Velázquez also had an extensive library of books on perspective, geometry, architecture, art theory and optics, among them not only Alberti's *Della pittura*, and works by Dürer and Leonardo, but also multiple copies of Euclid's *Optics* and *Catoptrics* – that is, the science of mirrors – then wrongly attributed to him. He owned that last text both in Spanish and Italian translations.

Although Euclid is not now thought to have written the *Catoptrics*, this treatise – which evidently fascinated Velázquez – demonstrates the antiquity of human interest in mirrors. They are, in fact, almost as old as pictures. In Anatolia, polished stone mirrors some six thousand years old have been discovered. When human beings began to mine and smelt metal, an artificially reflective surface appeared as a by-product: a better mirror. The ancient Greeks had mirrors made of polished bronze and other metals. There are pictures of reflections in ancient art.

The shining shield in the foreground of the mosaic in Naples of the Battle of Issus between Alexander the Great and the Persian king Darius has been analysed by the art historian David Summers. It is a huge disk, possibly of polished silver, that has fallen to the ground and is just toppling over. 'White highlights reflect the light of the sun from the mirror's rim to our eyes,' Summers writes, 'and the surface of the shield is shown more or less precisely as a reflection in a convex mirror.'

A fallen soldier has raised his hand in an effort to prevent the thing crashing on him. His sad face is shown much smaller, as it should be in a convex mirror. The image of the soldier reflected in the shield recalls Parmigianino's *Self-Portrait in a Convex Mirror*. When we look at the edge of the shield falling on the soldier we can tell both that it's curved and that it is made of gleaming metal.

Left
ERETRIA PAINTER
Seated woman holding a mirror, 430 BC
Athenian red-figure amphoriskos

Opposite
*The Battle of Issus between Alexander
the Great and Darius* (detail showing
reflection in shield at bottom right),
from the House of the Faun, Pompeii,
c. 315 BC
Tesserae

The mosaic is a copy of a copy of the original painting, which has been attributed to various ancient artists, among them the great painter Apelles. According to Pliny, Apelles was the first to use what in Latin was called *splendor*: the highlight. And whether or not, as is sometimes argued, the battle mosaic was derived from a work by him, it certainly shows knowledge of the behaviour of light.

DH Highlights are a way of adding more information to pictures. That's still true. The button you have for applying them in Photoshop is intended to polish photographs. When I started drawing on the iPhone and iPad, where the image itself was glowing, I was attracted to luminous subjects such as vases with water in them, which catch reflections, and the shine on glass – or this gleaming silver fruit-dish. On its surface you can see the surroundings, as if in a curved mirror; there are also highlights, which are reflections so bright you don't see the image, just the sparkling brilliance. There are highlights on the apples as well, but duller ones because their skins are less shiny. The glitters and gleams on the jewels and clothes in *Las Meninas* are all reflections, too, of a kind.

DAVID HOCKNEY
Untitled, 24 February 2011
iPad Drawing

6 Mirrors and Reflections

MG Even slightly glossy surfaces such as moist human skin will also reflect light. You will then see a highlight, or, on a very shiny surface, a reflection. The highlight and reflection are the same; the lustre on a top hat is caused by the individual threads acting as mirrors and by the curvature of the hat. You won't see your face in a top hat, though you might, just, in a highly polished boot.

In an essay entitled 'The Heritage of Apelles' (1976), Gombrich told the history of the highlight. It not only helps to reveal volumes but also provides clues to what we are seeing. A curved shiny object, Gombrich points out, will 'collect and reflect the images from a wider sweep of its surroundings; in thus gathering more of the light the steeply curved surface ... will also appear to intensify it'.

HENRI FANTIN-LATOUR
Édouard Manet, 1867
Oil on canvas

DH No one has ever grasped this better than Jan van Eyck. In his paintings you see every possible variety of reflective surface, reflecting in every possible way – and all the jewels sparkle!

MG The works of Van Eyck and his immediate followers, such as Petrus Christus, were anthologies of reflections on every conceivable kind of surface. A smooth, shiny surface such as the moist human eye will function almost like a mirror. The eye of Van Eyck's *Portrait of a Man* seems to reflect the window of the room in which he was painting (it could be the eye of Van Eyck, observing himself at work, since this is very possibly a self-portrait). According to a late medieval theory, the eye itself was a mirror: a living convex mirror, 'speculum animatum convexum', as the 13th-century Dominican thinker Albertus Magnus put it. If a mirror possessed a soul, the Iranian polymath and writer on numerous scientific and philosophical subjects Avicenna (Ibn Sīnā, *c.* 980–1037) wrote, 'it would see the image that is formed on it'.

Right and opposite
JAN VAN EYCK
Portrait of a Man (Self-Portrait?)
and detail, 1433
Oil on oak

6 Mirrors and Reflections

Reflections could prompt metaphysical thoughts. Cardinal Nicholas of Cusa – a contemporary of Van Eyck who was almost certainly acquainted with Brunelleschi – compared God's mind to the pointed tip of a highly polished diamond. 'By looking at itself', this glittering facet of the jewel would see everything that existed: 'the likenesses of all things'.

Reflections and reality were one of Claude Monet's most profound subjects. In his great water-lily paintings, the surface of the painting, the water, and the reflections of sky and trees – microcosm and macrocosm – seem to merge into one. Looking at Monet's late masterpieces is like looking at a grand Chinese landscape: the cosmos seems to be constantly vanishing and appearing in front of you. Plato would have hated them.

DH For Monet, the ultimate subject was in his garden. It took a lot of doing to create it. The water for the lily ponds had to be still not running, for example, to create the reflections he wanted. It was a fantastic thing to do. Monet was almost 60 when he began the *Nymphéas*; smoking and painting, he lived on to be 86.

Opposite
HUBERT and JAN VAN EYCK
Ghent Altarpiece: *Virgin Mary*
(detail), 1426–29
Oil on wood

Above
CLAUDE MONET
Nymphéas, 1905
Oil on canvas

7 Renaissance: Naturalism and Idealism

Van Eyck's studio would have been like MGM.

DH In Giotto's *Ognissanti Madonna*, painted around 1310, there's dark at the side of her nose and the Christ child's and under their brows and chins. Their features aren't in real chiaroscuro but there are enough shadows on them for you to feel the mass and the volumes. But the light and shade he used on faces seem a bit crude to us because they aren't quite *optical*; that is, they don't appear the way they would if seen in an image projected by a lens or in a mirror.

Also, in Giotto's pictures the people do not look as if they were studied from living models. Their noses are always a bit the same, although the mouths vary. The eyes are different but they are consistently painted in a slightly flat way. Even so, his figures have vivid expressions and personality.

Now look at Masaccio's painting of the elderly beggar in *St Peter Healing the Sick with His Shadow*, from his frescoes in the Brancacci Chapel, Florence, which date from the mid-1420s – over a century after the Giotto. Note the way the light from above is hitting his cheekbone: it's dark underneath there and in the hollow of his cheek. The shadows under the forearms, below the jaw and at the top of the ear are very dark. Masaccio's figure has shadows in absolutely the right places, subtly painted. This is a much more accurate depiction of shadow than Giotto's: it's what we would describe as more naturalistic. Indeed, these are the first shadows in Italian art that look like a photograph of a shadow.

MG The same is true of other figures in the picture. The second beggar, a young man with withered legs, not only has the face of an individual, but also paralysed legs that could almost be an illustration in a medical textbook. The play of light and shade on the pitiful crutches on which he rests his arms makes a perfect naturalistic still life.

GIOTTO
Ognissanti Madonna (Madonna in Maestà), c. 1310
Tempera on wood

126

DH Before he painted the older beggar Masaccio must have looked hard at a real man, a model. This is a depiction of an *individual*. And the shadows on his face are placed as they would be seen in a camera. There are no faces in Italian or Flemish art before 1420 that look like this, and that implies that the reason for the change was technological. It must have been.

MG Many aspects of this picture are like that. It concerns a miracle caused by a shadow, and it is full of marvellously precise observations of the fall of light. Another example is the rusticated masonry of the wall behind the beggars. Its surface is particularized, so that each stone – and its shadow – seems to have been examined and depicted individually. The result looks surprisingly similar to a photograph of a real Florentine wall, like the Palazzo Strozzi or Brunelleschi's Palazzo Pitti.

DH I think Masaccio had a mirror or a lens and used it to project images. An optical projection needed shadows; you cannot make one without them. The first optical projection I made in my studio in California was with a concave mirror; when I saw it I realized the light causes the shadows. A photograph requires the same conditions.

MG Obviously, there has been a revolutionary development in the history of pictures between these two paintings: Giotto's from the early 14th century and Masaccio's fresco around 1426. This transformation involved the use of naturalistic shadow, real models and what we call linear or Renaissance perspective. These elements appear altogether as a package in Masaccio's pictures.

 In just the same way as with the beggars, it is obvious that Masaccio's naked Adam being expelled from Paradise, also in the Brancacci Chapel, was studied from a specific person's anatomy, which has been scrutinized closely under strong light coming from above. The same is true of another work by a contemporary painter who lived north of the Alps: Jan van Eyck's *Adam* from the Ghent Altarpiece (completed 1432). The body of Van Eyck's Adam is seen in astonishing detail, as if through some sort of magnifying device, so that, for example, each individual hair on his skin is separately depicted, as are the swollen veins on his arms.

DH The naturalism is not quite so obvious in Masaccio's work because he was using fresco, not oil paint. Fresco is light, and in a picture painted in fresco the shadows are not seen as such rich things, they are just a lack of light. Van Eyck was using oil paint in a new way. His shadows are extremely rich, and his naturalism is astonishing.

MG There had been a tendency towards greater naturalism in some northern painting around 1400, for example the illuminations of the Très Riches Heures du Duc de Berry, painted around 1412 to 1416 by the Limburg brothers from Nijmegen (about fifty miles north of Maaseik, which was apparently the place where Jan van Eyck and his brother Hubert originated). Nonetheless, there is a staggering leap in verisimilitude between the Très Riches Heures and the Ghent Altarpiece, completed a decade and a half later. It is perhaps the most extraordinary development in the history of pictures, and one for which art historians have had no adequate explanation.

Opposite left
HUBERT and JAN VAN EYCK
Ghent Altarpiece: *Adam*,
1425–29
Oil on wood

Opposite right
MASACCIO
Expulsion from the Garden of Eden, *c.* 1424–27, Brancacci Chapel, Santa Maria del Carmine, Florence
Fresco

7 Renaissance: Naturalism and Idealism

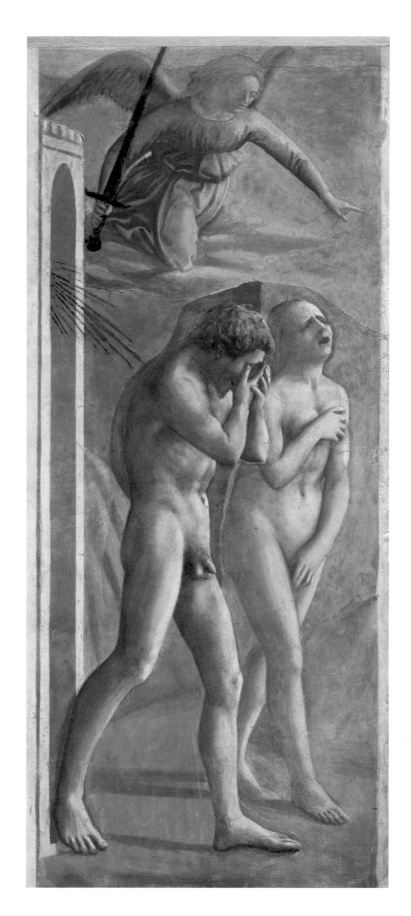

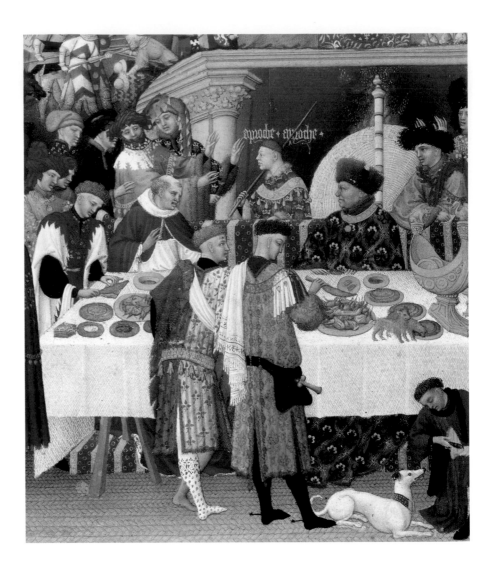

DH The extraordinary thing about Van Eyck is how he comes out of
nowhere, and has somehow worked out how to translate into paint
the different kinds of sheen on brocade cloth, glass, wood, different
kinds of metal, stone, glass, wax, flesh, and all sorts of diverse shine
and reflections, all absolutely perfectly. It's almost unbelievable, isn't
it, the more you think about it?

Van Eyck's paintings are full of objects that had never been depicted
in that way before, such as the mirror in *The Arnolfini Portrait*. Anyone
who drew one afterwards would have the example of Van Eyck's
paintings, but Van Eyck himself would never have seen a picture of a
convex mirror. If you hadn't seen a previous depiction like that, it would
be much more difficult to draw. The same applies to almost everything in
the picture: the slightly dirty wooden clogs, the oranges, the chandelier.
Once those things appear in Van Eyck they appear in numerous other

paintings. When Van Eyck had found ways to represent them, other painters could imitate him. After the first chandelier, in *The Arnolfini Portrait*, there are lots of chandeliers by other artists. There are hundreds of pictures of chandeliers now. Anyone who drew one subsequently would have seen other pictures, but Van Eyck would have had no model to follow. The basic principle is that pictures influence pictures.

MG So how on earth was that mirror painted? Recent research offers some startling information about that. A team including the art historian Martin Kemp examined two mid-15th-century paintings: *The Arnolfini Portrait* and the left-hand wing of the Werl Triptych attributed to the artist who used to be called 'the Master of Flémalle' and is often identified as Robert Campin.

The panel from the Werl Triptych, almost certainly following the example of Van Eyck, also depicts a convex mirror, which reflects the little room in which the donor kneels with St John the Baptist. Computer algorithms have been used to 'rectify' the images in the two mirrors, that is to reconfigure them as if the images had been seen in a flat mirror. The results were remarkable. The accuracy of the reflection in Van Eyck's mirror is 'striking', but shows signs of having been altered by the artist to eliminate some of the wilder distortions caused by the curvature of the surface.

The Werl Triptych mirror was even more precisely correct, so much so that the researchers concluded that it must have been based on observation of a real mirror, hanging in a room like that shown in the painting with a model standing in it wearing the red cloak of St John and two friars seen praying beyond him. It was even possible to calculate the position from which the artist looked at the reflection, to the right of the mirror and low down, so shielded by the open wooden door in the picture.

'It is inconceivable that such consistently accurate optical effects could have been achieved by simply thinking about it', the researchers determined. 'We are drawn to what seems to be the inescapable conclusion that the artist has directly observed and recorded the effects visible when actual figures and objects are located in a specific interior.'

ROBERT CAMPIN
Werl Triptych (detail of left wing),
1438
Oil on panel

Opposite
ROBERT CAMPIN
Werl Triptych, left wing
depicting donor Heinrich von Werl
and John the Baptist, 1438
Oil on panel

DH Some historians seem to imagine that Van Eyck's studio would have been like Cézanne's: the artist's lonely vigil. It wouldn't have been like that at all. It would have been more like MGM. There would have been costumes, wigs, armour, chandeliers, models; all kinds of props. You just have to look at the paintings to see that. It isn't possible to paint like that from imagination. So his workshop must have been close to a Hollywood movie: costumes, lighting, camera, let's go!

MG Presumably Van Eyck used the same procedure as Campin. But what was it? It is possible that the painter could have copied the image in the mirror, but that would have posed problems – the image would have shifted each time the artist's head moved. It would certainly have been easier if he had had some method of projecting it onto a flat surface.

DH I believe that Van Eyck had a mirror and/or a lens that could make optical projections of the objects he wanted to paint. Van Eyck wouldn't have been surprised by a television picture, because he could have seen things much like that in 1430, they are quite simple to make. I demonstrated that with a small concave mirror in Bruges itself. But of course the delivery system would have been mysterious to him. Television isn't a new kind of image – it's a new form of delivery.

MG We know a great deal less about the life and career of Jan van Eyck than we do about those of Filippo Brunelleschi. Indeed, from contemporary sources we can learn almost nothing: a few details about his travels and payment by the Duke of Burgundy, that is all. However, it seems highly probable that early in his career he worked as a miniaturist, possibly in partnership with his brother Hubert.

A couple of pages attributed to Jan van Eyck survive in a manuscript known as the Turin-Milan Hours, one of which has a tiny landscape painted at its foot, a true microcosm, receding into a misty distance. A whole world is crammed into this minute space.

Could anyone work on such a tiny scale with unassisted eyesight? It seems highly likely that Van Eyck and other painters of extremely detailed miniatures used the optical aids that were widely available in the late Middle Ages. There were two of these, in addition to spectacles: magnifying glasses and concave mirrors. Both, if of high enough quality, would perhaps have been able to project an image. In conjunction they might have produced a better, brighter one.

7 Renaissance: Naturalism and Idealism

e uentre matus mee uocauut me dñs
nomine meo. et posuit os meũ siaut
gladium acutum sub tegumento
manus sue protexit me posuit me

South of the Alps, the Italian artists and connoisseurs greatly admired the naturalism of Northern art. The earliest biography of Jan van Eyck was by an Italian humanist based in Naples, Bartolomeo Fazio. Italians collected works by Van Eyck, Hugo van der Goes and Roger van der Weyden. The Venetian painter Giovanni Bellini questioned Dürer closely about how he depicted hair so precisely and delicately. But this naturalism was only half of what Italian artists came to aim for themselves. They combined it with more cerebral ways of analysing what they saw: through the mathematics of linear perspective, study of classical art, and more accurate knowledge of human anatomy.

DH I love Piero della Francesca's work and Fra Angelico's. For me, they are fantastic artists, putting figures in space in a marvellous way. Piero must have sensed that space in his head.

MG Piero's naturalism has a different feeling from that of a painting by Van Eyck because it is based on a deeply internalized sense of geometrical structure. He was in several ways the predecessor of Leonardo da Vinci: a painter/ intellectual fascinated by theoretical questions that he believed essential to his art.

HUBERT and JAN VAN EYCK (?)
The Baptism of Christ, from the Turin-Milan Hours, *c.* 1420

In later life, Piero wrote three works on mathematical matters. The second, *De prospectiva pingendi* (On Perspective in Painting), outlined the geometry necessary for depicting forms in foreshortening and recession. If there is any painter Plato would have approved of, it's Piero, who actually wrote a treatise on the five regular convex polyhedrons that are known as the 'Platonic Solids'.

He paid less attention to the qualities of materials and surfaces: highlights in eyes, hairs on arms, gleaming armour, than a Flemish painter would have done. This made northern painting more expressive in certain ways – few paintings of the Crucifixion are more horrifying in their depiction of physical suffering than the German master Grünewald's – and less so in others. On the other hand, no Adam is more perfect than Michelangelo's, no Resurrection more solemn than Piero's.

DH There are lots and lots of pictures of the Crucifixion in Western art. According to the Video Recordings Act of 1984, one of the things you cannot depict is terrible cruelty to another human being. I laughed when I read that. I thought, the bishops of the Church of England signed this. They must have forgotten that the major image of the West is precisely that: being very, very cruel to a person and nailing him to a cross. In any case, you could argue that the whole point of Christianity is the Resurrection, not the Crucifixion. It's more difficult to paint, certainly more difficult to photograph.

MG In a dialogue written in the mid-16th century, the author put a complaint about naturalistic art into Michelangelo's mouth. Whether or not he ever uttered any such speech, Michelangelo is here the spokesman for the Florentine point of view: too much naturalism misses the point, which is to convey the ideal, God-given beauty of the world, and particularly the human body, at its most perfect. 'They paint in Flanders', he grumbles, 'only to deceive the external eye.' This Flemish art, Michelangelo goes on, is all about trivialities, depictions of 'bricks and mortar, the grass of the fields, the shadows of trees, and bridges and rivers, which they call landscapes, and little figures here and there'. This could be a description of the landscape by Van Eyck but, to Michelangelo, at least in this dialogue, such pictures are ignoble: done, 'without reasonableness or art, without symmetry or proportion, without care in selecting or rejecting'.

Michelangelo's own work was certainly done with care for symmetry, proportion, selection and rejection of what he saw around him. His Adam

PIERO DELLA FRANCESCA
Resurrection, 1463–65,
Pinacoteca Comunale,
Sansepolcro
Fresco and tempera

7 Renaissance: Naturalism and Idealism

TITIAN
Charles V at the Battle of Mühlberg
(detail), 1548
Oil on canvas

140

or David do not look like real human beings, they are images of how an ideal body should appear.

The paintings of Michelangelo's great Venetian rival, Titian, were in some respects more naturalistic. They included beautiful landscapes, and mimicked the textures of gleaming armour, soft flesh and rich cloth. But part of Titian's professional skill was introducing subtle improvement into his sitter's appearance – a feat he carried to heroic lengths when he transformed the Emperor Charles V's grotesquely projecting jaw into an emblem of nobility. A comparison between Titian's portrait of Charles with one by a Flemish painter, Bernard van Orley, makes the point. The mainstream of Italian Renaissance picture-making consisted of a subtle blend of naturalism and idealization, observation of the appearances of the world and reshaping of it, fact and fiction.

BERNAERT VAN ORLEY
Portrait of Charles V, 1519–20
Oil on wood

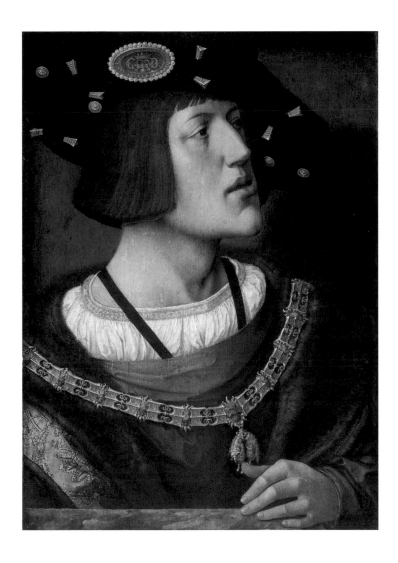

8 Paper, Paint and Multiplying Pictures

I get ideas from a new piece of technology.

DH I've always been interested in any technology that's about picture-making. Is it useful to a painter? People invent something for one purpose, and it sometimes turns out that it's just as good, or even a lot better, for something else. For example, oil painting on canvas became a standard thing in 16th-century Venice. There would have been sail-makers in a big port like that, so plenty of canvas was readily available.

Titian's paintings, such as *Diana and Actaeon*, are among the first where all the edges are very soft. That gives you a lot of information; you can see the figures have got soft skin. Until then, edges in pictures had been harder, although Van Eyck's are a tiny bit soft. In reality, you can't put your finger on a sharp line between, say, a red coat and a green background, because they don't meet in that way.

MG Willem de Kooning famously remarked that flesh was the reason why oil paint was invented. Venetian painters such as Giorgione and Titian were the first to discover how oil paint – applied with looser brushstrokes, and frequently on canvas – could be used to depict the human face and body with a novel, sensuous immediacy. It is a quality as much tactile as visual: if you touched these people they would feel warm and living. The texture of the canvas, especially if it is coarsely woven, gives a different surface to a picture.

This combination – oil paint and canvas – proved hugely successful for depicting flesh. The dominant tradition in European painting descends not from Michelangelo and the Florentines, who emphasized draughtsmanship and favoured the media of fresco and tempera, but from Titian and the Venetians. His followers include Velázquez, Rembrandt and Goya.

TITIAN
Diana and Actaeon, 1556–59
Oil on canvas

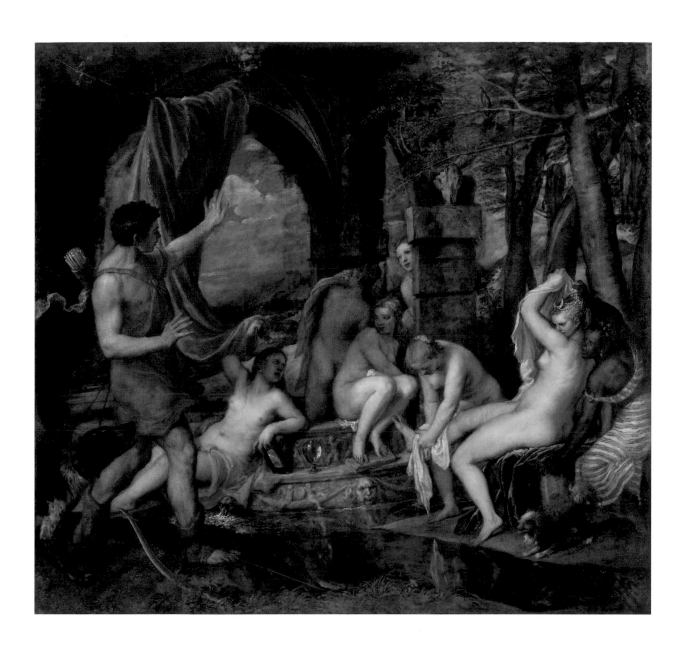

143

DH With oil paint you have a superb range of colour if you know how to use it. Painted colour always will be better than printed colour, because it is the pigment itself. But some still fade. In high-quality paint the colour intensity is incredible because you get more pigment in the tube. And if you put it on right, it will last a long time. That's all there is to it. As soon as I could afford it, I started buying better-quality paint. I don't know whether iPad images will last or not. At the moment I don't care, or, rather, I do a bit.

Mark Rothko's paintings have lost their lustre, some of Warhol's have, too. He used screenprinting inks and as a result I think the pictures are going darker. There are many pictures painted in Britain in the 1950s that have now gone very dark. I was a bit shocked to discover that some contemporary painters use household paint. Why don't they use oil, because household paint will fade?

Leonardo did mad things when he painted *The Last Supper* (1494–99) and *The Battle of Anghiari* (1505). He started using the wrong techniques for mural painting, and it began to damage the pictures straight away. That was his fault. There are rules of painting, you can break them if you want to, but if you do the painting won't be preserved very well. Of course, when he was doing it he wouldn't have been thinking 'I am painting this immortal picture, *The Last Supper* by Leonardo da Vinci'.

Conversely, Van Eyck's Ghent Altarpiece is in a superb state of preservation. When I go there I look at it through binoculars because you can't get physically that close to it. The colour is stunning. The green of the grass is still intense, which I would call an optical colour. You get a terrific green through optical projections. Many painters had problems with that colour for a long, long time. But the Van Eyck green is superb.

MG The old story that Van Eyck 'invented oil painting' has been comprehensively debunked. The use of oil as a medium may date back to the 9th century. But Van Eyck did initiate *something*. No previous paintings looked like this. The question is: why conduct such research in painting technique? The answer is provided by the work. Van Eyck's technique sometimes seems to have involved complex layering of paint. The woman's green dress in *The Arnolfni Portrait*, for example, is made up of two under-layers of verdigris pigment mixed with lead white and tin-lead yellow, with over the top a final translucent glaze of verdigris in boiled linseed oil with additional pine-resin. The effect is to create the soft richness of expensive cloth.

DH Also, you can blend oil much more easily than fresco. You can do it, Masaccio does in the Brancacci Chapel, but in the same way as with acrylic where you have to use small lines to make a blended transition of tones and colours. Painting a steady variation of light across a wall is very difficult in acrylic; in oil it's simple.

MG Marshall McLuhan famously argued that the medium is the message. Certainly every medium is also a constraint; it can be used in particular ways, but does not lend itself to others. And a new technique can suggest novel possibilities.

DH Every medium has its particular strengths. With watercolour, for example, you have to work from light to dark; you can't put a light colour on top of a dark one, it won't work. So if you want real colour, you have to plan it. In Yorkshire, one summer I worked with watercolours. I used that medium, which I had not used much before, because I wanted a flow from my hand.

In a watercolour portrait, once you put things down, that's it. In oil paint it doesn't matter; whereas with watercolour, after a while the surface of the paper gets overworked and you can't deal with it. About three layers are the maximum in watercolour. Beyond that it starts to get

HUBERT and JAN VAN EYCK
Ghent Altarpiece: *Adoration of the Lamb* (detail), 1425–29
Oil on wood

Overleaf
HUBERT and JAN VAN EYCK
Ghent Altarpiece: *Adoration of the Lamb*, 1425–29
Oil on wood

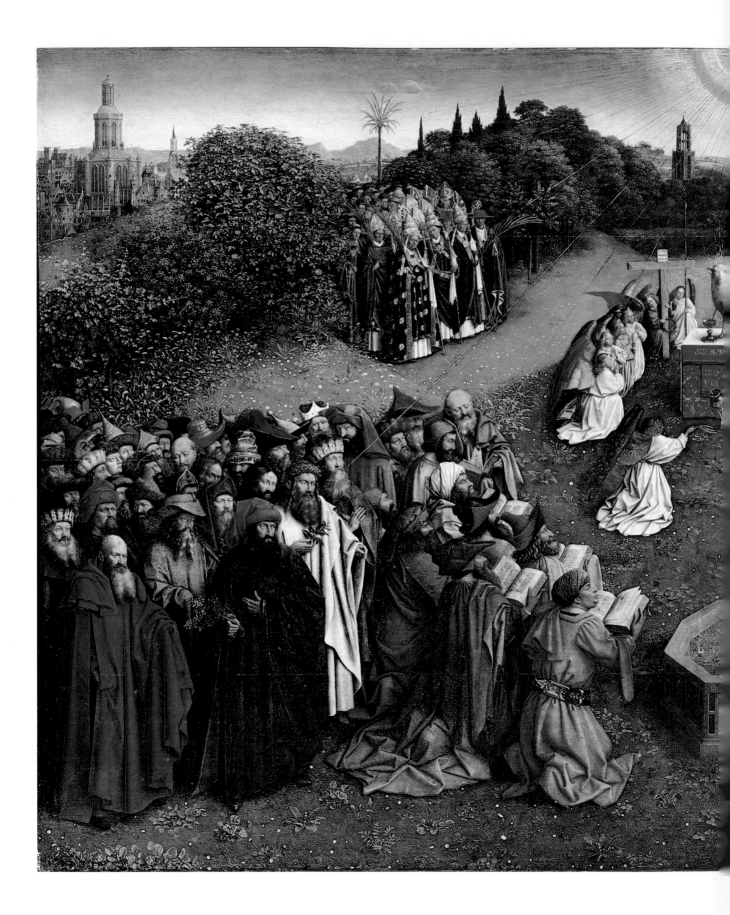

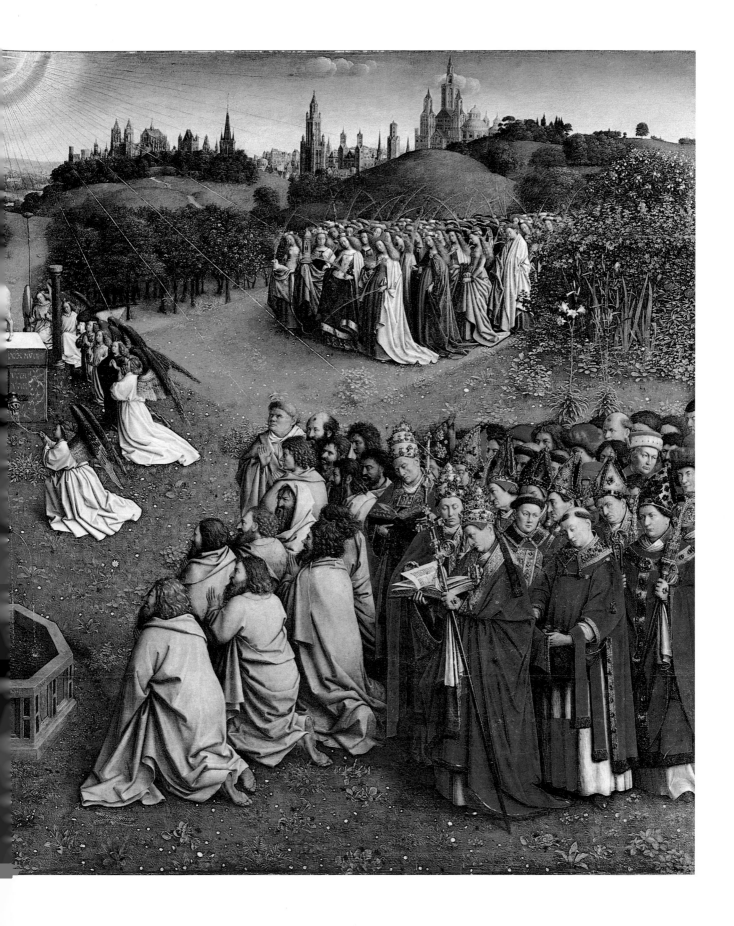

muddy. When you know that, you've got to be careful – build up slowly. Once you've put a dark colour down all you can do is make it darker. But it's a superb medium for some things. Turner could be very, very subtle with transparent layers.

MG Technological revolutions change everything, including art. That statement was just as true in the 15th century as it is in the 21st, but of course the media involved were not the same. What altered everything in the mid-fourteen hundreds was printing, initially printed books, but almost as soon, printed pictures. This was a means of reproducing that could be cheaper than an original drawing or painting. More people could own a copy, and the work could be distributed widely, more than five hundred years before Google Images.

Paper itself, of course, was far from new at that time; it was invented by the Chinese some two thousand years ago. But it was Johannes Gutenberg's new printing press and moveable type, which were first mentioned in 1439, that really boosted production. Within three decades, the printing revolution spread to Italy, which increased the

Above
J. M. W. TURNER
The Blue Rigi, Sunrise, 1842
Watercolour on paper

Opposite
LEONARDO DA VINCI
Studies for *The Adoration of the Magi* and *The Last Supper*, late 15th century
Ink on paper

8 Paper, Paint and Multiplying Pictures

quantity of books being produced, and in turn meant a lot more paper was made. As a result, the price went down.

Therefore, one unintended consequence of the Gutenberg revolution was that painters could use more paper for drawing. Leonardo da Vinci, the most innovatory artist of his generation, found ways of using paper to invent and imagine pictures: on certain sheets you can watch him brainstorming new ideas. The wider availability of paper changed the way painters thought about pictures, and the way they made them. Simultaneously, new print-making techniques meant that pictures could be multiplied and spread from place to place.

DH I've always been interested in printing as a medium and also as a means for my work to be known, so I became aware of what each printing process would do. In a way, you draw with that palette. I have found generally that first a new piece of technology arrives and then I get new ideas from it. When the fax appeared in the 1980s people said, 'This is just a bad printing machine'. I realized that they were putting images through the fax that it had difficulty with. But if you put the right things in the machine, it would be able to do what you desired. For example, I found out quite quickly that if you wanted what looked like washes, you didn't put washes into the fax, you put opaque greys; I used

gouache – opaque watercolour. If you put in four different greys you'll get what looks like four different washes.

I'm intrigued by any technology to do with image making: printing, cameras, reproduction itself.

MG Among the earliest exponents of the printed picture was an artist from southwest Germany or Switzerland known to art history only from the initials with which he signed his name: Master ES. It has been deduced that he was a goldsmith by training, and found an application in the novel medium of engraved prints for the traditional skill of incising lines on metal. He was one of the artists who evolved a graphic language for engraving, and the techniques that evolved in the 1450s and 1460s were used for hundreds of years.

MASTER ES
Samson and Delilah,
15th century
Engraving

8 Paper, Paint and Multiplying Pictures

DH In engraving the idea of tonality is made by lines and cross-hatching. And the cross-hatching has to be at the right scale. All media are about how you make marks, or don't make them. Limitations in art have never been a hindrance. I think they are a stimulant. How do I get round them? If you're told you've to do a drawing using only ten lines or a hundred, you've got to be a lot more inventive with ten. If you can only use three colours, you've got to make them look whatever colour you want.

MG Dürer was the one of the first truly great artists to work principally in print media. His printed pictures, however, differ strikingly according to the medium he employed. It is not a matter of quality – they are equally powerful – but of the visual language used. Dürer's great *Apocalypse*

Opposite
ALBRECHT DÜRER
Four Horsemen of the Apocalypse,
c. 1497–98
Woodcut

Right
ALBRECHT DÜRER
Melencolia I, 1514
Engraving

with Pictures (Apocalypsis cum Figuris) of *c.* 1497–98 made his name. The fifteen images that make up the series were cut into woodblock, and are consequently vigorous and chunky.

In contrast, his *Melencolia I* of 1514 is an engraving, and far finer in its lines and subtle in its effects. The sheen on the allegorical figure's dress, and the light shadow across her face, would both be hard to represent with the thicker lines and marks of a woodcut. A work such as Dürer's *Apocalypse* was quickly seen across Europe.

Prints were the first pictorial mass medium. In Venice, his woodcuts and engravings were pirated, which led him to try to bring a legal case for breach of copyright. Pictures by painters such as Michelangelo and Raphael were soon copied and reproduced. The original might be a fresco attached to a wall in Rome, but the idea could be printed on paper and influence artists in other places who had never set foot in Italy.

DH I've always followed printing techniques, they're interesting things. If new ones come along, often they are quickly improved. But what is an improvement in some ways won't necessarily be in others. You couldn't print a really good Cobalt blue on a machine, you need real Cobalt to do it – and that's what the paint is: Cobalt itself.

MG The invention of the chiaroscuro print-making process early in the 16th century made possible a closer approximation of prints to paintings. This involved the superimposition of one or more woodblocks so that – as in the print based on Raphael's tapestry cartoon of the *Miraculous Draught of Fishes* – highlights and shadows could be depicted in multiple pictures. This technique, like many methods of print-making, requires a great deal of technical expertise.

Some artists learnt these skills; others collaborated with specialist print-makers as Parmigianino did with Ugo da Carpi, making a design that was then translated into the form of a chiaroscuro print. One product of this partnership, *Diogenes*, could be bought in different colour combinations: beige/brown or grey/green.

Similarly, the expert tapestry weavers of Brussels translated the cartoons Raphael sent from Rome into textile terms, transforming the robes of Christ and the Apostles into richer hues from the weavers' palate of coloured threads and adding decorative highlights in gold. They interpreted Raphael's painterly ideas freely, as a musician might arrange a score for a certain combination of instruments.

8 Paper, Paint and Multiplying Pictures

DH Sometimes you need a specialist to help you. My assistant Jonathan
Wilkinson has certainly made a big difference to me; he is an expert in
the latest technology. Without him, I wouldn't have done certain things.
Jonathan keeps pointing out there's new software coming out every
week that allows us to do something that last year we wouldn't have
been able to. As long as it gets done, I don't care how it actually happens.
But he's telling me, 'Well, that would have taken a few days, now we can
do it in twenty minutes'.

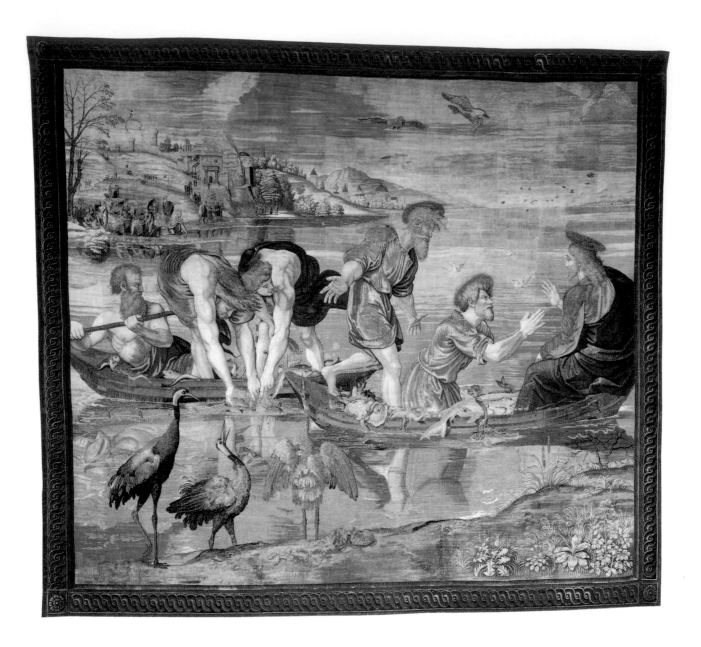

PIETER VAN EDINGEN
VAN AELST
*The Miraculous Draught
of Fishes*, c. 1519
Tapestry in silk and wool with
silver-gilt threads

MG Tapestry was a technique so costly that only the rich could afford
it. Each design, however, was at least potentially a multiple. Sets of
hangings continued to be made from Raphael's cartoons for two
centuries before they themselves began to be seen as works of art.
To Raphael and his patron Pope Leo X, they were no more finished
pictures than Dürer's woodblocks.

From the 15th century onwards, an important part of the history of
pictures is concerned with reproduction: how to multiply pictures and
how to transmit them around the world. Some techniques emerged
from chemistry, or in earlier centuries, alchemy.

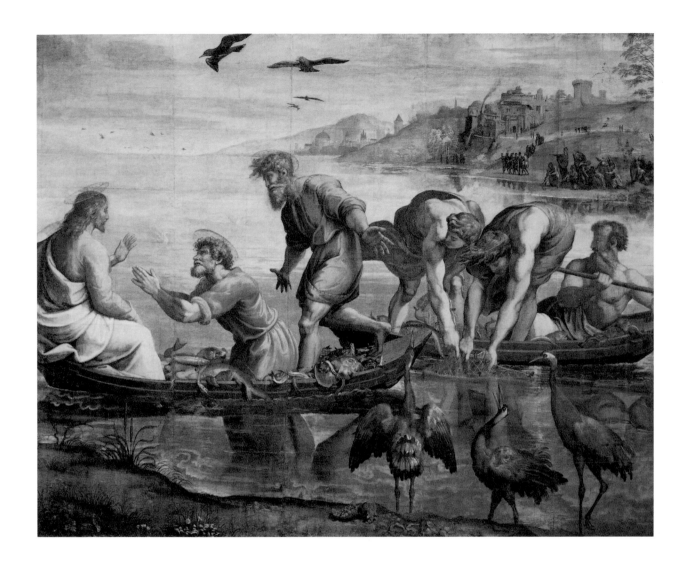

Etching depends on the way that acid affects different materials. The process involves, first, the artist drawing through an acid-resistant ground on a metal plate. This is then placed in a bath of ferric-chloride acid, which bites grooves into the metal, but only where the ground has been cut through by the drawing tool. When the plate is inked, and the ink wiped from the surface, the grooves print as black lines. The technique was invented in the 16th century, and became a medium of great subtlety and complexity in the hands of Rembrandt in the 17th century. Using etching, an artist who was not a specialist print-maker could make multiple images.

RAPHAEL
The Miraculous Draught
of Fishes, 1515–16
Bodycolour over charcoal
underdrawing on paper,
mounted on canvas

DH There is a difference between an etching and a linocut or woodcut. If you are doing a linocut you are forced to be bold because that is the nature of the medium; with an etching it's about fine lines.

9 Painting the Stage and Staging Pictures

The theatre is to do with space and illusion.

DH Performance is now. You can't really have a museum of performance art: equally, you can't really have a museum of theatre. However, in some ways, drama, film and painting are all linked. For example, it's odd how people think about realism in the cinema. They forget that it can't be that realistic, because you always have to have the camera there. If you have people around a table there'll always be one side empty, so that you can look at it. That's the same in a picture such as Leonardo's *Last Supper*.

MG Alberti's treatise on painting was only partly about perspective, it was also concerned with how to tell a story in a picture: what he called an '*istoria*', which was later called 'history painting' in English. As described by Alberti, an istoria presented an important event from the Bible or mythology in an image every aspect of which was calculated to engage the emotions, instruct, clarify the story, embellish it and draw the viewer into the drama. *The Last Supper* was such a work. In the process, artists encountered a conundrum: how to depict a sequence of events in a single image – what, in movie terms, we call a still. This generated many difficulties, but the painter also had certain advantages.

DH There's a story about a woman who used to work for the Art Institute of Chicago, and then went to Hollywood to work for a movie person. He said to her, 'Don't give up going to the museums to look at pictures, because they don't move and they don't talk, and they last longer.' My God, they certainly do.

LEONARDO DA VINCI
The Last Supper, 1494–99,
Santa Maria delle Grazie, Milan
Tempera on gesso, pitch
and mastic

MG The eternal challenge to narrative artists is how to recount a story, unfolding through time, in a fixed, still image. There are several ways to solve the problem. Events might be shown successively, or side by

Agony in the Garden, 1215–20
St Mark's Basilica, Venice
Tesserae

Trajan's Column, Rome
(detail), 107–113 AD
Marble

side in the same space in the medieval manner. Or artists might depict a sequence of dramatic episodes one after another. That is the method used on Trajan's Column in Rome, in which the history of a military campaign is presented in a long curving panel of carved pictures. This was to be the principle of the strip cartoon, an idiom that grew up in the 19th century.

DH You bring your own time to a picture, whereas film and video art bring their own time to you. In Egyptian, Chinese, Medieval or Persian paintings, it can be different times in different parts of the image. You find the flight to Egypt and arrival at the destination on the same panel. If you use linear perspective with a single viewpoint it's more difficult for that to happen.

MG In Fra Filippo Lippi's fresco of the *Feast of Herod* in Prato Cathedral, Salome dances prettily in the centre, receives her reward in the form of John the Baptist's head on the left, and presents it on a plate to Queen Herodias on the right. Here, a separation in space becomes a substitute for a separation in time. Lippi has used what was then the new system of linear perspective, but retained the medieval habit of painting successive moments from a narrative in the same picture. But the

whole scene seems strange, because all the events appear to be taking place in the same room simultaneously.

DH Perspective is for architecture, it wasn't really made for narrative painters. But in pictures, as in the theatre, sightlines are important: don't have the lead performers where half the audience can't see them. The first thing I did when I was preparing to design operas at Glyndebourne and the Met was to draw the views from the back of the theatres right upstairs in the balcony. It's rather good up there in the Met, but you are looking down on the stage. So I realized that there you have to *design* the floor.

MG Exactly the same was true for a painter working in the Renaissance tradition. In *Christ Handing the Keys of the Kingdom to St Peter* in the Sistine Chapel, Perugino arranged his figures in a row in front of a grand piazza, the paving of which marks out the linear perspective. The figures in the sacred story, however, are not receding into space: they are silhouetted against it. Designing for the stage and devising a picture

FILIPPO LIPPI
The Feast of Herod:
Salome's Dance, c. 1452–64,
Prato Cathedral
Fresco

162

that told a story in the way that Alberti suggested were similar activities. Paper, which as we have seen was more widely and cheaply available in the Renaissance, provided a virtual theatre in which artists could arrange and pose their figures – or rehearse them – before the final performance of the finished picture.

Thus in 15th- and 16th-century Italy composition evolved through a series of drawings, studies of individual figures and of how they interrelated in the whole work. Raphael followed this method of working out compositions, for example in his *Entombment* of 1507. Taking his cue from a relief on an ancient Roman sarcophagus, he made a series of studies of the composition as a whole and of the individual figures. He drew some of his actors naked, even if they were going to be dressed in the completed picture, so he could understand their anatomy better.

Raphael's completed picture was a carefully assembled intellectual construction, not a direct response to anything he had seen. Consequently, it is easy to grasp the relation of one person to another in space. The whole group interacts like a complex multi-figure sculpture. In fact, his painting could be used as a blueprint for a version in 3-D.

PIETRO PERUGINO
Christ Handing the Keys of the Kingdom to St Peter, 1481–83, Sistine Chapel, Vatican
Fresco

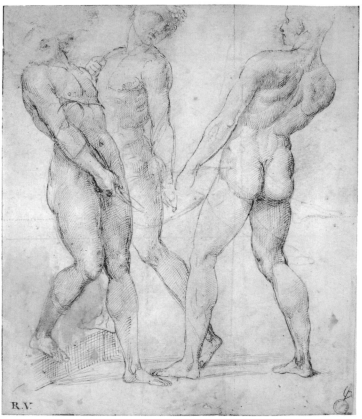

Above
RAPHAEL
Study for *The
Entombment*, 1507
Chalk on paper

Right
RAPHAEL
*Study of Three Nude
Bearers*, c. 1507
Pen, ink and chalk
on paper

9 Painting the Stage and Staging Pictures

RAPHAEL
The Entombment or *The Deposition*, 1507
Oil on wood

DH A painter such as Raphael sensed the scene in his head, so he always created a coherent space. On the other hand, though his pictures were very three dimensional, they were not very naturalistic: more about roundness and polish.

His figures are like actors on a shallow stage in front of a backdrop. If the actors were all behind each other, going into depth, the viewer would only see the figure in the front. That would be a confusing method of narrating something. It's better the other way. That's true in a painting, on stage and in film actually. You put people in front of a backdrop.

Isn't that like a Poussin, too? He told his story *across* the canvas. You look at each group or figure separately, and follow the narrative. If the figures were receding in space the picture would all be set at exactly at the same moment, it would be like a snapshot. But if they are next to each other on a horizontal across the painting they can each be at a different time, so you can tell a story better.

MG What's more, Nicolas Poussin did not merely stage his paintings metaphorically, arranging his figures as if in front of a backdrop, he did so quite literally. A biography of Poussin by his near contemporary Joachim von Sandrart described his method like this: 'if he was painting a history [that is, a picture telling a dramatic story], he made little

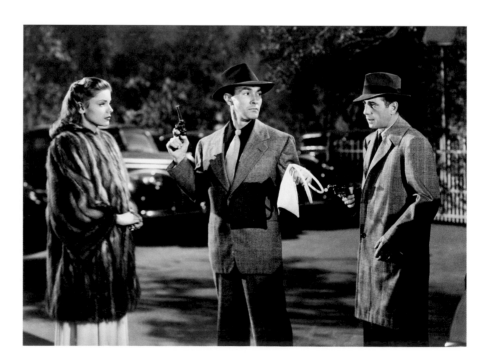

HOWARD HAWKS
The Big Sleep, 1946,
starring Lauren Bacall
and Humphrey Bogart
Film still

9 Painting the Stage and Staging Pictures

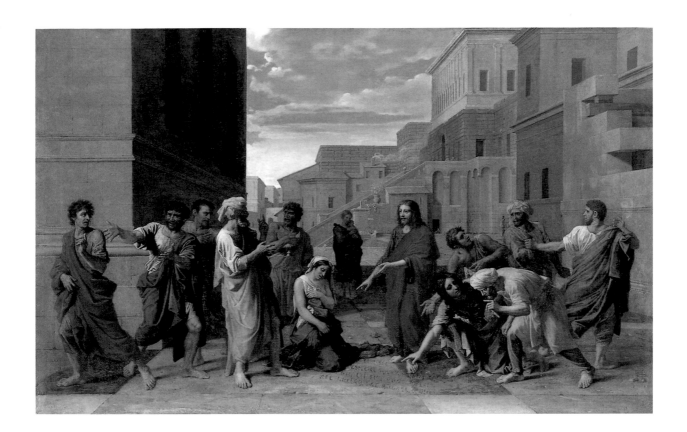

wax figures in the nude in the proper attitudes, as he needed them to represent the whole story, and set them up on a smooth board, marked out in squares.' Another writer, Le Blond de la Tour, describes Poussin using a sort of model theatre to work out the lighting and composition of his picture: in other words, staging the narrative.

Poussin's reliance on little models came to be regarded as a bad habit. Delacroix blamed it for what he considered the 'extreme aridity' of Poussin's work. Theoretically at least, art was considered far too elevated an affair, intellectually and spiritually, for its practitioners to stoop to employing such gadgets.

Long before Poussin's day, painters had been using mannequins or lay-figures: dummies that could be used as studio props. Vasari described how 'in order to be able to draw draperies, armour, and other suchlike things', the Florentine master Fra Bartolommeo (1472–1517) 'caused a life-sized figure of wood to be made, which moved at its joints'. The drapery of Christ in a study for the *Last Judgement* suggests he must have used this ever-patient, inanimate model. In the following centuries, such lay-figures became standard pieces of studio equipment, owned by, among many others, Thomas Gainsborough and Gustave Courbet.

FRA BARTOLOMMEO
Study of drapery for the figure
of Christ in the *Last Judgement*,
1499–1500
Grey-brown and white pigment
on dark grey prepared linen

An artist's studio is a sort of theatre. Indeed, there is an old sense of the word 'theatre' – as it is used in the phrase 'anatomy theatre' and 'operating theatre' – that means a place for examining something closely. A studio is also a place where lighting can be controlled, and in a sense pictures – even ones involving only a single figure – are staged. So it is hardly surprising that many artists have moved between art and drama.

DH I've always loved the theatre because it is to do with space and illusion. The Italian stage goes in beyond the plane of the curtain and the proscenium arch, as it does in Vincenzo Scamozzi's *trompe-l'œil* set in the 16th-century Palladian Teatro Olimpico in Vicenza.

MG The steeply receding streets in the set at the Teatro Olimpico are actually only a few feet deep. The street narrows sharply, and the buildings beside it rapidly diminish in height, so a real person walking into the set seems to grow into a giant.

DH Theatrical sets are about creating different kinds of perspective, but the perspectives can't be quite real in the theatre, because they have to be made in such a way that they create an illusion. And remember that in the Renaissance and baroque periods artists organized spectacles. Brunelleschi, Raphael, Leonardo and Bernini all worked on them. They were always being asked to design masques, pageants and plays. A lot of artists did things in the theatre, but of course the sets weren't kept.

MG In the 16th and 17th centuries, some Italian artists became astonishingly skilful at creating *quadratura*, or illusionistic architecture. The methods they used were much the same as those needed to design for plays. Works such as the frescoes in the Palazzo Lancellotti in Rome by Agostino Tassi and collaborators in 1619–21 create a virtual environment: a stage set of painted columns and arches, with a landscapes beyond, extending around the viewer in every direction. In many baroque churches and palaces, heavens open above one's head filled with flying angels, saints and gods. Like theatrical scenery, these are both real and not real.

DH I'm sure Italian theatre in those days was very, very spectacular. Bernini's effects must have been fantastic. Transformation scenes – in which the light or the scenery changed – were a big thing in the theatre going back to the Renaissance and baroque periods. Bernini specialized

9 Painting the Stage and Staging Pictures

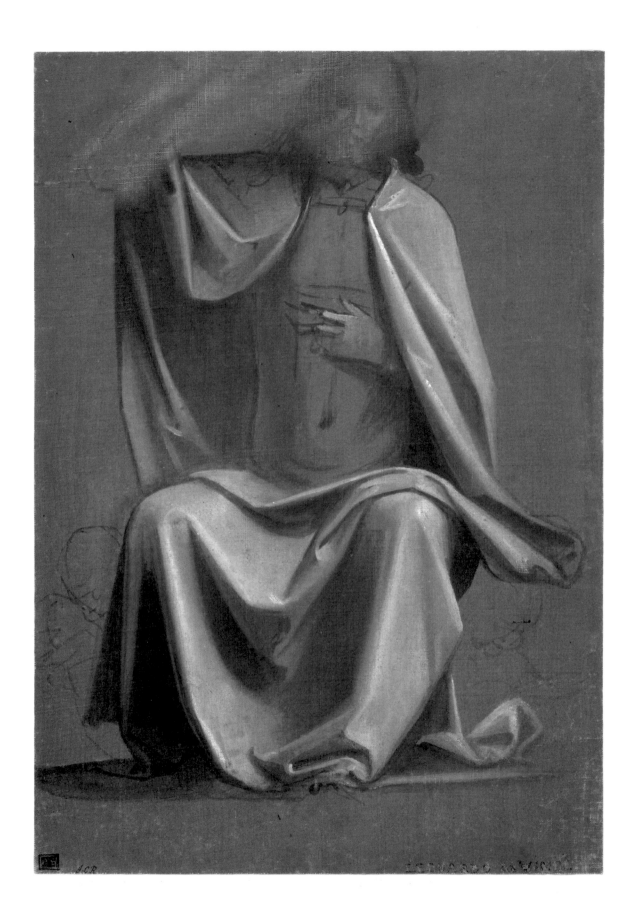

169

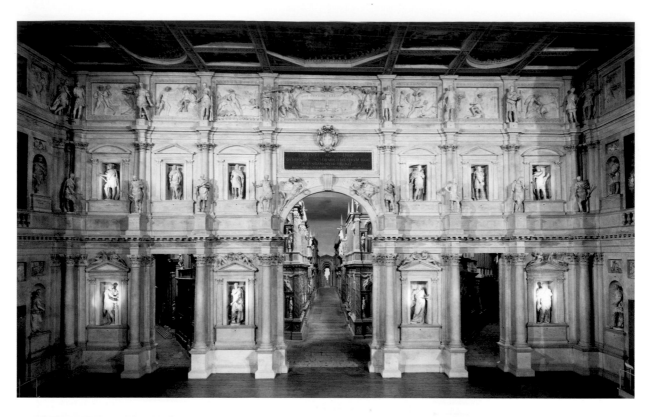

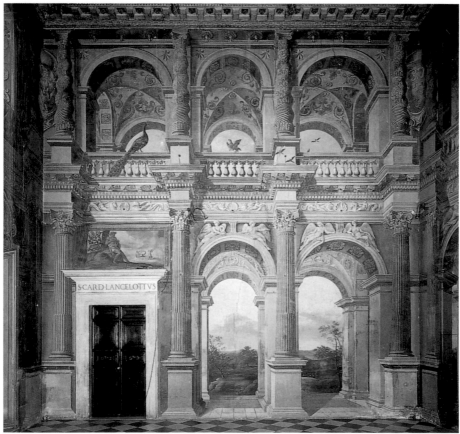

ANDREA PALLADIO
Teatro Olimpico, Vicenza, Italy, 1580–85

AGOSTINO TASSI
Trompe-l'œil decoration of the Sala dei Palafrenieri,
Palazzo Lancellotti, Rome, 1619–21
Fresco

CLAUDE LORRAIN
Landscape with Ascanius
Shooting the Stag of Sylvia, 1682
Oil on canvas

in them. If you alter space in the theatre, it's very effective. The spectacle is partly created by the fact that the audience know it's difficult to do.

MG Inigo Jones thought that the theatre was related to painting and drawing. 'These shows', he wrote in 1632 of the sensational masques he designed for the Stuart court, 'are nothing else but pictures with light and motion.' And many 17th-century pictures look very much like a dramatic mise-en-scène.

DH Claude's paintings are beautifully composed, with the spatial effects carefully organized. His placing of trees or architecture on the right and left and the deep space in the middle is very much like a set behind a proscenium arch. That was his usual way of putting a picture together. It's similar to having flats on either side of the stage and deep space like a backdrop behind. In that way his pictures are very theatrical.

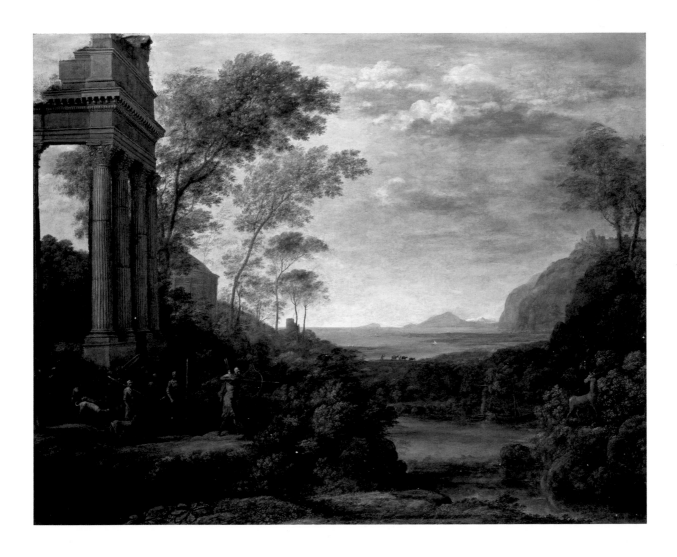

10 Caravaggio and the Academy of the Lynx-Eyed

Caravaggio invented Hollywood lighting.

DH What is naturalism? Is it derived from the optical projection of nature? I think people have been looking at the equivalent of photographs for hundreds of years. A projection, whether it's of a person, object or a scene, is going to be of *deep* interest to anyone who's making images. If you are involved with making depictions, you are bound to be alert to how many ways there are of portraying the world. I think Caravaggio, for example, made his pictures by a form of drawing with a camera. He was projecting first this figure then that figure – or part of a figure, an arm or a face – onto his canvas. His paintings are a kind of collage of different projections.

MG As was argued in *Secret Knowledge*, there are visible traces in Caravaggio's paintings that reveal how they were made. From these it is clear he did not construct a painting in the manner that Raphael would have done, by preconceiving it on paper. That is, working out the arrangement of the figures in a series of drawings; next studying the poses of each; then finally fitting the whole image together in an imagined space. Instead, what Caravaggio did was find a novel way of fusing the Italian tradition of the istoria with the radical naturalism of the north. Caravaggio posed each model – like an actor in a play – and painted them more or less precisely as he saw them. We can tell that by looking closely at his paintings. To a modern eye, the results look photographic or cinematic – in other words, like pictures made with a camera, which they may well have been.

CARAVAGGIO
The Incredulity of Saint Thomas, 1601–02
Oil on canvas

DH In Caravaggio's pictures you can see he used a team of people, like a sort of repertory company. The same person appears in different paintings. In the *Taking of Christ*, for example, there weren't two models for the

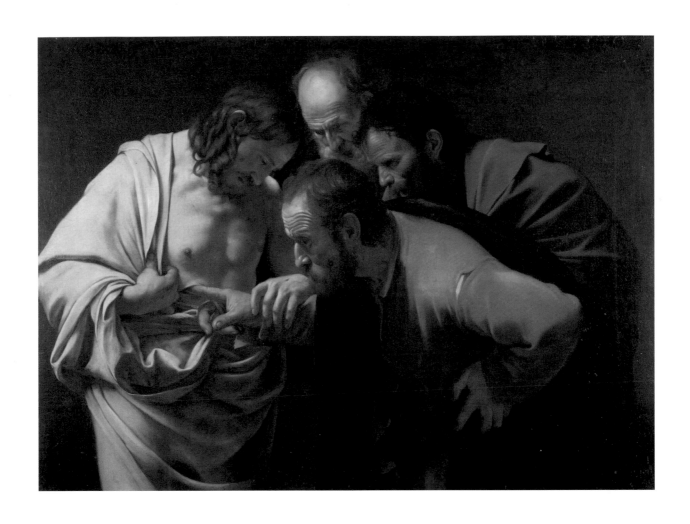

 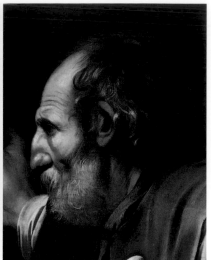

guards in armour; they're the same man. They've got the identical little spot on their noses.

MG This man with a growth on his nostril, walrus moustache and grizzled hair turns up in at least three paintings from around the same period: 1601–02. He is the disciple on the right in *The Supper at Emmaus* and with slight variations in his appearance he turns up as the rear disciple in the *Saint Thomas*. A second glance reveals that the same balding, wrinkle-browed, eagle-nosed fellow posed for the figure of St Thomas in the foreground as well, but with a sort of toupee and browner hair. This tells us that Caravaggio was almost pedantically transcribing what he saw, which was exactly his method as reported by a Dutch contemporary, Karel van Mander: 'he will not make a single brushstroke without the close study of life, which he copies and paints.'

The result was a stunning increase in verisimilitude. You feel you are in the same room as the man with the warty nose. But there was a loss in visual coherence. Caravaggio was like a director filming each actor separately, and then trying to fit their images together into a shot. Consequently, St Thomas, for example, does not stare at the wound in Christ's side but looks right past it.

DH Caravaggio pieced together the figures and the whole picture, but doing it that way you'd never get it to join completely, because of the angles. You'd just want to try to keep it coherent. One of the amazing things is how close the methods he used are to what Photoshop can do.

Above left
CARAVAGGIO
The Incredulity of Saint Thomas
(detail), 1601–02
Oil on canvas

Above centre
CARAVAGGIO
The Taking of Christ (detail),
c. 1602
Oil on canvas

Above right
CARAVAGGIO
The Supper at Emmaus (detail),
1601
Oil on canvas

Opposite above
CARAVAGGIO
The Taking of Christ, c. 1602
Oil on canvas

Opposite below
CARAVAGGIO
The Supper at Emmaus, 1601
Oil on canvas

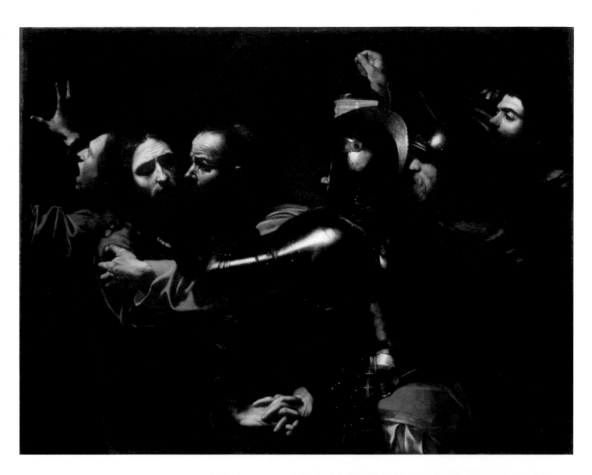

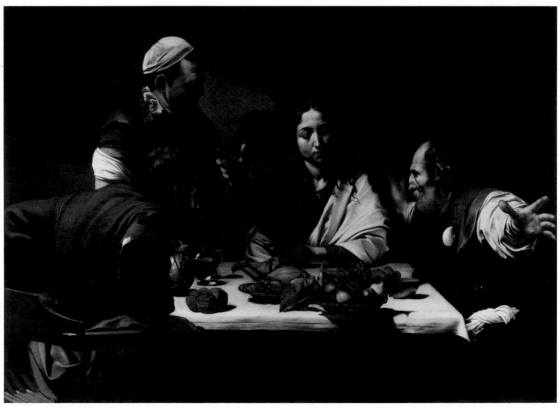

MG This also explains the lack of recession in the figure in the *Supper at Emmaus*. What we are looking at is two close-ups of hands in differing positions (the one near us the same size as the one much further away), fitted onto a view of his head. Obviously, it would have been impossibly painful to hold such a pose for more than a few minutes.

DH When I tried to recreate the process by which *Supper at Emmaus* was painted, I rested people's hands on a blue bucket, then took it away in the picture. A Caravaggio scholar said to me, 'Oh, I can see now where those blue buckets must have gone in other paintings!' That's how they were done. Caravaggio's angels look as if they were hung from string, and they probably were. Obviously, if he worked like this Caravaggio had to record the models' positions from one session to the next. And in fact there are incisions on his canvases. They are exactly like the chalk marks we put around the model at the art school in Bradford so that he could go back to the same pose. The floor would be covered with them.

Caravaggio must have had an idea of scale in his mind while he was putting these pictures together; although he sometimes gets the scale wrong, it's only slightly wrong. The fact that the figures in Caravaggio's pictures don't fit into a planned perspective space is not always obvious until it is pointed out. It doesn't matter much to the viewer because of the heightened naturalism; his pictures look so real we just accept them.

MG The question of exactly how Caravaggio pieced his compositions together has been debated. It might be asked, for example, whether it would not have been more straightforward for him simply to have posed his models one after another, and painted them from life.

Caravaggio could have done this, and probably did in his later years after his abrupt departure from Rome in 1606. From that point, while wandering between Naples, Malta and Sicily, the visual evidence suggests he used optical tools much less. A use of optics, however, or lack of training in drawing and anatomy, might explain the hash he makes of the executioner's legs in *The Beheading of Saint John the Baptist* from 1608.

DH You don't have to use lenses and mirrors all your life. Anyone very skilful would develop those painting techniques and habits of looking. After a while they wouldn't need a camera. It was the experience of

CARAVAGGIO
The Supper at Emmaus
(detail), 1601
Oil on canvas

10 Caravaggio and the Academy of the Lynx-Eyed

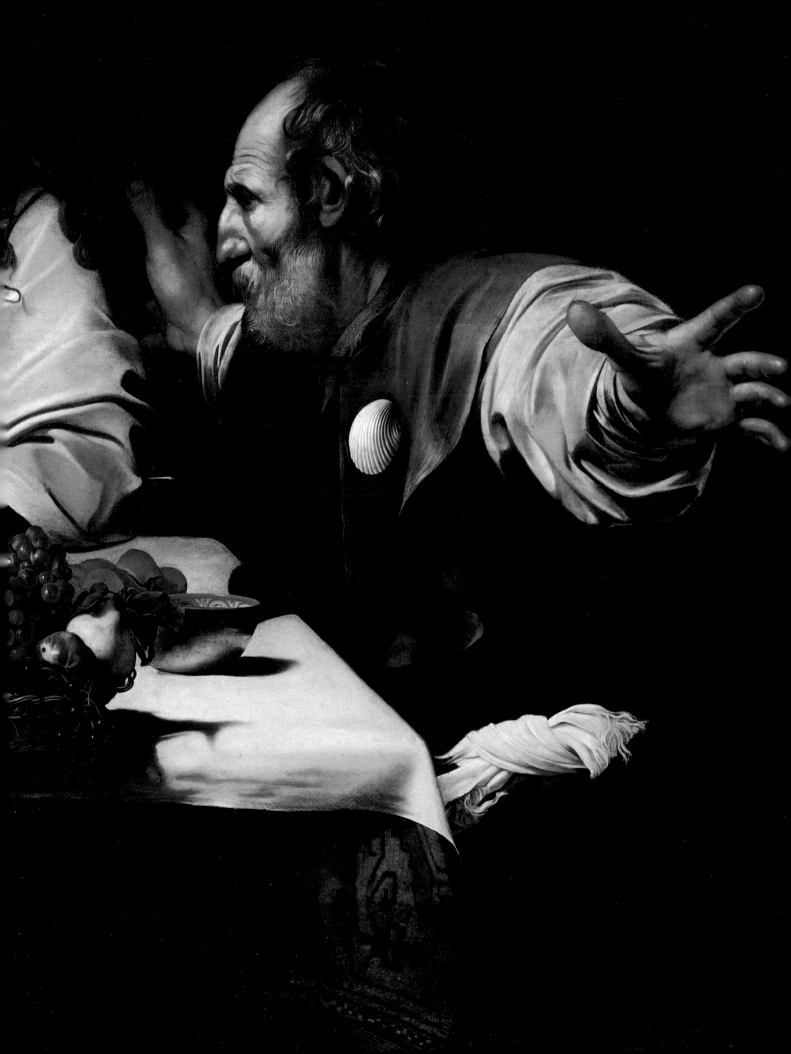

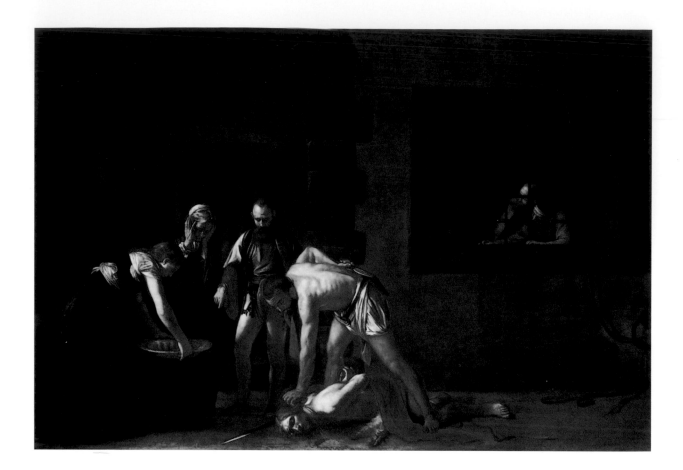

having looked through it to observe the world that would have been important. The main point is that while he was developing his style Caravaggio wasn't really looking at the world, he was looking at a flat projection of it, which is a very different thing. I don't think there's any other explanation of how those pictures were made. There is no known drawing by Caravaggio and without making drawings how else would you construct pictures like that?

MG The pictures Caravaggio made in Rome in the years before he fled in 1606 – having killed a man in a quarrel – reveal telltale signs that he was using optical tools in some way. These include the manner in which the paintings consist not only of figures seen separately, and fitting together, but also – as we have seen – of parts of people assembled in a manner resembling a photo-collage.

There was another startling development in Caravaggio's paintings: the way that from the late 1590s they are set in inky darkness, as if – a contemporary critic said – they were painted in a dark room with one window and the walls painted black.

CARAVAGGIO
The Beheading of Saint John the Baptist, 1608
Oil on canvas

10 Caravaggio and the Academy of the Lynx-Eyed

DH Perhaps they were done in the basement of his patron Cardinal del Monte's palace? But the darkness also came out of the technique. It was built into the system. The optical projection of nature needs light and dark. That's why I say Caravaggio invented Hollywood lighting. As soon as you use optics, you have to use strong lighting to see anything clearly.

MG Finally, there is the supersaturated *look* of his pictures. They are not just realistic; they are hyper-real. This is not the world as seen by an eye, but as it appears sumptuously spotlit and rendered by a lens.

DH When you look at an optical projection you see the simplifications that they make in texture and colour. There are many ways of translating three dimensions into marks on a flat surface. That's the missing bit in most accounts of art and how it's made. An optical projection does it in a particular way. And that is what some painters painted.

To see one would be to use it; artists are influenced by pictures and such an image was, in effect, a picture. Optical projections are remarkably beautiful. I made marvellous ones, for example, of a vase. You could see more in the projection than you could when looking at the vase itself. But a photograph of a projection is not the same because you can't quite see this marvellous *extra* quality they have. When you see a real one in front of you on the wall, it just *looks* like a Caravaggio or a Velázquez.

MG When *Secret Knowledge* was published in 2001, the suggestion that an old master such as Caravaggio might have based his work on optical projections seemed startling to some readers. It becomes much less so, however, when you realize that other people in his world were looking at them, too, and had been for generations. In 1600, such images were regarded as wonders worth remarking on, but were by no means unknown.

Around 1600, for example, the astronomer Johannes Kepler saw a camera in the Elector of Saxony's 'theatre of artifices' in Dresden. He described how 'A crystalline lens, a foot in diameter, was standing at the entrance of a closed chamber against a little window, which was the only thing that was open, slanted a little to the right.' The walls were in deep darkness, so, he noted, the eye was caught not by the lens itself, but by the image it projected of the world outside.

DH Optical projections are not that difficult to make. We've been led to believe that before photography cameras were always big bulky things like early television sets. Actually, all you need to make an optical projection is a piece of glass. You can set it up in a cupboard, but for it to work well you have to pay attention to lighting, time of day, all sorts of factors. If the projections don't look good the first time, you have to try harder. Artists would have made them brilliantly.

MG In the second edition of his treatise *Magia naturalis* (1589), a Neapolitan scholar, playwright and proto-scientist named Giambattista della Porta described a real-time performance of hunts, battles or games he projected on white sheets inside a dark room 'so clear and luminously, and minutely, as if you had them right before your eyes'.

DH Obviously, della Porta could put on a show for his friends. He used a lens and a dark room, where his audience sat. Outside, he had actors and props: real animals and pantomime ones with children inside them, trees, horses, riders and weapons. They were projected onto a wall of the dark room, from the brightly lit scene outside. His picture was in colour and it moved. In effect, it was like a cinema, though the image was possibly not much bigger than the one you see on an iPad.

MG Such sights gave thoughtful people such as Kepler ideas. The eye, he realized, functioned like that dark room in Dresden. The image was not formed, as was generally thought up to that time, on the surface of the cornea, or transparent outer surface of the eye. It was projected by the eye's lens onto the retina. In other words, the human eye functioned like a natural camera, a notion adopted and illustrated by René Descartes in *La dioptrique* (1637). This implied that what we see is exactly like a lens projection: it *was* reality.

DH We still live in an age when vast numbers of images are made that do not claim to be art but to be reality. 'Reality' is a slippery concept, though, because it is not separate from us.

MG Not only did lens projections suggest new ways of making pictures, but the lens itself was also an innovative means of discovering information about the world. In the 17th century, optical equipment such as the microscope and telescope was a vital new tool for what we now think

Above
GIUGLIO PARIGI
Drawing of a camera obscura, *c.* 1590,
from *Strumenti e Macchine*, 1590–1600

Right
Illustration of Descartes' explanation
of vision: a diagram showing the function
of the eye, optic nerve and brain, 1692
Woodcut

of as science. Looking further and closer than the unaided eye was capable of seeing led to spectacular increases in knowledge. Galileo studied the moon through a telescope, and he saw a surface covered in blemishes and craters. Previously, with only a couple of exceptions, the moon had always been represented as a pure white disc. This was how Aristotle had argued the moon must be. Galileo's drawings are beautifully observed: works of art, we would now say.

The first occasion on which he looked through a telescope at the moon was on 30 November 1609. But at around the same time, or just before, Adam Elsheimer had made a painting (dated 1609) that not only showed the moon much as Galileo had drawn it, but also for the first time in art more or less accurately depicted the starry heavens and Milky Way. Elsheimer was in touch with a group of enthusiastic scientists in Rome, so it is possible he was able to look through one of the earliest telescopes to reach the city. The first such instrument had been

GALILEO GALILEI
Drawings of the Moon, 1609
Watercolour

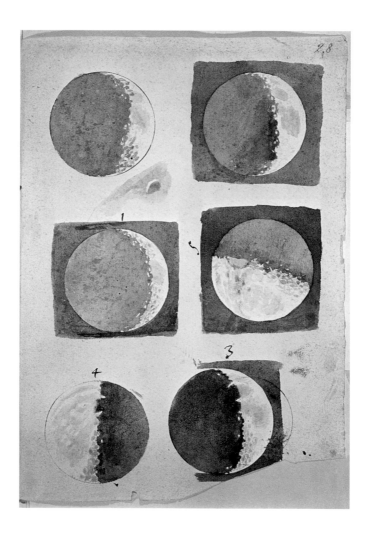

10 Caravaggio and the Academy of the Lynx-Eyed

A projecting telescope being
used to view the sun indirectly.
From *Rosa Ursina* by Christoph
Scheiner, 1630
Engraving

revealed to the world only a year before, in 1608, in the Netherlands.
But Elsheimer's scientific friends would also have known that Kepler had
observed the moon though a camera obscura, which threw its image on
a sheet of paper, an experiment he had described in a book published five
years before, in 1604.

Projections and astronomical observations went together. One
of the most frequent scientific uses of the camera was to observe
the sun without damaging the eyes. Kepler had used such an instrument
to follow the transit of Mercury across the solar disc in 1607, and
a German Jesuit astronomer, Christoph Scheiner, later constructed
a telescope-cum-camera.

DH Elsheimer could have plotted the surface of the moon and the stars
accurately from an optical projection. The night became a big subject
in painting about then and, like Caravaggio's pictures, in a way it's
all about lighting. There are three different sources of light in
The Flight into Egypt: a fire that's throwing up sparks; the torch
in Joseph's hand; and the night sky with the moon. The stars,
the trees and the reflection in the water are all shown very, very
naturalistically.

MG Pictures were also a crucial way of cataloguing, classifying and hence
understanding such phenomena as plants, animals and rocks.

The *museo cartaceo* or 'paper museum' assembled by Cassiano dal Pozzo (1588–1657) consisted of some 7,000 watercolours and was a visual inventory covering such subjects as botany, geology, palaeontology, art history and classical archaeology. Although much of this sounds like a scientific enterprise, art and science were not entirely separated in the mind and life of a man such as Cassiano. He was an alchemist and antiquary, doctor, avid collector of drawings, correspondent of Galileo, friend of Poussin, and patron of many artists, including Caravaggio.

Sometimes 'art' and 'science' overlapped. *Two Shells* by Filippo Napoletano was painted for Grand Duke Cosimo II de' Medici, a connoisseur of painting to whom Galileo dedicated one of his most important books. It is simultaneously a still life and a contribution to the study of conchology, and painted in a manner, spotlit against deep darkness, close to Caravaggio. This little picture looks very much as if it was painted with the help of a projection. Note the deep shadow of the background and the sumptuous, hyper-reality of the pattern and surface texture, whether glossy or slightly roughened.

Right
Attributed to VINCENZO LEONARDI
Citrus medica L. (Digitated Citron),
from the 'paper museum' of Cassiano dal
Pozzo, *c.* 1640
Watercolour and bodycolour with gum
heightening over black chalk

Below
FILIPPO NAPOLETANO
Two Shells, 1618
Oil on canvas

DH Those shiny textures on the surface of the shells would have looked marvellous in an optical projection. Every little highlight would have been there, and Napoletano would have known exactly where to place it. You could figure that sort of thing out slowly just by looking, but you'd have to do an awful lot of peering to do it. But on a flat surface with an optical projection, there it is! Whether the artists traced it this way or that way is neither here nor there. They saw it in two dimensions, not three.

MG In this period there were as many ways to make pictures using optical projections as there were after 1839 to make paintings with the aid of photographs. Therefore, we should no more expect all 17th-century artists using lenses and mirrors to produce the same sort of result than we would Francis Bacon's work to look like Gerhard Richter's. Caravaggio, we have argued, used optics to make a radically novel kind of picture of religious and mythological subjects. He did so by painting models directly in his studio, and therefore needed no drawings. In fact, an absence of drawing can be a sign that artists might have been using optical tools. Vermeer left none either, except some marks directly on his canvases.

Other artists, however, who worked in a different way, may have left a paper trail: camera drawings. One of these is Ottavio Leoni (1578–1630), who was known to Caravaggio. Visual evidence suggests he traced his numerous portraits on paper using a projection in some way. They are all on the same scale, drawn – according to his contemporary Giovanni Baglione – 'after having seen the subject only once and rapidly'.

DH When you use a camera to draw a face what you are doing is fast-forwarding the measuring. Leoni would only have had to put down a few dots for the eyes, nose and mouth. If you get those relationships, you automatically get a likeness. That's all it is. But that is not to dismiss artists who work that way. You still have to be extremely observant and skilful to draw like that. Making a drawing from a projected image involves thought and choice in the same way as making any other kind of line. There are always decisions about how to depict the subject.

MG An 18th-century British topographical artist, Thomas Sandby, marked a sheet 'Windsor from the Goswells drawn in a camera'. This is the

OTTAVIO LEONI
Portrait of Pietro Altemps, 1617
Black chalk with white chalk on blue laid paper

Rosetta Stone of camera drawings because it provides a definite example of what they look like: the line looping in loose squiggles around trees and masses of vegetation and finding the contours of walls and roofs with unerring precision.

It is not hard to find other drawings that have these characteristics. There is a huge number from the 18th century, and several from the 17th. Wenceslaus Hollar's *View from St Mary's, Southwark, Looking Towards Westminster* is similar in handling and technique (pen and ink over pencil) to Sandby's of over a century later. It has just the same wiggly shorthand for vegetation and a comparable assured precision in the architectural lines.

DH In camera tracing, the line always goes *around* something. It's a guided line. Your hand is not being directed by something in your head, but by something outside it. Normally, when drawing freehand you'd grope just a bit. In camera drawings, there is no groping.

MG Few written accounts exist of artists using cameras at this date, though there are some references. In 1636, Daniel Schwenter, a professor at the University of Altdorf, described his own invention of a scioptric ball – two lenses mounted in a wooden sphere to form a predecessor to the wide-angle lens – and how one Hans Hauer had used it to draw a panorama of Nuremberg, which was much the same kind of project as Hollar's view of London.

Windsor from the Goswells drawn

DH There were various reasons why artists wouldn't have mentioned using a camera. One is that it was a trade secret. Another is that from the Renaissance, artists were very keen to place themselves above the level of trade, so they played down the element of craft. I believe they used cameras, but they were a bit ashamed of them, or, at least, secretive.

MG The first detailed description we have of a landscape being drawn in a camera dates from 1620, and concerned – once again – Johannes Kepler. Even he was a little reticent about the matter, but an English diplomat, Sir Henry Wotton, seeing a remarkable panoramic drawing in Kepler's study, wormed the information out of him. The astronomer described

Drawing belonging to Johannes
Kepler of an optical device
based on a design by the
astronomer Christoph Scheiner,
c. 1615
Pen and ink on paper

how he had 'a little black tent' that could be turned through 360 degrees 'like a windmill'. There was a hole in the fabric, 'about an inch and a half in the diameter, to which he applies a long perspective trunk'. This tube – which seems to be shown in a drawing found among Kepler's papers, plus an example of the kind of landscape that could be made with it – had convex and concave lenses that projected an image onto a sheet of paper. 'And so he traceth them with his pen in their natural appearance.'

DH When looking at Claude's paintings I have wondered whether he was well acquainted with the camera. A drawing of the Pyramid of Cestius suggests he was. Perhaps the drawing required two different focusings and the lens moved a bit. You can see by the shadows under the arches that it was drawn near midday when the sun was high and the light very bright. The camera would have produced a very clear image with the shadows under each brick. The lines are bold and always in the right place; there seems to be no groping. But the pyramid is narrower than the actual structure, as if he could only see a small area in sharp focus, and it is misaligned with the three arches of the Aurelian wall beside it: the effect is almost like two images cut and pasted together.

10 Caravaggio and the Academy of the Lynx-Eyed

CLAUDE LORRAIN
The Pyramid of Caius Cestius,
c. 1630
Pen and brown ink on
off-white paper

MG One supremely delicate and poetic painting by Elsheimer seems to
anticipate Claude's mastery of luminous dawn landscapes: *Aurora*,
which dates from around 1606. This must have been based on close
and sensitive observation of a real landscape at dawn, with milky clouds
and still darkened woods. Moreover, one of Elsheimer's rare surviving
drawings is obviously related to *Aurora*. It shows the same landscape,
with the addition of a rapidly jotted train of pack mules and drovers.
This might be the earliest camera drawing to survive: it has the telltale
rapid, traced line.

Artists such as Elsheimer and Claude were hugely influential, even
on painters who did not use optical tools. Rubens, for example, followed
Elsheimer's moonlit landscape with a lovely picture of his own. Rubens,
however, clearly did not use a camera. As for Caravaggio, his style was
imitated by artists from Spain, France and the Netherlands, as well as
Italy. But in some hands his radical novelties turned into clichés.

ADAM ELSHEIMER
*Large Campagna Drawing with
a Mule Train*, early 17th
century
Brown ink on paper

ADAM ELSHEIMER
Aurora, c. 1606
Oil on copper

DH A two-dimensional surface can easily be copied on two dimensions. It's three dimensions that are hard to get on two; that involves making a lot of decisions. You have to stylize it, interpret it. Copyists are very good at flat surfaces – that's why they are copyists – but they would have trouble making a picture from a real space.

In the Capodimonte Museum in Naples there are some great paintings, such as Caravaggio's *Flagellation of Christ* (1607), but there are also rooms full of dark, dreary pictures of religious subjects using deep, dark shadows. The artists who painted them got carried away with all the light and shade, and the darkness. I got tired of them; they weren't quite good enough. Once Caravaggio had done it, his effects could be copied easily.

PETER PAUL RUBENS
Landscape by Moonlight, 1635–40
Oil on canvas

11 Vermeer and Rembrandt: the Hand, the Lens and the Heart

Understanding a tool doesn't explain the magic of creation.

DH There's an early Vermeer in Dresden, *The Procuress*. If you look at its construction closely you can see it's very like a Caravaggio, in that the figures don't quite fit into a coherent space. The figure on the left holding the glass in his hand seems to be a bit too big. Where is he in relation to the girl? They're squeezed in. All this hints at the use of optics.

Half the painting is a depiction of a Turkish kilim; those very neat people the Dutch often screwed up carpets and tablecloths in their paintings. This produced complexities that they no doubt liked to paint. The way those woven forms in the pattern were altered by the folds would have been picked up and emphasized by a camera. That kind of thing would have been very difficult to do by eye. So, too, would the details of the lace collar worn by the smiling man, who is spotlit from the upper left.

The young woman is not sitting at a table, by the way; the carpet and cloth seem to be hung on a rail. The blue-and-white jug is floating. We are looking at a collage made up of separate projections.

MG Behind the figures the space is shallow, but also indistinct and shadowy in the manner of a Caravaggio painting. The two men, on closer examination, could have been posed by a single model (same nose, same chin). Scholars have been puzzled by the oddities of the picture, noting the 'fun-house construction of space' and the way the smiling man seems to be 'spliced' into the group. Despite its being signed and dated 1656 – when Vermeer was 24 – some have even doubted the picture is by Vermeer at all. Its inconsistencies in space, lighting, focus and texture made it seem untypical for the painter. But these are easily comprehensible if he was using a slightly different method from the one he employed for his later works.

JOHANNES VERMEER
The Procuress, 1656
Oil on canvas

DH The lenses Vermeer was using were probably better than the ones that were available to Caravaggio, because the colours in *The Procuress* are wonderful: the red, blue and yellow. The better the lens, the better the colour. Every lens is different, that's still true now, even of mass-manufactured ones. And in those days, some would have been much better than others. So Caravaggio probably wouldn't have been too carried away by the colour he saw, and in fact there is little bright colour in his pictures.

The difference was I think Vermeer had a lens made of very good clear glass – meaning the green tints had gone, so the reds, blues and yellows would have looked really beautiful. The picture was originally full of all three: the greys in the carpet were originally blue, but the pigment he used has altered. And the projections would have harmonized the colours. That's what you see in the picture.

MG Between 1656 when he signed *The Procuress* and 1657–58, the period to which scholars date *The Little Street*, Vermeer's method of working seems to have changed. In photographic terms, the later painting is much more of a long shot, and if it's a collage it's made up of only two or three elements. It is an extraordinarily convincing urban streetscape, so much so that you instinctively believe that a colour photograph of a 17th-century Dutch town would look much like this.

Perhaps this actually is based on something much like that. Philip Steadman, author of *Vermeer's Camera* (2001), has made a good case for believing that this was part of the view from the rear of the Mechelen inn on the market square in Delft, which was owned by Vermeer's family. This was the building in which the painter grew up.

In the picture, the brickwork, worn whitewash and mortar of the walls are meticulously recorded – each joint, every accident of slippage and repair in the wall. This picture is the work of someone utterly fascinated by the truth of what he sees: to whom the exact appearance of reality comes as a sort of revelation.

If this was done from a projection, it must have been one of great precision, which picked up and transmitted the smallest visual nuance with great clarity over a considerable distance. Could Vermeer have had access to such a lens or combination of lenses? In all likelihood, the answer is yes.

JOHANNES VERMEER
The Little Street, c. 1658
Oil on canvas

DH The discovery of the telescope by eye-glass makers from the Netherlands was announced in 1608. The instruments spread around Europe incredibly fast, not so much because people wanted to look at the sky but because every military organization wanted them for looking at the enemy on the horizon and for navigation. As a result, higher-quality lenses began to be made in larger quantities in the 17th century. So the period from 1600 to the 1650s was a tremendously active period in lens production. The Netherlands in particular was a centre of lens making. Some have questioned whether lenses at that time were good enough to project sharp images. But either a lens is good or it isn't, and clearly Galileo's telescope was good. So some of the lenses made at that time were of very high quality.

MG Truly exceptional lenses, however, remained hard to obtain. Galileo ground his own, as did Vermeer's close contemporary in Delft, Antonie van Leeuwenhoek, the founder of modern microbiology, who refused to reveal how he made the lenses for his greatly improved microscopes. This was information – he explained – 'I keep that for myself alone'.

DH Very high-quality lenses are all slightly different because of the way they are polished. There's no history of the lens, which is because lens-makers have always been a bit secretive about their methods. They still are. I think Vermeer's lenses would have been a bit bigger than Caravaggio's, and certainly made of better glass. In Vermeer's time one lens in two hundred would have been good. Today, it's more like one in twenty, but the best ones are still handmade. Vermeer and the other painters of Delft were living only streets away from some of the few people in Europe who could make high-quality lenses.

MG It has long been noted that Vermeer and Van Leeuwenhoek lived not far from one another (the great scientist was in charge of the painter's estate after his death). New research has recently revealed that these two world-famous figures were part of an interlocking and overlapping group of local artisans, artists and amateur scientists that had existed since the late 16th century.

Two of these men are particularly relevant to Vermeer's work. Jacob Spoors (*c.* 1595–1677), a notary, surgeon and surveyor, conducted optical experiments and wrote a book, *Oration on the New Wonders of the World* (1638), expounding the idea that mathematics, geometry and – hence

11 Vermeer and Rembrandt: the Hand, the Lens and the Heart

– optics could uncover the secrets of God's universe. This idea provides a hint as to why Vermeer would have spent such time and effort in depicting with immense fidelity the appearance of the real world around him: it was a revelation of divine design.

A military engineer named Johan van der Wyck (1623–1679) who was working in Delft in the 1650s was internationally renowned as a master lens-maker and deviser of ingenious optical equipment. In 1655, he carried out a public demonstration in The Hague in which he placed 'a paire of glasse' (presumably a lens or perhaps arrangement of lenses) in a window, and this projected 'all the objects without upon the Streets' onto a 'table' inside the room. What the audience in The Hague would have seen would have been something very much like *The Little Street*.

There is an account of an artist using a lens in just this way about half a century later. It exists because the Bolognese master Giuseppe Maria Crespi (1665–1747) had a son, Luigi, who became a writer as well as a painter. Luigi Crespi described his father's diligent study of shadows and the fall of light; how he would carefully study the way light struck people and animals in the streets, and the manner in which the white of walls was reflected in human flesh by the light of the sun. Eventually, Luigi went on, 'he made a hole in the door of his house, which faced a wall on the opposite side of the street'. Crespi put a lens in the hole, facing it with 'a blank canvas' in the dark room within.

According to his son, Crespi would spend 'entire days' studying everything he could see projected by the lens, including the effects of light, shadow and reflected light, 'just as in a camera ottica' (an alternative term in Italian for the camera obscura). Crespi's *Scene in a Courtyard*, with its careful attention to the textures of worn plaster and brick, is not very different from the Parisian courtyard photographed by Eugène Atget around two centuries later.

DH But there is a difference. When the first photographs were made, the thing that surprised people who were used to looking through cameras was that they weren't in colour. Projections had wonderful colour.

Vermeer and other artists using a camera obscura weren't really looking at the world, they were looking at a flat projection of it and sometimes you see more that way, especially such things as textures on brickwork or in cloth, and patterns in fabrics.

A crucial development in Vermeer's mature work is that – unlike Caravaggio's – it presents a daylight world. In the past this has been a problem for those attempting to explain how he might have painted such scenes. Philip Steadman suggested he could have worked, partly at least, in a large cubicle in his studio: a walk-in camera. Perhaps this is correct; such items were manufactured in the 18th century. In the film *Tim's Vermeer* (2013), however, Tim Jenison demonstrated another possibility.

In the course of his attempt to replicate a picture by Vermeer – *The Music Lesson* (early 1660s) – in a carefully reconstructed facsimile of Vermeer's studio using optical technology available in the 17th century, initially he hit a problem that the artist would also have encountered. The projection was too faint for him to see the fine detail of the scene, for example the decoration of the Flemish virginals, in sufficient detail. After struggling for some time with this impasse, he found a solution: he projected the image from the 4-inch lens into a 7-inch concave mirror

GIUSEPPE MARIA CRESPI
Courtyard Scene, c. 1710–15
Oil on canvas

EUGÈNE ATGET
Cour, 41 rue Broca, 1912
Albumen silver print

and thence onto a flat mirror above his painting. This had the effect of vastly intensifying the level of light. Perhaps Vermeer could have used a similar system, at least some of the time. A camera image provided information from which an artist might trace outlines and perspective; but by working directly from a projection, using a method such as Jenison's, it would also be possible to match colours and tones. And it is perhaps the precision of tones, above all, that gives the Vermeers their 'photographic' quality.

Whatever the precise methods he used, Vermeer was an artist visibly enthralled by optical devices. His pictures reveal how he loved the heightened detail and texture he could see with the aid of a lens. But he clearly also appreciated the strange transformations, glitches and distortions it produced. In this respect, Vermeer resembles a contemporary artist such as Gerhard Richter (an avowed admirer of Vermeer). Richter seems fascinated by the way photography does not

so much represent the world as obscure it, creating a veil of blur and fuzz. Richter uses these side effects of the camera brilliantly, and no one thinks the less of him because his source was a photograph. On the contrary, if you do not realize that you haven't understood his paintings.

Nearly two centuries before the advent of photography, Vermeer must have felt the same. Often it is the soft lack of focus in certain areas – an effect that can only have been seen in an optically created image – that generates the mystery and beauty of his art. Therefore, to deny he used a lens is to misunderstand his achievement, which lay, precisely, in finding the poetry in this new way of seeing the world.

DH The works of many of Vermeer's contemporaries also hint at the use of optical projections. Look at Jan Steen's *Burgomaster of Delft and his Daughter*. It's signed and dated 1655 – the year before Vermeer's *The Procuress*. I believe the picture is also a sort of collage, but in a different way. Clearly, the people have been studied separately and fitted onto the street scene.

The girl on the left is the nearest figure to us, but she's very, very small. Actually she's about ten per cent too small, because I blew her up by that amount and then the picture looked better. On her dress, the shadows are extremely accurate and the highlights beautifully done. There's no shadow being cast by the bottom of the step as you move along, but there is a shadow being cast to the right from the beggar woman. So this is not coherent light, is it?

MG Jan Steen was born and died in Leiden but spent some time in Delft during the 1650s, where he rented a brewery on the Oude Delft canal, not far from the Vermeer family's Mechelen inn on the market square. Here, he too painted a street scene in the town, and one that probably made use of optical devices, but the result is very different – neither so meticulously detailed nor mesmerizingly naturalistic – from Vermeer's *Little Street*. There are, as we have seen, an infinite number of ways to use a camera projection, as many, no doubt, as there were artists. But their pictures, however differently, might well reveal that the subject had been seen via a lens. Joshua Reynolds saw – and praised – Van der Heyden's picture of the church of San Andreas, Düsseldorf, when he was in Amsterdam on his visit to the Netherlands in 1781. He noted that though it was 'very minutely' finished, 'he has not forgot to preserve at the same time a great breadth of light'. Reynolds added

JAN STEEN
The Burgomaster of Delft and his Daughter, 1655
Oil on canvas

11 Vermeer and Rembrandt: the Hand, the Lens and the Heart

that Van der Heyden's pictures 'have very much the effect of nature, seen in a camera obscura'. Indeed, that was his conclusion about Dutch pictures in general, after seeing the Royal Collection at The Hague.

Reynolds knew what he was talking about since he owned and presumably used a camera himself: an unusual model, perhaps revealingly, which until it is unfolded is disguised as a book with the word 'Ancient' stamped on the spine. It is now in the Science Museum in London. He may well have been correct about Dutch art: it looked like a camera image, because in one way or another many Dutch artists were using them.

There is one remaining preparatory drawing by Van der Heyden: it is for his *View of the Oudezijds Voorburgwal with the Oude Kerk in Amsterdam*. It is reversed, as a drawing would be if it had been made in a camera in which the image was not corrected by a mirror. It also corresponds in remarkably close detail to the finished painting.

Van de Heyden's background was in a practical aspect of the optics trade; his family made and sold mirrors. His topographical pictures have a marvellous clarity and accuracy but they cannot compare with the poetic intensity of Vermeer's *Little Street*. Vermeer was special partly perhaps because he lived in a community that contained people making extraordinarily fine and inventive optical equipment, and who perhaps believed that through these lens they could see God's creation as it had never been seen before. The other reason why Vermeer stands out from his contemporaries, however, is easier to state than to analyse: he was an exceptionally gifted painter.

DH In the end, nobody knows really how the finished painting was achieved. It can't be entirely explained. Vermeer probably used similar techniques to many other artists. He just painted his pictures better.

Understanding a tool doesn't explain the magic of creation. Nothing can. People say leave some mystery, but actually it's impossible to take it away. Optical devices don't make marks; they don't make the painting. No lens could see the whole of Vermeer's *The Art of Painting* with everything in focus. No lens could today, no lens ever could; therefore, he had to refocus and put things where he wanted. He had to construct the scene. It's a fantastic painting. Also, I like the title: *The Art of Painting*. It's not called *The Craft of Painting* – I know it was once called *The Artist's Studio* as well – but it is also immensely about the craft.

11 Vermeer and Rembrandt: the Hand, the Lens and the Heart

Right
JAN VAN DER HEYDEN
*View of the Oudezijds
Voorburgwal with the Oude Kerk
in Amsterdam, c.* 1670
Red chalk on paper

Below
JAN VAN DER HEYDEN
*View of the Oudezijds
Voorburgwal with the Oude Kerk
in Amsterdam, c.* 1670
Oil on panel

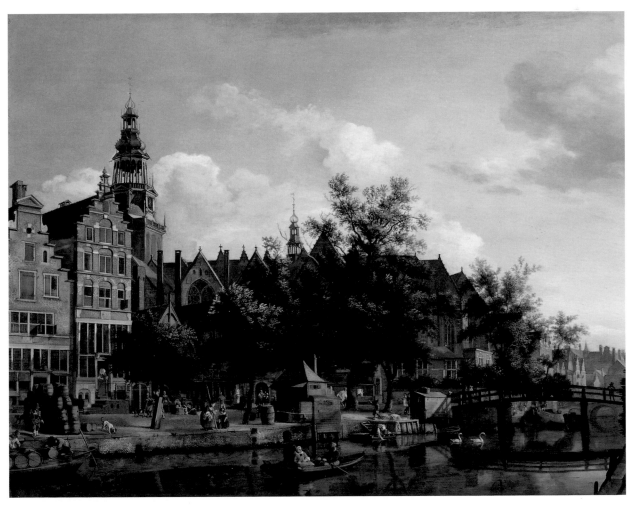

When painting the lovely map on the back wall, Vermeer picks up every little crease, every little fold. The sharpest things in the painting are the map and the chandelier, and they are the furthest away. The human eye would not see those so clearly at that distance, but they are the kind of thing exaggerated by a camera. That map would be a perfect subject for optical projections because it's flat, but not quite flat – and that's why we're interested in looking at it, actually. What's more, I don't think Vermeer could have painted the map freehand with such precision and detail.

Spatially, the two figures relate quite well, although she's a bit small, meaning that if he stood up, he'd be a lot higher than her. Maybe she was small. But what is so amazing is the way the figures fit in space. Your eye looks from the girl's hand on the trombone to the knob of the map, and there is space there. It's done through control and modulation of tones and edges, with unbelievable skill. Finding those equivalents in paint is tremendously hard. The softness between the painter's hair and the map is fantastic. Pieter de Hooch probably used a similar method but he couldn't get those delicate transitions.

The shadow on the painter's legs is still rather light compared to his shoe, but then Vermeer wanted to make a piece of light over there on his right leg to create the sense of space. That's what's so gorgeous to look at when you are standing in front of it.

Kenneth Clark compared Vermeer's *The View of Delft* (*c.* 1660–61) to a 'coloured photograph'. That photographic look would explain why Vermeer's reputation began to rise in the mid-19th century, after the invention of photography. But colour photography couldn't get tones like those as it has to rely on dyes or printing ink. Those aren't like paint, and never will be. You wouldn't be able to get all those blacks with colour photography, or the different blues, which are stunning and subtle in that painting. Also, most importantly, landscape is a spatial thrill, or so it seems to me, and photography – and the camera – can't deal very well with space, just surfaces.

MG Landscape was a subject that was depicted supremely well by Vermeer's great contemporary, Rembrandt van Rijn, without using a camera – or any equipment at all except a pen, paper, ink and a little wash. And he did so very fast, as rapidly perhaps as the clouds could move or the light change.

JOHANNES VERMEER
The Art of Painting, 1666–68
Oil on canvas

11 Vermeer and Rembrandt: the Hand, the Lens and the Heart

DH Kenneth Clark wrote that in Rembrandt's landscape drawings 'the white paper between three strokes of the pen seems to be full of air'. It's true, it does. I also see the speed that they were done at, in the early mornings, usually with a little bit of shadow.

MG Rembrandt could paint other intangible items apart from air and space. He is the supreme painter of the inner life. Rembrandt brings you close to the people in his pictures and to what they are feeling. Where Vermeer's people are reticent and withdrawn, with Rembrandt's you have the impression that you can read their thoughts. Louis Armstrong was once asked who was the better of two trumpeters called Billy and Bobby. He considered the matter, and pronounced, 'Bobby, because he's got more ingredients.'

DH In a way, Vermeer and Rembrandt are opposites. But Rembrandt is the greater artist, I think, because he's got more ingredients than Vermeer. The artists who last are the ones in whose work each generation sees something different – and loves it. Vermeer came into fashion in the 19th century, and is very popular today. Rembrandt has always been admired.

 Vermeer's faces are often not that substantial. *The Milkmaid* (c. 1657) is the best, perhaps because she was a servant. Maybe she couldn't say, 'Oh Jan, I've got a headache, could I lie down and stop posing?' The other sitters were ladies, but a servant takes orders. The clothes can always be put on a mannequin while the painter carries on painting, but the heads can't. Even so, Vermeer's figures can be a little bit weaker than his objects.

 In contrast, Rembrandt put more in the face than anyone else ever has, before or since, because he saw more. And that was not a matter of using a camera. That was to do with his heart. The Chinese say you need three things for paintings: the hand, the eye and the heart. I think that remark is very, very good. Two won't do. A good eye and heart is not enough, neither is a good hand and eye. It applies to every drawing and painting Rembrandt ever made. His work is a great example of the hand, the eye – and the heart. There is incredible empathy in it.

MG As we have seen, Caravaggio had many imitators throughout Europe, not all of whom used optical tools. One of these was the young Rembrandt. He took Caravaggio's optical drama and reconfigured it as a language of mark-making, a way of communicating with the brush that became more powerful as he aged and matured.

DH All the great painters – Rembrandt, Titian, Picasso – got looser as they got older. They knew that economy of means and the inventiveness of the mark are all that is needed. In old age artists like that don't repeat themselves. The late work is the best. There's something else there, something new.

 I met Chagall's granddaughter around 1980. Talking about her grandfather, who was then over 90, she said, 'All he wants to do is sit in the studio and paint.' I thought, Well, of course, what else would you want to do when you've done this all of your life? When you are older you realize that everything else is just nothing compared to this.

MG In an 18th-century volume of biographies of Dutch artists, Arnold Houbraken quotes Rembrandt as saying, 'If I want to relieve my spirit, then I should seek not honour but freedom.' Whether or not he said it, that sounds convincing. Certainly freedom was what he sought in his painterly and graphic techniques, in the most audacious way.

 One of the most modern things about Rembrandt, again according to Houbraken, is that he insisted that the only criterion by which you could judge a painting complete was if the artist thought it was: 'a work is finished when the master has achieved his intention in it.' That could have been said by Picasso or Jackson Pollock.

REMBRANDT VAN RIJN
View of Houtewael near the Sint Anthoniespoort, c. 1650
Reed pen and brown ink with grey-brown wash and touches of white on laid paper

Rembrandt's oil paintings were unconventional, in that he used extremely thick paint, loose and free brushstokes, scratched with the handle of his brush, and slathered on pigment with his palette knife. But he was not just unorthodox, he was unorthodox in a different way almost every time he painted a fresh picture. He was able to transform paint-marks – however thick and gnarled or loose and wild – into the equivalents of things. As Vincent van Gogh once put it, Rembrandt was a 'magician'. Talking of *The Jewish Bride*, Van Gogh – characteristically – went over the top: 'I should be happy to give ten years of my life', he exclaimed, 'if I could go on sitting here in front of this picture for a fortnight, with only a crust of dry bread for food.' It was not only a supreme evocation of textures and materials, but also of emotions. It is, as Van Gogh intuited, a picture about intimacy, about love. Nor was human greatness, or spiritual grandeur as Lucian Freud said, the only quality Rembrandt could show us. He could depict squalor, pathos and tragedy, too: the worst as well as the best.

REMBRANDT VAN RIJN
The Jewish Bride, *c.* 1665–69
Oil on canvas

11 Vermeer and Rembrandt: the Hand, the Lens and the Heart

REMBRANDT VAN RIJN
The Blinding of Samson, 1636
Oil on canvas

DH When terrorists blew up the big Federal Building in Oklahoma City in 1995, I saw on television how CNN weren't allowed inside. So they got hold of a person who'd come out and he said, 'It's not like television in there, it's terrible!' and walked off. I thought, That's a very good thing to say, because television couldn't show you how appalling it was. The pictures would be too attractive. That's what he was saying. Television can't show you this horror.

What can? Not much, perhaps written descriptions. But a picture that conveys a unique degree of awfulness is Rembrandt's *Blinding of Samson*. One of the reasons is that you are looking at it with your eyes and you are seeing the eye being taken out, so you are horrified by it, or I am. It's a fantastically powerful thing. It's about looking, and the Philistines are robbing him of his eyes – taking away the power of looking.

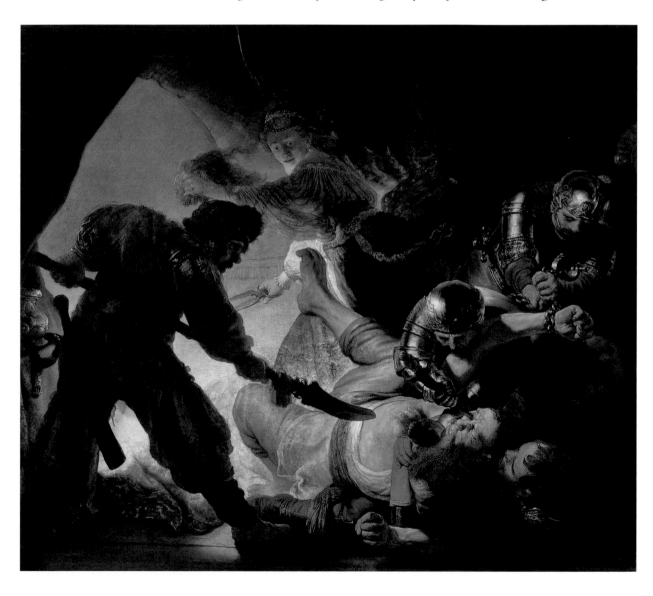

Reality and truth are always dubious concepts.

DH The *Camera Obscura* by Charles Amédée Philippe van Loo is an amazing, interesting picture: the little girl is coming out of the frame; the two children are looking into the lens, but the woman is gazing out at us. Is that the lens that van Loo was looking at them through? It probably was. The painter is making a comment about reality and the camera.

MG This painting is one of the few pictures from the 18th century to depict what was by then a common piece of equipment. It is a useful reminder of an important fact: the camera existed for centuries before the invention of photography in the early 19th century. Van Loo's painting depicts much the same device William Henry Fox Talbot, the pioneer photographer, was using more than eighty years later.

Around 1800 the Dutch artist Christiaan Andriessen made a sketch of a camera in use. The figure – presumably a self-portrait – is not employing his optical aid to draw, but simply looking through it. At the start of the 19th century the camera-view was taking over from reality itself; indeed, it had been doing so for many years.

John Locke's *An Essay Concerning Human Understanding* (1690) was one of the fundamental texts of 18th-century thought in the Anglo-Saxon world. In it Locke made a remarkable comparison between 'ideas' – which were, according to his theory, the building blocks of thought – and the images seen in a camera obscura, or, as Locke puts it in English, a dark room:

> Would the pictures coming into such a dark room but stay there, and lie so orderly as to be found upon occasion, it would very much resemble the understanding of a man, in reference to all objects of sight, and the ideas of them.

CHARLES AMÉDÉE PHILIPPE
VAN LOO
The Camera Obscura, 1764
Oil on canvas

Above
WILLIAM HENRY FOX TALBOT
William Henry Fox Talbot (right) with
assistants at their calotype production
facility in Baker Street, Reading,
Berkshire, 1846
Calotype

Right
CHRISTIAAN ANDRIESSEN
Artist with a Camera Obscura, 1806
Pen, ink and wash

Locke's leap of imagination – camera images that persist rather than disappearing, and that can be retrieved (which 'stay there, and lie so orderly as to be found upon occasion') – is, of course, an anticipation of photography. That is exactly what photographs are: camera obscura images that last and can be ordered into a visual archive.

According to Locke's philosophy, the mind is stocked with 'ideas' that are very like photographs: 'external visible resemblances'. The camera image thus provides the index of reality and, in fact, the only way we have of knowing about the world around us. We learn about the world by looking at pictures – pictures of a certain sort: optically projected ones. These provide 'ideas of things without'. In other words, they depict reality.

The camera image was thus frequently regarded by Locke and others as, simply, the truth. A Venetian aristocrat, Count Francesco Algarotti, declared as much in his internationally successful *Essay on Painting*, which was translated into English in 1764. This artificial eye, he wrote, presents to the artist 'a picture of inexpressible force and brightness; and, as nothing is more delightful to behold, so nothing can be more useful to study, than such a picture'. Painters, he went on, should 'make the same use of the Camera Obscura, which Naturalists and Astronomers make of the microscope and telescope', and the best of them already were.

DH In just the same way, people today have been led to believe that the photograph is reality. But it's always questionable. There are an awful lot of people who have stopped thinking about pictures, who just accept the photograph as the ultimate visual veracity. This is it! It isn't 'it' at all. Reality and truth are always dubious concepts.

MG By the early 18th century people were familiar with the sight of camera images. Willem Jacob 's Gravesande in his *Essai de perspective* (1711) simply took it for granted that 'Everyone knows how easy it is by one convex glass only, to represent Outward objects in any darken'd place, according to their natural Appearences.'

In 1712, Joseph Addison visited the camera at Greenwich, and wrote an enthusiastic editorial in the *Spectator* as a result: 'The prettiest Landskip I ever saw, was one drawn on the walls of a dark Room ... Here you might discover the Waves and Fluctuations of the Water in strong and proper Colours, with the Picture of a Ship entering at one end, and sailing by Degrees through the whole Piece.' The poet Alexander Pope

A. J. DEFEHRT after LOUIS-JACQUES GOUSSIER
Dessein: Chambre obscure, Plates IV and V, Plates vol. 3, 1763, from the *Encyclopédie*, 1751–72, edited by Denis Diderot
Engraving

described a camera obscura effect in the grotto he made in his garden in Twickenham in 1719: 'a luminous Room, a Camera Obscura, on the walls of which all the objects of the River, Hills, Woods, and Boats, are forming a moving Picture'.

An entry on the *Chambre obscure, ou Chambre close* (vol. 3, 1753), in the great *Encyclopédie* (1751–72) edited by Denis Diderot, described how this produced the highly amusing spectacle of images perfectly resembling objects in all their colours and movements, and added that it would enable someone who does not know how to draw to imitate the appearance of things with great exactitude, and even someone who does know how to paint could use it to perfect their art. Two accompanying plates illustrated a range of cameras, including walk-in room-sized models, and a desk-sized version with a hood under which the artist could work.

DH I set up a camera obscura in a few places around Bridlington, and made fantastic images in colour. Everyone who saw them thought they were stunning, especially because there was no electricity involved. But when

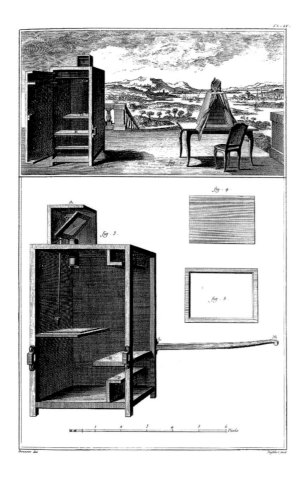
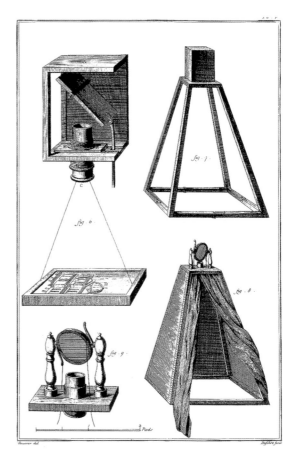

you look through a camera obscura everything is *over there*; you are cut off from what you are seeing, sitting in a black tent. In other words, the camera does not see as we do.

In looking at Canaletto's *Piazza San Marco* we are fixed in one position. Perhaps we can turn our head from left to right, but we cannot look under the arches at either side. In a sense we are outside this space, not in it. And as anyone taking photographs knows, in the lens-view of buildings perspective rushes, perpendicular lines tilt, and everything seems much further away than it does to the eye. The optical projection of nature, which is what a camera does, pushes you away.

MG These problems were noted in the age of the Enlightenment. Algarotti mentioned that 'the best modern painters among the Italians have availed themselves greatly of this contrivance; nor is it possible they should have otherwise represented things so much to the life'.

The Italian school of *vedute*, or topographical, painting was founded by a Dutchman from the generation after Vermeer and Van der Heyden: Gaspar van Wittel. He was born in Amersfoort, near Utrecht, in 1652 or 1653, but moved to Italy in the mid-1670s where he became known as Vanvitelli. To draw an urban view, he probably used a portable camera

CANALETTO
Piazza San Marco, late 1720s
Oil on canvas

of the kind first described and illustrated in print by the German author Johann Zahn in his book *Oculus artificialis*, or the *Artificial Eye* (1685). There is a caricature of a Venetian topographical painter, Michele Marieschi (1696–1743), with just such a camera as a sort of humorous prop in the background.

Vanvitelli's drawings were executed over a grid of lines, which suggests he had a similar grid on his screen so that he could locate precisely the position of every architectural feature. It would also have given him the opportunity to make adjustments, such as making important monuments look larger than they did to the camera (which is how we actually see them). Thus Vanvitelli had found a method that allowed him to use a camera, but simultaneously manipulate its image: a hand-draw version of Photoshop.

Similarly, Antonio Zanetti the Younger, writing in a work published in 1768, three years after the artist's death, praised Canaletto for avoiding the errors of the lens-eye view. He taught by example 'the correct way of using the *camera ottica* [camera obscura]; and how to understand the errors that occur in the picture when the artist follows too closely the lines of the perspective'. Such mistakes occurred, Zanetti explained, where 'scientific accuracy offends against common sense'.

ANTONIO ZANETTI
THE ELDER
Caricature of Michele Marieschi,
c. 1740–41
Pen and ink with pencil
on paper

The rushing perspective we saw in the Canaletto can also be seen in a 19th-century photograph and a painting by Canaletto's contemporary, Francesco Guardi. According to a note in the diary of Pietro Gradenigo for 24 April 1764, it was precisely for help with the perspective that Guardi turned to his camera. He was 'well able through his use of the Camera Ottica to paint two canvases not of small dimensions, commissioned by an English foreigner'. One of these showed a view of 'Piazza S. Marco towards the church'. For him, as for many painters, it was a rapid and accurate way of noting down the lines of an urban landscape. Pages from a sketchbook by Canaletto clearly reveal the 'traced' line that is a strong indication of a camera drawing, as we have seen before.

DH That doesn't mean Canaletto was 'cheating' or that it is a bad drawing. I was appalled when people said after *Secret Knowledge* was published, 'Well, suggesting famous artists used the camera obscura or camera lucida is saying they just traced their images – and that's easy'. That's a bit childish. Those arguments seemed dumb about drawing itself.

MG Canaletto subjected his initial, camera-based visual data to tremendous feats of mental and imaginative adjustment. The position from which we seem to be viewing *Venice: The Feast Day of Saint Roch* is, in fact, impossible: actually it is inside the chancel of the Frari church. It seems likely that Canaletto was combining the observations he made through his camera with another set of skills he had gained from his initial training in theatrical design. His art is a mix of the two: the highly naturalistic camera 'look' fused with the illusionistic skill of baroque Italian theatrical scenery.

Artists of the 18th century were clearly familiar with the problems of using a camera, and the best of them found ways to use this tool without becoming its slave. There was, however, a tension between the idea that the camera image simply was the truth, and the feeling that painting offered a way of depicting the world that was richer, and in an imaginative and emotional way, truer.

Charles-Antoine Jombert, an 18th-century Parisian bookseller, wrestled with this problem. He was the author of a history of Flemish, Dutch and German painting and also of a treatise on drawing. Many northern artists had used a camera, he noted, as it was a useful way to study 'the way in which it presents nature' and especially light and shade.

Opposite above
Piazza San Marco, c. 1885
Albumen print

Opposite below
FRANCESCO GUARDI
Venice: Piazza San Marco,
after 1780
Oil on canvas

Right
CANALETTO
*Views of the Campo San
Giovanni e Paolo in Venice,*
c. 1740
Pen and brown ink
on cream paper

Below
CANALETTO
*Venice: The Feast Day of
Saint Roch, c.* 1735
Oil on canvas

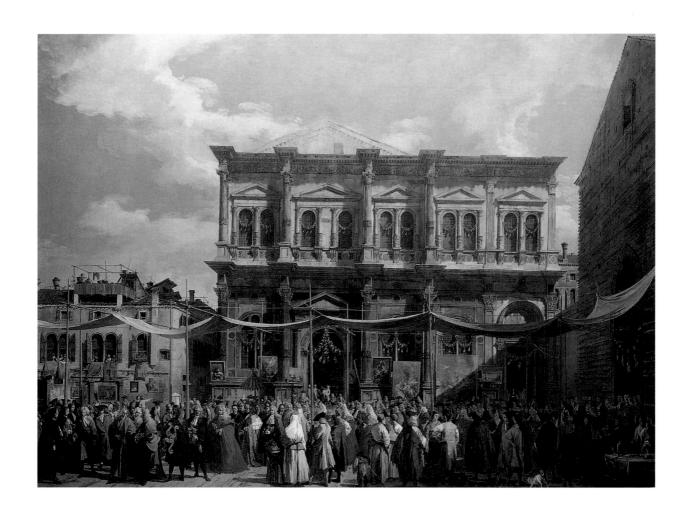

But an artist should not imitate the image he saw in a camera too closely: 'The effect is indeed heightened but it is false.' The shadows were too dark, the colours too intense.

According to an early biographer of Jean-Siméon Chardin, when he set out to paint his first still life, of game, he told himself that in order to reproduce the dead rabbits he must forget everything he had ever seen, including the way others had painted such things. To achieve this, he had to avoid slavish imitation of surface details like the animals' fur, which would make his picture 'dry and cold'. Instead, he should try to capture the 'general mass', and the 'colours, contours' and 'effects of light and shade'. The camera is not mentioned, but the whole discussion is very close to the way his contemporaries such as Jombert wrote about optical aids: what one saw in them was truthful to some degree, but the painter should avoid copying the manner in which they distorted the way we see 'naturally'.

DH Chardin was very secretive about his methods of working. But I think he used a camera obscura. For example, his paintings of sculpture, such as *Still Life with the Attributes of the Arts*, had to be done from optical observation. Otherwise you wouldn't get shadows like that. But he still painted better than other people using the same tool. As I've pointed out, Vermeer's figures can be ghostly – not quite there – but Chardin's are absolutely *there*. That's partly to do with the way he got his surface. Chardin must have put on the paint then *patted* it with the top of his brush.

MG How truthful was the image made by a lens? The point was controversial. When describing the utterly candid approach he intended to take in his *Confessions* (1769), Jean-Jacques Rousseau used the metaphor of drawing in a camera obscura as a way of emphasizing his truthfulness. 'This is my portrait, not a book. I shall be working, as it were, in a camera obscura. No art is needed beyond that of tracing exactly the features I see there.' Rousseau took it for granted that a painted portrait might contain elements of dishonesty – flattery of the sitter, for example. But one traced in a camera would be not more or less than the truth.

Conversely, Joshua Reynolds wrote: 'If we suppose a view of nature represented with all the truth of the camera obscura, and the same scene represented by a great artist, how little and mean will the one appear in comparison of the other.' In other words, he felt this truthful image of reality was, in a sense, untrue. On the other hand, like other 18th-century artists who criticized the camera in print, he owned, and used, one himself.

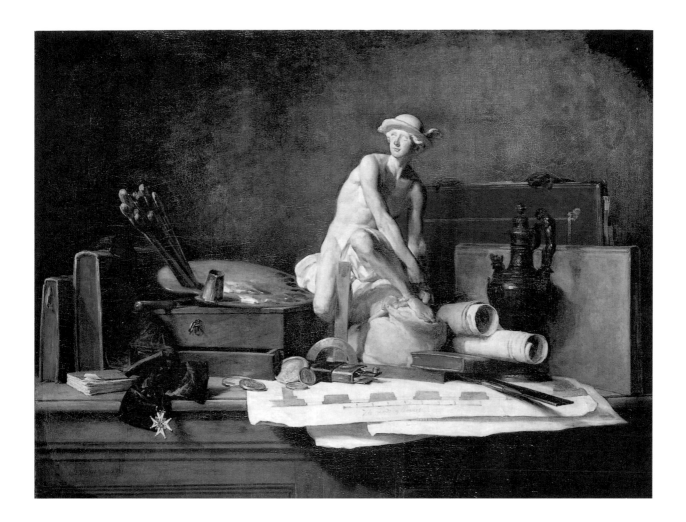

JEAN-SIMÉON CHARDIN
*Still Life with the Attributes
of the Arts*, 1766
Oil on canvas

DH I suspect Reynolds drew faces with his camera. Probably he'd just do points – the eyes, nose and mouth – quickly. Reynolds's sitters would have sat for quite a bit of time, but not for many hours on end. So it would have been helpful to get a kind of likeness down rapidly, and the quick way to do that is with a camera.

MG According to the gossip and novelist Horace Walpole, in 1777 Reynolds and his successor as President of the Royal Academy, Benjamin West, both owned a camera-based drawing aid known as the 'Delineator', invented by William Storer. An optician from Norfolk, Storer devised a camera in which the light was intensified by a concave mirror, thus meaning that it could be used in daylight – and even, he claimed, by candlelight. 'Reynolds and West', Walpole wrote, 'are gone mad with it, and it will be their faults if they do not excel Rubens in light and shade, and all the Flemish masters in truth.' West not only made camera drawings himself, according to a letter written between painter

223

acquaintances in 1802, but also 'would recommend the camera to any artist, whether portrait, history or landscape'.

DH It's amazing how much was written about optics in the 18th century, when you start to look for it. But that's always true: you have to have an idea of what you are looking for. Otherwise you won't find anything. It's the case, too, of paintings that were made by using cameras. You need to know what you are looking for; then you begin to discover the evidence.

The history of painting and photography in the 18th and early 19th centuries has yet to be explored. Early photographs correspond a great deal with paintings that were done in the period just before photography. Pioneer photographers and artists working with optical devices were using similar equipment under comparable conditions. There are a lot of overlaps to be found between the two.

MG West went so far in his enthusiasm for the camera as to claim to have independently invented the device himself as a teenager, when a chink in his window shutter projected a moving picture of a cow onto his bedroom ceiling. His fellow countryman John Singleton Copley (1738–1815) seems to have shared an American forthrightness about using this gadget. In a series of letters from Paris dating from 1774–75, he extolled the use of the camera to his half brother.

This was of great value, he wrote, to one such as himself who had not been clearly informed about the camera in his native land, and thus had 'not had an opportunity of knowing the manner the great Masters have pursued their Goddess with success'. Copley clearly assumed that many old masters had used the device, and that European artists knew about it. He thought it especially useful for studying light and shade. Copley's self-portrait from 1780–84 – apparently not seen in a mirror, since his eyes are averted – has just the bluish and reddish tints he describes seeing in the shadows of a projected image. 'I wish I could convey to you a more perfect Idea of what I see, but' he advised, 'study the Camera for human figures and in short every Piece of Nature.'

Not surprisingly, given that a leader of the profession such as Benjamin West was advocating the use of the camera for 'portrait, history or landscape', it seems many British painters in the later 18th century were using optical tools. Among those whose drawings and painting show telltale signs are Joseph Wright of Derby and

JOHN SINGLETON COPLEY
Self-Portrait, 1780–84
Oil on canvas

J. M. W. Turner. Another was Thomas Jones (1742–1803). The drawings Jones did during the years of his stay in Italy between 1776 and 1782 have a line much like that in Thomas Sandby's study of Windsor Castle 'drawn in a camera'. Evidently Jones had one with him on his Italian journey. It looks very much as if he looked through it to make the little oil sketches on paper, such as *A Wall in Naples*, for which he is now best known.

DH When I saw the 'Thomas Jones in Italy' exhibition (2003–04) at the National Gallery in London I knew the oil sketches were camera pictures. Nobody's ever said that, but it's incredibly obvious, partly because of the paintings' dullness.

MG In Spain, too, the device was known. Francisco Goya's close friend Ceán Bermúdez wrote about it, speculating that Velázquez might have employed one to observe 'the gradual decrease of light and shade at a distance and the sharper contrast in the foreground'. Goya's own early portrait of *María Teresa de Vallabriga y Rozas* itself has an 'optical' look in the sharp precision of her features and close attention

monte Dragone from y.e Falconeri Gardens al Frescati 28 April 1777

to the textures of hair and fur; it was based on a quick graphite sketch, detailing especially the area around her eyes. Goya's early portraits, like this one, were noted to have been painted with great rapidity, in one hour or two, in which case 'fast-forwarding' with a camera would have been a handy aid. Many artists would have found the same, although up to now the phenomenon has not been properly analysed.

DH I've spent a lot of time looking at Christen Købke's paintings. I think there is a lot of camera work in them. It doesn't diminish his work; he has a lovely touch with the pencil and the brush. In *Portrait of a Young Man* look at the way everything is accurately defined immediately. But what would people have thought of Købke's pictures before photography existed? You couldn't call them 'photographic'. How would you describe an optical projection without using the word 'photograph'? So, in fact, before the photograph existed, how could you describe it?

13 The Camera Before and After 1839

Photography is the child of painting.

DH The date 1839 is not a big one in conventional art history; in fact, I've seen chronologies of art in which it is not even mentioned. It seems the history of art is all very comfortable until the invention of photography. Then it becomes rather uncomfortable because nobody knows what the photograph really is. But photography can't be isolated from the history of painting. The normal view of photography is that it was an immaculate conception: it came from nowhere. The truth is that photography is the child of painting.

When you look, you find there's a terrific overlap in art and photography from around 1780 to 1850, the period that covers the birth of photography. It's very visible. That's how it was moving along. Paintings in that period began to look like early photographs: same lighting, same subjects.

Relief sculpture was a terrific subject both for painting and for photography. Using a camera with reliefs you could give the illusion of the image being real, especially if you viewed it from not too far away. You find sculptures and reliefs frequently in paintings in the late 18th and early 19th centuries, which were probably made using cameras, and you also come across them in early photographs. Sculpture was good because they could light it very well, getting the shadows in just the right places. Look, for example, at the *trompe-l'œil* painting by Anne Vallayer-Coster (1744–1818) of a bas-relief. It's very, very real. Then compare the photograph by Hippolyte Bayard from 1853 of a similar object. If you photograph something that's about an inch deep, the illusion is very strong on a flat surface. The pictures look very similar because the people who made them are using the same piece of equipment.

ANNE VALLAYER-COSTER
Spring: A trompe-l'œil of a bas-relief within a frame, 1776
Oil on canvas

HIPPOLYTE BAYARD
Terre cuite de Clodion, dite la fête à Pan, 1853
Salted paper print from glass negative

MG Thomas Wedgwood (1771–1805) is the first person known to have attempted to make what came to be called a 'photograph'. The third son of the pottery manufacturer, Josiah Wedgwood, Thomas – or Tom – was a scientific prodigy. He grew up in the circle of the Lunar Society of Birmingham, a group of extraordinary talents that included James Watt, the improver of the steam engine, Joseph Priestley, the discoverer of oxygen, and Erasmus Darwin, the scientific poet.

Erasmus Darwin, a close friend of Wedgwood's father and a mentor to young Tom, presented *The Botanic Garden*, a bestselling poem of the 1790s, in terms of a camera image. In fact, his introduction makes it sound like a film, projected onto a cloth like an oil painting: 'GENTLE READER! Lo, here a CAMERA OBSCURA is presented to thy view, in which are lights and shades dancing on a whited canvas, and magnified into apparent life!'

At some point, Wedgwood conceived an ambition to find a way of fixing the pictures that could be seen in the camera. He made a series of attempts to capture images using 'white paper, or white leather, moistened with a solution of nitrate of silver'. This phenomenon was the basis of photography, in principle: a light-sensitive chemical such as silver nitrate retained the pattern of light that fell upon it.

Wedgwood's experiments, however, were a failure. His efforts to fix a camera obscura image produced nothing. Nonetheless, he did succeed in making images of small objects that were in direct contact with the paper. They would have looked much like those made several decades later by William Henry Fox Talbot, except that even these images of Wedgwood's faded on exposure to daylight.

The earliest surviving photographic image of the world was made by Joseph Nicéphore Niépce (1765–1833). It dates from *c*. 1826, although it seems Niépce had made photographic negatives as early as 1816, but – like Tom Wedgwood twenty years before – he was unable to fix them. This first photograph is strikingly close to the views that, as we have seen, the British artist Thomas Jones painted in Naples in the early 1780s – probably also pointing his camera obscura out of a window.

DH Niépce's first photograph was of his henhouse roof; Jones's paintings were also of what could be seen from the window of his apartment. Of course, early photographs correspond a great deal with paintings that were done in the period just before photography, because they were made with the same tool.

13 The Camera Before and After 1839

WILLIAM HENRY FOX TALBOT
Buckler Fern, 1839
Photogenic drawing negative

THOMAS JONES
Rooftops in Naples, 1782
Oil on paper

JOSEPH NICÉPHORE NIÉPCE
View from the Window at Le Gras, c. 1826
(enhanced version printed *c.* 1952)

You have to link photography with the past. If you believe that the photograph was something totally new, which is what the orthodox history claims, then it looks modern. But it wasn't really like that.

MG In the decades leading up to 1839 more improvements and variations on the filmless, pre-photographic camera appeared. A painter named Cornelius Varley devised a gadget that he dubbed 'the graphic telescope'. It could project an enlarged image of a distant object onto a sheet of paper. He used it to make a drawing, which – it has been proposed – captured a ruggedly handsome, early middle-aged J. M. W. Turner.

In 1807, the distinguished scientist William Hyde Wollaston (1766–1828) patented a much more successful rival to the camera obscura, which he called the 'camera lucida'. A chemist and physicist who also took an interest in optics, Wollaston had noticed a double reflection one morning while shaving and looking at himself in a cracked mirror. This gave him the idea for the device, which he described as 'an instrument whereby any person may draw in perspective'.

It consisted of a prism mounted on a brass rod so its angle was adjustable. By carefully positioning the eye and the prism, it was possible to see the reflection of the subject superimposed on the drawing paper. The camera lucida, like the camera obscura, allowed the image to be traced, but in the light, not the dark. Wollaston was interested in methods of drawing because making images of objects and phenomena was a crucial aspect of science.

Camera lucida in use,
Scientific American,
January 11, 1879
Engraving

234

The name he gave the apparatus literally means 'light chamber', as opposed to the dark room of the camera obscura. But the camera lucida requires no room at all, dark or illuminated. What Wollaston meant was that this was 'a camera that can be used in the light'. In other words, 'camera' had already taken on its modern meaning: a device for making pictures.

A young protégé of Wollaston's was John – later Sir John – Herschel (1792–1871), the only child of the great astronomer Sir William Herschel, who took up the camera lucida after visiting Wollaston in 1816, and eventually came to produce one of the largest bodies of drawings known to have been made with this tool (he later used an improved version invented by Giovanni Battista Amici). Herschel signed and dated his sketches, adding 'del Cam. Luc.' (delineated by camera lucida).

DH There was an exhibition called, 'Before Photography' put on by the Museum of Modern Art, New York, in 1981. It insinuated that just before 1839 there were various painters painting, and, my God, their pictures looked just like photographs. Then the photograph came along and confirmed their vision.

Well, that's not what happened at all. Their vision was coming out of the camera. But if you don't know that, it looks as if the artists got their pictures right, and the photograph came along and proved it. All this is not in history books. But the visual evidence demolishes what I've called the immaculate-conception theory of photography: that it came from nowhere and was inherently modern. The spirit of photography is much older than the photograph itself.

MG As had been true since the Renaissance, professional artists tended to be more reticent about the use of visual tools. A long correspondence in the *Mechanics' Magazine* between 1829 and 1830 included, among many comments on the camera lucida, the claim that it was 'used by most of them very privately'. One who was not secretive on the subject was Sir Francis Chantrey RA (1781–1841), the leading British sculptor of the late Georgian period and a specialist in portrait busts and statues.

He habitually used a camera for his preliminary studies of his subjects. These were the basis for a clay model, made under his supervision, which was then carved in marble by assistants. Chantrey, in fact, was practising camera-based portrait sculpture using quasi-industrial production techniques. His methods sound strikingly similar to those used by early portrait photographers a few decades later, especially his use of a clamp to prevent the sitter moving. According to an eyewitness, he fixed the sitter's head 'in a wooden machine to keep him perfectly still, then drew with a Camera Lucida the profile and full face the size of life'.

Chantrey's line has the characteristic qualities of a camera drawing, combined with a sculptor's interest in noting forms – the curls of the hair, the convolutions of the ear – in a way that can easily be transferred to three dimensions. They are works of art, revealing a personal style. A connoisseur could attribute them without much trouble to Chantrey.

A contributor to the *Athenaeum* in 1830 argued that drawing with a camera required skill. 'Such means are like the railings on the road: they may keep the active traveller on the right course, but they cannot make the lame walk. Let not anyone imagine that he can learn to draw, merely by purchasing a Camera Lucida, he might as soon learn music, by merely buying a fiddle.'

The sheer difficulty of using optical tools was indeed one of the spurs that led William Henry Fox Talbot – one of the pioneers of photography – to attempt to fix a camera-obscura image using chemicals rather than his own hand. He complained that as a drawing aid the camera was 'in

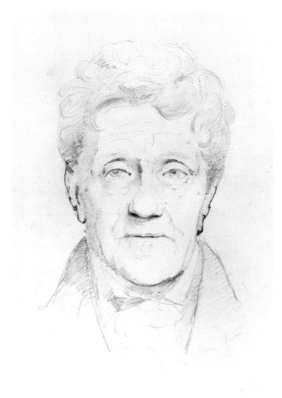

SIR FRANCIS LEGGATT
CHANTREY
Sir John Soane, c. 1827
Pencil on paper

practice somewhat difficult to manage because the pressure of the hand and pencil on the paper tends to shake and displace the instrument'. But there was a deeper difficulty. Talbot had no aptitude for drawing.

Talbot became determined to find a technical solution to the problem of making pictures, it seems, when sketching on Lake Como in October 1833. He lamented that his 'faithless pencil had left only traces on the paper melancholy to behold'. His efforts were inferior not only to those of a professional artist such as Chantrey, but also to those of more gifted amateurs such as John Herschel, and his own wife and sister (who were also sketching with Talbot on Lake Como). The historian of photography Larry Schaaf suggested that the urge to invent photography might have come to him while he was making a painfully poor camera drawing of the Villa Melzi on 5 October.

DH I know the Villa Melzi, and I know that view. It really is a feeble drawing. Talbot couldn't draw at all; Herschel would have drawn it much better.

MG After that, Talbot experimented with methods for fixing camera-obscura images for several years. He was not the first to try, as we have seen.

DH His discovery, really, was the chemicals. That was what the invention of photography was: they found a way to make the picture permanent. Talbot asked John Herschel how to fix the projected images he had got on paper, and Herschel gave him the formula for fixative to stabilize them, which was manufactured by Kodak until about two years ago.

MG Talbot had made some progress by 1839, when he was shocked by the news from Paris that a Frenchman, Louis Daguerre, had developed a rival, and quite different, way of making permanent camera pictures. Daguerre's process involved first coating copper plates with iodized silver. These were then exposed in a camera, next developed with mercury vapour, and finally fixed – or made permanent – with hyposulphite of soda. The outcome was a small, unique image that was beautifully precise, like the view of the Boulevard du Temple in Paris, taken at eight in the morning one day in 1838.

Earlier, we described how Herschel was stunned when he saw the first daguerreotypes. 'It is hardly saying too much', he enthused to Talbot, 'to call them miraculous.' Talbot had already produced photographic images – or, as he called them, 'photogenic drawings' – but these were printed on paper from a translucent paper negative and were far less sharply detailed than the daguerreotypes. His first success, an image not much larger than a smartphone screen, represented the oriel window at his country house, Lacock Abbey, in which the sunlight flooding in darkened the paper brushed with silver nitrate.

13 The Camera Before and After 1839

Above
LOUIS DAGUERRE
Boulevard du Temple, 1838
Daguerreotype

Right
WILLIAM HENRY FOX TALBOT
The Oriel Window, South Gallery,
Lacock Abbey, 1835
Photogenic drawing negative

It dates from as early as August 1835, when Talbot noted, 'if the paper is transparent, the first [photogenic] drawing may serve as an object, to produce a second drawing, in which the lights and shadows would be reversed'. Therefore, whereas each daguerreotype was as unique as a painting, Talbot's images could be reproduced, like an engraving, an indefinite number of times.

DH That made a big difference. With the invention of a system of reproduction, photography became a mass medium. The daguerreotype was just a one-off thing.

MG Some of the very earliest photographs are also among the best ones: as good as any that have been taken since. Talbot, who could not draw, turned out to be a photographer of great sensitivity. In 1840, he developed an improved system – allowing for much briefer exposures – that he dubbed the 'calotype', from the Greek word for 'beauty', *kalos*.

These were indeed beautiful, with deep Rembrandt-like shadows. Many of the finest early calotypes, however, were made not by Talbot himself, but by a professional though undistinguished painter, David Octavius Hill, working, as we have seen, in Edinburgh, in collaboration with a young chemist, Robert Adamson.

Hill and Adamson were the prototype for the division of roles in cinema between the director and cameraman; they also foreshadowed later partnerships between painters and photographic technicians. Yet there is a mystery about their collaboration. After Adamson's early death in 1848 Hill worked with other photographers, but never again made such remarkable pictures. Perhaps Hill/Adamson were a little like the partnerships in contemporary art, such as Gilbert & George.

In the 1840s, at least in Edinburgh, there was no sharp division between painting and photography. Hill was happy to exhibit the calotypes as 'preliminary studies and sketches' for a painting. John Harden, a watercolourist, on seeing them in 1843, wrote that, 'The pictures produced are as Rembrandt's but improved so like his style & the oldest & finest masters that doubtless a great progress in Portrait painting & effect must be the consequence.' William Etty RA seems to have agreed, since he translated the Hill/Adamson portrait of him from 1844 into a self-portrait painted in a Rembrandt-like idiom of impasto and rich shadow. Etty was by no means the only painter who began to use photography almost as soon as it was developed.

Below left
DAVID OCTAVIUS HILL and
ROBERT ADAMSON
William Etty, 1844
Calotype

Below right
WILLIAM ETTY
Self-Portrait, 1844
Oil on millboard

DH Many painters would have regarded photographs as something to follow, in the same way as earlier artists would have seen the optical projection of nature by the camera obscura as something to aim at. It would have been the most realistic-looking picture they would've seen. They would have registered all the little differences in tonality that the photograph revealed, and they would have noticed you see in a photograph more clearly than you do in ordinary vision. It's done some editing for you.

MG We can watch the transition from before 1839 into the brave new world of photography in the work of a long-lived artist such as Jean-Auguste-Dominique Ingres (1780–1867). Several of Ingres's landscape drawings from shortly after 1800 were clearly drawn with a camera. His sketch of the Villa Medici from 1807 is a case in point, with its telltale, traced lines. While he worked on it perhaps he was looking at an image somewhat like the daguerreotype of the Boulevard du Temple.

DH It's a very good drawing, no matter what tool he used. I believe, a year or two later, when the camera lucida came along, he used that for his portraits on paper (which I wrote about in *Secret Knowledge*). Of course,

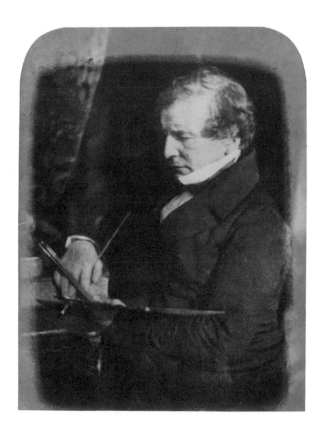

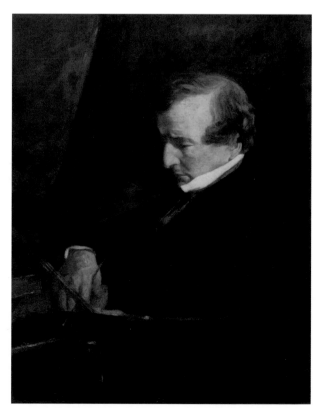

241

Ingres would have taken advantage of anything that was useful. If you think about it, what he was doing was making portraits and selling them immediately to people. He was just earning money, and probably getting paid rather well for them.

Naturally, he would have employed anything that helped. Lots of camera-lucida drawings were very, very dull; Ingres's were the best of all, I think. That was because of the quality of his drawing, not the camera lucida. Nonetheless, the camera was useful for getting the likeness. In the same way, he would have found a camera obscura handy for getting the lines of the architecture right.

MG After a long spell in Italy, Ingres returned to Paris in the spring of 1841. Soon after that he would have encountered the daguerreotype, which had been invented by then. By the next year he was already sufficiently familiar with photography to fit it into his studio procedure. He had some daguerreotypes taken of a picture that he had just finished, before showing it in public.

JEAN-AUGUSTE-
DOMINIQUE INGRES
View of the Villa Medici, Rome,
1807
Pencil on white wove paper

DH He had already caught on that it was very good at photographing pictures. That's its only true documentary role, otherwise it's just a point

13 The Camera Before and After 1839

of view. If you are photographing a flat surface there's no question of choosing an angle of vision, it's a copy. Actually, it's that which made art history, isn't it? Before photography, you had engravings and so on, but it was photography that really made it possible to compare and compile numerous pictures from different places. That's what art history is.

MG One beautiful painting by Ingres, a nude for which his first wife had posed and that was apparently destroyed to please the second Madame Ingres, now exists only in the form of a photograph of it on an easel in his studio (with one of his portraits of Madame Moitessier in the background).

DH I'm sure Ingres must have been looking closely at the daguerreotype. Anyone who made pictures would have been interested in it, because the daguerreotype was something new and quite incredible. As we've seen, Ingres already knew the camera as a tool for drawing, but this took the hand out of the camera.

DÉSIRÉ-FRANÇOIS MILLET
View of the interior of Ingres'
studio, with the lost painting
of Madame Ingres, c. 1852
Daguerreotype

MG A historian of photography, Aaron Scharf, noticed that after 1840 Ingres's pictures of people started to have the 'metallic' colours of a tinted daguerreotype, together with 'the fine precision with which this type of photograph described textured surfaces'. To be influenced in this way, of course, he would not have needed to copy photographic images, merely look at them. Until the final decade of Ingres's life, however, there is no absolutely conclusive evidence of his using a photograph as the basis of a painting. Then, however, he unquestionably did make two self-portraits in exactly that way: in 1858 and 1864–65.

DH But the forehead in those late self-portraits isn't as good as the forehead of Monsieur Bertin done in 1832, seven years before the daguerreotype appeared. *Monsieur Bertin* is a magnificent portrait, one of the best ever painted of anyone. Obviously Ingres was really observing there. And the forehead has a lot more subtlety in it. His paintings were better when they were not based so closely on photography. Nonetheless, Ingres would have come to believe that the optical projection of nature in photographs was the truth. Anybody would have believed that in those days. Even today, most people believe that.

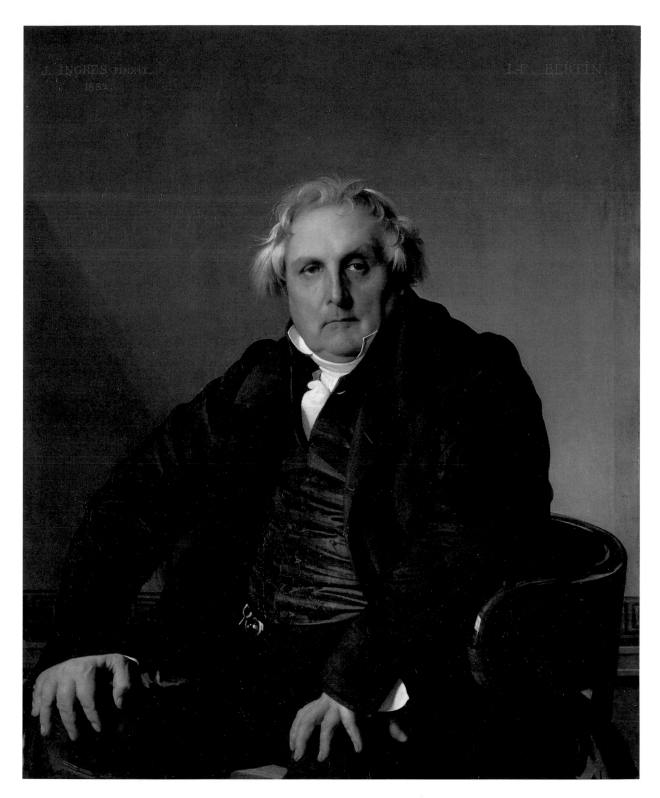

JEAN-AUGUSTE-DOMINIQUE
INGRES
Louis-François Bertin, 1832
Oil on canvas

14 Photography, Truth and Painting

You ask yourself, what is reality?

DH I've always been fascinated by the photograph and by the question: what is it? Everybody who uses the camera has doubts about it. You ask yourself, what is reality? What is it you are getting in the picture? Reality is a slippery concept; as I've said before, it is not separate from us. But that is what the photograph does: it separates us from the world.

MG Eighteenth-century artists such as Joshua Reynolds warned sternly against the use of the camera obscura by artists, while employing it themselves. But this discrepancy between private techniques and public declarations was not confined to the 18th century. It continued after the appearance of photography in 1839, in much the same way. The behaviour of the Belgian Symbolist Fernand Khnopff (1858–1921) resembles that of Reynolds and de Valenciennes a century later. The art historian Dominique de Font-Réaulx has described how, throughout his life, Khnopff 'did his best to hush up his use of photography; in 1916 he even gave a lecture at the Academy of Fine Arts in Brussels in which he denounced the claims of the invention to artistic status'.

Officially, 'Khnopff considered photography as a medium slavishly rooted in the commonplace, all imitation of which would be disastrous'. After his death, many photographs were found in his studio, including some of his sister Marguerite that are clearly related to his paintings. It would be easy to diagnose hypocrisy in Khnopff, and many other artists who privately used but publicly disowned the camera: easy, but unfair. His ambivalence towards photography resulted from a combination of fascination with misgiving; mixed feelings characterized the reaction of many artists to camera images over the centuries.

In 1862, before Ingres completed his last, photo-based *Self-Portrait*, there was a cause célèbre in France. The photographic partnership Mayer

FERNAND KHNOPFF
The artist's sister Marguerite
Khnopff in a study for *The Secret*,
c. 1901
Aristotype (citrate print)
from a glass negative

FERNAND KHNOPFF
The Secret, 1902
Crayon on paper

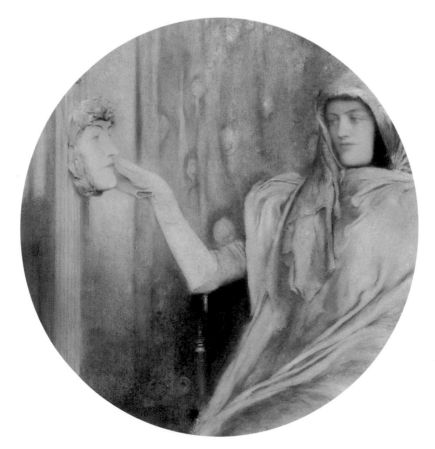

and Pierson accused rival firms of pirating their work (portraits of Lord Palmerston and Count Cavour). They sued for a breach of copyright, but the relevant French law applied to the arts, so photography had to be declared an art in order for Mayer and Pierson to win the case.

They lost in a lower court, then appealed and won. Their attorney argued that a painter both invents and copies reality ('Is the painter any less of a painter when he reproduces exactly?'). Conversely, to make a good photograph, a photographer must first think, composing the picture in his mind. Therefore, the photographer, like the painter, used the imagination. This argument was too much for a number of senior painters, who petitioned the court. 'Photography', they protested, 'consists of a series of completely mechanical manipulations which no doubt require some skill in the manipulations involved, but never resulting in works which could *in any circumstances* ever be compared to those works which are the fruits of intelligence and the study of art.' The first signature was Ingres's, followed by that of his pupil Jean-Hippolyte Flandrin, and Pierre Puvis de Chavannes, among others. The court found against them.

DH Wrongly, perhaps: I don't know whether photography is an art. Some photographers considered themselves artists, and some didn't. Perhaps some who didn't, such as Atget, *were* artists, and some who said they were artists weren't. Just because you say you are one doesn't mean anybody else thinks so. Good photography does require intelligence and imagination, but a lot of it is very mechanical. It requires less skill now, because you can't take an out-of-focus or underexposed picture.

MG Perhaps you can be an artist without realizing it. Eugène Atget (1857–1927) was a modest, professional photographer. But his eerily poetic photographs recall the empty urban spaces of Georgio de Chirico (1888–1978). Towards the end of Atget's life, Man Ray bought a number of his pictures, perhaps seeing in them a Surrealist sensibility. However, Atget's streets were deserted largely because of the big, old bellows camera he used, which required long exposures. What we see in Atget's pictures, therefore, is partly *time*.

DH Many of the best early photographs are portraits: by Hill and Adamson, Julia Margaret Cameron and others. The portraits by Nadar (the pseudonym of Gaspard-Félix Tournachon, 1820–1910) have hardly been

bettered in a hundred and forty years, and I wonder whether it might be
to do with the length of the exposure. A one- or two-minute exposure
would, in effect, pick up tiny movements in the flesh. Nadar's certainly
are marvellous: Rossini, Delacroix, Baudelaire.

MG All she required as a studio, Julia Margaret Cameron (1815–79) wrote,
was a room 'capable of having all light excluded except one window',
and that she would drape with yellow calico. Restricting the illumination
lengthened the duration of the exposure even further, so she favoured
those requiring up to four minutes of motionlessness for the sitter. But
in conjunction with Cameron's tendency to take her pictures slightly out
of focus, and probably slight movements from the model, this lighting
created a wonderful softness.

Dante Gabriel Rossetti – an astute observer if a bad speller – put his
finger on just what that was when he thanked her for 'the most beautiful
photograph' she had sent him, adding, 'It is like a Lionardo'. It was
indeed the photographic equivalent to Leonardo's *sfumato*, defined by
the master himself as 'without lines or borders, in the manner of smoke'.
Obviously, Rossetti saw affinities between painting and photography.

In 1853, the painter and critic Ernest Lacan divided photographers,
who had then only been in existence for a little over a decade, into

four types: the amateur, the professional, the scientific, and the artist
photographer. In many ways the last was the most fascinating.

DH Why did Paul Delaroche talk about the death of painting in 1839? If
painting is dead, all that is left is photographs and that's not enough!
But it's true painters took good photographs. They would know
what they were doing it for. You'd gain something but you'd also lose
something. There might not be very good definition of the volume, for
instance, which would have mattered to Courbet. But that would not
have concerned Degas very much, probably. It is interesting to note that
Degas, a great admirer of Ingres, was fascinated with photography.

MG His interest in the subject, though deep, was – like many aspects of the
life and art of this quixotic man – paradoxical to the point of perversity.
On occasion he based paintings on photographs, as he did in the case
of his portrait of Princess Pauline de Metternich, where he used a carte-
de-visite photograph by Disdéri as a basis. But the painting is, in a sense,

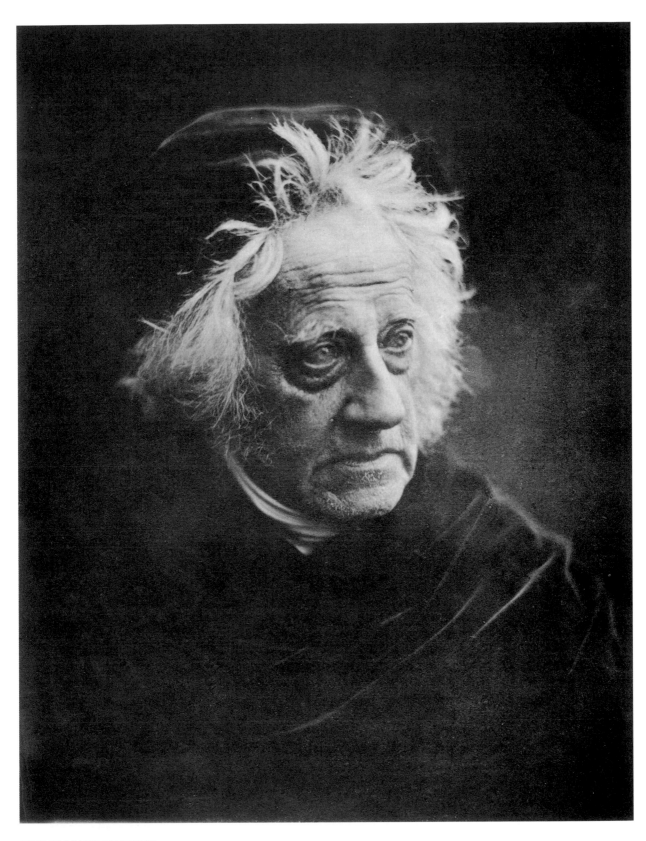

JULIA MARGARET CAMERON
Sir John Herschel, 1867
Albumen silver print from glass negative

ANDRÉ-ADOLPHE-EUGÈNE DISDÉRI
Prince Richard de Metternich and Princess
Pauline de Metternich, 1860
Carte-de-visite

EDGAR DEGAS
Princess Pauline de Metternich, c. 1865
Oil on canvas

more photographic than the photograph. Degas added the quality of blur characteristic of an out-of-focus image, or one in which the subject has moved.

In this respect he resembled Vermeer and Richter, who, as we've noted before, were enthralled by the distortions and beauties of the camera image itself, as opposed to reality. They, too, painted fuzz and blur. But Degas, when he briefly became an enthusiastic photographer in the mid-1890s, made great efforts to make his camera do things it wasn't normally capable of, such as taking pictures in the near dark – photographs that included a surprising amount of time.

Paul Valéry described the session for one of these, a shot of the poet Stéphane Mallarmé and fellow-artist Auguste Renoir in Degas's Parisian apartment by night. The image is also, since there is a mirror in the background, a kind of ghostly selfie. Valéry recalled: 'This photograph was given to me by Degas, whose camera and spectre can be glimpsed in the mirror. Mallarmé stands next to Renoir seated on the divan. Degas inflicted on them a pose of some fifteen minutes beneath the glare of nine oil lamps.' It looks like a photograph taken against the instantaneous spirit of photography. Degas's American contemporary Thomas Eakins (1833–1916) was a prolific photographer, taking hundreds of pictures that he used on occasion in place of sketches, and sometimes even – it has been suggested – projecting them onto his canvases.

As the 21st-century artist Jeff Wall has noted, there was a strange situation in the later 19th and early 20th centuries: some of the best photographs were taken by painters – such as Degas and Eakins – meanwhile many photographers strove to imitate the effects of painting. This movement is often called 'Pictorialism'. Edward J. Steichen's photograph of the *Flatiron Building* of 1904 mimics the soft atmospheric and tonal effects of a painting by, for example, Whistler, or of a Japanese woodblock print. Steichen added layers of colour to the original image, making this as much a work of the hand as the lens.

Earlier, there had been a determined effort to parallel the way that painters built up their compositions from multiple figures. The results were made in a manner similar to the technique Caravaggio used to construct his painted dramas from numerous optical observations (though generally much more crudely pieced together).

EDGAR DEGAS
Pierre-Auguste Renoir and Stéphane Mallarmé, 1895
Gelatin silver print

DH Every serious photographic collection has a group of photographs from about 1860 that show elaborate interiors, with exterior views though

14 Photography, Truth and Painting

EDWARD J. STEICHEN
The Flatiron, 1904
Gum bichromate over
platinum print

256

windows. You can see gardens and objects outside. Well, you can't photograph the interior and get the outside as well in that way, because of exposure times. In fact, these were made of several negatives, so in a sense they are collages. They are not very well known because later the photographic world dismissed them as not being pure photography, which was one exposure, but they existed, so they have to be dealt with.

MG Putting together a photograph and a painting could involve remarkably similar processes. *The Two Ways of Life* by Oscar Gustave Rejlander was pieced together from over thirty negatives (and it shows). Rejlander (1813–1875) invented the technique of making such combination prints. His younger contemporary Henry Peach Robinson (1830–1901) combined negatives with more skill and aplomb. His *Fading Away* from a year later, 1858, is in effect a photographed equivalent to a Victorian genre painting, with a heart-wrenching subject (a young girl on her deathbed), a composition carefully worked out in advance, and models posed individually. Like *The Two Ways of Life*, it was purchased by Queen Victoria.

DH What these people around 1860 were doing is exactly the same as what Jeff Wall and Geoffrey Crewdson are doing now, and what Caravaggio was doing in 1600. The techniques are old, not new. A new tool – Photoshop – has emerged, but it has revealed an old tool: the lens and the projection.

MG Ironically, both Henry Peach Robinson and Jeff Wall are much more successful at creating complex, integrated photographic compositions than David Octavius Hill, who took such wonderful photographs in collaboration with Robert Adamson, but spent many years trying to produce a hand-painted version of just such a photographic mosaic.

Hill decided to paint a group portrait recording an event known as the 'Disruption', a schism in the established Church of Scotland that led to the signing of the Act of Separation in May 1843 and the creation of the Free Church of Scotland. The occasion was watched in Edinburgh by almost five hundred people. Drawing portraits of the assembled ministers before they dispersed would have been challenging and the painter was advised by the physicist Sir David Brewster to use the new invention of photography to take individual portraits – and was introduced by him to Robert Adamson to assist in the task.

OSCAR GUSTAV RIJLANDER
Two Ways of Life, 1857 (printed
1920s)
Carbon print

HENRY PEACH ROBINSON
Fading Away, 1858
Albumen silver print
from glass negatives

JEFF WALL
A View from an Apartment,
2004–05
Transparency on lightbox

It took him twenty-three years to complete his painting, and the final result was vastly less impressive than the photographs he produced with Adamson. Hill was an early example of a recurring type: the modestly talented painter who becomes a brilliant photographer. His painting resembles, in fact, a huge photo-collage, with all the faults of the 'badly drawn photograph': the disjunctions in space; the awkward seams between one figure and the next, resulting from their having been studied separately. It looks a bit like Peter Blake's witty pastiche of a Victorian group portrait for the Beatles' *Sgt. Pepper's Lonely Hearts Club Band* album cover. In fact, when you look closely, a surprising number of 19th-century academic paintings look like that cover, because they were put together in essentially the same way.

Piecing together different photographic images to make a new picture was something done from the earliest days of photography. A celebrated portrait of Abraham Lincoln was assembled out of a shot of the President's head by Mathew Brady, which was reversed and stuck onto the body of Southern politician John C. Calhoun (an inspiration to Lincoln's Confederate enemies).

Above
DAVID OCTAVIUS HILL
The First General Assembly of the
Free Church of Scotland; Signing
the Act of Separation and Deed of
Demission – 23 May 1843, 1866
Oil on canvas

Right
PETER BLAKE and JANN HAWORTH
Sgt. Pepper's Lonely Hearts Club Band,
1967
Record sleeve

staged or otherwise to be 'fakes'. One of the earliest masterpieces of photography was a fake, or, more correctly, it was a staged version of reality. It was created by Hippolyte Bayard (1801–1887), a French civil servant, who pioneered a process, direct positive printing, which he believed preceded the discoveries of Daguerre and Talbot. But whereas Daguerre was rewarded by the French government, he was not. In ironic protest he created an image, *Self-Portrait as a Drowned Man*, purporting to be his own dead body.

An accompanying text explained he had been driven to suicide by official neglect. 'The Government, which has been only too generous to Monsieur Daguerre, has said it can do nothing for Monsieur Bayard, and the unhappy wretch has drowned himself.' In fact, Bayard lived for another forty-seven years. Thus, photographs that present a false or fictionalized image date back to the dawn of the medium.

Among the most celebrated early images of war was Alexander Gardner's *Home of a Rebel Sharpshooter, Gettysburg*, from the American Civil War. To create this image Gardner seems to have selected a suitable corpse (one that was not hideously decomposed like most on the battlefield), moved it to a good location and posed it with his own gun. In other words, he made a picture – which, in the approved Victorian manner, told a story – out of elements he found on the scene. His procedure was 'unmasked' by the historian William A. Frassanito in 1975 (the era of Szarkowski and Cartier-Bresson). But in 1863 it would have seemed a natural way to make a good picture, indeed staging *is* the natural way to make a good picture.

Intense debate has swirled for decades about whether Robert Capa's photograph of a dying Spanish Republican combatant, *The Falling Soldier*, is a record of a real event or a carefully staged one. The original title emphasizes its reality: *Loyalist Militiaman at the Moment of Death, Cerro Muriano, September 5, 1936*. It has now been established that the picture was not, in fact, taken at Cerro Muriano but at Espejo, a place that was some miles from the battle line on that day.

DH It was either totally accidental or staged. You can't tell from the photograph, but I strongly suspect that it was set up because cameras in those days were slow and catching someone like that in the instant of death was not easy at all. So I'm fairly sure it was arranged. Capa would have said, 'Well, it's all for a cause'. The cause was bigger than his picture.

ROBERT RAUSCHENBERG
Retroactive I, 1963
Oil and silk screen ink

Right
HIPPOLYTE BAYARD
Self-Portrait as a Drowned Man,
1840
Direct positive print

Opposite above
ALEXANDER GARDNER
Home of a Rebel Sharpshooter,
Gettyburg, 1863
Albumen silver print

Opposite below
ROBERT CAPA
The Falling Soldier (Death of
a Loyalist Militiaman), 1936
Gelatin silver print

MG Of course, the question of whether or not the militiaman had actually been hit by a bullet at the moment Capa took his picture is irrelevant to the quality of the photograph. It also has no impact on the wider truth that unquestionably soldiers like him were dying in just that way at exactly that time in the Spanish Civil War. Nonetheless, it seems to make a difference to the way we look at it.

This is partly because of a lingering belief that photography presents the truth. Capa himself gave powerful voice to this conception of war photography: 'If your photographs aren't good enough, you're not close enough.' Eventually, like many war photographers, he died for it, stepping on a landmine in Indochina in 1954. So there is a bitter irony in the fact – if it is a fact – that his most celebrated image was staged. Other photographs taken that day definitely were arranged, in the sense that they depict troops performing for the camera far from the front line. It matters that this one was not. Why? Because it is so powerful.

It is much easier, however, to take a good picture if you know what is going to happen. This is true in love and war. Another of the most renowned images in photographic history is Robert Doisneau's *The Kiss*

14 Photography, Truth and Painting

ROBERT DOISNEAU
The Kiss by the Hôtel de Ville,
1950
Gelatin silver print

by the Hôtel de Ville. This hugely popular image of young love in postwar Paris was revealed to be just as confected as a Caravaggio.

In 1992, a couple who imagined they were the lovers in the photograph sued Doisneau for taking their picture without permission, forcing him to disclose that the subjects were two young actors, who posed in three different locations before he got the shot he wanted. Again, this fact does not affect the quality of the picture in the slightest. It is revealing, however, that Doisneau felt obliged to disguise it: the ideology of photography in 1950 required him to find his images in reality. But the fact remained that it was much easier to take a good picture if you knew what was going to happen, and could decide the composition and lighting a little in advance.

DH For photography, it's useful to have some expectation of what may be about to happen. When we were rehearsing operas, they used to let the photographers in for the dress rehearsal, but I knew we'd get much better shots if the photographers had seen the other rehearsals and knew what was coming. If you don't know the performers are going to do something, you are usually too late to catch it. When we did *Parade* at

14 Photography, Truth and Painting

DAVID HOCKNEY
*The Massacre and the Problems
of Depiction, after Picasso*, 2003
Watercolour on seven
sheets of paper

the Met, I got my own photographer to take scenes from a certain point at particular times. As a result, we got images unlike anyone else's.

MG The distinction between staged photographs and ones that were simply taken becomes more elusive and less valid the more you think about it. Almost any good picture will involve some degree of pre-planning and in some circumstances would have to be staged.

DH My interpretation of Picasso's *Massacre in Korea* (1951) was about photography. I did a version of it at the time of the first Gulf War. I put a photographer in the middle, to make the point that actually he couldn't conceivably be there. There's no photograph like that, and they'll never be one. There are no photographs of armies deliberately killing women and children, are there?

15 Painting with and without Photography

A painter would steal anything and colour it.

DH By 1865, most academic painting in France was based on photographic images: Meissonier, Bouguereau, Gérôme. Other artists knew there was something wrong with it and wanted to get away from that way of working; the early modernists did. But with the ubiquity of photography, we now think that vision is perfectly normal, don't we? I don't agree. When I published *Secret Knowledge*, a lot of people thought I was suggesting artists should use optics. Actually, I was saying the world doesn't necessarily look like that at all.

MG Among the most successful exponents of airbrushed, academic photo-based art in the second half of the 19th century was Jean-Léon Gérôme (1824–1904). A late work of his was called *Truth Coming Out of Her Well to Shame Mankind*. After painting it he commented, 'Thanks to photography, Truth has at last left her well.' That is to say, as far as he was concerned, photography was visual truth. But not everyone agreed.

Ingres's great rival, Eugène Delacroix (1798–1863), was ambivalent about photography. In some ways, he felt, it was wonderful. But it showed, in a sense, too much. The daguerreotype was 'a translator commissioned to initiate us further into the secrets of nature', but it was 'a copy, in some ways false just because it is so exact ... the eye corrects'. In other words, it was a marvellous source of information, but information that he felt needed to be sifted by the mind of the artist.

DH The photograph puts too much in. When you look out at the world, there is a lot there. We edit it.

JEAN-LÉON GÉRÔME
*Truth Coming Out of Her
Well to Shame Mankind*, 1896
Oil on canvas

MG Delacroix felt that photography could make old masters look all wrong. On one occasion, he and a few friends examined some photographs of

271

nude models. Then he took out a group of engravings by Marcantonio Raimondi (*c*. 1480–*c*, 1534), High Renaissance print maker and associate of Raphael. On looking at these much-venerated works immediately after the photographs, Delacroix commented that 'We experienced a feeling of repulsion, and almost of disgust, at the incorrectness, the mannerism, the lack of naturalness, despite the quality of style, the only one there was to admire, but which we no longer admired at that moment.'

Delacroix was evidently torn: photography was almost the truth about reality, but not quite. It made painting and drawing look false, but it also looked wrong itself. Despite these misgivings, Delacroix was an early sitter for a daguerreotype portrait, in 1842. Twelve years later, in 1854, he acted as the 'director' – rather as David Octavius Hill had done – of two photographic sessions at the studio of the photographer Eugène Durieu (1800–1874). These took place on the Sundays of 18 and 25 June, and resulted in the bulk of an album of nude studies that Delacroix then used as a source for drawings and one painting. These were some of the finest nude photographs of the 19th century, much better than independent works by Durieu alone (and greatly superior to a photo-based painted nude by Gérôme). To an extent, then, they

EUGÈNE DURIEU
Male Nude, 1854
Calotype

15 Painting with and without Photography

can be counted as camera-works by Delacroix. He, like Degas, is an example of the truth that painters can make marvellous photographers. The painting he made using one of Durieu's studies, however, is so different from the photograph that if the latter did not survive it would be hard to guess that Delacroix had used a photograph at all.

The technology that made and distributed pictures was changing, but the notion that photographic images transmit the truth still lingered (as it still does today). The true appearance of reality, however, is always elusive. Much of figurative painting since 1839 has been done with the use of photographs; but a great deal has been aimed at depicting aspects of the world that photography cannot capture. There were as many different ways to use photographs as there were painters.

DH By the mid-19th century academic paintings had become these absurd pictures with a rigid perspective. They had a deep space, but it went into the picture, not across it. They were ridiculous because they were trying to tell a story in depth that way. You could see that every event was happening at the same instant, so there was actually no time in the picture.

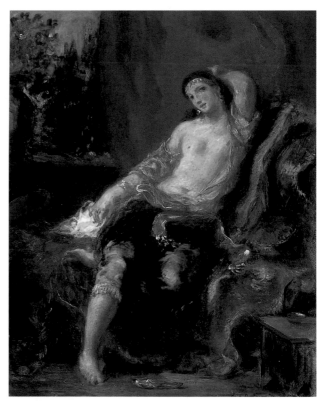

273

There's a painting by Degas of Viscount Lepic standing in the Place de la Concorde with his daughters; they are in an amazing space. The figures, in the way they are cut off at the edges, are a bit photographic, but the space is not. When the photograph attempts space it can't really see it. The lens image is something measured, and we don't see that way.

The historian of Impressionism John Rewald reproduced a photograph of Mont Sainte-Victoire in his book on Paul Cézanne. Did he do that to show us what the mountain really looked like, and to compare it with Cézanne's version? Rewald must have seen the photograph as a mechanical picture that can't lie. I think Cézanne's mountain is much more real.

Cézanne, painting with two eyes, was seeing things from two slightly different points of view. That's why his curves are a bit odd. He said his painting was about sensation, but it was sensation seen through *both* eyes. Of course, everyone agrees Cézanne's pictures of card players are marvellous paintings, but why? It isn't that easy to say. It isn't just the sense of volume, it isn't just colour. I think they are almost the first truly honest attempts at putting a group of figures in a picture.

Opposite
JOHN WILLIAM WATERHOUSE
Saint Eulalia, 1885
Oil on canvas

Above
EDGAR DEGAS
Place de la Concorde, 1875
Oil on canvas

JOHN REWALD
*Mont Sainte-Victoire seen
from Les Lauves, c.* 1935
Photograph

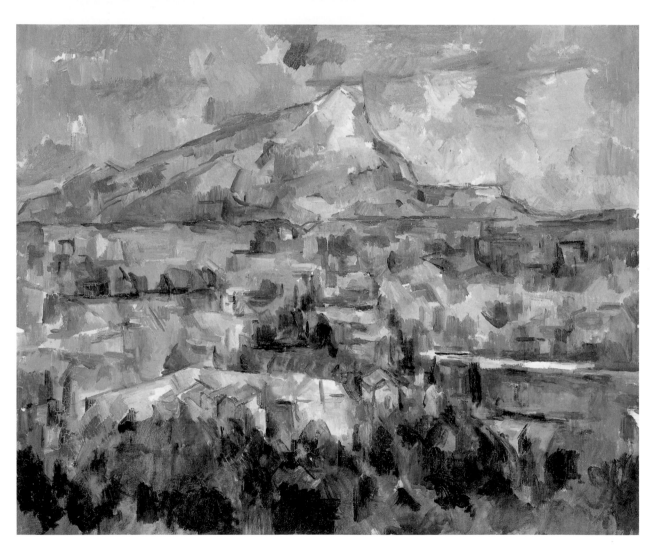

PAUL CÉZANNE
Mont Sainte-Victoire, 1902–06
Oil on canvas

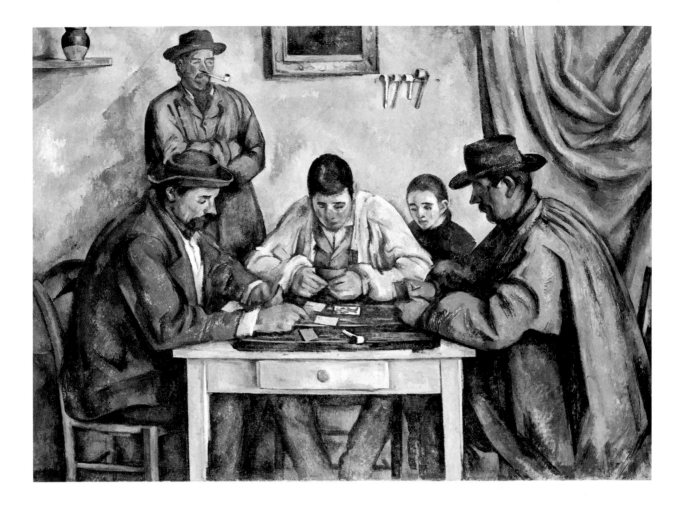

In the later 19th century painting was changing in many ways. There were other new technologies, apart from photography. There were new colours, too: the coal-tar pigments, from aniline dyes such as mauve and magenta, and synthetic lake colours, like madder lake. They were discovered by the chemical industry and used by painters. You can see them in paintings by Renoir and Van Gogh. And Impressionism could not have happened without the invention of the collapsible tube, which made it possible to paint outside. That was technology again.

MG Painters such as Monet, Pissarro and Sisley depended on being able to execute large pictures, not just sketches, outdoors. Indeed, one of their most radical steps, which caused outrage, was precisely exhibiting works that looked like sketches as finished paintings.

PAUL CÉZANNE
The Card Players, 1890–92
Oil on canvas

DH Monet's skies are terrific. I think I understand what Monet's technique must have been. For example, painting clouds isn't easy, they move faster

than you think. It's only when you start trying to paint them that you realize how fast they are moving. They'd have to be very high for you not to notice that. Mostly, they are quite low and constantly changing.

Monet must have had a method of notating tone, positions and colours, just putting in bits; then back in the studio he could finish the picture. I noticed how quickly the light and the sky changed in Yorkshire when I was painting there. Normandy has a very similar climate to the one in East Yorkshire: they are both maritime, northern European places. There are lovely pictures by Monet of the river Seine near Giverny with early morning mist done in 1896–97. The compositions are all the same but the lights are wonderfully different. But they are all morning lights; you can see that.

MG The naturalistic, optical way of looking at landscape was combining with very different traditions. In its sense of limitlessness, with the sky merging with the water, Monet's *Branch of the Seine near Giverny (Mist)* seems oriental. Like many European artists, he was an enthusiastic collector of Japanese woodblock prints. The existence of these in plentiful supply made them a global mass medium. In avant-garde circles in 19th-century Europe they suggested an alternative way of making a picture to the academic orthodoxy, by then heavily influenced by photography.

DH After about 1870 European painting looked at Japanese art because it wanted to escape from Renaissance perspective and the photograph. Van Gogh was one of the first to adopt Japanese ways of making pictures. When he went to Arles in the South of France he said he was going because he wanted to see the colours he saw in Japanese art, which came from a strong sun. His use of intense colour in portraits, for example, must have influenced a lot of artists later, such as Matisse and the Expressionists; of course it came to him from the Japanese.

At the beginning of the 19th century all European paintings were done with chiaroscuro. By the end of the century shadows had gone from a lot of painting. There are no shadows in Van Gogh's *Sunflowers*, nor in Gauguin, nor Bonnard. There is no comment in art history on this movement away from shadows; perhaps the writers are not conscious of their existence. As I've pointed out before, in a way, you can just not see them, as the artists of China and Japan did not. A great deal of modernist painting depended on looking at Japanese prints.

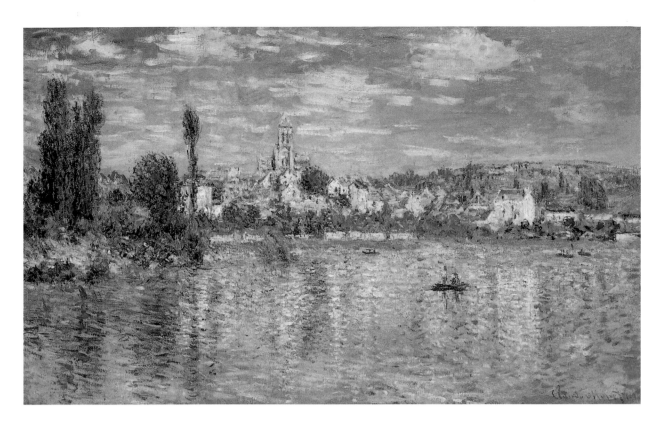

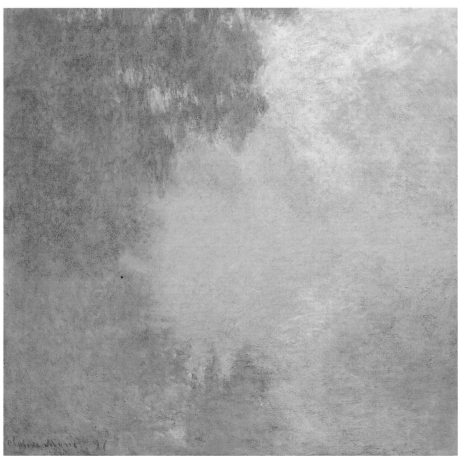

Above
CLAUDE MONET
Vétheuil in Summer, 1880
Oil on canvas

Right
CLAUDE MONET
*Branch of the Seine near
Giverny (Mist)*, 1897
Oil on canvas

MG One of the most adventurous European paintings in this period is Paul Gauguin's *Vision of the Sermon*. It has no vanishing point; the figures do not diminish in size according to how far away they appear to be, or, at least, not consistently. The bull in the top left is closer to us than the kneeling women behind, but seems far smaller. Gauguin's space is largely created by a field of intense red, with a tree trunk curving across it. To some extent, he learned how to create such an effect from studying Japanese woodblock prints. Gauguin's painting echoes the print of a flowering plum tree by Hiroshige, which was copied by Vincent van Gogh. The effect of Gauguin's *Vision of the Sermon*, however, is even more reminiscent of the grand screen paintings of late 16th- and early 17th-century Japan, such as *Old Plum* by Kano Sansetsu. These are pictures he could not have seen, but which influenced the prints that found their way to Europe.

In *Old Plum* a gnarled tree juts out across a field of gold – no distance, no recession – and yet the impression of volume, growth and space is stunning. There is a story about a Japanese artist who painted a picture of a garden with trees. When it was finished, the patron asked why there was almost nothing in view – just a sprig of cherry with a small bird on it in one corner. 'If I had filled the picture with things,' the painter replied, 'where would the bird have been able to fly?'

Above
UTAGAWA HIROSHIGE
View of the Harbour (Miya: Station no. 42), from *Fifty-three Stations of the Tōkaidō*, c. 1847–52
Woodblock print

Opposite
VINCENT VAN GOGH
Père Tanguy, 1887
Oil on canvas

15 Painting with and without Photography

UTAGAWA HIROSHIGE
Plum Estate, Kameido, No. 30 from
One Hundred Famous Views of Edo, 1857
Woodblock print

VINCENT VAN GOGH
Flowering Plum Orchard
(*after Hiroshige*), 1887
Oil on canvas

KANO SANSETSU
Old Plum, 1646
Four sliding-door panels
(fusuma); ink, colour, gold
and gold leaf on paper

282

DH In another way, photography deeply affected the way we look at the past. As we have seen, there were prints and engraved reproductions of famous works, but it was the photographing of paintings from 1850 onwards that must have helped organize a history of the various schools and styles that had existed in European picture making.

MG This affected artists too. When Gauguin sailed to the South Pacific in 1891, he took with him a visual reference library of photographic images: the Parthenon frieze, ancient Egyptian paintings, the sculptures of the temple of Borobudur in Java. These entered into the pictures he painted in Tahiti just as much as what he actually saw there.

PAUL GAUGUIN
Vision of the Sermon (Jacob Wrestling with the Angel), 1888
Oil on canvas

DH It would have been very difficult before photography to see and remember all the pictures that had been made in geographically separate places. Art history was a German invention, intended to tidy things up.

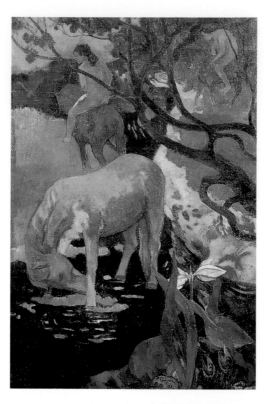

TA MATETE

But it overlooked some important considerations, and those are what now concern us.

MG Gauguin's painting *Ta matete (The Market)* is derived from a photograph of an 18th-dynasty Egyptian painting, but to the monochrome image he carried with him he added crucial ingredients: bright red and yellow, cool blues and greens.

DH When Woody Allen came out against the colourization of black-and-white movies in the 1980s, I said he's actually taking a conservator's line, not an artist's approach. A painter would steal anything and colour it.

MG In comparison with photography, painting still had two great advantages. It was, potentially at least, much larger in size and brighter in colour even than hand-tinted photographs. These two qualities – scale and chromatic vividness – could intensify each other.

It was the symphonic variations of differing shades of yellow that astonished even Gauguin when he first saw Van Gogh's *Sunflowers* in Arles in the autumn of 1888. 'Merde! Merde! I don't know what painting is any longer!' Van Gogh was wrong in thinking that there is an emotional language of colour, but it is perfectly true that colour has a powerful, almost physical, impact. It is part of what Damien Hirst has called the 'yumminess' of painting. Increasing chromatic intensity became a hallmark of the avant-garde.

DH The greater the area of a certain colour, the more powerful it is. There's a wonderful remark of Cézanne's: two kilos of blue are a lot bluer than one kilo. It's very true. Gauguin liked to repeat that remark, and exploited the principle, so did Matisse. Colour can make space, or rather, *colour*s can. You need more than one. *The Red Studio* by Henri Matisse is mainly just red – as the title tells you – but it is the way it works with the other colours that makes the space.

Looking back, we sometimes think of the past as monochrome, but that's not true. The ancient world was all coloured, so were the Middle Ages. The paint has come off now. They discovered that in the 1930s when Lord Duveen persuaded the British Museum to clean the Elgin Marbles; it turns out they were cleaning off the paint. In Mexico City there is a model of the Aztec town, all in white. When I went there, I said, 'Why don't you paint it, it wasn't really white?' There's

Opposite above left
Detail from the Parthenon
frieze, *c.* 440 BC
Marble

Opposite above right
PAUL GAUGUIN
The White Horse, 1898
Oil on canvas

Opposite below
PAUL GAUGUIN
Ta matete (The Market), 1892
Oil on canvas

a description by Bernal Díaz of seeing the place for the first time and it all being full of colour. Pompeii was the Beverly Hills of its time; there were brothels and masses of pictures everywhere. It was probably the 19th century that was the colourless one, because of photography.

MG Human beings, of course, have more than one sense (indeed, according to most counts, several more than five, too). We relate in all sorts of ways to what we are looking at. A painting can include some of those sensations, a sense of texture, for example, and a feeling of mass and weight, whereas a photograph cannot. We don't just see space, we occupy it as well, that is, our body is filling a certain bit of the world, and we know without looking just where our arm and legs are placed in it. We are in the environment, and touching it, and moving bits of it around. The Cubists were well aware of this.

DH Most Cubist painting is of something very close to us: a still life on a table. Unlike Brunelleschi's pictures, it wasn't for representing architecture. How do you do a room, in Cubist terms? Cubism was an attack on the perspective that had been known and used for five hundred years. It was the first big, big change.

MG The co-founder of Cubism, Georges Braque, once made a fascinating remark: 'When a still life is no longer within reach, it ceases to be a still life.' Later, he expanded on the idea: 'For me that expressed the desire I have always had to touch a thing, not just to look at it. It was that space that attracted me strongly, for that was the earliest Cubist painting – the quest for space.' For Braque, 'the main line of advance of Cubism – was how to give material expression to this new space of which I had an inkling. So I began to paint chiefly still lifes, because in nature there is a tactile, I would almost say a manual space.' This new way of depicting space permeated much later painting.

DH I saw the Jackson Pollock exhibition at the Whitechapel in 1956; I'd hitchhiked to London especially. There was a lot of excitement because it looked as though this was a new modern artist, uninfluenced by Picasso. Everything else could be traced back to him. Henry Moore comes out of about a couple of weeks of drawings by Picasso, even if Moore added to it; Francis Bacon is from Picasso. He was very good, but he couldn't paint a pretty girl and make you think she was. Picasso could. You know she is

15 Painting with and without Photography

HENRI MATISSE
The Red Studio, 1911
Oil on canvas

extremely pretty, just as in a painting by Titian you know the subject has soft skin; you are given all sorts of information.

The art of the 20th century hasn't really been understood. What happened was complex; it takes a bit of time to see it. I lived through a period when artists were not looking at Picasso at all, but Picasso won't go away. There are always people wanting to get rid of giants. Take Wagner: in the 19th century his influence was so enormous, most musicians were trying to find out how you got out from under this gigantic figure. In the end even Pollock was derived from Picasso; in some of his later pictures he was going back to depicting big heads.

I own the 33-volume Zervos catalogue of Picasso's work. It's fantastic. If Picasso did three things on one day, they're number one, two, three, so you know what he was doing in the morning and in the afternoon. I've sat down and looked through the whole thing from beginning to end several times. That takes some doing, but it's a fascinating experience. It doesn't bore you.

Above
GEORGES BRAQUE
Still Life (with clarinet), 1927
Oil on canvas

Opposite
PABLO PICASSO
The Dream, 1932
Oil on canvas

15 Painting with and without Photography

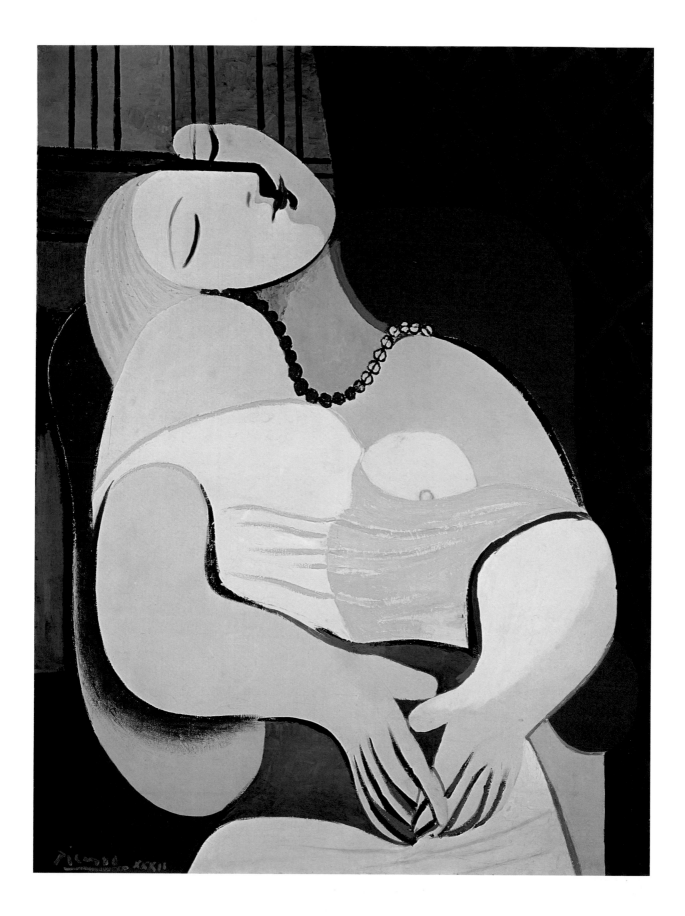

It took me quite a long time to *see Les Demoiselles d'Avignon*, but the last time I was looking at it in New York I could understand it. My God, it is quite an amazing picture. It is the first painting in which the ground and the figures interlock totally, which is something the camera couldn't do; it doesn't see that way. So again it's anti-photographic. Picasso just kept it in his studio and didn't show it for nearly a decade. When he did so, some people thought it was just terrible.

PABLO PICASSO
Les Demoiselles d'Avignon,
1907
Oil on canvas

MG Once I went straight from the Met, where I had been looking at El Greco's
The Vision of Saint John to MoMA, where I spent a long time in front of
Les Demoiselles, and I could see what Picasso got from El Greco. Picasso's
nudes and El Greco's figures seem almost pressed into crumpled, jagged
drapery. And figures, sky and drapery all seem more or less on the same
plane. Of course, El Greco was trained on Crete before he travelled to
Italy and Spain; his way of painting originally came from Byzantine art.

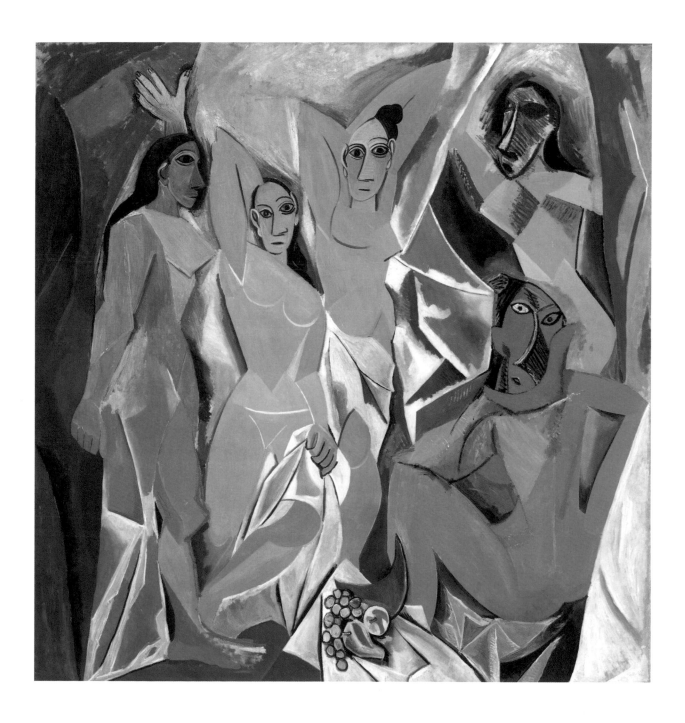

DH Which, of course, is quite different from pictures seen through Alberti's window: no shadows, isometric or reverse perspective, intense colour. There were doctors who wrote books claiming that El Greco had bad eyesight. I always used to smile about that. But, if you think about it, it is based on the doctors obviously believing they know exactly what things look like. That was what Hitler and Stalin were saying about modern art: the horses aren't red, the trees aren't blue. I suppose Hitler was complaining about Franz Marc and the Blaue Reiter painters. You come back to this feeling: we're pretty sure we know what it all looks like. Picasso, on the contrary, seems to be saying that actually we're not really sure about that. Or, what it all looks like depends on our attitude to time.

MG The work of Matisse, Picasso, Gauguin, Van Gogh and Braque led on to the development of abstraction, which is outside our history of pictures, devoted as that is to depictions of the world. At one time, abstract art was seen as the path of the future. However, from the vantage point of the second decade in the 21st century, that looks far less obvious.

DH In the 1950s and 1960s, Francis Bacon was always seen as being slightly to one side of what was going on in the avant-garde. But in retrospect, it turns out that it was the other artists who were in that position and Bacon was the greatest British painter of a certain period, by far.

MG The distinction between figurative and non-figurative painting is not clear-cut. Throughout the history of pictures even if an artist sets out to make a mark that is just itself – a form, a line – it may end up resembling something real (just as a random patch on a cave wall suggested a bull to the prehistoric eye). The human propensity to see depictions is deep rooted.

DH Ellsworth Kelly accepts nature. He said one work was two boys' bums together and it was very good. I once saw a room of just Ellsworth's paintings, and because of the way they were arranged the negative shapes were just as important as the positive ones. They were balanced. It was marvellous; there was a harmony about it that was thrilling.

MG In many of the best, most memorable pictures from all times and places what you might call abstract qualities – the harmony of forms

15 Painting with and without Photography

ELLSWORTH KELLY
Study for Rebound, 1955
Ink and pencil on paper

and the energy of lines – are inseparable from depiction. A few months before he died, Jackson Pollock told an interviewer that he did not care for such labels as 'abstract expressionist', 'non-objective' and 'non-representational'. He went on: 'I'm very representational some of the time, and a little bit all of the time. When you're painting from your unconscious, figures are bound to emerge.'

DH In Pollock's drip paintings every area is covered and meaningful: you can see that they were not just splashing, that they were organized. At the same time, it's exuberance and it's freedom. To paint, he used his whole arm, in fact his whole body. That's why I have long brushes, so that the fulcrum of the brushstroke is at my shoulder; when I use them, I want the movement that makes the mark *bigger*.

When Pollock was first shown in London, his pictures seemed huge, and so were Barnett Newman's and Rothko's; they were on a scale beyond the easel painting. In a small gallery, they dominate you. But they are also full of space. In that way, Pollock is a bit Chinese: limitless, with the focus always moving.

MG In the globalized world of picture-making east affects west and west, east, and neither retains a distinct identity. For example, Zeng Fanzhi (b. 1964), a leading contemporary Chinese painter, makes pictures that are related to classical Eastern painting. But they also seem connected to Jackson Pollock.

DH People like Mondrian appear heroic, but in the end his pure abstraction was not the future of painting. Neither Picasso nor Matisse ever left the visible world. It was Europeans who needed abstraction, because of photography. The Chinese would have always understood it. But they did not need it. A scholar's rock is an abstraction, yet it evokes the visible world. They didn't have naturalism in the Western sense: they never had a glass industry, so there were no lenses being made. So photography came suddenly and late to China.

JACKSON POLLOCK
Autumn Rhythm (Number 30), 1950
Enamel on canvas

ZENG FANZHI
Untitled 07–14, 2007
Oil on canvas

16 Snapshots and Moving Pictures

Technology comes and goes.

DH Someone asked a friend of mine if he thought photography was an art, and he answered that he'd always understood it was a hobby. That's true in a way. But in the mid-19th century it was only rich people who could take their own photographs; it was a wealthy man's pastime. More and more as time went on, it was something more people could do. But sophisticated cameras still needed skills: the main one was to judge exposure times and focus. Under or over exposure was fatal. Until twenty-five years ago, when you looked through a camera you still had to take a while to adjust needles, focus and so forth. You couldn't just shoot.

I can remember when I bought my first camera, then the next: a Pentax, my first 35mm camera; it was rather a good one. But you still had to get the needle in the middle. Now everybody can just shoot. You can't take an under-exposed picture; they are almost perfect each time. So everyone now is a photographer. In my lifetime, cameras have become ubiquitous. That's what's happened. These days, if somebody tells me they are a photographer, I'm not sure what they do.

MG The spread of photography was extremely rapid. Daguerre carried out a public demonstration of his technique on 17 September 1839. By September 1840, the artist Honoré Daumier was satirizing the long exposure times required by the new craze in a lithograph: *Patience is the Virtue of Donkeys*. By 1847, it was estimated that half a million photographic plates were sold annually in Paris, mostly portraits. But the process remained cumbersome. Exposures were very long and equipment was bulky. It took two men to carry the camera Julia Margaret Cameron used in the 1860s.

JOHN MINIHAN
*David Hockney with camera,
London,* 1975

DH Technology comes and goes. With a light, hand-held camera and a roll of film it was possible to take a lot of pictures rapidly, and often without the subjects knowing they were being photographed. Until then you were limited by plates. Because of the invention of photography, cameras, which up until that time had been handmade, began slowly to be manufactured. By the end of the 19th century, they were mass-marketed. This was a new way to make pictures; there were new places to see them, and novel ways to distribute them. But it was not a new way of seeing the world.

MG Both the daguerreotype and Talbot's calotype had obvious disadvantages: the first was small, metallic and could only be seen in certain light conditions; the second was restricted by the grain of the paper negative. In 1851, the wet collodion process was invented, but this, too, was far from user-friendly, since it involved spreading a syrup of poisonous chemicals on a glass plate and then taking the picture before it could dry. The wet plate was succeeded in the 1880s by the dry plate, which was easier to develop but still needed someone who knew what they were doing. Then the roll film was popularized by George Eastman, who used it in the Kodak, the first mass-market portable box camera, made in 1888. The age of photography for everyman had arrived.

HONORÉ DAUMIER
Patience is the Virtue of Donkeys,
Le Charivari, 2 September 1840
Lithograph

16 Snapshots and Moving Pictures

DH There's a picture of my father aged about 17 or 18 with a cap, holding a big box camera. He was always interested in photography, but he struggled with it and wasn't very good. He died just before automatic focus and exposure came in. Most of his pictures weren't taken at the right exposure or they were out of focus.

MG The Kodak came with film inside it, which was returned to the manufacturer for development. Twelve years later, in 1900, Kodak introduced the first Brownie, an inexpensive camera aimed at the mass market with the slogan: 'You press the button, we do the rest.'

 In earlier ages, a household might have had some formal portraits – painted or photographic – of ancestors and relations. The cheap portable camera meant that passing moments of everyday life – holidays, parties – could be transformed into pictures and gathered in a photo album. This wasn't so much a novel variety of picture as an unprecedented method of remembering events. Thus the painter Maurice Denis (1870–1943) clicked his shutter and caught two women, paddling in the sea, while swinging his little daughter Madeleine between them on the beach in Brittany in 1909. It was the kind of moment that millions of people were now able to fix (though not necessarily with the artist's eye for shapes, and the edges of a composition that Denis instinctively had).

MAURICE DENIS
Two girls, wading in the sea, swinging little Madeleine, Perros-Guirec, 1909
Gelatin silver print

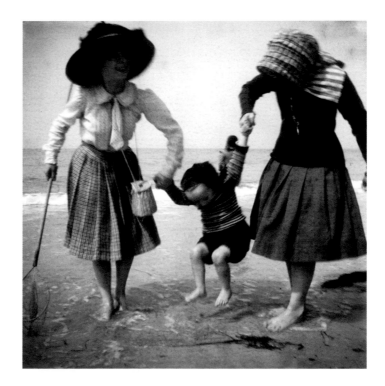

Not surprisingly, the great literary investigator of memory, Marcel Proust, was also an enthusiast of the snap. The central character in his novel *À la recherche du temps perdu* (1913–27) contemplates a photograph as a sort of second memory of the Duchesse de Guermantes: as if 'she had stopped beside me, in her garden hat, and had let me examine at my leisure, for the first time, that full cheek, that turn of the neck, that corner of the eyebrows'.

DH Proust was a very visual author. That's quite a Cubist idea, so was his description of how when you kiss someone you see their face so close it keeps changing. 'During this brief passage of my lips toward her cheek, it was ten Albertines that I saw; she was like a goddess with several heads, and whenever I sought to approach one of them, it was replaced by another.'

MG Denis's fellow member of the Nabis group Édouard Vuillard (1868–1940) was also a brilliant exponent of the snapshot. Degas had controlled every aspect of the photographs he took, but Vuillard was the opposite. His instrument was a Kodak box Brownie.

ÉDOUARD VUILLARD
Madame Vuillard and Romain Coolus, c. 1905
Gelatin silver print

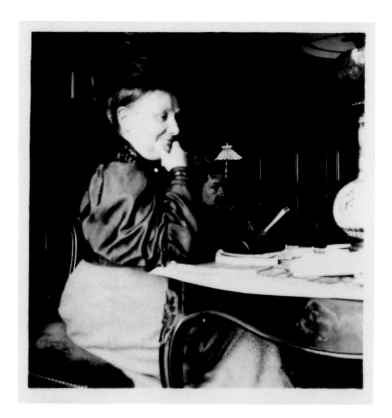

16 Snapshots and Moving Pictures

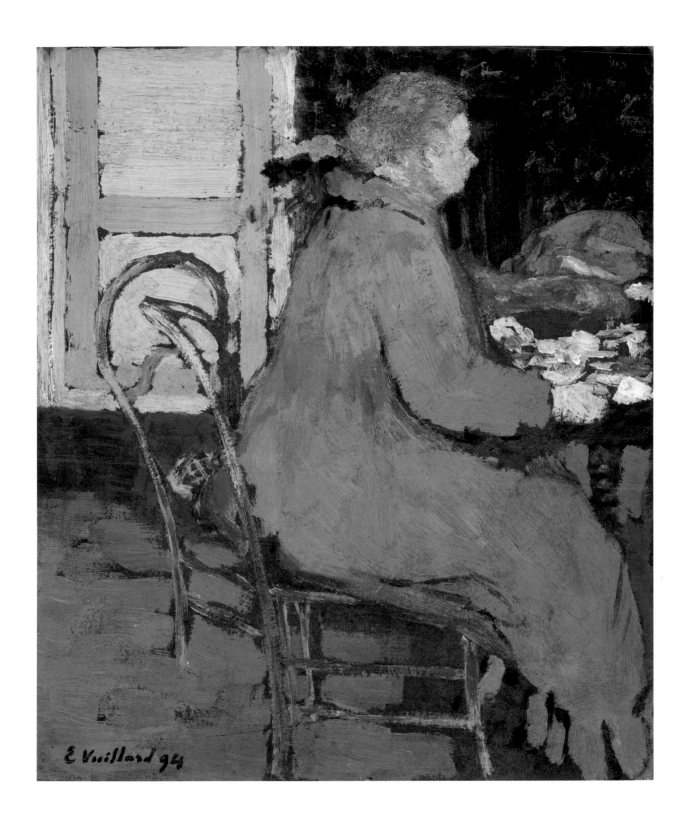

ÉDOUARD VUILLARD
Le Petit Déjeuner, 1894
Oil on cardboard

A friend remembered how sometimes, during a conversation, Vuillard would pick up his Kodak, and 'resting it on some furniture or even on the back of a chair, oblivious of its viewfinder, would point the lens in the direction of the image he wished to record. He would then give a brief warning, "Hold it, please" and we would hear the clic-clac of the time exposure.'

Vuillard's snapshots were a kind of sketchbook, a way of recording a group or a fleeting pose. On occasion he used photographs, in a Proustian manner, as a way of triggering memory. In his diary for 22 January 1908 he noted that he went into his studio for a moment, and 'the mauve of nature recurs in imagination as I look at the photo'.

DH There are all kinds of reasons why photographs might be useful to a painter, especially if they were made by the artists themselves. They would know why they were photographing something – to keep a difficult pose, for example. By doing that you'd gain something – the pose – but you'd also lose something. There might not be very good definition of the volume, for instance. I have used photographs as a basis for paintings myself but I always knew that you couldn't draw from them very well, because you couldn't see and feel volume in the way you can in life. Of course, there isn't a rule. If you set up a rule about anything, another artist will come along and break it. Each artist would go after something specific. The way Delacroix used photography was very different from the way Vuillard did.

MG Vuillard's painting, like that of Maurice Denis and another Nabis, Pierre Bonnard, had connections with the snapshot. Put simply, they often look very similar. The relationship, however, was not as straightforward. A painting of the artist's mother sitting at a table, dates from about a decade before the photograph of *Madame Vuillard and Romain Coolus, c.* 1905. It is more the case that Vuillard was attuned to a new world of pictures: images memorializing private fragments of experience.

Jacques Henri Lartigue (1894–1986) was the reverse of Vuillard and Denis. The latter were painters who also took striking snapshots; Lartigue was a society portrait painter, who from childhood took wonderful photographs. He was in fact, an example of a phenomenon we have met before, the mediocre painter who is simultaneously a photographer of extraordinary talent. Lartigue was the great exponent

of what might be called the Proustian snapshot. And his ability seems
to have been almost in-built. The shot of his cousin Bichonnade leaping
down a flight of steps like the angel in a Renaissance painting of the
Annunciation was taken in 1905, when he was 11.

The corollary of the private snapshot was the public newspaper
photograph, taken in much the same way, with a portable camera and roll
film, and sometimes producing equally informal results. Walter Sickert,
a painter of much the same generation as Vuillard, also painted intimate
and private moments in his earlier years. However, for *Miss Earhart's
Arrival*, one of his late masterpieces, he used as a source a photograph
that had appeared on the front page of the *Daily Sketch*. It showed Amelia
Earhart arriving at Hanworth aerodrome, after completing a solo flight
across the Atlantic (she was the second person to do so, the first being
Charles Lindbergh, which was why the newspaper dubbed her 'Lady
Lindy'). Sickert, however, has picked up on the way the newspaper
picture does *not* convey newsworthy information.

JACQUES HENRI LARTIGUE
Bichonnade, 40 rue Cortambert,
Paris, 1905
Gelatin silver print

DH If you'd taken a photograph yourself, you'd probably have decided what aspect of what you were looking at was interesting to you. But if someone else has taken it, they've done that. You are then reacting to the way they saw it, aren't you?

MG The front page mainly showed a crowd assembled on the runway; Sickert has cropped it even further so that it is mainly a mass of people's sodden backs as they stand in the rain. He seems interested in what the contemporary painter Peter Doig called 'the oddity of the photograph': the way it captures shapes and postures that seem strange because they are not the ones the eye and mind are primed to expect. That means, ones not familiar from other pictures.

DH Photography changed again with the appearance of the high-quality, high-speed, lightweight, hand-held camera using 35mm roll film, which was the Leica, first launched in 1925.

MG These changes naturally affected the kinds of picture that could be taken – and the people who were able to take them.

After its introduction, the Leica was the camera of choice for a couple of generations of photographers who found their subjects in the world around them: street photographers such as Henri Cartier-Bresson, Garry Winogrand and Robert Frank.

It was a piece of equipment that enabled someone with the necessary skills to take a picture of just about anything, anywhere. It promoted a mystique of the photographer as existential hero: constantly ready to shoot. 'You have to be quick to take something', as Robert Frank put it, 'the world changes all the time and it doesn't come back. You have to be ready.' Jack Kerouac, author of *On the Road* (1957), bible of the Beat generation, described a trip through Florida with Frank in 1958: 'It's pretty amazing to see a guy, while seated at the wheel, suddenly raise his little 300 dollar German camera with one hand and snap something that's on the move in front of him.'

In a similar spirit, Truman Capote described Cartier-Bresson working in the street in New Orleans, 'dancing along the pavement like an agitated dragonfly, three Leicas swinging from straps around his neck, a fourth hugged to his eye: click-click-click (the camera seemed to be part of his own body), clicking away with a joyous intensity, a religious absorption.'

No. 7,203. [Registered as a newspaper.] MONDAY, MAY 23, 1932. ONE PENNY.

WELCOME "LADY LINDY"!
HEROINE OF THE AIR REACHES LONDON IN A STORM

A storm of thunder and lightning and a cheering crowd of several
hundred people greeted Miss Amelia Earhart, heroine of the record long

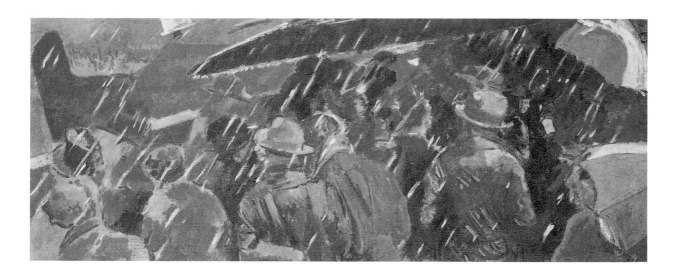

Daily Sketch, May 23, 1932

WALTER SICKERT
Miss Earhart's Arrival, 1932
Oil on canvas

HENRI CARTIER-BRESSON
Hyères, France, 1932
Gelatin silver print

DH Cartier-Bresson now looks very period. His world has gone forever: 'don't crop the picture', all that. A young photographer today wouldn't be able to understand it. You couldn't have another Cartier-Bresson because his work belongs to the era of a certain piece of equipment. It goes from the birth of the Leica to the computer changing the picture in the late 20th century.

MG Changing technology allowed Cartier-Bresson, Robert Frank – and millions of amateurs – to take photographs much more quickly, spontaneously, and in all manner of locations, but they remained *still* pictures. However, similar technical innovations in shutter-speed, lens technology and type of film made it possible to create something more profoundly novel: moving pictures.

 In 1878, an expatriate Englishman living in the western USA who called himself Eadweard Muybridge devised a system for photographing a horse in rapid motion. He set up a racetrack with thread laid across it that triggered the shutters of a series of cameras lined along the course. Muybridge's images of horses and people were

not yet quite moving pictures, more sequential images of movement. But in retrospect we can see that they were films in embryo.

DH Muybridge had a system of a lot of cameras clicking as the horse moved along. But as soon as a camera was developed that could follow the horse, his experiments ended. They led into film. In a way, he was doing little dramas that last a couple of seconds; film just took it over.

MG This new information about how movement occurred, too fast to be visible to the human eye, was of great interest to some painters. Degas used Muybridge's photographs as a basis for several drawings. Similarly, Marcel Duchamp's painting *Nude Descending a Staircase (No. 2)* from 1912 is obviously connected with the chronophotography of Muybridge's French contemporary and fellow experimenter in the photographing of motion, Étienne-Jules Marey, which showed multiple movements on the same photographic plate. It was a sort of collage without glue in which a sequence of exposures were superimposed.

ROBERT FRANK
Belle Isle – Detroit, 1955,
from *The Americans*
Gelatin silver print

307

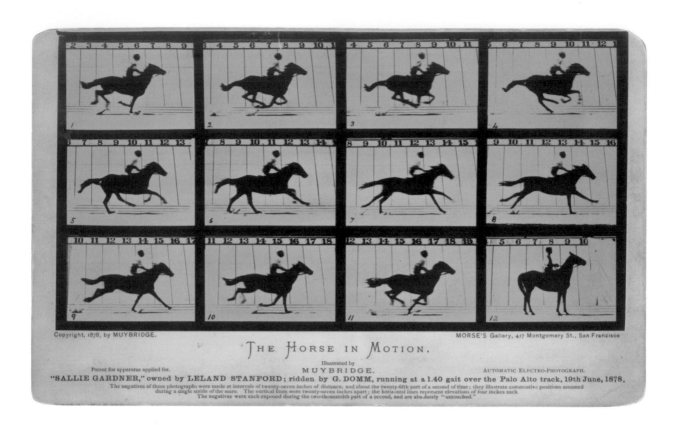

THE HORSE IN MOTION.

Illustrated by
MUYBRIDGE.

Copyright, 1878, by MUYBRIDGE.

MORSE'S Gallery, 417 Montgomery St., San Francisco

Patent for apparatus applied for.

AUTOMATIC ELECTRO-PHOTOGRAPH.

"SALLIE GARDNER," owned by LELAND STANFORD; ridden by G. DOMM, running at a 1.40 gait over the Palo Alto track, 19th June, 1878.

The negatives of these photographs were made at intervals of twenty-seven inches of distance, and about the twenty-fifth part of a second of time; they illustrate consecutive positions assumed during a single stride of the mare. The vertical lines were twenty-seven inches apart; the horizontal lines represent elevations of four inches each. The negatives were each exposed during the two-thousandth part of a second, and are absolutely "untouched."

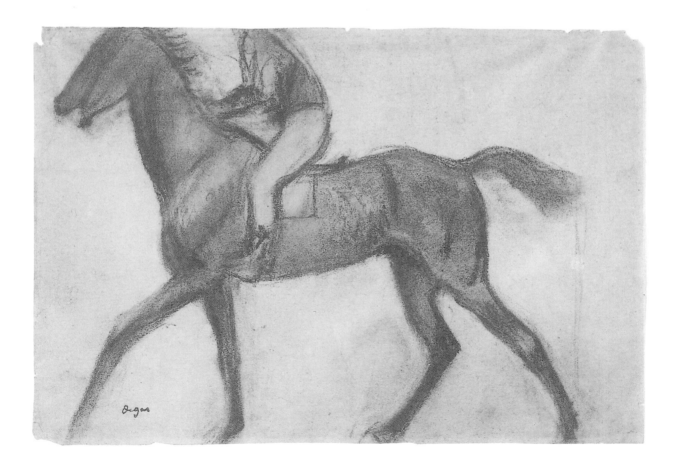

Opposite above
EADWEARD MUYBRIDGE
The Horse in Motion, 1878
Printed card

Opposite below
EDGAR DEGAS
Horse with Jockey in Profile, c. 1887–90
Red chalk on paper

Above
ÉTIENNE-JULES MAREY
Motion Study, c. 1884
Chronophotograph

Right
MARCEL DUCHAMP
Nude Descending a Staircase (No. 2), 1912
Oil on canvas

DH Duchamp's picture is about the movement of the nude. Picasso's Cubism was more profound. He was concerned with the movement of the spectator. In his pictures you can see the front and back of a person at the same time. That means you've walked round them. That's why it's a sort of memory picture and a moving picture, too. But we do make pictures like that in our heads. Even so, the moving picture was a big invention. It had been seen before, because you can see moving projections from a camera obscura. But finding a way of fixing that with chemicals was a huge step.

MG The movie as we know it grew out of many systems for projecting images, making them move and misleading the eye that had been devised over centuries. Devices such as the zoetrope and the flick, or blow, book added the extra element of movement, which exploited the physiological fact that if the human eye sees more than sixteen images per second they seem to fuse into one. If they are sequential – stages in a step, say, or a dance – then the image will seem to walk or waltz. Of course, it is an illusion. Strictly speaking, there is no such thing as a moving picture: only a succession of still ones.

 The development of film enabled photography to merge with another, separately developing tradition of pictures as mass entertainment and popular spectacle. This had been going on for at least half a century before Muybridge began to capture motion on film.

DH Paintings were part of that history, too. Géricault's *Raft of the Medusa* was exhibited at the Egyptian Hall on Piccadilly in 1820, and it cost a shilling to see it. That was a lot of money then. The picture was brought to London to make money, and 40,000 people saw it there. The *Raft of the Medusa* was concerned with a topical subject (a shipwreck off the coast of Africa in 1816): it was *news* really. Later the tragedy would have been a Pathé newsreel at the cinema, or shown on television. Géricault painted it quite quickly so it was still in people's minds.

MG In the 19th century, paintings went on tour like films. The works of the American landscape artist Frederic Church were presented with curtains, like a play. John Martin's epic pictures toured Britain and America. In several ways, Martin presaged 20th- and even 21st-century popular culture. The vast pillared hall depicted in *Belshazzar's Feast* could be a set for a Hollywood epic by D. W. Griffith or Cecil B. DeMille.

Martin's seething crowds, epic landscapes and spectacular special effects sometimes bring the *Lord of the Rings* films to mind, and also the settings of computer fantasy games.

As we have seen before, the history of pictures is continuous and interlinked. One of the prime instigators of the photograph was a painter, Louis Daguerre, but the daguerreotype was his second sensational invention. The first had been the Diorama, a highly successful form of paintings that, effectively, performed. The Diorama was a specially constructed theatre, in which an audience viewed a painting on a translucent backing. By the manipulation of lighting behind the picture – opening and closing flaps across windows – volcanoes were made to appear to erupt, the sun set and rise. Daguerre's pictures moved.

They were not to everyone's taste. John Constable visited the London Diorama and enjoyed it: 'It is in part a transparency; the spectator is in a dark chamber, and it is very pleasing, and has great illusion.' But he also consigned Daguerre's spectacle to a lower level than proper painting: 'It is without the pale of art, because its object is deception. The art pleases by reminding, not deceiving.'

THÉODORE GÉRICAULT
Raft of the Medusa, 1818–19
Oil on canvas

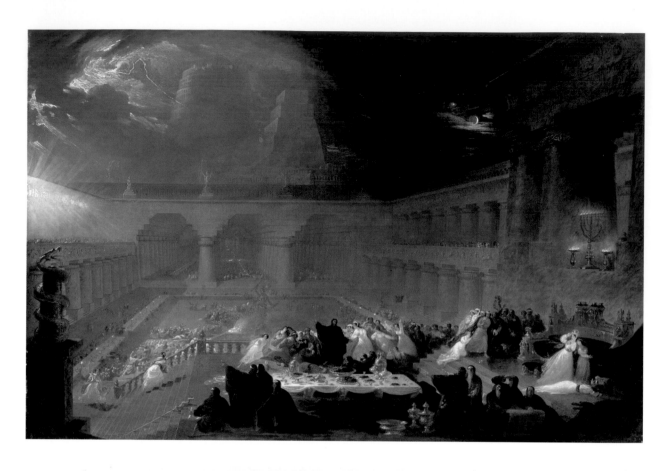

DH Daguerre painted the scenery for his Dioramas, obviously using cameras. That was probably the initial reason for his interest in photography. But the Diorama would have been a bit like waxworks. In art you've got to accept the flat surface. Not to try and pretend it's not there.

MG Whether it pleased Constable or not, the Diorama had mass appeal. When its theatrical scale and special effects were transferred to the new medium of film, the result was the most popular form of picture to date: the movies.

DH A man named Mihály Kertész described seeing his first film in a café in Budapest in about 1910. This moving picture was not in colour and possibly wasn't much bigger than an iPad. It wasn't the story or action that struck him, but the fact that everybody in the café watched it. Not everyone goes to the opera, nor the theatre, but he saw instantly that they would all go to the cinema. He was right: they did. By 1926, he was in Hollywood where they had the light, the money and the technology to make films for an eager world. He changed his name to Michael Curtiz and eventually directed *Casablanca*.

Opposite above
JOHN MARTIN
Belshazzar's Feast, c. 1820
Oil on canvas

Opposite below
UNKNOWN ARTIST
Audience Watching a Diorama, 1848
Engraving

Right
LOUIS DAGUERRE
Ruins of Holyrood Chapel, c. 1824
Oil on canvas

17 Movies and Stills

In a way, cameramen have to know about abstraction.

DH The moving image began in fairground tents as a popular entertainment; it wasn't that sophisticated. When I was at Bradford Grammar School I remember lots of people, educated in the 1920s, who didn't like the cinema because they saw it as plebeian, for workers. But the mass medium of the movies created the world's first truly global stars – Charlie Chaplin was known everywhere, quickly, because of pictures.

Before printing began, celebrities were mainly local. Very few people were famous nationally, let alone internationally: you needed to be on a coin, a statue in the square, or your name passed by word of mouth as a saint's might be. 'There's this man sitting on a pillar, called Simeon Stylites, perhaps next year we'll go and see him.' Books and the newspapers at their peak – when it was Stop Press! Latest News! – were the first mass media. But cinema brought moving pictures everywhere; it was a shared experience around the world.

MG Cinema is a language, a way of organizing moving pictures in time, which today almost everybody instinctively understands. That was not always the case. The first public film show is usually considered to be the one presented by the Lumière brothers at the Grand Café in Boulevard des Capucines, Paris, on 28 December 1895. It featured ten films, including the first they ever made, *Employees Leaving the Lumière Factory*, a brief sequence of their workers streaming out of the gate. The subjects of the others were no more interesting. At this point the fact that – astonishingly – the picture moved was entertainment enough.

DH Around 1900, there was a lot developing in pictures: Cubism, abstraction, Fauvism and films evolved at the same time. But the movie would have looked like the most radical picture of all, simply because it actually *moved*.

Charlie Chaplin, 1931

314

MG The cinema rapidly developed its own language, a vocabulary that depended on something only film can do: cut between one sequence of movement, one angle of vision, one time and another. *The Vanishing Lady* (1896), an early film by Georges Méliès, a theatrical impresario and magician, depended for its effect on the audience being unfamiliar with the way film worked. In the theatre a trap door and other props would be required for the lady to disappear, whereas in the film, of course, all Méliès needed to do was stop the camera while the woman walked out of shot. To early audiences it seemed like magic. Soon, however, the public learned the vocabulary of the movies. That is, they discovered how the trick was done.

DH In Franco Zeffirelli's production of *La Bohème* at the Metropolitan Opera in New York, the first act is a little rooftop studio. Then the curtain goes down for thirty seconds, and when it comes up there's a whole street in Paris with 300 people on stage. The audience just loves it; it's a fantastic thing and a real spectacle. That's why Zeffirelli gets applause.

 The spectacle is partly created by the fact that the audience knows it's difficult to do. If you alter space in the theatre, it's very effective. In the cinema you can change the scene in a fraction of a second, in the theatre you can't. It's a stunning moment; I fall for it every time I go to see it. In the cinema, it would be nothing. Just an edit, and we'd know that.

MG It was Méliès more than anyone else who transformed moving pictures from a simple novelty – a picture that moved – into an imaginative performance. His masterpiece, the first international cinematic sensation, was *A Trip to the Moon* of 1902. Essentially, this is a filmed play – a series of scenes, each shot by a single static camera. It is also closely connected with the traditions of painting. The images largely consist of scenery – that is, hand-painted pictures – and, in a version discovered in Barcelona and restored, each frame was painted by hand (a common procedure in the early days of film). *A Trip to the Moon* belongs almost as much to the history of animation as to that of the cinema.

 Those two histories are closely interconnected. The first programme of animated films was presented by the inventor of the process, Charles-Émile Reynaud, at his Pantomimes Lumineuses at the Musée Grévin in Paris three years before the Lumière brothers put on the first programme of films. Drawing has always been part of the history of moving pictures, and was more important than is sometimes realized.

DH *Snow White and the Seven Dwarfs*, from 1937, was a marvellous piece
of work; it still is, although it was Walt Disney's first animated feature
film. Children today love it and are frightened by it. You can understand
more about how an elephant walks from looking at a Disney animation
of elephants in motion than you could from a photograph, because
the artists who drew that sequence had analysed the way the animals'
muscles and bones moved, and they made it very clear.

MG Many early films are much like Inigo Jones's description of 17th-century plays: 'nothing else but pictures with light and motion'. Méliès not only transformed moving pictures into a medium for telling stories, he also established some techniques that were specific to film – the jump cut, for example, and the fade between one shot and the next – because they were to do with the way that one moving picture could relate to another in time. That is the essence of editing. But Méliès continued to think in terms of putting a theatrical spectacle on the screen.

Over the following years, the techniques of film editing were worked out by a series of individuals. Essentially, they discovered how film might function as a sequence of moving pictures: that is, a series of shots. As early as 1903, in *The Great Train Robbery*, Edwin S. Porter used crosscutting – moving between shots showing events happening at different places, but simultaneously. This was a freedom, as Porter's protégé D. W. Griffith pointed out, that had always been available to writers of stories in words, such as Charles Dickens, but impossible in the theatre. *The Great Train Robbery* also contained an early example of what has been a staple of moving-picture entertainment ever since: the chase.

DH Movement is crucial in films. That's what you are being asked to look at, and you take it in almost unconsciously. It's partly what keeps you there. The silent movie loved the chase. That was a very exciting thing to film, it still is actually: a car chase, a police chase, anyone pursuing somebody is a good subject for a film for that reason. Westerns are all about horse riding. Every good genre of film is about movement, because it has to be. The movement is also in the editing because suddenly the view on the screen changes, then again.

Fritz Lang's *The Nibelungs* from 1924 demonstrates how necessary the development of editing techniques was for the movies: crosscutting, the close-up, the jump cut. He places a camera, but then he just leaves it there. People walk on and off the set, and it's very boring. If the camera doesn't move, there has to be some other motion in the picture. Andy Warhol's *Empire* (1964) – eight hours of the Empire State Building, in a fixed shot – was an ironic comment on movies: by making the movement very slow, almost turning it back into a still, he made it a bore.

The most successful silent movies have incessant motion and visual jokes such as the one with Buster Keaton in *Steamboat Bill, Jr.* (1928), where he is walking down a street in a cyclone and a whole house front is blown down on top of him, but the open window just fits around his

GEORGES MÉLIÈS
A Trip to the Moon, 1902
Film still

CHARLES-ÉMILE REYNAUD
Pauvre Pierrot, 1892
Film still

WALT DISNEY PRODUCTIONS
Jungle Book, 1967
Film still

body. Movement attracts us. If there is a group of people standing still in front of us, and one person moves, we see it. The eye is always looking for motion.

MG In post-revolutionary Russia, the editing techniques of Americans such as Porter and Griffith were intensively studied. Lev Kuleshov, an influential teacher, together with his pupils such as Sergei Eisenstein, pointed out that you could cut between one shot and another not only to tell a story, but also to make an emotional or an intellectual point.

Their ideas were dubbed 'montage theory' and were a close equivalent to the Dadaist technique of photomontage, which was developed at the same time. A photomontage glued parts of different photographs together to make a new image. Montage editing placed moving pictures one after another in *time*.

In Eisenstein's celebrated Odessa Steps sequence from the *Battleship Potemkin* (1925), the Cossack troops are intercut with close-ups of victims and distance shots of the terrified crowd cascading down the stairs in a crescendo of horror. The result is a masterly demonstration of the possibilities of moving pictures. It is, in fact, superb propaganda. In Eisenstein's subsequent film, *October* (1928), shots of the pre-revolutionary leader Kerensky are intercut with others of a mechanical peacock, to suggest preening vanity.

Opposite
CHARLES REISNER
Steamboat Bill, Jr., starring
Buster Keaton, 1928
Film stills

Right
SERGEI M. EISENSTEIN
Battleship Potemkin, 1925
Film still

DH Eisenstein, if anything, edited too much and as a result you can't tell who is doing what. In *October*, you don't know if it's the revolutionaries or the other lot running up and down the stairs of the Winter Palace, but he certainly keeps the picture going.

Many films are propaganda in a way. Goebbels said that the whole point of propaganda was to control the masses, and in the 1920s and 1930s you could do that using the new medium of cinema. In Fritz Lang's *Metropolis*, where you see that first shot of the workers, coming up the elevator and then marching down to work again, they look as if no one is an individual. They are all clones, marching along. That was in 1927. Did film make governments view the people in that way, as faceless?

MG Luis Buñuel and Salvador Dalí used similar techniques to Eisenstein, intercutting one shot with another without any conventional narrative, but put them to completely dissimilar ends. *Un Chien Andalou* (1929) is a plotless movie that consists of a sequence of startling images – most famously an eye being sliced open by a razor – connected only by the logic of a dream. This was a Surrealist collage that moved. The wider public, however, preferred their movies with plot, plus other popular ingredients such as humour, romance, pathos, action and suspense. As the 1920s were succeeded by the 1930s – the age of talkies – the ways in which these were delivered continued to vary as technical possibilities unfolded.

Fritz Lang filming *Metropolis*, 1927

17 Movies and Stills

DH The viewer doesn't always recognize just how artificial movies are, and how the picture altered as the technology developed. Technology changed films constantly from the start. In silent movies there was a great deal of eye movement, the eyes were underlined with make-up, and they were always looking this way and that way – speaking with the eyes – and making exaggerated gestures. After talkies arrived, things calmed down and movement diminished because of the sound. The actors had to stay near the microphone. Once you know that, some scenes can be rather funny.

When colour came in a decade later it needed much brighter illumination. I remember a veteran movie technician telling me: 'The lights were really strong; you could light your cigar from the bulbs.' That was the first Technicolor, which came in around 1938. It was very good with yellow, which is why you have the Yellow Brick Road in the *Wizard of Oz* (1939). The other systems, DeLuxe Color and so forth, weren't so good with the yellows, reds and blues. Technicolor was the best system. Everything evolved rapidly; they got better-quality film.

For a long time you needed a lot of money to make a good film. That's why everybody went to Hollywood, because the studios had the cash. They were looking for film technicians all the time and the best German and English cameramen went there because the pay was more. For decades Hollywood could do things nobody else could do.

MG Techniques of filming moving pictures continued to evolve rapidly in the mid-20th century, and as they did, each suggested new ways of telling stories. The new methods of composing shots in Orson Welles's *Citizen Kane* (1941), for example, were made possible by developments pioneered by a brilliant cinematographer, Gregg Toland, such as 'deep focus'.

This is a method of increasing the focal depth of an image, by reducing the aperture of the lens, using faster film and intensifying the lighting. In combination, these meant that figures in the background, middle ground and foreground of a shot could be seen equally sharply. It made it possible to film a scene in a way that was closer to how the eye sees, and to the manner that painters had been telling stories for centuries, as Lorenzo Lotto did in his *Annunciation*.

In one big, obvious fashion the moving picture is different from all others: it moves and that opens up new possibilities and creates fresh problems. But it is still a type of *picture*, which is why it is part of a common history. In the 20th and 21st centuries, film, painting and photography have fed off one another. It is a point made by Peter Doig, a painter who has used both photography and film as sources for his work.

Doig painted a series of pictures touched off by seeing the horror film *Friday the 13th* (1980), among them *Canoe-Lake*, which directly uses the imagery of a scene from the movie (although completely

ORSON WELLES
Citizen Kane, 1941
Film still

LORENZO LOTTO
Annunciation, c. 1534
Oil on canvas

Right
SEAN S. CUNNINGHAM
Friday the 13th, 1980
Film still

Below
PETER DOIG
Canoe-Lake, 1997–98
Oil on canvas

altering colour, tone and many visual aspects of the shot). In other
pictures, he has used the canoe motif from the movie, blended with other
ingredients, including a painting by George Caleb Bingham, *Fur Traders
Descending the Missouri* (1845), the photographic cover of an album by
the Allman Brothers, and another painting, Arnold Böcklin's *Island of the
Dead* (1880). Thus cinema has come to be part of a world of pictures –
photographic, painted and moving – that co-exist and affect each other.

DH In a way, cameramen have to know about abstraction. So does the movie director. The Battle on the Ice in Eisenstein's *Alexander Nevsky* (1938) is full of tremendous, almost abstract, compositions, with armies sweeping across the frozen battlefield. But of course those lances owe something to Velázquez's *Surrender of Breda*.

In his Hollywood musicals, Busby Berkeley used scale: he'd have cameras shooting from above, and below there were chorus girls making a flower in a swimming pool. Again, it's almost abstract, a human kaleidoscope.

Some moving pictures, like certain paintings, are just stronger than others. When I was surfing through television channels one time, I came across a picture that just looked *better* than everything else I'd seen. It turned out to be from Francis Ford Coppola's film about Vietnam, *Apocalypse Now* (1979), in which every shot is really good. I noticed it straightaway.

MG Coppola is a director – like David Lynch and Alfred Hitchcock – from whose work almost any frame could be frozen, and it would be a beautiful still photograph. Lynch's almost hallucinatory images of small-town America in the television series *Twin Peaks* (1990–91) were partly inspired by the photographs of William Eggleston, which were in turn influenced by Cartier-Bresson.

Douglas Gordon's video installation *24 Hour Psycho* (1993) exploits precisely this aspect of Hitchcock's films by slowing his masterpiece, *Psycho* (1960), from the standard twenty-four frames a second to two, thereby extending its length from 109 minutes to twenty-four hours. The effect is to remove the film's impact as drama, and to leave the viewer lingering over the eerie magnificence of each slowly morphing shot.

Gordon's installation recycled a Hollywood movie as avant-garde art, but the movie itself contained borrowings and echoes from other, earlier, pictures. For example, the gothic house in which Norman Bates lived with his mummified mother was based on *House by the Railroad*, a painting by Edward Hopper.

DH The basic principle – as always – is that pictures influence pictures, and still images can influence moving ones (and vice versa). Hitchcock's films are still very viewable, because he was an extremely *visual* director. He liked to use a storyboard, which is a sort of cartoon strip depicting the movie shot by shot. That means he was imagining how the pictures would

Above
DIEGO VELÁZQUEZ
The Surrender of Breda, c. 1635
Oil on canvas

Right
SERGEI M. EISENSTEIN
Alexander Nevsky, 1938
Film still

LLOYD BACON
Footlight Parade, 1933
Musical numbers created and
directed by Busby Berkeley

look. Even if details changed a bit when it was actually shot, the whole
movie was carefully thought out in advance as a sequence of pictures.

MG The director Martin Scorsese has acknowledged an unexpected visual
source for his own work. About the time he made *Taxi Driver* in 1976,
Scorsese was looking at Jack Hazan's film about David Hockney,
A Bigger Splash (1974).

'There was something about the way Hazan shot David Hockney's
paintings,' Scorsese has remembered, 'and also the way the paintings,
particularly the ones in Los Angeles, had, well, "flatness" is the
wrong word, but it was a direct composition, and it just lent itself to
establishing shots. And if you look at *Taxi Driver*, a lot of the establishing
shots are head-on, and it came from the simplicity or what looked like
simplicity to me of the Hockney angle.'

A dramatic film is a complex collaboration, in which the script,
acting, musical score, set design and camera work all play a part.
That is why the auteur theory of film – that a movie is or should be a
work of art of which the creative mind, the author, is the director – is
debatable. Consequently, a piece of cinema can succeed or fail in many

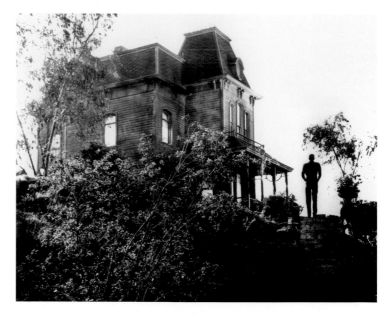

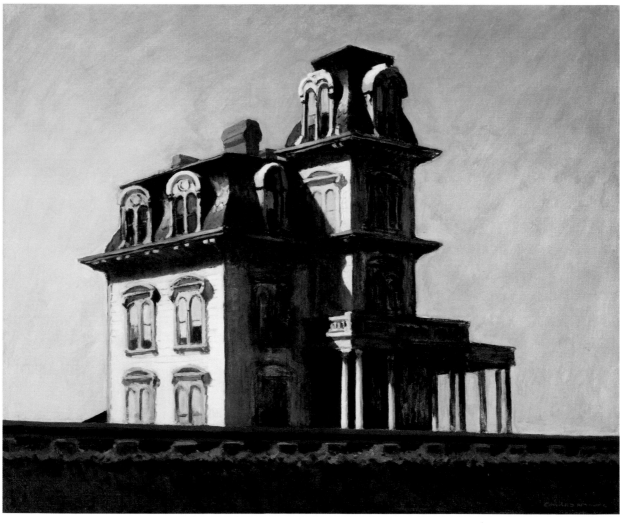

Right
MARTIN SCORSESE
Taxi Driver, 1976
Film still

Below
DAVID HOCKNEY
Santa Monica Blvd, 1978–80
Acrylic on canvas

ways. But if it is powerful as a *picture*, its other shortcomings may seem less important. No less a critic than Luis Buñuel analysed Fritz Lang's *Metropolis* when it was first released in 1927: 'Those who consider the cinema as a discreet teller of tales will suffer a profound disillusion with *Metropolis*', he wrote, 'what it tells us is trivial, pedantic, hackneyed romanticism.' It is hard to deny this judgment: as drama, the film seems even more flimsy and the characters cardboard ninety years later. But, considered visually, Buñuel went on, the film 'will overwhelm us as the most marvellous picture book imaginable'. That's still true, too.

In *Metropolis* the image of a city of the future is based on a picture from the past. It is a mixture in equal parts of New York and Pieter Bruegel the Elder's *Tower of Babel* (which was itself a fantasy based on the Coliseum in Rome). But it is a Bruegel that moves, at least for the length of the sequence.

Right
FRITZ LANG
Metropolis, 1927
Film still

Below
PIETER BRUEGEL THE ELDER
The Tower of Babel, c. 1565
Oil on panel

In many of his video and film works, the artist Bill Viola slows the action down, as in *The Greeting*, which is in essence a moving version of a 16th-century painting: Pontormo's *Visitation*. Viola dwells on the beauty of ordinary actions and gestures, while simultaneously revealing how much movement – and hence time – was frozen in Pontormo's original painting.

DH But there is a fundamental distinction between a still picture and a movie, apart from the fact that one moves and the other does not. You bring your time to the painting; the film imposes its time on you. If somebody said, 'Come home and watch the world's greatest movie', you might say, 'Another day', because it's going to take up a considerable amount of your time. Painting doesn't do that.

And painting is more likely to be memorable. I think we remember still pictures better. They go into the head much more deeply. It's difficult to recall a movie sequence. Billy Wilder once told me he thought it was the still that you retain best.

Above left
PONTORMO
The Visitation, c. 1528
Oil on panel

Above right
BILL VIOLA
The Greeting, 1995
Still from video/sound
installation

18 The Unending History of Pictures

Now is an exciting moment in the history of pictures.

DH Pictures will go on changing, as they always have in the past. In the 23rd century they won't look back at 21st-century television, and think: Well, this was reality, as it looked then! They'll regard it as some old-fashioned method of depiction. Of course, everything is going to be so different in the future, in ways we can't know. The Internet wasn't predicted, not even in science fiction, but it's a big, big thing. What's it going to obliterate? It will cause unbelievable destruction – and creation.

One thing that is not being destroyed, though, is drawing. There are many handmade images in the digital world. For example, video games are drawn pictures. And a lot of them are rather good, actually. Now you can live in a virtual world if you want to, and perhaps that's where most people are going to finish up – in a world of pictures.

MG In 2008, Cao Fei, a young Chinese artist, created a work of art in the form not of an animated film but of an interactive, computer-generated environment: *RMB City*, which exists in the on-line virtual world, *Second Life* (developed by the Linden Lab of San Francisco). This is both a work of art and a platform in which further performances could be staged, among them films by Cao Fei that feature her virtual avatar, China Tracy.

DH I must confess that a conventional photograph to me now seems very flat indeed. *The Great War* by Joe Sacco is a single, enormous drawing of the first day of the Battle of the Somme on 1 July 1916, which contains more than every photograph or film of the subject I've ever seen. It's like a Chinese scroll: a 24-foot black-and-white drawing. The detail Sacco shows you is much better than a film, with the faces of each little figure. It's amazing, stunning. Here's the field kitchen, there the latrines; it goes on and on, through the battlefield, with a mass of explosions.

DAVID HOCKNEY
LA studio, 9 March 2015
Photograph

It ends where they are just burying dead people. You don't see that much in photographs. Once, the photograph was seen as the ultimate picture, but it isn't really. At the moment, it is in crisis. Photoshop and digital editing have made it obvious that there is no reason why you should believe anything in a photograph anymore than you do in a painting. You may believe more in paintings, actually.

MG As we've seen, that question – can you believe in a picture – is one of the constant factors in the history we've been telling. It bothered Plato in the 4th century BC; and it worried the critics of Caravaggio that he used real people as models for sacred figures. The same concern lurks behind the recurrent controversies about 'faking' photographs, and also the news stories and Twitter-storms about the Photoshopping of advertisements, celebrities and political events. There is a persisting expectation that pictures somehow truthfully represent the world. Perhaps some do so more than others, but none do so completely – because that is impossible.

DH At the moment there is a lot more going on in picture construction than there has been for decades. It's all changing. Photography came out of painting and as far as I can see that's where it is returning. The photograph is becoming more like painting, although some photographers don't know it. I can take a photograph on an iPad, alter it, cut out figures, draw on them, transfer them, all sorts of things.

JOE SACCO
The Great War: July 1st, 1916,
The First Day of the Battle of the
Somme (detail), 2013

In *4 Blue Stools*, every single figure, face and chair was photographed separately, even the small ones at the back. I think that is why you have to *look* at everything – because I *saw* every single element one by one. Anyway, it's a far more compelling picture than if I had taken them all together. There's always some other way to do it.

MG Throughout this book, we have argued that there is a single history embracing all pictures that attempt to represent what we see around us: people, things, the earth and sky. At the high-water mark of modernism, in the mid-20th century, there were dominant theories that claimed pictures were divided fundamentally by the media in which they were made. Painting and photography, therefore, had completely different natures. In reality, as it is now easier to understand, they have been intertwined from the beginning, which was long before 1839.

In the past, again and again developments in media, techniques and equipment have altered the manner in which pictures are made, and also the ways that they have been seen. They have moved from the cave wall, to the temple, the church, the photograph album, the cinema, television and the computer screen. Numerous methods of making pictures have been devised, beginning with applying pigment with a stick or a finger, and ending, for now, with computer drawing. There are, however, certain constants; some pictures *last*. That is, we carry on looking at them, for reasons that are ultimately hard to explain.

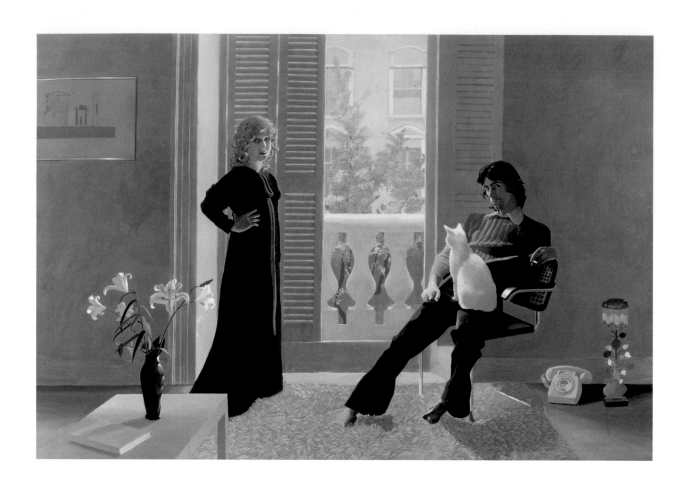

DAVID HOCKNEY
Mr and Mrs Clark and Percy, 1970–71
Acrylic on canvas

DH The dial telephone dates my painting *Mr and Mrs Clark and Percy*, doesn't it? Phones always date fast, but I don't think the picture itself has dated. *Mr and Mrs Clark and Percy* is a memorable picture; I realize that now, forty-five years after I painted it. But I'm not sure why.

MG Pictures can be unforgettable, while depicting nothing out of the ordinary. Two people in a room, a view out of the window, a pet: those are the ingredients of *Mr and Mrs Clark and Percy*, and also of Van Eyck's *Arnolfini Portrait*, painted over four and a half centuries before. Some pictures prove to be perennial; they always appeal to us even if the objects in them become unfamiliar. In time, the exact significance of that white dial telephone, rather smart and stylish in 1971, will be remembered only by social historians (just as is true to today of Giovanni Arnolfini's strange hat or his wife's green gown). Perhaps gallery-goers of the future will wonder what on earth the white phone was, but they'll probably still be looking with pleasure and interest at Celia Birtwell and Ossie Clark, the flowers and Percy the cat – just as we look at the animals painted on the walls of the cave at Lascaux, without knowing who depicted them or why they did so. Conversely, no one in 1971 could have guessed that the humble phone would bring about a revolution in visual communication.

DH In the 21st century phones have become completely amazing. We've moved into a new era, and it's because of what I've got in my pocket. Moreover, the changes are greatly about pictures. Once Hollywood alone had the money to use film technology, but now the technology is everywhere; everyone is becoming a bit of a film-maker because they have a video camera on their phone.

MG We are living through a revolution as profound as that brought about by printing in the 15th century, photography in the 19th and moving pictures in the 20th. Within the last decade, technology has appeared that makes it possible for enormous numbers of people to take a picture – still or moving – and almost immediately publish it to the world, or at least to their followers and contacts, on Twitter, Instagram, WhatsApp and Snapchat.

 The addition of a selfie button to smart phones has transformed the form of pictures just as the appearance of the box Brownie did in the late 19th century. Now 30 per cent of images sent by younger users of social

media are selfies – meaning hundreds of millions of them are taken and sent each day. In a way, the effect is similar to that of the Claude glass on its owners in the 18th century. You start to see your surroundings in terms of a certain kind of picture: in this case, yourself posing with a significant companion or backdrop – beside George Clooney, in front of the *Mona Lisa*.

DH There's a corollary to Andy Warhol's idea that in the future everybody would be famous for fifteen minutes. Now, I think in the future *nobody* will be famous, only known locally to their friends and followers, because of the fragmentation of mass media.

The world today is full of images, but they aren't very memorable, most of them. The more photographs you take, the less time you'll spend looking at each one. At one time, there were only a few pictures around, now there are ever-increasing billions each year. What happens to them all? How will they be seen and how will they be kept? Probably most of them will be lost, almost immediately. Some people will save things, and it's those that will last. Preservation is always a question of somebody *deciding* to keep something. That's a matter of loving care.

MG Not many pictures have ever been awarded that type of attention. Of the millions of photographs taken in the 19th and 20th centuries, most got thrown away. Only the finest paintings enter museums and aristocratic collections. In 2015, Vint Cerf, a vice-president of Google, and one of the originators of the Internet, warned that all the images and documents currently stored on computers might be lost as hardware and software become obsolete. As a result, all records of the 21st century might vanish in a 'digital Dark Age'.

DH I think constantly about what I should update. I've printed out everything I've done on the iPhone and iPad, to make sure there's at least one copy. My assistants and I do it as best we can with the technology available. But if new machines came along we'd get them and print the work again.

MG The history of pictures, naturally, is all about the images that have happened to survive. Which they will be in the future is impossible

to say, but it is likely that they will have certain qualities we have noticed in these pages, such as memorability. They will be the product of hard looking, skill, and require the hand, the heart and the eye.

DH People like pictures. They won't go away. Everybody thought the cinema would kill the theatre, but the theatre will always be there because it's live. Drawing and painting will carry on, like singing and dancing, because people need them. I'm quite convinced that painting will be big in the future. If the history of art and the history of pictures diverge, the power will be with the images. Nobody's taking much notice of the avant-garde any more. They're finding they've lost their authority.

I like looking at the world; I've always been interested in how we see, and what we see. The world is exciting, even if a lot of pictures are not. And right now is an exciting moment in the history of pictures. Does art progress? Not many really think it does, do they? But why does art have to go anywhere? Art hasn't ended, and neither has the history of pictures. People get the idea from time to time that everything is finishing. It doesn't end at all; it just goes on and on and on.

Notes

Full publication details for works cited in abbreviated form below can be found in the Bibliography.

Introduction

11 In *Secret Knowledge* it was claimed: Many of the debates that arose from *Secret Knowledge* can be followed on the websites of Charles Falco (www.fp.optics.arizona.edu/SSD/art-optics/index.html) and David G. Stork (www.webexhibits.org/hockneyoptics/post/stork.html).

11 On 9 May 1839, Herschel wrote: Schaaf, *Out of the Shadows*, p. 75.

11 'this moment left Daguerre's...': ibid.

Chapter 1

20 The task of a map-maker is to describe: Jerry Brotton, *A History of the World in Twelve Maps* (London and New York, 2012), pp. 10–12.

20 To do so with complete fidelity: The impossibility was shown by Carl Friedrich Gauss in the 1820s, ibid., p. 12.

20 Like many medieval images of the world: Peter Whitfield, *The Image of the World: 20 Centuries of World Maps* (London, 1994), pp. 32–33.

20 Fifty years later, a map drawn by Johannes Ruysch: Donald L. McGuirk, Jr., 'Ruysch World Map: census and commentary', *Imago Mundi*, 41 (1989), pp. 133–141.

22 The 15th-century Korean Kangnido map: See Brotton, op. cit., pp. 114–45.

25 Picasso is supposed to have suggested: Ian Morris, *Why the West Rules – For Now: The Patterns of History, and What They Reveal About the Future* (New York and London, 2010), p. 74.

25 Vasari in his: Vasari, *Lives of the Painters, Sculptors and Architects*, 2 vols. The idea of progression is explicitly part of Vasari's theory and history of art: the work of Michelangelo is the culmination of a process that began with Cimabue.

33 A lot of the best photographers, such as Cartier-Bresson: On Cartier-Bresson's early training as a draughtsman, see Jean Leymarie, 'A passion for drawing', in *Henri Cartier-Bresson: The Man, the Image and the World* (London, 2001), pp. 323–24.

33 Cartier-Bresson's technique required: Claude Cookman, 'Henri Cartier-Bresson: Master of photographic reportage', in ibid., pp. 391–92.

33 The very earliest such items: In 2008, a workshop with tools including palettes made from abalone shells for mixing ochre pigments was found amid 100,000-year-old strata at Blombos Cave, South Africa. These did not seem to have been used for cave painting, but perhaps for use on other surfaces, such as the human body. Christopher S. Henshilwood et al., 'A 100,000-year-old ochre-processing workshop at Blombos Cave, South Africa', *Science*, 334 (2011), pp. 219–22.

33 a date that suggests we have lost the first two-thirds of the history of art: There is controversy about the earliest surviving work of art yet found, with a zigzag pattern some 500,000 years old being the first example nominated to date.

Chapter 2

34 'Sometime we see a cloud...': William Shakespeare, *Antony and Cleopatra*, 4:14.

34 'walls spotted with...'; 'landscapers adorned...'; 'divers combats...': Leonardo da Vinci, *Notebooks*, p. 173.

36 *Six Persimmons* by Muqi, a 13th-century: Laurence Sickman and Alexander Soper, *The Art and Architecture of China* (3rd edn, Harmondsworth, 1971), pp. 26–63.

36 Chinese scholar-painters: Yang Xin et al., *Three Thousand Years of Chinese Painting* (New Haven and London, 1997), pp. 215ff.

39 The Chinese painter, calligrapher, art theorist and scholar Dong Qichang: On Dong Qichang, see ibid., pp. 232–35.

39 Certain painters, such as the 14th-century artist Wu Zhen: ibid., pp. 191–92.

39 there was analysis of dry strokes, wet strokes: Sickman and Soper, op. cit., p. 335. In the 17th century, works such as the *Mustard Seed Garden Painting Manual* (1679–1701) illustrated and described how to make these brushstrokes.

46 Michelangelo's early penstrokes show a clear resemblance to those of his master: Michael Hirst, *Michelangelo and His Drawings* (New Haven and London, 1988), pp. 4–5.

46 He tried his utmost: Ascanio Condivi, 'Life of Michelangelo Buonarroti', in Michelangelo, *Life, Letters, and Poetry*, selected and trans. with an introduction by George Bull (Oxford, 1987), p. 10.

50 '10,000 Hour Rule': Malcolm Gladwell, *Outliers* (New York and London, 2008). The 10,000 hours of practice needed to master a discipline are mentioned frequently.

51 'took a quill pen...': Condivi, op. cit., pp. 19–20.

51 'I told him the objection...': Joseph Farington, *The Diary of Joseph Farington*, vol. 13, ed. Kathryn Cave (New Haven and London, 1984), entry for 23 July 1814, p. 4564.

Chapter 3

56 The shadow is a negative phenomenon: A good account of the shadow, scientifically and from the artist's point of view, is given in Michael Baxandall, *Shadows and Enlightenment* (New Haven and London, 1995), pp. 1–15.

56 Some of the best of the first photographs printed on paper: David Bruce, *Sun Pictures: The Hill-Adamson Calotypes* (London, 1973), p. 24.

58 The place where the portraits were mainly shot: ibid., p. 22.

58 Hill and Adamson were fortunate: ibid.

62 But there are other varieties of Hollywood lighting: In the context of DH's description of the *Mona Lisa*, it is worth noting that Leonardo was extremely interested in lighting. He recommends observing faces in dull weather and as evening falls, for soft shadows, and posing the model in a courtyard with black walls and a veil of cloth across the opening to the sky. Leonardo, *Notebooks*, p. 222.

63 Portraiture, according to the Roman author Pliny the Elder: Pollitt, *The Art of Ancient Greece*, p. 124.

63 'no certain knowledge'; 'The Egyptians affirm...': ibid.

64 At any rate, some of the images in the cave at Chauvet: Jean-Marie Chauvet et al., *Chauvet Cave: The Discovery of the World's Oldest Paintings* (London, 1996), pp. 38–40, 44.

64 Pliny went on to tell a tale: Pollitt, op. cit., p. 29.

66 A silhouette is very distinctive: Animals and birds, as well as people, can recognize silhouettes. Roy Sorensen, *Seeing Dark Things: The Philosophy of Shadows* (Oxford and New York, 2008), pp. 33–35.

66 'Silhouettes' were a cheap and popular type of portrait: ibid., p. 26.

67 Orson Welles, the actor playing Lime, was off set: Charles Drazin, *In Search of the Third Man* (London, 1999), p. 59.

67 If the light source is multiple, or diffused: Baxandall, op. cit., p. 5.

69 According to ancient sources: Pollitt, op. cit., pp. 147–48.

69 They were painted in the period of the Roman Empire, but by Greek painters: Euphrosyne Doxiadis, *The Mysterious Fayum Portraits: Faces from Ancient Egypt* (London, 1995), pp. 84–92.

70 Think of Pliny's story about the birds pecking Zeuxis' painting of grapes: Pollitt, op. cit., pp. 149–50.

70 Pliny tells us that Zeuxis: ibid., p. 150.

70 Famously, Plato banished the poets: Plato, *The Republic*, pp. 421–22.

73 Painting and poetry for Plato were both forms of *mimesis* or representation: See ibid., pp. 421–39.

73 'This process of representation...': ibid., p. 432.

73 'It is this natural weakness...': ibid.

73 The last actually appears debating with Socrates: In Xenophon's *Memorabilia*, probably composed after 371 BC.

75 'the element of reason in the mind': Plato, *The Republic*, p. 432.

75 'In this chamber are men...': ibid., p. 317.

76 'figures of men and animals...': ibid.

76 Cornford suggested: *The Republic of Plato*, trans F. M. Cornford (Oxford, 1941), p. 228.

Chapter 4

78 'Then I have an Arlésienne...': Vincent van Gogh to Theo van Gogh, Arles, on or about 3 November 1888, Vincent van Gogh, *The Letters*, eds Leo Jansen, Hans Luijten and Nienke Bakker (London and New York, 2009), vol. 4, Letter 717, p. 352.

80 There are some wonderfully free Monet paintings of the ice melting on the Seine at Vétheuil: See Annette Dixon, Carole McNamara and Charles Stuckey, *Monet at Vétheuil: The Turning Point* (exh. cat., Ann Arbor, MI, 1998), pp. 41–86.

80 The winter of 1879–80 was exceptionally harsh: ibid., p. 78.

80 'On Monday...': ibid., p. 82.

80 Three days later Monet wrote: ibid., p. 83.

84 Friar Roger Bacon stayed up: Amanda Power, *Roger Bacon and the Defence of Christendom* (Cambridge, 2013), p. 87.

84 Sir Charles Wheatstone gave a lecture: Charles Wheatstone, 'Contributions to the physiology of vision – Part the first. On some remarkable, and hitherto unobserved, phenomena of binocular vision', *Philosophical Transactions of the Royal Society of London*, 128 (1838), pp. 371–94. See Ian P. Howard, *Perceiving in Depth, Vol. 1: Basic Mechanisms* (Oxford and New York, 2012), pp. 79–82.

85 Ten years later, in 1849, Sir David Brewster: Howard, op. cit., pp. 82–83.

89 'a space which implied...': George Rowley, *The Principles of Chinese Painting* (Princeton, NJ, 1947), pp. 61–63.

89 made a film with Philip Haas: *A Day on the Grand Canal with the Emperor of China, or, Surface is Illusion But So is Depth*, by David Hockney and Philip Haas (1988).

91 As a 12th-century critic put it, 'a thousand miles...': Zhang Hongxing (ed.), *Masterpieces of Chinese Painting, 700–1900* (London, 2013), p. 157.

91 In his view, there was high distance: William Watson, *The Arts of China, 900–1620* (New Haven and London, 2000), p. 13.

92 'shapes of objects...': Zhang Hongxing (ed.), op. cit., p. 172.

Chapter 5

94 'the perspective expert...': Samuel Y. Edgerton, *The Mirror, the Window and the Telescope: How Renaissance Linear Perspective Changed our Vision of the Universe* (Ithaca, 2009), pp. 39–40.

96 the second of the Palazzo Vecchio viewed across the piazza: Philip Steadman has pointed out (personal communication with the authors) that this second panel of the Piazza della Signoria and Palazzo, though seldom discussed, is highly significant, since from Manetti's description it did not – like the view of the Baptistery – have a single vanishing point. 'The buildings', Steadman writes, 'were seen at angles, and the Palazzo itself must have been shown with two vanishing points, that is, in a "two-point perspective" or "oblique perspective". (There would have been in addition other vanishing points for other buildings.) What Alberti described, and 15th-century artists such as Piero della Francesca took up, were methods for setting up frontal, single vanishing-point perspective. Methods for setting up two-point perspectives were only published in the 16th century by Jean Cousin. Steadman concludes: 'What this says to me is that the perspectives in both Brunelleschi's panels were indeed derived empirically, optically, and not by geometrical construction.'

96 'a representation of the exterior...'; 'In order to paint...': Antonio di Tuccio Manetti, *The Life of Brunelleschi*, ed. Howard Saalman, trans. Catherine Enggass (University Park, PA, and London, 1970), p. 42.

96 'as tiny as a lentil bean': ibid., p. 44.

97 'I have had it in my hands...': ibid.

97 The spirit of photography is much older: The question of whether Brunelleschi could have used optical means to make his panels of the Baptistery and the Palazzo Vecchio is an intriguing one, first raised by Shigeru Tsuji in 'Brunelleschi and the camera obscura: the discovery of pictorial perspective', *Art History*, 13:3 (September 1990), pp. 276–92. In practical terms, the answer seems quite definitely 'yes'. Indeed, the Baptistery and its surrounds have now been traced using three different optical techniques: by DH using a concave mirror to project an image; Malcolm Park has successfully employed a simple pinhole camera to do the same thing (see Malcolm Park, 'Brunelleschi's discovery of perspective's "rule"', *Leonardo*, 46:3 (June 2013), pp. 259–66); and Philip Steadman used a flat mirror to do the job (a method also proposed by Edgerton, op. cit., p. 64). It is also quite possible that Brunelleschi could have made a camera *with a* lens, since these were easily available in early 15th-century Florence, though probably of variable quality (see below).

97 One thing we do know about him: Ross King, *Brunelleschi's Dome* (London, 2000), p. 42.

97 A younger contemporary of Brunelleschi: Ilardi, *Renaissance Vision from Spectacles to Telescope*, p. 191.

98 He was apprenticed: Manetti, op. cit., pp. 38–40.

98 Tuscan goldsmiths were functioning much like modern opticians: Ilardi, op. cit., pp. 76–77. Goldsmiths were associated with articles made of glass as well as gems from antiquity, and especially with the new invention of spectacles, which naturally required frames: sometimes these were made of precious metals, but even humbler models were part of their repertoire. A contract between three Pisan goldsmiths survives from 1445, in which they agree to manufacture eyeglasses with bone frames (ibid., p. 77). They swore on the Bible not to reveal the secrets of the trade – perhaps to do with grinding the lenses to differing prescription strengths, which were common in the mid-15th century – on pain of a 100-florin fine. Spectacles and magnifying lenses became common items – the Duke of Milan was ordering them by the dozen for his court in the mid-15th century, in different prescription strengths (ibid., p. 82).

98 Eye-glasses were invented around: Ilardi, op. cit., pp. 3–18. The invention of spectacles in the late 13th century caused a boom in the manufacture of glass lenses, many of which were probably of low quality. The medieval French term for spectacles was 'bericles' (derived from 'beryl') because of the practice of making them from clear minerals such as quartz and transparent gemstones. However, the fact that a regulation was issued in 14th-century Venice forbidding passing off glass spectacles as crystal implies, as Vincent Ilardi pointed out (ibid., pp. 8–11), that some glass lenses at least were good enough to be confused with crystal lenses; it also indicates that the latter were still the best and most

expensive. Doubts have been raised as to whether the quality of glass in the 15th and 16th centuries was sufficiently high to project good quality images (see Sara J. Schechner, 'Between knowing and doing: Mirrors and their imperfections in the Renaissance', *Early Science and Medicine*, 10:2 (2005), pp. 137–62). But there were several other materials and methods that might have been used, including polished metal for mirrors, rock crystal and gem stones for lenses, and water-filled lenses.

100 examples from the 11th and 12th centuries have been found: Olaf Schmidt, Karl-Heinz Wilms and Bernd Lingelbach, 'The Visby Lenses', *Optometry and Vision Science*, 76:9 (September 1999), pp. 624–30.

100 The receding lines of the barrel vault: Kim W. Woods, *Making Renaissance Art* (New Haven and London, 2007), p. 70.

102 'the willow wands...': Alberti, *On Painting*, p. 47.

102 'to be an open window': ibid., p. 56.

106 'Perspective, no, because it seemed...': Caroline Elam, '"Ché ultima mano!": Tiberio Calcagni's marginal annotations to Condivi's 'Life of Michelangelo", *Renaissance Quarterly*, 51:2 (Summer 1998), pp. 475–97 at p. 492.

Chapter 6

108 Leonardo suggests painters should judge their works by looking at them in a flat mirror: Leonardo, *Notebooks*, p. 221. Alberti made the same point: Alberti, *On Painting*, p. 83.

108 Historically, many people saw paintings and mirror images as much the same thing: Among them Leonardo, who wrote that mirrors and paintings were alike in that they both had flat surfaces, which by means of 'outlines, shadows, and lights' made objects appear in relief.

110 'that if I could transmit to you...': Thomas Gray, *Journal of A Visit to the Lake District in 1769*, 4 October, www.thomasgray.org/texts/

110 Vasari described how Parmigianino: Vasari, *Lives of the Painters, Sculptors and Architects*, vol. 1, p. 935.

110 'So happily, indeed...': ibid.

111 There are dark mirrors like the one in which the Elizabethan alchemist and astrologer John Dee: See Arnaud Maillet, *The Claude Glass: Use and Meaning of the Black Mirror in Western Art*, trans. Jeff Fort (New York, 2009), pp. 50–55.

112 'The quickest way...' Plato, *The Republic*, p. 423.

112 A profound meditation on this very distinction: For a thorough account of *Las Meninas*, see Jonathan Brown, *Velázquez: Painter and Courtier* (New Haven and London, 1986), pp. 256–64.

112 According to an early description by Antonio Palomino: ibid., p. 257.

112 We know from an inventory made after his death that Velázquez owned ten large mirrors: Kemp, *The Science of Art*, pp. 104–5.

115 'big crystal mirror': Ilardi, *Renaissance Vision from Spectacles to Telescopes*, p. 198.

115 'shimmers': Brown, op. cit., p. 261.

115 the man in the doorway – a courtier named José Nieto: ibid., p. 257.

116 'for it is truth, not painting': ibid., p. 261.

116 E. H. Gombrich was one of many: See
 Gombrich's use of Velázquez's name as
 shorthand for the achievements of Western
 art in 'The knowing eye', interview with
 Martin Gayford, *Modern Painters*, 5:4 (Winter
 1992), pp. 68–71.

117 'little bronze instrument...'; 'a thick round
 glass...': Kemp, op. cit., p. 105.

117 The shining shield in the foreground of the
 mosaic: Summers, *Vision, Reflection, and Desire in
 Western Painting*, pp. 40–41.

117 'White highlights reflect...': ibid., p. 41.

120 According to Pliny: Gombrich, *The Heritage
 of Apelles*, pp. 1–2.

121 'collect and reflect...': ibid., p. 4.

122 The works of Van Eyck and his immediate
 followers, such as Petrus Christus, were
 anthologies of reflections on every conceivable
 kind of surface: Anyone wishing to investigate
 this question is recommended to study the
 astonishing examples in Annick Born and
 Maximiliaan P. J. Martens, *Van Eyck in Detail*
 (New York, 2013).

122 According to a late medieval theory, the eye
 itself was a mirror: Summers, op. cit., p. 60.

122 If a mirror possessed a soul, the Iranian
 polymath: Summers, op. cit., p. 60.

125 'By looking at itself...': Nicholas of Cusa,
 Idiota de Mente: The Layman, About Mind,
 trans. with an introduction by Clyde Lee
 Miller (New York, 1979), p. 55.

Chapter 7

133 After the first chandelier, in *The Arnolfini
 Portrait*, there are lots of chandeliers: For
 more on the chandelier, see Hockney, *Secret
 Knowledge*, p. 82.

133 A team including the art historian Martin
 Kemp examined two mid-15th-century
 paintings: A. Criminisi, M. Kemp and
 S. B. Kang, 'Reflections of reality in Jan
 van Eyck and Robert Campin', *Historical
 Methods*, 37:3 (Summer 2004), pp. 109–21.

134 'striking': ibid., p. 118.

134 'It is inconceivable...': ibid., p. 117.

136 We know a great deal less about the life and
 career of Jan van Eyck: Amanda Simpson, *Van
 Eyck: The Complete Works* (London, 2007),
 pp. 5–7; on his controversial role as a miniaturist,
 pp. 26–28.

136 There were two of these, in addition to
 spectacles: magnifying glasses and concave
 mirrors: On concave mirrors as medieval
 reading aids, see Ilardi, *Renaissance Vision
 from Spectacles to Telescopes*, pp. 43–44.

137 The earliest biography of Jan van Eyck: Michael
 Baxandall, 'Bartholomaeus Facius on Painting',
 Journal of the Warburg and Courtauld Institutes,
 27 (1964), pp. 90–107.

137 Italians collected works by Van Eyck: For
 discussion of the Italian taste for Flemish art
 in the 15th century, see Till-Holger Borchert,
 The Age of Van Eyck (London and New York,
 2002), pp. 78–127.

137 The Venetian painter Giovanni Bellini
 questioned Dürer: Albrecht Dürer, *Dürer's
 Record of Journeys to Venice and the Low Countries*
 (New York and London, 1995).

137 Piero's naturalism has a different feeling from
 that of a painting by Van Eyck: Leonardo,
 speaking for the Italian artistic point of view,
 noted that those who painted without 'science'
 and 'the use of reason' were like a mirror
 that copies everything in front of it without
 knowledge of what it sees. Leonardo, *Notebooks*,
 p. 225.

138 In later life, Piero wrote three works on
 mathematical matters: On Piero as a writer and
 theoretician, see Judith Veronica Field, *Piero
 della Francesca: A Mathematician's Art* (New
 Haven and London, 2005).

138 In a dialogue written in the mid-16th century:
 Francisco de Holanda, *Dialogues with
 Michelangelo*, trans. C. B. Holroyd (London,
 2006).

138 'They paint in Flanders...'; ibid., p. 46.

138 'without reasonableness...': ibid. p. 47.

Chapter 8

142 Willem de Kooning famously remarked that
 flesh was the reason why oil paint was invented:
 On oil paint, flesh and Venice, see Martin
 Gayford, 'A grand tradition', *Modern Painters*, 8:3
 (Autumn 1995), pp. 30–33.

144 Leonardo did mad things: On Leonardo's
 technique in *The Last Supper*, see Luke Syson
 et al., *Leonardo da Vinci: Painter at the Court of
 Milan* (New Haven and London), pp. 73–74,
 247–51.

144 The woman's green dress in *The Arnolfini
 Portrait*: Lorne Campbell, *The Fifteenth
 Century Netherlandish Schools (National Gallery
 Catalogues)* (London, 1998), p. 182; Van Eyck
 blotted the green glazes, perhaps with his
 fingers, p. 184.

148 Within three decades, the printing revolution
 spread to Italy: Chapman and Faietti, *Fra
 Angelico to Leonardo: Italian Renaissance
 Drawings*, p. 38.

150 Leonardo da Vinci, the most innovatory artist
 of his generation: ibid., pp. 68, 206.

151 Among the earliest exponents of the printed
 picture: Landau and Parshall, *The Renaissance
 Print, 1470–1550*, pp. 46–50.

153 Dürer's great *Apocalypse*: Norbert Wolf, *Dürer*
 (Munich and London, 2010), pp. 81–114.

154 In contrast, his *Melencolia I* of 1514 is an
 engraving: ibid., pp. 178–84.

154 A work such as Dürer's *Apocalypse* was
 quickly seen across Europe: ibid., p. 81. It was
 echoed, for example, by Raphael in the Stanza
 d'Eliodoro and in murals on Mount Athos.

154 Pictures by painters such as Michelangelo and
 Raphael: Landau and Parshall, op. cit.,
 pp. 143–47.

154 The invention of the chiaroscuro print-making
 process: ibid., pp. 179–202.

154 Some artists learnt these skills; others
 collaborated: Achim Gnann, with David
 Ekserdjian and Michael Foster, *Chiaroscuro:
 Renaissance Woodcuts from the Collections of
 Georg Baselitz and the Albertina, Vienna*
 (exh. cat., London, 2014), pp. 62–81.

154 Similarly, the expert tapestry weavers of
 Brussels: Mark Evans, Clare Browne and
 Arnold Nesselrath (eds), *Raphael: Cartoons
 and Tapestries for the Sistine Chapel* (exh. cat.,
 London, 2010), pp. 33–36, 71, 79.

156 Tapestry was a technique so costly: Thomas B.
 Campbell, *Tapestry in the Renaissance: Art and
 Magnificence* (exh. cat., New York, 2002),
 pp. 3–13.

157 Etching depends on the way that acid: On the
 inception of etching, see Landau and Parshall,
 op. cit., pp. 27–28.

Chapter 9

158 As described by Alberti, an istoria: Alberti,
 On Painting, pp. 72–83, 95–97.

163 Raphael followed this method of working out
 compositions: The genesis of *The Entombment*
 is analysed in Hugo Chapman et al, *Raphael:
 From Urbino to Rome* (exh. cat., London, 2004),
 pp. 212–71.

166 Nicolas Poussin did not merely stage his
 paintings: Anthony Blunt, *Nicolas Poussin* (new
 edn, London, 1995), pp. 242–45.

166 'if he was painting a history...': ibid., p. 242.

167 Le Blond de la Tour, describes Poussin: ibid.

167 Delacroix blamed it for what he considered the
 'extreme aridity': Jane Munro, *Silent Partners:
 Artist and Mannequin from Function to Fetish*
 (New Haven and London, 2014), p. 18.

167 Long before Poussin's day, painters had been
 using mannequins: ibid., pp. 15–16.

167 'in order to be able...': Vasari, *Lives of the Painters,
 Sculptors and Architects*, vol. 1, p. 679.

167 In the following centuries, such lay figures:
 Munro, op. cit., pp. 20–29.

168 Brunelleschi, Raphael, Leonardo and Bernini
 all worked on them: For an account of the sets
 designed by Brunelleschi, see Vasari, op. cit.,
 pp. 355–58.

168 Bernini specialized in them: Charles Avery,
 Bernini: Genius of the Baroque (London, 1997),
 pp. 268–69.

171 'These shows', he wrote in 1632: John Peacock,
 *The Stage Designs of Inigo Jones: The European
 Context* (Cambridge and New York, 1995), p. 48.

Chapter 10

174 This tells us that Caravaggio was almost
 pedantically transcribing: Karel van Mander's
 account of Caravaggio in Howard Hibbard,
 Caravaggio (London, 1983), p. 344.

176 The question of exactly how Caravaggio pieced
 his compositions together has been debated: For
 a summary of opposing views, and an advocacy
 of the idea Caravaggio might have pieced his
 compositions together without optical aids,
 see John L. Varriano, *Caravaggio: The Art
 of Realism* (University Park, PA, 2006),
 pp. 2–16. For an opposing view, see Whitfield,
 Caravaggio's Eye.

178 There was another startling development:
 Giulio Mancini in Hibbard, op. cit., p. 350.

179 Perhaps they were done in the basement
 of his patron: On Caravaggio and Del Monte,
 see Whitfield, op. cit., pp. 47–75.

179 Around 1600, for example, the astronomer
 Johannes Kepler: Sven Dupré, 'Playing with
 images in a dark room: Kepler's *Ludi* inside
 the camera obscura', in Lefèvre (ed.), *Inside the
 Camera Obscura*, pp. 59–73 at p. 59.

180 In the second edition of his treatise *Magia naturalis* (1589), a Neapolitan scholar: Michael John Gorman, 'Projecting nature in early-modern Europe', in Lefèvre (ed.), *Inside the Camera Obscura*, pp. 31–50 at p. 42.

180 In other words, the human eye functioned like a natural camera: Alpers, *The Art of Describing*, pp. 33–41.

182 Galileo studied the moon through a telescope, and he saw a surface covered in blemishes and craters: Donald G. York, Owen Gingerich, Shuang-Nan Zhang (eds), *The Astronomy Revolution: 400 Years of Exploring the Cosmos* (London, 2012), pp. 271–72.

182 Elsheimer was in touch with a group of enthusiastic scientists: Rüdiger Klessmann (ed.), *Adam Elsheimer 1578–1610* (exh. cat., London, 2006), pp. 23, 37, 174–77.

183 Kepler had used such an instrument to follow the transit: Ofer Gal and Raz Chen-Morris, 'Baroque optics and the disappearance of the observer: From Kepler's optics to Descartes' doubt', *Journal of the History of Ideas*, 71:2 (April 2010), pp. 191–217 at p. 191.

183 Pictures were also a crucial way of cataloguing: On art and science in 17th-century Rome, see David Freedberg, *The Eye of the Lynx: Galileo, His Friends, and the Beginnings of Modern Natural History* (Chicago and London, 2002).

186 One of these is Ottavio Leoni (1578–1630), who was known to Caravaggio: On Leoni, see Whitfield, op. cit., pp. 93–97.

186 An 18th-century British topographical artist, Thomas Sandby: John Bonehill and Stephen Daniels (eds), *Paul Sandby: Picturing Britain* (exh. cat., London, 2009), pp. 170–71.

188 In 1636, Daniel Schwenter, a professor: Helmut Gernsheim, *The Origins of Photography* (London and New York, 1982), p. 4.

189 The first detailed description we have of a landscape being drawn in a camera: Alpers, op. cit., pp. 50–51.

190 When looking at Claude's paintings: It has not been suggested previously that Claude might have used a camera, but his career postdates the description of Kepler using a camera to draw landscape, and he was living in Rome – an active centre of scientific and astronomical research. In this context, it is noteworthy that cameras were often used to observe the sun, and Claude's dazzling sunsets and sunrises over the sea would have been hard to observe closely in nature *without* using some such device.

191 One supremely delicate and poetic painting by Elsheimer: Klessmann (ed.), op. cit., pp. 32, 148–51.

Chapter 11

194 'fun-house construction of space': Walter Liedtke et al., *Vermeer and the Delft School* (exh. cat. New York and London, 2001), p. 368.

197 The lenses Vermeer was using were probably better: For a technical analysis of 17th-century lenses, and the requirements and deficiencies of those required for a camera obscura, see Giuseppe Molesini, 'The optical quality of seventeenth-century lenses', in Lefèvre (ed.), *Inside the Camera Obscura*, pp. 117–27. His

conclusion was that 'Overall, it appears that lenses of very good optical quality could be fabricated in seventeenth century', though he doubted that for a camera obscura very high quality was necessary, and certain technical trade-offs were required. See also, Tiemen Cocquyt, 'The camera obscura and the availability of seventeenth century optics – some notes and an account of a test', in Lefèvre (ed.), op. cit., pp. 129–40. Cocquyt experimented by producing images with lenses from the period. His conclusions were that 'To begin with, it was clear that images from *preserved* seventeenth-century lenses are remarkably acceptable, even from notoriously mediocre ones. Furthermore, quality improvement can be observed with increasing lens quality.' Differences in quality, however, led to variations in brilliance and sharpness of detail.

197 In photographic terms, the later painting is much more of a long shot: Carsten Wirth, 'The camera obscura as a model of a new concept of mimesis in seventeenth-century painting', in Lefèvre (ed.), op. cit., pp. 149–93, conducted a number of reconstructions of ways in which a camera might have been used by 17th-century artists such as Vermeer. Wirth writes (p. 168) that 'After a variety of experiments with the camera obscura it can be established that Vermeer's depictions of complex interiors can never correspond to one *single* projection by a historical camera obscura optic.' He would have been piecing together his pictures, using a 'complex method that allowed him to manipulate projected images'. The question would be how many projected images were required, with an outdoor light and a better lens, perhaps fewer would have been necessary.

197 Philip Steadman, author of *Vermeer's Camera*, has made a good case: Philip Steadman, 'Vermeer's *The Little Street*: A more credible detective story', www.essentialvermeer.com. However, Frans Grijzenhout, *Vermeer's Little Street: A View of the Penspoort in Delft* (Amsterdam, 2015) has argued on the basis of archival evidence for another location, nos 40 and 42 Vlamingstraat in Delft. In either case, it seems that Vermeer would have been painting a real place.

198 The discovery of the telescope: On the question of 17th-century lenses, telescopes and cameras, see Molesini, also Cocquyt and Wirth, in Lefèvre (ed.), op. cit.

198 Galileo ground his own: Robert D. Huerta, *Giants of Delft: Johannes Vermeer and the Natural Philosophers* (Lewisburg, PA, and London, 2003), p. 34.

198 'I keep that for myself alone': Savile Bradbury, *The Evolution of the Microscope* (Oxford, 1967), p. 77.

198 New research has recently revealed: Huib J. Zuidervaart and Marlise Rijks, 'Most rare workmen: optical practitioners in early seventeenth-century Delft', *British Journal for the History of Science*, 48:1 (2015), pp. 53–85.

199 'a paire of glasse…': ibid., p. 70.

199 There is an account of an artist: Luigi Crespi, *Vite de' pittori bolognesi non descritte nella Felsina pittrice* (Rome, 1769), p. 218, trans. MG.

202 Jan Steen was born and died in Leiden: H. Perry Chapman et al., *Jan Steen: Painter and Storyteller* (exh. cat., Washington, DC, 1996), pp. 29–30, see pp. 119–21 for the *Burgomaster of Delft and His Daughter*.

202 There are, as we have seen, an infinite number: See Wirth, in Lefèvre (ed.), op. cit., who reconstructs differing methods for Vermeer and Velázquez, and Steadman, *Vermeer's Camera*.

202 Joshua Reynolds saw – and praised – Van der Heyden's picture: Peter C. Sutton, *Jan van der Heyden, 1637–1712* (exh. cat., Greenwich, CT, and Amsterdam, 2007), p. 69.

204 Reynolds knew what he was talking about: ibid.

206 'coloured photograph': Kenneth Clark, *Landscape into Art* (London, 1949), p. 33.

208 'the white paper…': ibid., p. 31.

209 In an 18th-century volume of biographies of Dutch artists: Quoted Jonathan Bikker et al., *Rembrandt: The Late Works* (exh. cat., London, 2014), p. 21.

209 'a work is finished…': Ernst van de Wetering (ed.), *A Corpus of Rembrandt Paintings IV: Self-Portraits* (Heidelberg, 2005), p. 116.

210 'magician': Vincent van Gogh to Theo van Gogh, on or about 10 October 1885, Vincent van Gogh, *The Letters*, eds Leo Jansen, Hans Luijten and Nienke Bakker (London and New York, 2009), vol. 3, Letter 534, p. 291.

210 'I should be happy to give ten years…': the remark was recorded by Van Gogh's friend Anton Kerssemakers, quoted Bikker, op. cit., p. 193.

Chapter 12

212 'Would the pictures…': John Locke, *The Works of John Locke* (London, 1722), vol. 1, p. 46.

215 presents to the artist: Francesco Algarotti, *An Essay on Painting* (London, 1764), pp. 61–62.

215 'make the same use…': ibid., p. 66.

215 'Everyone knows how easy…': Willem Jacob 's Gravesande, *An Essay on Perspective*, trans. Edmund Stone (London, 1724), p. 101.

215 'The prettiest Landskip…': Joseph Addison, *Spectator*, 414 (25 June 1712).

216 'a luminous Room…': *The Works of Alexander Pope, Esq., in Verse and Prose*, ed. William Lisle Bowles (London, 1806), vol. 8, pp. 42–43.

216 An entry on the *Chambre obscure*: Denis Diderot, *Encyclopédie, ou dictionnaire raisonné des sciences, des arts et des metiers*, vol. 3 (Paris, 1753), p. 62.

217 'the best modern painters…': Algarotti, op. cit., pp. 64–65.

218 'the correct way…'; 'scientific accuracy…': Antonio Zanetti the Younger, quoted J. G. Links, *Canaletto* (Oxford, 1982), p. 104.

219 'well able through his use…': Pietro Gradenigo, Journal entry, 25 April 1764, in *Notizie d'arte tratte dai notatori e dagli annali del N. H. Pietro Gradenigo*, ed. Lina Livan (Venice, 1942), p. 106.

219 'the way in which…': Charles-Antoine Jombert, quoted Scharf, *Art and Photography*, p. 21.

222 According to an early biographer: Charles-Nicolas Cochin, in Pierre Rosenberg et al., *Chardin* (exh. cat. London and New York, 2000), p. 116.

222 To achieve this, he had to avoid: ibid.

222 'This is my portrait...': John T. Scott (ed.), *Jean-Jacques Rousseau: Critical Assessments of Leading Political Philosophers* (London and New York, 2006), vol. 4, p. 165.

222 'If we suppose a view...': Reynolds, *Discourses on Art*, p. 237.

223 'Reynolds and West...': Jenny Carson and Ann Shafer, 'West, Copley, and the Camera Obscura', *American Art*, 22:2 (Summer 2008), pp. 24–41 at p. 31.

224 'would recommend the camera...': Lance Mayer and Gay Myers, *American Painters on Technique, Vol. I: The Colonial Period to 1860* (Los Angeles, 2011), p. 14.

224 'not had an opportunity...': Carson and Shafer, op. cit., p. 26.

224 'I wish I could convey...': ibid., p. 35.

225 In Spain, too, the device: Xavier Bray, *Goya: The Portraits* (exh. cat., London, 2015), p. 51.

225 'the gradual decrease of light...': ibid.

Chapter 13

230 'GENTLE READER! Lo...': Erasmus Darwin, *The Botanic Garden; A Poem, in Two Parts* (4th edn, London, 1799), p. xv.

230 'white paper, or white leather...': H. Davy, 'An account of a method of copying paintings upon glass, and of making profiles, by the agency of light upon nitrate of silver. Invented by T. Wedgwood, Esq., With observations by H. Davy', *Journals of the Royal Institution of Great Britain*, 1 (1802), pp. 170–74 at p. 170. Wedgwood's experiments were revealed by the chemist Humphry Davy in this paper. For more on Wedgwood, see Nicholas J. Wade, 'Accentuating the negative: Tom Wedgwood (1771–1805), photography and perception', *Perception*, 34:5 (May 2005), pp. 513–20.

230 The earliest surviving photographic image: For a full account of the remarkable career of Nicéphore Niépce, and his brother Claude, who came close to discovering both photography and the internal combustion engine in the early 19th century, see Victor Fouque, *The Truth Concerning the Invention of Photography: Nicéphore Niépce, His Life, Letters, and Works* (New York, 1935), and Schaaf, *Out of the Shadows*, pp. 30–33.

233 A painter named Cornelius Varley devised a gadget: Varley's own description of his invention can be read in *Transactions of the Society, Instituted at London, for the Encouragement of Arts, Manufactures, and Commerce*, 50 (1834), pp. 119–39.

233 In 1807, the distinguished scientist William Hyde Wollaston: For an account of Wollaston, the invention of the camera lucida, and its use, see Schaaf, op. cit., pp. 28–31.

233 'an instrument whereby...': From the specification of the patent granted to Wollaston, 4 December 1806, *The Repertory of Arts, Manufactures, and Agriculture*, 57:10, Second Series (1807), pp. 160–63.

235 'a camera that can be used...': ibid.

235 A young protégé of Wollaston's: See Schaaf, op. cit., pp. 27–28.

236 'used by most...': *Mechanics' Magazine*, 11 (1829), p. 182.

236 'in a wooden machine...': C. R. Leslie, *Autobiographical Recollections*, ed. Tom Taylor (London, 1860; reprinted Wakefield, 1978), p. 156.

236 'Such means are like...': *Athenaeum*, 3:148 (28 August 1830), p. 540.

236 The sheer difficulty of using optical tools: For Talbot's struggles with the camera lucida, see Schaaf, op. cit., pp. 35–36.

236 'in practice somewhat difficult...': ibid., p. 36. The device in question was a camera obscura.

237 'faithless pencil had left...': ibid., p. 35.

237 Larry Schaaf suggested: ibid., p. 36.

238 His discovery, really, was the chemicals: On the steps by which this came about, see ibid., pp. 45–74.

238 'It is hardly saying too much...': ibid., p. 75.

240 It dates from as early as August: ibid., pp. 41–42.

240 Some of the very earliest photographs: See David Bruce, *Sun Pictures: The Hill-Adamson Calotypes* (London, 1973).

240 'preliminary studies and sketches': '"The pictures are as Rembrandt's but improved": Calotypes by David Octavius Hill and Robert Adamson': *The Metropolitan Museum of Art Bulletin*, new series, 56:4 (Spring 1999), pp. 12–23 at p. 14.

240 'The pictures produced...': ibid.

240 William Etty RA seems to have agreed: Scharf, *Art and Photography*, p. 53.

241 Several of Ingres's landscape drawings: This observation was made by Lüthy, 'Hockney's Secret Knowledge, Vanvitelli's Camera Obscura', *Early Science and Medicine*, 10:2 (2005), pp. 318–20.

242 Naturally, he would have employed anything: On Ingres and the camera lucida, see Hockney, *Secret Knowledge*, pp. 23 and 33.

242 By the next year he was already sufficiently familiar with photography: Scharf, op. cit., p. 49.

243 One beautiful painting by Ingres: On this photograph of a vanished nude, see Font-Réaulx, *Painting and Photography: 1939–1914*, p. 98.

244 A historian of photography, Aaron Scharf: Scharf, op. cit., p. 50.

244 Until the final decade: On Ingres's photo-based self-portraits, see Gary Tinterow and Philip Conisbee (eds), *Portraits by Ingres: Image of an Epoch* (exh. cat., London, 1999), pp. 459–65.

Chapter 14

246 Eighteenth-century artists such as Joshua Reynolds: See above, pp. 222–23.

246 'did his best to...': Font-Réaulx, *Painting and Photography: 1939–1914*, pp. 282–84.

246 a cause célèbre in France: On the Mayer and Pierson case, see Scharf, *Art and Photography*, pp. 151–53.

248 'Is the painter any less of a painter...': ibid., pp. 151–52.

248 'Photography ... consists of a...': ibid., p. 153.

248 Eugène Atget (1857–1927) was a modest: Sylvie Aubenas and Guillaume Le Gall (eds), *Atget: une retrospective* (Paris, 2007).

249 'capable of having all light...': Colin Ford, *Julia Margaret Cameron: 19th Century Photographer of Genius* (London, 2003), p. 46.

249 'the most beautiful photograph...': ibid., p. 70.

249 'without lines or borders...': Ian Chivers (ed.), *Oxford Dictionary of Art* (Oxford, 2004), p. 648.

249 In 1853, the painter and critic Ernest Lacan: Font-Réaulx, op. cit., p. 263.

250 His interest in the subject: On Degas and photography, see Font-Réaulx, op. cit., pp. 277–82.

254 'This photograph was given to me by Degas...': ibid., p. 281.

254 As the 21st-century artist: Talk by Jeff Wall, Canada House, London, 20 February 2015.

254 This movement is often called 'Pictorialism': See Thomas Padon (ed.), *Truth Beauty: Pictorialism and the Photograph as Art, 1845–1945* (Vancouver, 2008).

254 Earlier, there had been a determined effort: See Mia Fineman, *Faking It: Manipulated Photography before Photoshop* (exh. cat., New York, 2012), pp. 26–27.

257 Oscar Gustave Rejlander: On Rejlander, see Edgar Yoxall Jones, *Father of Art Photography: O. G. Rejlander, 1813–1875* (Newton Abbot and Greenwich, CT), 1973.

257 His younger contemporary: Margaret F. Harker, *Henry Peach Robinson: Master of Photographic Art: 1830–1901* (Oxford, 1988).

257 Hill decided to paint a group portrait: David Bruce, *Sun Pictures: The Hill-Adamson Calotypes* (London, 1973), pp. 26–29.

261 The Dadaist technique of photomontage was invented: Hans Richter, *Dada: Art and Anti-Art* (London, 1965), p. 117.

261 'The first instances of this form...': Dawn Ades, Emily Butler and Daniel F. Herrmann (eds), *Hannah Höch* (exh. cat., London and Munich, 2014), p. 161.

262 Clement Greenberg argued: Notably in Clement Greenberg, 'Modernist Painting', *Arts Yearbook*, 4 (1961), pp. 101–8, in which he declared 'flatness alone was unique and exclusive to pictorial art'.

263 'The invention of photography...': John Szarkowski, *The Photographer's Eye* (New York, 1966), p. 6.

263 'laboriously pieced together': ibid., p. 9.

263 Greenberg dismissed: Clement Greenberg, *Art and Culture* (Boston, 1961), pp. 3–21.

265 One of the earliest masterpieces of photography: John Hannavy (ed.), *Encyclopedia of Nineteenth-Century Photography* (London and New York, 2007), vol. 1, pp. 122–25.

265 'The Government, which...': ibid., p. 124.

265 Among the most celebrated: Mary Warner Marien, *Photography: A Cultural History* (2nd edn, London, 2006), p. 110.

265 Intense debate has swirled for decades: Doubts were first raised by Phillip Knightley, *The First Casualty* (London and New York, 1975); for a handy index of the controversy, see www.photographers.it/articoli/cd_capa/index.html

265 It has now been established: By José Manuel Susperregui, *Sombras de la fotografía* (Bilbao, 2009).

266 Another of the most renowned: Peter Hamilton, *Robert Doisneau: A Photographer's Life* (New York and London, 1995), pp. 136–38, 142, 354.

Chapter 15

270 'Thanks to photography...': Font-Réaulx, *Painting and Photography: 1839–1914*, p. 236.

270 Ingres's great rival: On Delacroix and photography, see ibid., pp. 230–33; Scharf, *Art and Photography*, pp. 119–125; Christophe Leribault (ed.), *Delacroix et la photographie* (exh. cat., Paris, 2008).

270 'a translator commissioned...'; 'a copy...': Scharf, op. cit., p. 120.

270 On one occasion: ibid., pp. 121–22.

272 'We experienced a feeling...': ibid., p. 122.

272 Twelve years later, in 1854: Sylvie Aubenas, 'Les albums de nus d'Eugène Delacroix', in Leribault, op. cit., p. 23.

275 The historian of Impressionism John Rewald: John Rewald, *Paul Cézanne* (London, 1950), illustration nos 84 and 85.

277 In the later 19th century painting was changing: On the impact of synthetic colours on 19th-century painters, see John Gage, *Colour and Culture* (London, 1993), pp. 221–24.

277 Painters such as Monet, Pissarro and Sisley: Anthea Callen, *Techniques of the Impressionists* (London, 1987), pp. 23–24. Renoir apparently told his son Jean that without the paint tube there would have been no Impressionism. Victoria Finlay, *Colour* (London, 2002), p. 20.

278 Van Gogh was one of the first to adopt Japanese ways: See Chris Stolwijk et al., *Vincent's Choice: The Musée Imaginaire of Van Gogh* (exh. cat., Amsterdam, 2003), pp. 110–12, 288–97.

278 A great deal of modernist painting depended on looking at Japanese prints: See Siegfried Wichmann, *Japonisme: The Japanese Influence on Western Art since 1858* (London and New York, 1999), on Van Gogh see especially pp. 40–46, 52–57, and on the compositional devices derived from Japanese art by many artists, including Van Gogh, Gauguin, Degas, Manet and Monet, pp. 205–67.

280 One of the most adventurous European paintings: On the various influences blended into *Vision of the Sermon*, Japanese prints among them, see Belinda Thomson, *Gauguin's Vision* (Edinburgh, 2005), pp. 39–59, and Douglas W. Druick and Peter Kort Zegers, *Van Gogh and Gauguin: The Studio of the South* (exh. cat., Chicago and London, 2001), pp. 133–37.

280 'If I had filled the picture...': Alan Macfarlane, *Japan Through the Looking Glass* (London, 2007), p. 26.

283 When Gauguin sailed to the South Pacific: See Françoise Heilbrun, 'La Photographie "servante des arts"', in Claire Frèches-Thory and George T. M. Shackleford, *Gauguin Tahiti: l'atelier des Tropiques* (exh. cat., Paris, 2003), pp. 43–61, especially pp. 53–56.

285 Gauguin's painting *Ta matete*...: Frèches-Thory and Shackleford, op. cit., pp. 53–54, 74.

285 'Merde! Merde!...': Paul Gauguin, *The Intimate Journals of Paul Gauguin*, trans. Van Wyck Brooks (Bloomington, IN, 1958), p. 33; Gauguin attributes the reaction to 'an Italian painter', but it seems likely it was his own.

285 It is part of what Damien Hirst has called: Conversation with Martin Gayford, 2004.

285 There's a wonderful remark of Cézanne's: Quoted by Gauguin, repeated by Matisse, who stated Gauguin had left the quotation in the visitors' book at the Marie Gloanac boarding house in Pont-Aven, see Yves-Alain Bois, *Painting as Model* (Cambridge, MA, and London, 1990), pp. 36–37. But Matisse made it 'a kilogram of green is greener than half a kilo'.

285 They discovered that in the 1930s: See William St Clair, *Lord Elgin and the Marbles* (4th rev. edn, Oxford, 1998), pp. 292–302.

286 'When a still life is no longer within reach, it ceases to be a still life'; 'For me that expressed the desire...'; 'the main line...': From an interview with Dora Vallier in 1954, as quoted in Richard Friedenthal (ed.), *Letters of the Great Artists. Vol. 2: From Blake to Pollock*, trans. Daphne Woodward (New York and London, 1963), p. 264.

286 Henry Moore comes out of about a couple of weeks of drawings by Picasso: See James Beechey (ed.), *Picasso and Modern British Art* (London, 2012), for numerous examples of Picasso's ubiquitous influence on Moore and many others.

288 In the end even Pollock was derived from Picasso: On Pollock's early derivation from, and competition with, Picasso, see Kirk Varnadoe and Pepe Karmel, *Jackson Pollock* (exh. cat., New York and London), pp. 31–34.

291 Once I went straight from the Met: The relationship between El Greco's *Vision of St John* and Picasso's *Les Demoiselles* has been noted by several observers, notably John Richardson, see his *A Life of Picasso. Vol. 1: 1881–1906* (New York and London, 1991), pp. 429–31.

292 There were doctors who wrote books claiming: The idea that the elongation of El Greco's figures was caused by astigmatism dates back to 1913, and was frequently repeated. For bibliographical references and a refutation, see Trevor-Roper, *The World Through Blunted Sight*, pp. 52–57, 187.

292 That was what Hitler and Stalin: The Führer's fulminations about artists who painted the sky green and the clouds 'sulpherous yellow' were made in a speech in 1937. See Georg Bussmann, '"Degenerate art"; a look at a useful myth', in Christos M. Joachimides et al., *German Art in the 20th Century* (exh. cat., London, 1985), pp. 113–24.

292 He said one work was: on Ellsworth Kelly's inspiration by sights in the world about him, see his remarks in Martin Gayford, 'Where the eye leads', *Modern Painters*, 10:2 (Summer 1997), pp. 60–62.

294 'I'm very representational...': Varnadoe and Karmel, op. cit., p. 328.

Chapter 16

296 Someone asked a friend: The remark was made by Henry Geldzahler.

296 The spread of photography was extremely rapid: Scharf, *Art and Photography*, p. 39.

296 By 1847, it was estimated: ibid. p. 42.

296 It took two men to carry: Colin Ford, *Julia Margaret Cameron: 19th Century Photographer of Genius* (London, 2003), p. 41.

298 With a light, hand-held camera: For a summary of the development of the snapshot, see Sandra S. Phillips (ed.), *Exposed: Voyeurism, Surveillance and the Camera since 1870* (London and San Francisco, 2010).

298 In 1851, the wet collodion process: Ford, op. cit., p. 39.

298 Then the roll film was popularized by George Eastman: Michael R. Peres (ed.), *The Focal Encyclopedia of Photography* (Burlington, MA, and Abingdon, 2007), p. 78.

299 The Kodak came with film inside it: Todd Gustavson, *500 Cameras: 170 Years of Photographic Innovation* (New York, 2011), p. 96.

299 Thus the painter Maurice Denis: Elizabeth W. Easton (ed.), *Snapshot: Painters and Photography, Bonnard to Vuillard* (New Haven and London, 2011), pp. 114–15.

300 'she had stopped beside me...': Marcel Proust, *Remembrance of Things Past*, quoted by Elizabeth W. Easton, 'The intentional snapshot', in Guy Cogeval, *Édouard Vuillard* (exh. cat., New Haven and London, 2003), p. 430.

300 'During this brief passage...': ibid.

300 Denis's fellow member of the Nabis group Édouard Vuillard: On Vuillard as photographer, see Easton, 'The intentional snapshot', op. cit., pp. 423–38.

302 'resting it on some furniture...': Jacques Salomon, from an essay in the catalogue for an exhibition, *Vuillard et son Kodak* (Lefevre Gallery, London, 1964), quoted in Easton, 'The intentional snapshot', op. cit., p. 426.

302 'the mauve of nature...': Quoted Cogeval, op. cit., p. 242.

302 Vuillard's painting, like that of Maurice Denis: In his journal from 1890, Vuillard remarked, 'the expressive techniques of painting are capable of conveying an analogy but not an impossible photograph of a moment. How different are the snapshot and the image!', ibid., p. 242.

302 Jacques Henri Lartigue: On Lartigue, see Martine d'Astier et al., *Lartigue: Album of a Century* (New York, 2003; London, 2004).

303 And his ability seems to have been: Lartigue's Proustian interest in preserving memories through his camera comes across in a passage from his journal from 29 May 1910, when he was 14. He describes how he 'lies in wait' in the Bois de Boulogne to photograph elegant ladies, carefully calculating distance, shutter-speed and aperture. The click of his shutter makes a woman jump, and her companion shouts at him. 'What does it matter, though, all that counts is the pleasure of having a new photo ... which I will perhaps keep.' Quoted by Clément Chéroux, 'The memory of an instant', in d'Astier et al., op. cit., p. 23.

303 However, for *Miss Earhart's Arrival*: On *Miss Earhart's Arrival*, see the catalogue entry by Richard Shone in Wendy Baron (ed.), *Sickert: Paintings* (exh. cat., London, 1992), p. 314.

304 'the oddity of the photograph': Peter Doig in conversation with Martin Gayford, March, 2015.

304 Photography changed again: Gustavson, op. cit., pp. 224–32.

304 'You have to be quick...': Conversation with Martin Gayford, 2004.

304 'It's pretty amazing...': Jack Kerouac, 'On the road to Florida', *Evergreen Review*, 14:74 (January 1970), pp. 42–47 at p. 43; Kerouac also wrote the introduction to Frank's photographic book, *The Americans* (New York, 1959).

304 'dancing along the pavement...': Truman Capote, *Portraits and Observations: The Essays of Truman Capote* (New York, 2007), p. 366.

306 In 1878, an expatriate Englishman: Marta Braun, *Eadweard Muybridge* (London, 2010), pp. 133–58.

307 Similarly, Marcel Duchamp's painting: Duchamp was also aware of Muybridge's work, but recalled Marey's images as the trigger for his paintings of 1911–12. See Calvin Tomkins, *Duchamp: A Biography* (New York, 1996; London, 1997), p. 78.

310 The movie as we know it grew out of many systems: Barbara Maria Stafford and Frances Terpak, *Devices of Wonder: From the World in a Box to Images on a Screen* (Los Angeles, 2001), pp. 23–25. For the flip book, see Chris Webster, *Animation: The Mechanics of Motion* (Oxford and Burlington, MA, 2005), pp. 8–10.

310 Géricault's *Raft of the Medusa* was exhibited: Lee Johnson, 'The Raft of the Medusa in Great Britain', *Burlington Magazine*, 96:617 (August 1954), pp. 249–54.

310 The works of the American landscape artist Frederic Church: Church exhibited *The Heart of the Andes* (1859), for example, in a room of its own to an audience that paid an admission charge. It was in an architectural frame, between draped curtains, with potted palms surrounding it; he supplied viewing tubes to the audience to examine details. Andrew Wilton and Tim Barringer (eds), *American Sublime: Landscape Painting in the United States, 1820–1880* (exh. cat., London and Princeton, NJ, 2002), p. 29.

311 The first had been the Diorama: Stephen Bann and Linda Whiteley, *Painting History* (exh. cat., London, 2010), pp. 26, 50.

311 'It is in part a transparency...': R. B. Beckett (ed.), *John Constable's Correspondence. Vol. 6: The Fishers* (Ipswich, 1968), p. 134.

313 Daguerre painted the scenery for his Dioramas: Bann and Whiteley, op. cit.

Chapter 17

314 The moving image began in fairground tents: The films shown in fairgrounds were the ones that were primarily entertainments. See Joseph Garncarz, 'The European fairground cinema', in André Gaudreault et al., *A Companion to Early Cinema* (Oxford and Malden, MA, 2012), p. 317.

314 The first public film show: However, several other performances, in both the USA and Germany, are candidates for the honour of first public movie show, see André Gaudreault, *American Cinema, 1890–1909: Themes and Variations* (New Brunswick, NJ, 2009), pp. 3–6.

316 The cinema rapidly developed its own language: For a summary of cinematic devices used by Méliès, see Elizabeth Ezra, *Georges Méliès* (Manchester, 2000), pp. 29–34.

316 It was Méliès more than anyone else: See the documentary film on Méliès, *The Extraordinary Voyage* (*Le voyage extraordinaire*), directed by Serge Bromberg and Eric Lange, 2011.

316 The first programme of animated films: Laurent Mannoni, *The Great Art of Light and Shadow: Archaeology of the Cinema* (Exeter, 2000), p. 364.

318 Many early films are much like Inigo Jones's description: See ref. for p. 171.

318 Méliès not only transformed: Don Fairservice, *Film Editing: History, Theory and Practice: Looking at the Invisible* (Manchester and New York, 2001), p. 13.

321 In post-revolutionary Russia, the editing techniques: Gordon Gray, *Cinema: A Visual Anthropology* (Oxford and New York, 2010), pp. 113–14.

322 Goebbels said that the whole point of propaganda: David Welch (ed.), *Nazi Propaganda: The Power and the Limitations* (London, 1983), pp. 1–5.

324 The new methods of composing shots: On Toland, Welles and the cinematography of *Citizen Kane*, see Robert L. Carringer, *The Making of Citizen Kane* (Berkeley and London, 1985), pp. 67–86.

324 Doig painted a series of pictures touched off by seeing the horror film *Friday the 13th*: On the paintings derived from this film, see Adrian Searle et al., *Peter Doig* (London, 2007), pp. 10, 70–79.

327 Lynch's almost hallucinatory images of small-town America: On Eggleston's influence on Lynch, among other directors, see S. F. Said, 'A very singular vision', *Daily Telegraph*, 12 November 2005.

327 Douglas Gordon's video installation *24 Hour Psycho*: Klaus Biesenbach, *Douglas Gordon: Timeline* (exh. cat., New York, 2006), pp. 14–15.

327 For example, the gothic house in which Norman Bates lived: Sheena Wagstaff (ed.), *Edward Hopper* (exh. cat., London, 2004), p. 78.

327 He liked to use a storyboard: A large selection of storyboards drawn for Hitchcock's films can be seen at www.the.hitchcock.zone/ wiki/Hitchcock_Gallery:_storyboards. For a discussion of the collaboration this involved, see Chris Pallant and Steven Price, *Storyboarding: A Critical History* (Basingstoke, 2015).

329 The director Martin Scorsese has acknowledged: Jim Leach, 'The art of Martin Scorsese: An interview with the 2013 Jefferson Lecturer', *Humanities*, 34:4 (July/August 2013).

329 'There was something about...': ibid.

331 No less a critic than Luis Buñuel: Luis Buñuel, 'Metropolis', *Gazeta Literaia de Madrid*, 1927.

Chapter 18

339 Now 30 per cent of images sent by younger users: Melanie Hall, 'Family albums fade as the young put only themselves in picture', *Daily Telegraph*, 17 June 2013.

340 In a way, the effect is similar to that of the Claude glass: This parallel is explored further in Nathan Jurgenson, 'Life Becomes Picturesque: Facebook and the Claude Glass', http://thesocietypages.org/ cyborgology/2011/07/25.

340 In 2015, Vint Cerf, a vice-president of Google: Pallab Ghosh, 'Google's Vint Cerf warns of "digital Dark Age"', www.bbc.co.uk/news/ science-environment-31450389.

Bibliography

Alberti, Leon Battista, *On Painting*, trans. with an introduction by John R. Spencer, London, 1956

Alpers, Svetlana, *The Art of Describing: Dutch Art in the Seventeenth Century*, Chicago and London, 1983

Brewer, John, *The Pleasures of the Imagination: English Culture in the Eighteenth Century*, London and New York, 1997

Burns, Paul, *The History of the Discovery of Cinematography*, www.precinemahistory.net/index.html

Chapman, Hugo and Marzia Faietti, *Fra Angelico to Leonardo: Italian Renaissance Drawings*, exh. cat., British Museum, London, 2010

Dupré, Sven, 'Galileo, the telescope, and the science of optics in the sixteenth century', PhD dissertation, University of Ghent, 2002

Edgerton, Samuel Y., *The Mirror, the Window and the Telescope: How Renaissance Linear Perspective Changed our Vision of the Universe*, Ithaca, 2009

Font-Réaulx, Dominique de, *Painting and Photography: 1839–1914*, Paris, 2012

Galassi, Peter, *Before Photography: Painting and the Invention of Photography*, exh. cat., Museum of Modern Art, New York, 1981

Gombrich, E. H., *Art and Illusion: A Study in the Psychology of Pictorial Representation*, 4th edn, London, 1977

—, *The Heritage of Apelles*, Oxford, 1976

—, *Shadows: The Depiction of Cast Shadows in Western Art*, London, 1995

Hammond, John H., *The Camera Obscura: A Chronicle*, Bristol, 1981

— and Jill Austin, *The Camera Lucida in Art and Science*, Bristol, 1987

Hockney, David, *Secret Knowledge: Rediscovering the Lost Techniques of the Old Masters*, London and New York, 2001

Ilardi, Vincent, *Renaissance Vision from Spectacles to Telescopes*, Philadelphia, 2007

James, Christopher, *The Book of Alternative Photographic Processes*, 3rd edn, Boston, 2015

Jelley, Jane, 'From perception to paint: the practical use of the camera obscura in the time of Vermeer', *Art & Perception*, 1 (2013), pp. 19–47

Kemp, Martin, *The Science of Art: Optical Themes in Western Art from Brunelleschi to Seurat*, New Haven and London, 1990

Landau, David and Peter Parshall, *The Renaissance Print: 1470–1550*, New Haven and London, 1994

Lefèvre, Wolfgang (ed.), *Inside the Camera Obscura – Optics and Art under the Spell of the Projected Image*, Berlin, 2007

Leonardo da Vinci, *Notebooks*, selected by Irma A. Richter, ed. with an introduction by Thereza Wells, Oxford, 2008

Lindberg, David C., *Studies in the History of Medieval Optics*, London, 1983

Lüthy, Christoph, 'Hockney's Secret Knowledge, Vanvitelli's camera obscura', in *Early Science and Medicine, Special issue: Optics, Instruments and Painting, 1420–1720: Reflections on the Hockney-Falco Thesis*, 10:2 (2005), pp. 315–39

McCauley, Anne, 'Talbot's Rouen window: Romanticism, *Naturphilosophie* and the invention of photography', *History of Photography*, 26:2 (2002), pp. 124–31

Marbot, Bernard, *After Daguerre: Masterworks of French Photography (1848–1900) from the Bibliothèque Nationale*, exh. cat., Musée du Petit Palais, Paris; Metropolitan Museum of Art, New York, 1980

Melchior-Bonnet, Sabine, *The Mirror: A History*, trans. Katharine H. Jewett, New York and London, 2001

Phillipps, Evelyn March, *The Venetian School of Painting*, London, 1912

Plato, *The Republic*, trans. with an introduction by Desmond Lee, rev. edn, Harmondsworth and Baltimore, 1974

Pliny the Elder, *Natural History: A Selection*, trans. with an introduction by John F. Healy, London, 1991

Pollitt, J. J., *The Art of Ancient Greece: Sources and Documents*, Cambridge, 1990

Reeves, Eileen, *Evening News: Optics, Astronomy, and Journalism in Early Modern Europe*, Philadelphia, 2014

—, *Galileo's Glassworks: The Telescope and the Mirror*, Cambridge, MA, and London, 2008

—, *Painting the Heavens: Art and Science in the Age of Galileo*, Princeton, NJ, 1997

Rewald, John, *The History of Impressionism*, 4th rev. edn, London and New York, 1973

Reynolds, Joshua, *Discourses on Art*, ed. Robert R. Wark, London, 1981

Schaaf, Larry J., *Out of the Shadows: Herschel, Talbot & the Invention of Photography*, New Haven and London, 1992

Scharf, Aaron, *Art and Photography*, rev. edn, Harmondsworth and Baltimore, 1974

Snyder, Laura, J., *Eye of the Beholder: Johannes Vermeer, Antoni van Leeuwenhoek, and the Reinvention of Seeing*, New York and London, 2015

Sontag, Susan, *On Photography*, Harmondsworth, 1979

Steadman, Phillip, 'Allegory, realism, and Vermeer's use of the camera obscura', in *Early Science and Medicine, Special issue: Optics, Instruments and Painting, 1420–1720: Reflections on the Hockney-Falco Thesis*, 10:2 (2005), pp. 287–314

—, 'Gerrit Dou and the concave mirror', in *Inside the Camera Obscura – Optics and Art under the Spell of the Projected Image*, ed. Wolfgang Lefèvre, Berlin, 2007, pp. 227–42

—, *A Photograph of the 'Little Street'*, www.vermeerscamera.co.uk/essayhome.htm

—, *Vermeer's Camera: Uncovering the Truth Behind the Masterpieces*, Oxford, 2001

Summers, David, *Vision, Reflection, and Desire in Western Painting*, Chapel Hill, NC, 2007

Trevor-Roper, Patrick, *The World Through Blunted Sight: An Inquiry into the Influence of Defective Vision on Art and Character*, rev. edn, London, 1997

Vasari, Giorgio, *Lives of the Painters, Sculptors and Architects*, trans. Gaston de Vere, 2 vols, London, 1912

Wheelock, Arthur K. and C. J. Kaldenbach, 'Vermeer's *View of Delft* and his vision of reality', *Artibus et Historiae*, 3:6 (1982), pp. 9–35

Whitfield, Clovis, *Caravaggio's Eye*, London, 2011

List of Illustrations

a=above, b=below, c=centre,
l=left, r=right
Dimensions are given in
centimetres, followed by inches

astronomer Christoph Scheiner, *c.* 1615. Pen and ink on paper. Pulkovo collection, Archive of the Russian Academy of Sciences, St Petersburg branch

191 Claude Lorrain, *The Pyramid of Caius Cestius*, *c.* 1630. Pen and brown ink on off-white paper, 90 × 127 (35½ × 50). Ashmolean Museum, University of Oxford

192a Adam Elsheimer, *Large Campagna Drawing with a Mule Train*, early 17th century. Brown ink on paper, 17.7 × 26.6 (7 × 10½). Kupferstichkabinett, Staatliche Museen, Berlin. Photo bpk/Kupferstichkabinett, SMB/Jörg P. Anders

192b Adam Elsheimer, *Aurora*, *c.* 1606. Oil on copper, 17 × 22.5 (6¾ × 8⅞). Herzog Anton Ulrich Museum, Braunschweig

193 Peter Paul Rubens, *Landscape by Moonlight*, 1635–40. Oil on canvas, 31 × 22 (12¼ × 8⅝). The Courtauld Gallery, London

195 Jan Vermeer, *The Procuress*, 1656. Oil on canvas, 143 × 130 (56 × 51). Gemäldegalerie Alte Meister, Staatliche Kunstsammlungen, Dresden

196 Jan Vermeer, *View of Houses in Delft*, known as *The Little Street*, *c.* 1658. Oil on canvas, 54.3 × 44 (21⅜ × 17⅜). Rijksmuseum, Amsterdam

200 Giuseppe Maria Crespi, *Courtyard Scene*, *c.* 1710–15. Oil on canvas, 76 × 90 (29⅞ × 35⅜). National Art Gallery, Bologna. The Art Archive/Alamy Stock Photo

201 Eugène Atget, *Cour, 41 rue Broca*, 1912. Albumen silver print, 16.9 × 21 (6⅝ × 8¼). The Museum of Modern Art, New York. Photo The Museum of Modern Art, New York/Scala, Florence

203 Jan Steen, *The Burgomaster of Delft and his Daughter*, 1655. Oil on canvas, 106 × 96 (41¾ × 37¾). Rijksmuseum, Amsterdam

205a Jan van der Heyden, *View of the Oudezijds Voorburgwal with the Oude Kerk in Amsterdam*, *c.* 1670. Red chalk on paper, 33.5 × 22.5 (13 × 9). Rijksmuseum, Amsterdam. Courtesy Rijksmuseum, Amsterdam

205b Jan van der Heyden, *View of the Oudezijds Voorburgwal with the Oude Kerk in Amsterdam*, *c.* 1670. Oil on panel, 41.4 × 52.3 (16¼ × 20⅝). Royal Cabinet Paintings, Mauritshuis, The Hague

207 Johannes Vermeer, *The Art of Painting*, *c.* 1666–68. Oil on canvas, 130 × 110 (51 × 43).

Kunsthistorisches Museum, Vienna

209 Rembrandt van Rijn, *View of Houtewael near the Sint Anthoniespoort*, *c.* 1650. Reed pen and brown ink with grey-brown wash and touches of white on laid paper, 12.5 × 18.3 (5 × 7). National Gallery of Art, Washington, DC

210 Rembrandt van Rijn, *The Jewish Bride*, *c.* 1665–69. Oil on canvas, 121.5 × 166.5 (47⅞ × 65½). Rijksmuseum, Amsterdam

211 Rembrandt van Rijn, *The Blinding of Samson*, 1636. Oil on canvas, 206 × 276 (81⅛ × 108⅝). Städel Museum, Frankfurt

213 Charles Amédée Philippe van Loo, *The Camera Obscura*, 1764. Oil on canvas, 88.6 × 88.5 (34⅞ × 34⅞). National Gallery of Art, Washington, DC. Liszt collection/Alamy Stock Photo

214a William Henry Fox Talbot, William Henry Fox Talbot (right) with assistants at their calotype production facility in Baker Street, Reading, Berkshire, 1846. Photo Pictorial Press Ltd/Alamy Stock Photo

214b Christiaan Andriessen, *Artist with a Camera Obscura*, 20 July 1806. Pen, ink and wash, 25.8 × 18.1 (10³⁄₁₆ × 7⅛). Rijksmuseum, Amsterdam. Courtesy Rijksmuseum, Amsterdam

216l&r A. J. Deferhrt after Louis-Jacques Goussier, *Dessein: Chambre obscure*, Plates IV and V, Plates vol. 3, 1763, from *Encyclopédie*, edited by Denis Diderot, 1751–72

217 Canaletto, *Piazza San Marco*, late 1720s. Oil on canvas, 68.6 × 112.4 (27 × 44¼). The Metropolitan Museum of Art, New York

218 Antonio Zanetti the Elder, *Caricature of Michele Marieschi*, *c.* 1740–41. Pen and ink with pencil on paper, 23 × 20 (9 × 7⅞). Fondazione Giorgio Cini, Venice. Courtesy Fondazione Giorgio Cini, Venice

220a Unknown photographer, *Piazza San Marco*, *c.* 1885. Albumen print, 19 × 24 (7½ × 9½)

220b Francesco Guardi, *Venice: Piazza San Marco*, after 1780. Oil on canvas, 34.9 × 53.4 (13¾ × 21). National Gallery, London. Photo National Gallery, London/Scala, Florence

221a Canaletto, *Views of the Campo San Giovanni e Paolo in Venice*, *c.* 1740. Pen and brown ink on cream paper, Galleria dell'Accademia, Venice. Courtesy

Ministero Beni e Att. Culturali e del Turismo

221b Canaletto, *Venice: The Feast Day of Saint Roch*, *c.* 1735. Oil on canvas, 147.7 × 199.4 (58⅛ × 78½). National Gallery, London

223 Jean-Siméon Chardin, *Still Life with the Attributes of the Arts*, 1766. Oil on canvas, 112 × 140.5 (44⅛ × 55⅜). The State Hermitage Museum, St Petersburg

225 John Singleton Copley, *Self-Portrait*, *c.* 1780–84, Oil on canvas, diameter 56.5 (22¼), National Portrait Gallery, Smithsonian Institution, Washington, DC. Niday Picture Library/Alamy Stock Photo

226a Thomas Jones, Page from a sketchbook of the Villa Mondragone from the Villa Falconieri Gardens at Frascati, 1777. Pencil on paper, 21.5 × 27.7 (8½ × 10⅞). British Museum, London. Photo The Trustees of the British Museum

226b Thomas Jones, *A Wall in Naples*, *c.* 1782. Oil on paper, laid on canvas, 11.4 × 16 (4½ × 6¼). National Gallery, London

227l Francisco de Goya, *Doña María Teresa de Vallabriga y Rozas*, 1783. Oil on panel, 67.2 × 50.4 (26½ × 19⅞). Museo Thyssen-Bournemisza, Madrid

227r Christen Købke, *Portrait of a Young Man*, 1841. Pencil on paper, 17.9 × 12.2 (7 × 4¾). The Morgan Library & Museum, New York

229a Anne Vallayer-Coster, *Spring: A trompe l'oeil of a bas-relief within a frame*, 1776. Oil on canvas, 30 × 40 (11¾ × 15¾). Private collection

229b Hippolyte Bayard, *Terre cuite de Clodion, dite la fête à Pan*, 1853. Salted paper print from glass negative, 16.3 × 25 (6⅜ × 9⅞). École Nationale Supérieure des Beaux-Arts, Paris. Photo Beaux-Arts de Paris, Dist. RMN-Grand Palais/image Beaux-Arts de Paris

231 William Henry Fox Talbot, *Buckler Fern*, 1839. Photogenic drawing negative, 22.1 × 17.8 (8¾ × 7)

232a Thomas Jones, *Rooftops in Naples*, 1782. Oil on paper, mounted as a drawing, 14.3 × 35 (5⅝ × 13¾). Ashmolean Museum, University of Oxford

232b Joseph Nicéphore Niépce, *View from the Window at Le Gras*, *c.* 1826. Gernsheim Collection, Harry Ransom Humanities Research Center, The University of Texas at Austin

233 Camera lucida in use, *Scientific American*, January 11, 1879

234 Cornelius Varley, *Portrait of J. M. W. Turner*, 1815. Pencil on paper, 50.3 × 37.4 (19¾ × 14¾). Sheffield Galleries and Museums Trust. Photo Museums Sheffield/Bridgeman Images

235 Sir John Herschel, *The Temple of Juno, Girgenti, Sicily, 28 June 1824*, 1824. Pencil on paper. Science Museum, London. Science & Society Picture Library/Getty Images

237 Sir Francis Leggatt Chantrey, *Sir John Soane*, *c.* 1827. Pencil on paper, 47.3 × 64.5 (18⅝ × 25⅜). National Portrait Gallery, London. Photo National Portrait Gallery, London

238 William Henry Fox Talbot, *Villa Melzi, 5th October 1883*, 1883. Camera lucida drawing. National Media Museum, Bradford

238a Louis Daguerre, *Boulevard du Temple*, 1838. Bavarian National Museum, Munich

238b William Henry Fox Talbot, *The Oriel Window, South Gallery, Lacock Abbey*, 1835. Photogenic drawing negative, 8.3 × 10.7 (3¼ × 4¼) (irregular). The Metropolitan Museum of Art, New York

241l David Octavius Hill and Robert Adamson, *William Etty*, 1844. Calotype, 20 × 14 (7⅞ × 5⅝). National Portrait Gallery, London. Photo National Portrait Gallery, London

241r William Etty, *Self-Portrait*, 1844. Oil on millboard, 41 × 31 (16¼ × 12½). National Portrait Gallery, London. Photo National Portrait Gallery, London

242 Jean-Auguste-Dominique Ingres, *View of the Villa Medici, Rome*. Pencil on white paper, 1807, 12 × 20 (4¾ × 7⅞). Harvard Art Museums/Fogg Museum, Cambridge, MA. Imaging Department, President and Fellows of Harvard College

243 Désiré-François Millet, *View of the interior of Ingres' studio, with the lost painting of Madame Ingres*, *c.* 1852. Daguerreotype. Musée Ingres, Montauban

244l Gerothwohl and Tanner, *Jean-Auguste-Dominique Ingres*, *c.* 1855. Private collection

244r Jean-Auguste-Dominique Ingres, *Self-Portrait*, 1864–65. Oil on canvas, 96.7 × 86 (38⅛ × 33⅞). Royal Museum of Fine Art, Antwerp

245 Jean-Auguste-Dominique Ingres, *Louis-François Bertin*,

1832. Oil on canvas, 116.2 × 94.9 (45¾ × 37⅜). Musée du Louvre, Paris

247a Fernand Khnopff, The artist's sister Marguerite Khnopff in a study for *The Secret*, c. 1901. Aristotype (citrate print) from a glass negative, 15.5 × 11 (6⅛ × 4⅜). Musée d'Orsay, Paris. Photo RMN-Grand Palais (Musée d'Orsay)/Hervé Lewandowski

247b Fernand Khnopff, *The Secret*, 1902. Crayon on paper, 27.8 × 49 (11 × 19.2). Groeningemuseum, Bruges. Photo Lukas – Art in Flanders VZW/Bridgeman Images

249 Eugène Atget, *Rue de l'Hôtel de Ville, Paris*, 1921. Albumen silver print from glass negative, 17.6 × 22.1 (6⅞ × 8¾). Photo The Museum of Modern Art, New York/Scala, Florence

250 Nadar (Gaspard-Félix Tournachon), *Gioacchino Rossini*, 1856. Salted paper print from glass negative, 24.6 × 18.3 (9¾ × 7¼)

251 Julia Margaret Cameron, *Sir John Herschel*, 1867. Albumen silver print from glass negative, 35.9 × 27.9 (14⅛ × 11)

252 André-Adolphe-Eugène Disdéri, *Prince Richard de Metternich and Princess Pauline de Metternich*, 1860. Carte-de-visite. Château de Compiègne, France. Photo RMN-Grand Palais (Domaine de Compiègne)/Gérard Blot

253 Edgar Degas, *Princess Pauline de Metternich*, c. 1865. Oil on canvas, 41 × 29 (16⅛ × 11⅜). National Gallery, London

255 Edgar Degas, *Pierre-Auguste Renoir and Stéphane Mallarmé*, 1895. Gelatin silver print, 39.1 × 28.4 (15⅜ × 11⅛). The Museum of Modern Art, New York. Photo The Museum of Modern Art, New York/Scala, Florence

256 Edward J. Steichen, *The Flatiron*, 1904. Gum bichromate over platinum print, 47.8 × 38.4 (18⅞ × 15⅛). The Metropolitan Museum of Art, New York. © 2016 The Estate of Edward Steichen/ARS, NY and DACS, London

258a Oscar Gustav Rijlander, *Two Ways of Life*, 1857 (printed 1920s). Carbon print, 40.6 × 76.2 (16 × 30). The Metropolitan Museum of Art, New York

258b Henry Peach Robinson, *Fading Away*, 1858. Albumen silver print from glass negatives, 23.8 × 37.2 (9⅜ × 14⅝). The Metropolitan Museum of Art, New York

259 Jeff Wall, *A View from an Apartment*, 2004–05. Transparency on lightbox, 167 × 244 (65¾ × 96⅛). Courtesy of the artist

260a David Octavius Hill, *The First General Assembly of the Free Church of Scotland; Signing the Act of Separation and Deed of Demission – 23 May 1843*, 1866. Oil on canvas, 142.2 × 365.8 (56 × 144). Free Church of Scotland. Photo George T. Thompson LRPS, Free Church of Scotland

260b Peter Blake and Jann Haworth, *Sgt. Pepper's Lonely Hearts Club Band*, 1967. Record sleeve. Apple Records, Photo Pictorial Press Ltd/Alamy Stock Photo

261 Thomas Hicks (?), Composite portrait of Abraham Lincoln and John C. Calhoun, c. 1860s

262 Raoul Hausmann, *ABCD*, 1923–24. Photomontage, 40.4 × 28.2 (16 × 11). Centre Pompidou-Musée National d'Art Moderne, Paris. © ADAGP, Paris and DACS, London 2016

264 Robert Rauschenberg, *Retroactive I*, 1963. Oil and silk screen ink, 213.4 × 152.4 (84 × 60). Wadsworth Atheneum Museum of Art, Hartford, Connecticut. © Robert Rauschenberg Foundation/DACS, London/VAGA, New York 2016

266 Hippolyte Bayard, *Self-Portrait as a Drowned Man*, 1840. Direct positive print. Société Française de Photographie, Paris

267a Alexander Gardner, *Home of a Rebel Sharpshooter, Gettysburg*, from *Gardner's Photographic Sketchbook of the War*, 1865. Albumen silver print, 17.8 × 22.9 (7 × 9). Alexander Gardner/Getty Images

267b Robert Capa, *The Falling Soldier (Death of a Loyalist Militiaman)*, 1936. Gelatin silver print. © Robert Capa/Magnum Photos

268 Robert Doisneau, *The Kiss by the Hôtel de Ville*, 1950. Gelatin silver print. Robert Doisneau/Gamma-Rapho/Getty Images

269 David Hockney, *The Massacre and the Problems of Depiction, after Picasso*, 2003. Watercolour on 7 sheets of paper, 45.7 × 60.9 (18 × 24) each sheet, 143.5 × 183.5 (56½ × 72¼) overall. The David Hockney Foundation. Photo Richard Schmidt. © David Hockney

271 Jean-Léon Gérôme, *Truth Coming Out of Her Well to Shame Mankind*, 1896. Oil on canvas, 90.8 × 71.8 (35¾ × 28¼). Collection du Musée Anne-de-Beaujeu, Moulins

272 Eugène Durieu, *Male Nude*, 1854. Calotype. Bibliothèque Nationale de France, Paris. Photo BnF, Dist. RMN-Grand Palais/ image BnF

273l Eugène Durieu, *Female Nude*, 1854. Calotype. Bibliothèque Nationale de France, Paris

273r Eugène Delacroix, *Odalisque*, 1857. Oil on wood, 35.5 × 30.5 (13¾ × 12). Private collection

274 John William Waterhouse, *Saint Eulalia*, 1885. Oil on canvas, 188.6 × 117.5 (74.2 × 46.2). Tate, London

275 Edgar Degas, *Place de la Concorde*, 1875. Oil on canvas, 78.4 × 117.5 (30⅞ × 46¼). The State Hermitage Museum, St Petersburg

276a John Rewald, *Mont Sainte-Victoire seen from Les Lauves*, c. 1935. Photograph. Courtesy Sabine Rewald

276b Paul Cézanne, *Mont Sainte-Victoire*, 1902–06. Oil on canvas, 64.8 × 81.3 (25½ × 32). Philadelphia Museum of Art

277 Paul Cézanne, *The Card Players*, 1890–92. Oil on canvas, 135.3 × 181.9 (53¼ × 71⅝). The Barnes Foundation, Philadelphia

279a Claude Monet, *Vétheuil in Summer*, 1880. Oil on canvas, 60 × 99.7 (23⅝ × 39¼). The Metropolitan Museum of Art, New York

279b Claude Monet, *Branch of the Seine near Giverny (Mist)*, from the series *Mornings on the Seine*, 1897. Oil on canvas, 89.9 × 92.7 (35⅜ × 36½). Art Institute of Chicago

280 Utagawa Hiroshige, *View of the Harbour (Miya: Station no. 42)*, from *Fifty-three Stations of the Tōkaidō*, c. 1847–52. Woodblock print, 23.5 × 36.3 (9¼ × 14¼)

281 Vincent van Gogh, *Père Tanguy*, 1887. Oil on canvas, 92 × 75 (36¼ × 29½). Musée Rodin, Paris

282al Utagawa Hiroshige, *Plum Estate, Kameido*, No. 30 from *One Hundred Famous Views of Edo*, 1857. Woodblock print, image 34 × 22.6 (13⅜ × 8⅞), sheet 36 × 23.5 (14 × 9). Brooklyn Museum, New York

282ar Vincent van Gogh, *Flowering Plum Orchard (after Hiroshige)*, 1887. Oil on canvas, 55.6 × 46.8 (21⅞ × 18⅜). Van Gogh Museum, Amsterdam

282b Kano Sansetsu, *Old Plum*, 1646. Four sliding-door panels (fusuma); ink, colour, gold and gold leaf on paper, 174.6 × 485.5 (68¾ × 191⅛). The Metropolitan Museum of Art, New York

283 Paul Gauguin, *Vision of the Sermon (Jacob Wrestling with the Angel)*, 1888. Oil on canvas, 72.2 × 91 (28⅜ × 35¾). National Galleries of Scotland

284al Parthenon frieze (detail), c. 440 BC, Acropolis Museum, Athens

284ar Paul Gauguin, *The White Horse*, 1898. Oil on canvas, 140 × 91.5 (55 × 36). Musée d'Orsay, Paris

284b Paul Gauguin, *Ta matete (The Market)*, 1892. Oil on canvas, 73.2 × 91.5 (28⅞ × 36). Kunstmuseum Basel

287 Henri Matisse, *The Red Studio*, 1911. Oil on canvas, 181 × 219 (75 × 86). The Museum of Modern Art, New York. Photo The Museum of Modern Art, New York/Scala, Florence. © Succession H. Matisse/DACS 2016

288 Georges Braque, *Still Life (with clarinet)*, 1927. Oil on canvas, 53.9 × 73 (21¼ × 28¾). The Phillips Collection, Washington, DC. © ADAGP, Paris and DACS, London 2016

289 Pablo Picasso, *The Dream*, 1932. Oil on canvas, 130 × 97 (51 × 38). Private collection of Steven A. Cohen. Photo Scala 2016, Florence. © Succession Picasso/DACS, London 2016

290 El Greco, *The Vision of Saint John*, c. 1609–14. Oil on canvas, 224.8 × 199.4 (88½ × 78½) (with added strip). The Metropolitan Museum of Art, New York

291 Pablo Picasso, *Les Demoiselles d'Avignon*, 1907. Oil on canvas, 243.9 × 233.7 (96 × 92). The Museum of Modern Art. Photo The Museum of Modern Art, New York/Scala, Florence. © Succession Picasso/DACS, London 2016

293 Ellsworth Kelly, *Study for Rebound*, 1955. Ink and pencil on paper, 44.8 × 46.7 (17⅝ × 18⅜). The Museum of Modern Art, New York (gift of the artist in honor of Dorothy Miller). Courtesy Ellsworth Kelly Studio. © Ellsworth Kelly

295a Jackson Pollock, *Autumn Rhythm (Number 30)*, 1950. Enamel on canvas, 266.7 × 525.8 (105 × 207). The Metropolitan Museum of Art, New York. © The Pollock-Krasner Foundation ARS, NY and DACS, London 2016

295b Zeng Fanzhi, *Untitled 07–14*, 2007. Oil on canvas, 260 × 540 (102.3 × 212½). © 2016 Zeng Fanzhi Studio

297 John Minihan, *David Hockney with camera, London*, 1975. Photo John Minihan. © University College Cork

298 Honoré Daumier, *Patience is the Virtue of Donkeys*, Le Charivari, 2 September 1840. Lithograph. Bibliothèque Municipale de Lyon

299 Maurice Denis, *Two girls, wading in the sea, swinging little Madeleine, Perros-Guirec*, 1909. Gelatin silver print. Musée Maurice Denis, Saint-Germain-en-Laye. Photo Musée d'Orsay, Dist. RMN-Grand Palais/Patrice Schmidt

300 Édouard Vuillard, *Madame Vuillard and Romain Coolus*, c. 1905. Gelatin silver print. Private collection

301 Édouard Vuillard, *Le Petit Déjeuner*, 1894. Oil on cardboard, 26.9 × 22.9 (10⅝ × 9). National Gallery of Art, Washington, DC

303 Jacques Henri Lartigue, *Bichonnade, 40 rue Cortambert Paris*, 1905. Gelatin silver print. © Ministère de la Culture, France/ AAJHL

305a *Welcome 'Lady Lindy'!*, Daily Sketch, May 23, 1932

305b Walter Richard Sickert, *Miss Earhart's Arrival*, 1932. Oil on canvas, 717 × 183.2 (282¼ × 72⅛). Tate, London

306 Henri Cartier-Bresson, *Hyères, France*, 1932. Gelatin silver print. © Henri Cartier-Bresson/ Magnum Photos

307 Robert Frank, *Belle Isle – Detroit*, 1955, from The Americans. Gelatin silver print. © Robert Frank. Courtesy Pace/MacGill Gallery, New York

308a Eadweard Muybridge, *The Horse in Motion*, 1878

308b Edgar Degas, *Horse with Jockey in Profile*, c. 1887–90. Red chalk on off-white thin wove paper, 28.3 × 41.8 (11⅛ × 16½). Museum Boymans Van Beuningen, Rotterdam

309a Étienne-Jules Marey, *Motion Study*, c. 1884. Chronophotograph

309b Marcel Duchamp, *Nude Descending a Staircase (No. 2)*. Oil on canvas, 147 × 89.2 (57⅞ × 35⅛). Philadelphia Museum of Art. © Succession Marcel Duchamp/ADAGP, Paris and DACS, London 2016

311 Théodore Géricault, *The Raft of the Medusa*, 1818–19. Oil on canvas, 491 × 716 (193¼ × 281⅞). Louvre, Paris. Photo Scala, Florence

312a John Martin, *Belshazzar's Feast*, c. 1820. Oil on canvas, 80 × 120.7 (31½ × 47½). Yale Center for British Art. Liszt collection/Alamy Stock Photo

312b *Audience Watching a Diorama*, 1848. Engraving. Mary Evans Picture Library

313 Louis Daguerre, *Ruins of Holyrood Chapel*, c. 1824. Oil on canvas, 211 × 256.3 (83 × 100⅞). National Museums Liverpool

314 Still from Charlie Chaplin, *City Lights*, 1931. United Artists. United Artists/The Kobal Collection

317a Still from Louis Lumière, *Employees Leaving the Lumière Factory*, 1895

317b Still from Georges Méliès, *The Vanishing Lady*, 1896

319a Still from Georges Méliès, *A Trip to the Moon*, 1902

319c Still from Charles-Émile Reynaud, *Pauvre Pierrot*, 1892

319b Still from Walt Disney, *The Jungle Book*, 1967. © 1967 Walt Disney

320 Stills from Charles Reisner, *Steamboat Bill, Jr.*, 1928. Buster Keaton Productions, Joseph M. Schenck Productions

321 Still from Sergei M. Eisenstein, *Battleship Potemkin*, 1925. Goskino, Mosfilm

322 Fritz Lang filming *Metropolis*, 1927. Photos 12/Alamy Stock Photo

323 Luis Buñuel, *Un Chien Andalou*, 1929. Moviestore collection Ltd/Alamy Stock Photo

324 Still from Victor Fleming, *The Wizard of Oz*, 1939. Metro-Goldwyn-Mayer (now Warner Bros). © AF archive/Alamy Stock Photo

325a Still from Orson Welles, *Citizen Kane*, 1941. RKO Radio Pictures, Mercury Productions

325b Lorenzo Lotto, *Annunciation*, c. 1534. Oil on canvas, 166 × 114 (65⅜ × 44⅞). Museo Civico, Villa Colloredo Mels, Recanati, Marche

326a Still from Sean S. Cunningham, *Friday the 13th*, 1980. Paramount Pictures, Warner Bros, Georgetown Productions Inc.

326b Peter Doig, *Canoe-Lake*, 1997–98. Oil on canvas, 200 × 300 (78¾ × 118⅛). Yaego Foundation Collection, Taiwan. © Peter Doig. All Rights Reserved, DACS 2016

328a Diego Velázquez, *The Surrender of Breda*, c. 1635. Oil on canvas, 307 × 367 (120⅞ × 144½). Museo del Prado, Madrid

328b Still from Sergei M. Eisenstein, *Alexander Nevsky*, 1938. Mosfilm

329 Still from Lloyd Bacon, *Footlight Parade*, 1933. Warner Bros. Warner Bros/The Kobal Collection

330a Still from Alfred Hitchcock, *Psycho*, 1960. Shamley Productions. Paramount/The Kobal Collection

330b Edward Hopper, *House by the Railroad*, 1925. Oil on canvas, 61 × 73.7 (24 × 29). The Museum of Modern Art, New York. © Heritage Image Partnership Ltd/Alamy Stock

331a Still from Martin Scorsese, *Taxi Driver*, 1976. Columbia Pictures

331b David Hockney, *Santa Monica Blvd.*, 1978–80. Acrylic on canvas, 218.4 × 609 (86 × 240). The David Hockney Foundation. Photo Richard Schmidt. © David Hockney

332a Still from Fritz Lang, *Metropolis*, 1927. Universum Film (UFA)

332b Pieter Bruegel the Elder, *The Tower of Babel*, c. 1565. Oil on panel, 59.9 × 74.6 (23⅝ × 29⅜). Museum Boijmans Van Beuningen, Rotterdam

333l Pontormo, *The Visitation*, c. 1528. Oil on panel, 202 × 156 (79½ × 61⅜). Church of San Michele Carmignano, Tuscany

333r Bill Viola, *The Greeting*, 1995. Video/sound installation. Colour video projection on large vertical screen mounted on wall in darkened space; amplified stereo sound. Production still. Projected image size 280 × 240 (9 ft 3 in. × 7 ft 11 in.), room dimensions 430 × 670 × 760 (14 × 22 × 25 ft). Performers: Angela Black, Suzanne Peters, Bonnie Snyder. Photo Kira Perov, courtesy of Bill Viola Studio

335 LA studio, 9 March 2015. Photo David Hockney. © David Hockney

336–337 Joe Sacco, *The Great War: July 1st, 1916: The First Day of the Battle of the Somme* (detail). Used by permission of The Marsh Agency on behalf of Joe Sacco, W. W. Norton & Company, Inc. and Random House Group Limited. © 2013 by Joe Sacco

338 David Hockney, *Mr and Mrs Clark and Percy*, 1970–71. Acrylic on canvas, 213.3 × 304.8 (84 × 120). Tate, London. © David Hockney

341 David Hockney, *4 Blue Stools*, 2014. Photographic drawing printed on paper, mounted on Dibond, edition of 25, 108 × 176.5 (42½ × 69½). Photo Richard Schmidt. © David Hockney

Acknowledgments

The authors would like to thank Jean-Pierre Gonçalves de Lima, who took the beautiful photograph that opens the book, and also thank him, Gregory Evans, Jonathan Wilkinson, Jonathan Mills and Julie Green for their help and encouragement. At various points Dominique de Font-Réaulx, Josephine Gayford, Thomas Gayford, Vikram Jayanti, Martin Kemp, Anne Lyles, Philip Steadman, Ian Warrell and Clovis Whitfield have read part or all of the text and made valuable suggestions, for which we are most grateful. Thanks are also due to Sam Phillips, the editor of *RA Magazine*, for permission to reprint on p. 40 portions of DH's comments on Rembrandt's drawing that first appeared in the Summer 2004 issue. Finally, the team at Thames & Hudson deserves a bouquet for having done a tremendous job on the editing, image research and design of this complex book.

Index

Page numbers in *italic* refer
to the illustrations